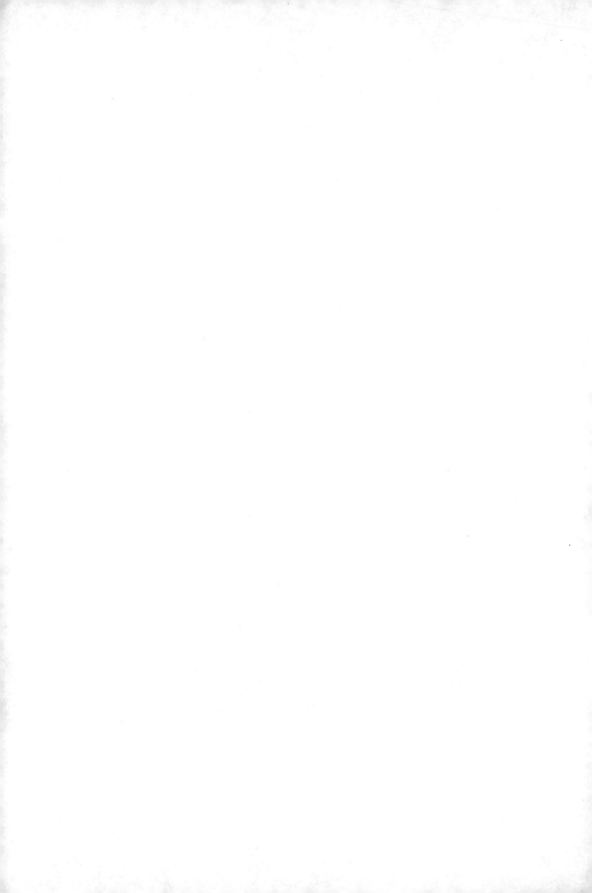

GOING, GOING, GONE:

REGULATING THE MARKET IN ILLICIT ANTIQUITIES

Dr S.R.M. Mackenzie
School of Law, University of Westminster
School of Criminology, Education,
Sociology and Social Work, Keele University

Copyright: Simon Mackenzie and the Institute of Art and Law.

Published in Great Britain in 2005 by the Institute of Art and Law, 1-5 Cank Street, Leicester, LE1 5GX

Tel: 0116 253 8888; Fax: 0116 251 1666

E-mail: info@ial.uk.com

ISBN: 1-903987-8-3 (hardback); 1-903987-07-5 (softback)

ACKNOWLEDGEMENTS

I should like to thank Professor Ken Polk, a scholar to emulate and a good friend, firstly for introducing me to the issue of the looting of antiquities, and secondly for his continuing support and encouragement in the production of this research.

For my wife I steal a dedication from John C. Meagher's 'Method and Meaning in Johnson's Masques'.[i] I feel I should beg both her and his indulgence in this theft, for different reasons. He wrote:

> "To my wife... whose utter indifference to the entire project was a constant source of perspective."

I must also give credit to the interviewees, without whom there would have been little new to say on the subject. Although there are serious problems with the way the market performs, I am sincerely of the view that these are remediable and would ask readers in the market to note at the outset that my standpoint is one of a proposed fix to a broken engine, rather than the relegation of that machine to scrap. For those interviewees who found themselves able to stand back and frankly criticise the market, and their place in it, I reserve my greatest admiration, and curiosity:

> *The whole thing is just a pastiche of lies, cheating and lack of integrity on all levels by most of the people involved. That's the art market, basically.* (London Dealer 4)

i J.C. Meagher, *Method and Meaning in Johnson's Masques* (1969, Indiana: University of Notre Dame Press).

CONTENTS

CHAPTER 1

THE PROBLEM

1.1 THE RESEARCH QUESTION

The question this book will try to answer is:

> "How should we regulate the antiquities market so as most appropriately to address the issue of looted antiquities in that market?"

The book will therefore take the form of:

(a) an analysis of the current legal position governing the movement and trade of antiquities, particularly looted antiquities;

(b) an assertion that this current legal structure is not optimal, supported by

 (i) legal argument based on the observed operation of the current laws,

 (ii) current theoretical approaches to the issue of market governance, and

 (iii) sociological argument based on the observed behaviour and interview data of key figures in the market, and their attitude toward regulation;

(c) a recommendation as to a more appropriate mode of regulation for the antiquities market.

This introductory chapter will address the questions 'what is looting?', 'what is its extent?' and 'where do the looted artefacts go?' Before we talk of how best to regulate the market, we must be sure of the existence and form of the looting problem we wish to address. Chapter 1 forms a brief overview of the looting issue; much of what is stated here will be explored further with reference to the interview data below.

Some initial points to explain the approach taken in the book: it is clichéd for a writer to appeal to size restrictions in reference to what might have been, given more time and space; it is clearly impossible, however, for a work of this size to examine the laws of all countries which are the source of antiquities and all countries which import them. Without intending to restrict the remit of the research unnecessarily – it remains concerned with the problems facing the market generally – I have chosen in some places to opt for a closer examination of the laws of specific States so as to provide some of

the detail that would otherwise be lacking from a general analysis. Where this is the case, I have chosen Thailand as an example of a 'source State' and New York and London as the major destination cities in the world's two largest 'market States'. Guided by this structure of analysis, the bulk of the interview data was gathered in these three locations. Scotland, of course has a legal system separate from that of England and Wales and now has power to legislate for itself in certain devolved matters, one of which is the criminal law. Northern Ireland, too, has a separate legislative framework. Our legal examination in relation to the movement of objects to and from London will therefore rather than exploring 'UK law', be restricted to that of England and Wales. The United Kingdom as a body will still be referred to where the discussion permits; for example where general matters such as import controls common to all of its constituent jurisdictions are analysed. Even here, though, we will see that specifics of local law become important, and for these specifics we shall revert to England and Wales as the subject. Where space permits I shall also mention the laws of Australia; specifically the State of Victoria, as three of the core interviews were carried out in Melbourne.

1.2 CLASSIFICATION OF THE ISSUE AND ITS TERMINOLOGY

My concern is with looted antiquities. That is to say, antiquities taken illicitly from somewhere. That *somewhere* can be categorised. My first concern is with antiquities taken illicitly from the ground,[1] or from their place as an integral part of, or attachment to, a temple or other ancient structure. My second concern (which is to some extent subsidiary) is with antiquities taken illicitly from the possession of individuals, institutions (such as museums or churches) or other resting places which do not harbour any archaeological interest in their link with the antiquity itself.

An example of the first category of looted antiquity is the Sevso treasure, undiscovered and unknown by the art world until it surfaced on the market.[2] While generally acknowledged to have been looted, it is still not certain from where. The case of the Sevso treasure is considered later in this chapter. An example of the second category of looted antiquity is the rare Koberg bible recently found to have been stolen from a Council safe in Scotland.[3]

1 Underwater cultural heritage is not directly addressed in this book. Many of the issues dealt with herein are transferable, *mutatis mutandis*, to the study of the protection of underwater cultural heritage. However, the circumstances surrounding the discovery and extraction of material from the seabed are sufficiently idiosyncratic to merit an analysis of that process in its own right and therefore while many of the dealers, collectors and museums interviewed for this project buy antiquities salvaged from wrecks as well as those extracted from the ground, any parallels the reader might wish to infer from the data presented here should be drawn with appropriate caution.

2 C. Renfew, *Loot, Legitimacy and Ownership: the Ethical Crisis in Archaeology* (1999, Amsterdam, Joh. Enschede).

3 S. England, '£800,000 Bible Vanishes from Council's Safe' *The Times, Scotland,* 6 February 2002, 5.

Hereinafter, to aid differentiation, the first category of antiquities will be referred to as 'looted', while where the term 'stolen' is used, this will include both the first ('looted') category and the second category. Some of the second category of objects stolen from individuals or institutions may of course have been looted prior to becoming part of those collections. This aside, however, the importance of the inclusion of the category 'stolen objects' in the book comes from the fact that in some instances the law will not differentiate between 'looted' objects stolen from countries and privately owned objects stolen from individuals or institutions. It will therefore be helpful to have a shorthand term to cover all objects which have been taken illegally from somewhere.

The remit of this work is to define a framework of regulation which would:

(a) in the first category, decrease the incidence of looting such that antiquities remain in the ground until such time as they are discovered and excavated by qualified archaeologists; and

(b) in the second category, decrease the incidence of theft from individuals and institutions while also increasing the likelihood that any such dispossessed individuals or institutions would be able to pursue their property and secure its return.

For reasons that will become clear, I am more concerned with the first category – looting – and have devoted much of my research to the investigation of that phenomenon and the search for solutions. Throughout the course of the research, however, it became apparent that a solution to the first category of cultural harm might well be compatible with the second category.

1.2.1 Illicit Antiquities

We talk of *illicit* antiquities. This recognises that owing to laws which will be explored in due course, an artefact may well be legally owned or traded in one country even though it has at some stage been the object of a violation of criminal or administrative provisions in another country. In order therefore to distinguish items with a breach of the law in their history from those which have been the subject of no such breach, we term the former 'illicit':

> An object being illicitly trafficked, then, is one in respect of which some offence has been committed: such an offence is defined by the laws of the country of origin and may include clandestine excavation, theft, breach of inalienability or rights of pre-emption, failure to comply with trading regulations or violation of export control.[4]

4 L.V. Prott and P.J. O'Keefe, *Law and the Cultural Heritage, Volume 3: Movement*, (1989, London, Butterworths) at p. 561.

Antiquities being sold on the open market today fall into three categories, listed below. The first is licit, the second is a grey area, and the third is illicit:

1. Antiquities excavated by an authorised person. That person would usually be an archaeologist, who would have documented the find and its context for publication in research journals before relinquishing possession of the objects found to their appropriate legal owner who, depending on the country where the object is found, will usually be either the State or the owner of the land on which the find was made. With a few exceptions,[5] countries where antiquities are found try hard to retain their heritage; the result is that the number of objects entering the market as part of this category is small.

2. Looted antiquities not excavated by an authorised person, but which have been out of the ground, or other context, for such a length of time that their presence on the market, or (sometimes more accurately) in private collections with the potential in the future to enter the market, is tolerated by those with a legal interest in the trade of stolen goods. Remember that in this context we apply the term 'looting' to any illegal excavation of antiquities or their illegal removal from sites or structures to which they are attached or properly belong. Illegal, of course, by the law which governs individuals at the time of excavation; always the *lex situs* (the law of the State where the object is when it is looted). These, therefore, are originally illicit antiquities made licit by the operation of time. It is currently not possible to know the relative size of this category.

3. Recently-looted antiquities, whose presence on the market would not be similarly tolerated by the law, but which are accepted by the market for either or both of two reasons. They can masquerade as category 2 antiquities.[6] It is this masquerade, of stolen goods being sold in apparently legitimate circumstances, which partly holds the key to the open trade in looted antiquities that currently persists. In addition to this masquerade, the market holds out that many antiquities are accidental finds,

5 One such exception is the United Kingdom which allows landowners for the most part to sell antiquities found in their soil. Even here, mechanisms are in place to encourage the retention of important finds within the UK, although as we shall see these are only partially effective. Another exception is the case of the sharing of underwater finds between the country with jurisdiction over the relevant waters and the salvage firm which extracts the antiquities. A topcial example of this is the excavation of the Hoi Ahn shipwreck. The recent UNESCO Convention on Underwater Cultural Heritage attempts to outlaw any commercial exploitation of underwater cultural heritage, however, and if effective in its goals will put an end to this category of co-operation between source governments and business enterprises; on the Convention generally, see P.J. O'Keefe, *Shipwrecked Heritage* (2002, Leicester, Institute of Art and Law).

6 They may also masquerade as category 1 antiquities, but this is rare as compared to the category 2 masquerade.

discovered for example in the course of roadworks. This enables chance finds to be viewed as morally acceptable subjects of purchase for the market, although they are illicit.

One might add a fourth category – 'fakes' – being modern reproductions which masquerade as antiquities, but the issue of faking is not of much relevance to the problem this research sets out to solve, being a fraud on buyers which does not involve the destruction of context.[7]

1.2.2 Provenance and Provenience

The masquerade in category 3 above is made possible by the mechanisms which the market uses to transfer ownership of antiquities. 'Provenance' in this regard has two senses. It can mean the past history of ownership of the item, and it can mean the documented circumstances (time, place, context) of excavation. Archaeologists sometimes call the second type of provenance 'provenience'. Its use is particularly prevalent in American archaeological circles. One such archaeologist explains:

> The differences are exemplified by the difference between the stark English provenience, meaning the original context of an object, and the more melodious French provenance, used by the art world, which may include the original source but is primarily concerned with a history of ownership.[8]

We shall adopt this distinction here. Hereinafter, where details of the findspot of an object are discussed, the word 'provenience' will be used. Where, however, the broader concept of the history of the object from finding, through its various owners to present day, is to be discussed, the word 'provenance' will be used. In the sense in which they are used in this book, therefore, provenance includes provenience, but provenience does not include provenance. This will enable us to reduce the verbosity required to discuss legal questions of title to a chattel, while allowing identification of the importance of the findspot in legal and archaeological terms.

Market sales of antiquities very rarely include details of provenience. They sometimes include provenance, in different degrees, from the unusual case of the tracing of ownership far enough back to assure the purchaser that the object was not recently looted, to the more

7 It would be useful to include the problem of fakes alongside the problem of looting in this work, as both rest on the same inability to tell where an object has come from, but space dictates otherwise. The solution set out in ch. 7 which addresses the central problem of looting would also go some way towards ameliorating the problem of fakes in the market, but I leave this as a collateral benefit for those interested in that issue to consider further, and retain my focus on addressing the looting problem.

8 C. Coggins, 'United States Cultural Property Legislation: Observations of a Combatant', (1998) 7 *International Journal of Cultural Property* 57.

usual case of the provision of a general reassurance that someone of repute currently owns the object and therefore the buyer will get good title to it on payment of the purchase price. Study the pages of auction catalogues advertising antiquities and one sees the ubiquitous lure 'from the collection of a Swiss gentleman'.

Geneva, Switzerland is a 'free port'. It gives export documentation to all sorts of imported goods, whether they enter Switzerland with legitimate papers or not, and for this reason is a site of considerable importance globally in relation to transactions involving antiquities which have originated elsewhere.[9] Hong Kong and Singapore are also free ports, and were recognised as far back as 1972 as important exit points for antiquities from southeast Asia owing to their lack of regulation of imports and exports and their central position as tourist destinations.[10] The borders of such free ports are relatively open. By way of example, it is not illegal *per se* to import antiquities into Hong Kong, although import without a manifest (a document detailing the particulars of cargo for customs) amounts to smuggling and is an offence under Hong Kong law by virtue of its Import and Export Ordinance cap. 60, sections 17, 18 and 18A.[11] Hong Kong is the Asian centre for the sale of Chinese antiquities, but many Thai antiquities also move through Hong Kong on their way out of the region – Hong Kong has increasingly been developed as a centre for auctions of Southeast Asian antiquities owing to its favourable position geographically, commercially and in terms of its import/export regulation.[12]

Imagine a recently-looted Thai antiquity which enters Switzerland and then promptly leaves, to be sold on the market in New York. It is sold, at auction or by a dealer, on the premise not that it was 'recently looted' but rather that it is the property of a Swiss collector who wishes to remain anonymous but who has had the object for a number of years and now wishes to realise the value of his investment. The object has legal export papers from Switzerland, and it therefore has no trouble penetrating the customs barrier of the United States of America. How might a wary buyer find out that it has been recently looted? The answer, of course, is that the buyer will not know, or perhaps even suspect, that the object has provenance other than that represented to him by the dealer.

The reader might legitimately ask whether this example attributes too devious a mind to international dealers in antiquities. To that, there are two retorts. Firstly, there is evidence that dealers do make use of this technique of representation to 'legitimise' their possession

9 P. Watson, *Sotheby's: the Inside Story*, pp. 113-126 (1997, London, Bloomsbury).
10 ICOM, 'Protection of Cultural Property in Southeast Asia', *Report and Recommendations of a Meeting of Experts, Malacca, Malaysia, 12-13 December 1972.* (1973, New Delhi, International Council of Museums).
11 J.D. Murphy, *Plunder and Preservation: Cultural Property Law and Practice in the People's Republic of China* at p. 58 (1995, Hong Kong, Oxford University Press).
12 J. Thompson, 'The Hong Kong Auction Market', *Connoisseur*, May 1981, p. 36.

and sale of looted antiquities.[13] The recent conviction of New York dealer Frederick Schultz[14] – a case which will be referred to on several issues in the course of this book – provides an example. Mr Schultz bought several Egyptian antiquities from Jonathan Tokeley-Parry, an English art smuggler. In evidence it emerged that Schultz had, with Tokeley-Parry, invented a collector named Thomas Alcock and used this fictional collector as the apparent source of the looted antiquities, even going so far as to affix labels artificially 'aged' in tea to the objects, which made reference to their possession by Mr Alcock.

The second reply to the question as to whether dealers deliberately take advantage of the lack of required provenance – both by not asking too much when buying and not telling too much when selling – is that while some certainly do, many do not. Yet even those who do not exploit the market with such active intent can be implicated in the flow of illicit antiquities through their passive approach to the issue of provenance. Nearly fifteen years ago, seminal writers in this field Lyndel Prott and Patrick O'Keefe cited the former director of the Metropolitan Museum in New York, Thomas Hoving[15] in support of their contention that:

> Despite the body of evidence that a large proportion of material which is illicitly traded is directly connected with other offences against cultural property in the country of origin, it is difficult to escape the conclusion that some members of the trade are indifferent to the origin of the goods being serviced. Though these dealers and experts prefer not to be engaged in outright dishonest practices, they may not enquire into the provenance or authenticity of an object brought to them for service.[16]

Therefore even if not exploited in a deceitful and Machiavellian way, foggy provenance details still confound our aim of the reduction of looting. For those dealers, museum buyers and collectors who wish to avoid dealing in looted antiquities, the reluctance of the market to accommodate detailed requests for provenance can prove frustrating. Without having to allege at this stage in the analysis that much of what is on the antiquities market is looted, we can simply surmise that there is little way for buyers to tell, so long as issues such as the protection of the privacy of sellers continue to be regarded as acceptable barriers to the disclosure of provenance. If the demand for looted antiquities is to be reduced, one of the most

13 The inverted commas are used as a recognition that such techniques do not actually legitimise stolen goods. If the truth were to be discovered, the goods would be seen as illegitimate. But the technique gives antiquities the appearance of legitimacy, and without dogged inquiry by the buyer, that appearance is usually enough to secure a sale.

14 178 F. Supp. 2d 445 (S.D.N.Y. 2002), 333 F.2d 393 (2d Cir. 2003). 147 L.Ed 2d 891 (2004).

15 T.P.F. Hoving, *King of the Confessors* (1981, New York, Simon and Schuster).

16 Prott and O'Keefe, *op. cit.* note 4, at pp. 538-9.

important preliminary steps in such a reduction must be the incorporation of mechanisms into the market system which enable looted antiquities to be identified as such.

1.2.3 Source States and Market States

John Henry Merryman succinctly summarises a broad classification which we shall use here. Countries may be classified for theoretical analysis of the issue as 'source' or 'market' countries, depending upon their net levels of export and import of cultural property:

> ... the world divides itself into source nations and market nations. In source nations, the supply of desirable cultural property exceeds the internal demand. Nations like Mexico, Egypt, Greece and India are obvious examples. They are rich in cultural artefacts beyond any conceivable local use. In market nations, the demand exceeds the supply. France, Germany, Japan, the Scandinavian nations, Switzerland and the United States are examples. Demand in the market nation encourages export from source nations. When, as is often (but not always) the case, the source nation is relatively poor and the market nation wealthy, an unrestricted market will encourage the net export of cultural property.[17]

Our discussion will therefore proceed on the basis of a distinction made between 'source States' and 'market States'. Such a geographical division is to some extent artificial. Many countries are both source States and market States. Australia, for example, is the source of Aboriginal remains and artefacts, prized by archaeologists for their historical relevance, and also home to a small but healthy market in international antiquities. Much of the archaeological debate in the United States is currently focused around the issue of the looting of Native American graves. The United Kingdom, for its part, has soil rich in a wide variety of antiquities, including many from the Roman Empire. Both the US and the UK are home to prosperous markets in internationally-sourced antiquities.

The division is used for two reasons. Firstly, one of the problems addressed in this book is the mechanism of international recovery of stolen antiquities or other misappropriated items of cultural property. Our hypothetical case must therefore involve the recovery of art which now resides in a different country from the claimant, so as fully to explore the international law aspects of the claim. The source/market division is thus useful for analytical purposes. This is true also on the level of domestic law. Many of the problems which obstruct the repatriation of antiquities and other items of stolen

17 J.H. Merryman, 'Two Ways of Thinking about Cultural Property', (1986) *American Journal of International Law* 80 at p. 831.

cultural property are caused by issues arising out of the differences between national legal systems, and it is useful to separate the source and market countries in our hypothetical cases in order more clearly to identify these issues. In support of this first reason for the source/ market division, most of the case law involves claims by source nations such as Greece and Turkey against consuming market nations such as the US and the UK rather than vice versa. Witness the current political wrangle over the Elgin Marbles (or the Parthenon Marbles, as they are to Greece) for a good illustration.

Secondly, while most States are a source for *something* in the way of antiquities or other cultural property and a market for something else, on a systemic level we can see that there is a continuing trend for large amounts of antiquities to flow from impoverished source countries to relatively wealthy consumer nations, as indeed Merryman (himself something of a free-market proponent for the movement of antiquities) acknowledges above. For all that the US and the UK are sources of antiquities, an analysis of the international market reveals that they are the greatest consumers. The world trade in antiquities has its home in New York and London. While, therefore, we should be mindful of the reality of the dynamics of the particular market under study when the terms 'source' and 'market' are used, and acknowledge that market States such as the United Kingdom as well as poorer source nations such as Thailand experience looting problems, the source/market terminology allows us to identify the problems at the heart of the market generally and further allows us to talk about them in terms which are not tied down to the specifics of the parochial experiences of individual nations.

1.2.4 Context

As noted above, the primary concern of this book is with the issue of antiquities illicitly dug out of the ground or removed from standing ancient structures. The issues surrounding the movement of cultural property more generally, such as loss of national patrimony in the case of paintings and other artworks which travel abroad, are pertinent here as well, but there is one facet of the market in stolen art which is of singular importance to the problem of illicit antiquities and which does not occur in relation to the movement of other items of cultural property. That facet is the loss of stratified context. The association between artefacts *inter se*, and the earth in which they are found, can add greatly to our knowledge about the human past.[18] The collection of such knowledge and its publication is the essence of archaeology.

18 A rich vein of sentiment runs through the literature raising awareness of the worth of context, but for a succinct statement of its importance see P. Gerstenblith, (2000) 'Museums, the Market and Antiquities' Part I, *University of Chicago Cultural Property Workshop website* at http://culturalpolicy.uchicago.edu/workshop/gerstenblith.html (version current at 4 December 2003).

1.3 The Scale of the Problem Generally: International

1.3.1 Is the Looting Problem Real?

An early record of looting comes from Dr Carlo Lerici, the inventor of electronic 'spades' for the location of Etruscan tombs. In a 1958 speech to the Rotary club of Rome he reported that of the 550 chamber tombs he and his team had discovered in Cerveteri using his invention, nearly 400 of them had been previously stripped by 'tombaroli' – the Italian word for tomb robbers.[19] Italy's Carabinieri Unit for the Protection of Cultural Heritage, since its establishment on 3rd May 1969 claims to have recovered 455,771 objects looted from under Italian soil, together with 185,295 works of art stolen mostly from churches and private homes.[20]

As a final initial example, a study of a 125-square mile area in Mali undertaken between 1989 and 1991 revealed that 45% of a total of 834 sites found had been looted.[21] Recorded incidences of looting are readily available, and will be introduced throughout the book, where relevant.

1.3.2 Provenance, Provenience and the Inference of Looting

Two sets of quantitative studies should be mentioned here, being the most prominent of the few studies into looting which have been performed using statistical analysis. The first is the ongoing research project of Ricardo Elia, Professor of Archaeology at Boston University.

1.3.2.1 Elia: Apulian vases

Professor Elia has conducted investigations into South Italian vases, particularly those from the region of Apulia. More than 20,000 vases are known from South Italy and Sicily,[22] including some 13,631 Apulian.[23] Of these recorded Apulian vases, he found 88% to have no provenience at all. Almost all (94.5%) had not been excavated archaeologically, rather their excavation was by other, less scientific, means. Elia studied the auction catalogues of Sotheby's, the leading vendor of Apulian vases, for the period 1960-1998. During that period, he found 1,550 such vases put up for auction, some of those more than once, making the total number of catalogue entries 1,886.[24] None had provenience – all were undocumented as to their

19 K. Meyer, *The Plundered Past: the Traffic in Art Treasures* (1973, New York, Atheneum), at p. 84.

20 L. Hales, 'Art-Theft Cops and the Loot of All Evil' *Washington Post*, Sunday 10 August 2003: N01.

21 N.E. Palmer, P. Addyman, R. Anderson, A. Browne, A. Somers Cocks, M. Davies, J. Ede, J. Van der Lande & C. Renfrew, 'Ministerial Advisory Panel on Illicit Trade', December 2000 (hereinafter: ITAP Report) London, UK Home Office Department for Culture, Media and Sport, 51, Annex A para. 54c.

22 A.D. Trendall, (1989) *Red Figure Vases of South Italy and Sicily: a Handbook*. (1989, London, Thames and Hudson).

23 'Analysis of the Looting, Selling and Collecting of Apulian Red-Figure Vases: a Quantitative Approach', in N. Brodie, J. Doole & C. Renfrew (eds) *Trade in Illicit Antiquities: the Destruction of the World's Archaeological Heritage*, (2001, Cambridge, MacDonald Institute for Archaeological Research) at p. 146.

24 *Ibid.*, at p. 150.

place of origin or discovery. Provenance, in terms of previous owner/ collector history, was offered for 15%. Elia presents evidence of much looting in the region from which these vases come,[25] and implicates Sotheby's in the looting:

> Sotheby's ability to offer a large steady supply of Apulian vases each year since 1966, coupled with the fact that 85% of these vases have no previous ownership history, indicates that Sotheby's has had direct links to large-scale, commercial sources of undocumented Apulian vases.[26]

This is a bit of a leap, if 'undocumented' is intended to be taken as synonymous with 'looted', as is the suggestion in his next paragraph: "The source of these unprovenienced pots must be recently looted archaeological sites". The numbers might well indicate a simple reticence on the part of the auction house to reveal details of prior ownership, perhaps at the behest of those owners themselves. That is a problem in itself. The lack of provenience is more damning. It is hard to think of a reason why provenience information would not be given if it were available. Perhaps in many cases it becomes lost over time. That too is a problem to which we can turn our attention. Elia may have it right, and my caution with his interpretation of the figures may award too much noble spirit to auctioneers who do not provide information. But even if that is the case, measures which require the keeping and passing on of both provenience and provenance will reduce the ability of sellers to pass undocumented antiquities into the market.

1.3.2.2 Chippindale & Gill: (a) Cycladic figures and classical collecting

The second set of quantitative studies are those of UK academics Christopher Chippindale and David Gill, who in 1993 published a study of the Cycladic figures known to the world, a corpus which is estimated at 1,600.[27] Their investigations conclude that only 143 of these figures were recovered archaeologically; the remaining 1,400 or so figures having surfaced on the antiquities market without explanation.[28] Nearly 90%, then, of all the Cycladic figures known to scholarship as at 1993 had no provenience:

> A first and immediate consequence of the circumstances under which some 90% of known Cycladic figures have

25 *Ibid.*, at pp. 150-151.
26 *Ibid.*, at p. 150.
27 D.J.W. Gill, & C. Chippindale, 'Material and Intellectual Consequences of Esteem for Cycladic Figures', (1993) 97 (3) *American Journal of Archaeology* at pp. 602-73.
28 'Surfacing' is a term used by commentators in this field to describe the first time an antiquity becomes known to the market generally. Usually this will be through publication in an auction catalogue or as part of a private collection opened for exhibition. Objects may surface with varying degrees of proffered provenance, although it will be unverifiable. This is because the only way currently to be sure that an object has the provenance stated is to check the publications for its prior sales or exhibitions, and by definition there will be no record available for a surfacing object.

been removed from the ground and moved around the world is a total loss of reliable information about their archaeological context.[29]

From the cemeteries in the region which have been excavated, it appears that Cycladic figures are found in approximately one grave in ten. Of the figures, 350 came from the Keros hoard, a single site subjected to mass looting. If these 350 are excluded from the calculation, along with the 143 which give indication of having been properly excavated, the remaining 1,100 figures represent some 11,000 looted graves.[30]

Following issue taken with their work by a dealer who, probably fairly, objected that their work on Cycladic figures could not be said to be representative of all areas of classical antiquity collecting, Chippindale and Gill produced a broader study of seven contemporary classical collections and exhibitions.[31] Three of the seven collections studied were those of prominent collectors: Shelby White and Leon Levy's 'Glories of the Past' exhibition at the Metropolitan Museum of Art in New York (14th September 1990-27th January 1991); Barbara and Lawrence Fleischman's 'A Passion for Antiquities' exhibition at the J. Paul Getty Museum in Malibu (13th October 1994-15th January 1995) and at the Cleveland Museum of Art (15th February-23rd April 1995); and George Ortiz's 'In Pursuit of the Absolute' exhibition at the Royal Academy in London (20th January-6th April 1994). The four other groups of art studied were: 'Italy of the Etruscans' at the Israel Museum in Jerusalem (summer 1991); 'The Crossroads of Asia: Transformation in Image and Symbol in the Art of Ancient Afghanistan and Pakistan' at the Fitzwilliam Museum at the University of Cambridge (6th October-13th December 1992); 'The Fire of Hephaistos: Large Classical Bronzes from North American Collections' at the Arthur M. Sackler Art Museum at Harvard University (20th April-11th August 1996), the Toledo Museum of Art, Toledo (13th October-5th January 1997) and at the Tampa Museum of Art, Tampa (2nd February-13th April 1997); and finally 'Greek Vases in the San Antonio Museum of Art' at the San Antonio Museum of Art (permanent collection) as published in the 1995 catalogue of the same name.

Of the 1,396 objects in these exhibitions, around three-quarters displayed no evidence of having a known and recorded findspot.[32] Where provenience is known it is usually displayed, the authors insist, as it adds value: 'one sees this in the auction catalogues, where even scraps of information are carefully offered'.[33] One

29 Gill & Chippindale, *op. cit.* note 27.
30 *Ibid.*
31 C. Chippindale, & D.J.W. Gill, 'Material Consequences of Contemporary Classical Collecting', (2000) 104 *American Journal of Archaeology* at pp. 463-511.
32 *Ibid.*, at p. 479.
33 *Ibid.*, at p. 467.

suspects that exhibitors might be wary of publicising the provenience of an object lest it be pursued by a source country which claims that it was looted, but there appears no reason why an object with legitimate provenience should not be displayed along with that information. In terms of provenance (i.e. history of ownership), only 10% of all of the objects in the sample had named provenance, and of that 10% one third surfaced for the first time on the occasion of the exhibitions.[34] This would seem to render the number with verifiable named provenances in the region of 7% of the sample.

1.3.2.3 Chippindale & Gill:
(b) Provenance and provenience in auction sales

These same authors also studied five auction sales from the spring 1997 auction season. A mere six objects out of the 1595 in the five sales had details of provenience. As for provenance, 82% of the objects surfaced without offered provenance in the catalogues studied, i.e. 1,314 out of the 1,595 in the study.[35]

Linked with Chippindale and Gill's work is another quantitative study of the London auction market since the Second World War.[36] Catalogues of two major auction houses in London were sampled at ten-year intervals over the 40-year period from 1958-98. This amounted to 2,051 individual lots studied. Of these lots, 81% were offered on behalf of unnamed vendors. These included anonymous vendors, and those alluded to without identifying information: 'property of a lady' or 'property of a Swiss/Belgian gentlemen' were among the entries, the latter phrase recurring commonly. Objects offered with no indication of findspot (i.e. no provenience) comprised 95% of the sample, and just under 90% were offered without historical information (i.e. no provenance), surfacing for the first time in the catalogues studied.

1.3.2.4 Chippindale & Gill:
(c) Problems and conclusions

In all of these figures, the authors admit there may be a significant flaw. Whether published details of provenience stem from actual knowledge of the findspot cannot be known. The alternative is that the stated provenience of the few objects in the study for which such details were given comes from attribution. Association with other objects whose origin is known might lead scholars or collectors to interpret the style of the object, e.g. 'Thai', as implying the findspot of the object as 'Thailand'. Catalogues and collections may therefore appear to offer information on provenience when in fact there is none. The potential flaw which the authors see in their work, and which

34 Ibid., at p. 481.
35 Ibid., at pp. 481-482.
36 E. Salter, The Auction Market in Antiquities Since the Second World War. (1999, University of Cambridge. Unpublished M.Phil dissertation for the Department of Archaeology).

cannot be measured or eliminated, therefore makes their exposition of the routine lack of provenience-giving all the more strong.

There are other difficulties in the fit of the type of quantitative analysis that the authors have used here with the type of data which are the subject of their study, and accuracy in reported results is diluted by problems of data classification and categorisation, but even with these difficulties the results are impressive. Yet a point which they do not seem to have considered as fully as they might, is cultural. Perhaps the collectors and institutions displaying the collections studied did have more specific details of provenance/provenience, but simply did not publish those details with the display? In a market which promotes a culture where such matters are not routinely displayed, to infer a cover-up into the standard non-provision of information could be misleading.

Working on the assumption, however, that provenience information is valuable, we can suppose that the collectors, museums and auction houses studied did not display it because they did not have it. Does this mean that the objects were looted? In charitable spirit we can suppose that provenience might have been lost through the mists of time over the course of many transactions, perhaps by vendors and purchasers who did not value such information as highly as they should have. It is possible that the objects were in private collections unknown to the scholarly world until surfacing in the exhibitions studied. It is also possible, however, that they were looted shortly prior to being acquired by their new owners. We might at this early point in our investigation therefore opt for a more open-ended conclusion than the inference of looting that Chippindale and Gill offer. We know that looting persists in source countries. There is evidence that at least some of these looted objects enter the international market. The lack of provenance and provenience information in the exhibitions and auction catalogues studied leaves us unable to tell whether the objects studied were recently looted or not.

1.3.3 Instances of Looted Objects from Various Source Countries Appearing on Western Markets

There are many examples in the case law of looted antiquities being recovered from western trading centres by source countries. We shall briefly look at three of these here.

1.3.3.1 The Lydian Hoard[37]

The Metropolitan Museum of Art in New York in 1984 put on permanent display a collection of objects under the banner 'East Greek Treasure'. The Republic of Turkey recognised these objects as originating in the Ushak region of west-central Turkey, where they were buried in tumuli until the region was subject to looting by local

37 *Republic of Turkey v. The Metropolitan Museum of Art* 762 F. Supp. 44 [S.D.N.Y. 1990].

villagers in the mid-1960s.[38] Turkey commenced proceedings for the return of the objects against the Met before the New York courts. The Museum initially defended the claim on the basis that the time period in the relevant statute of limitations had expired, and therefore title to the antiquities had passed to it. The court found in favour of Turkey, mainly because the objects, acquired by the Met between 1966 and 1970, had been concealed by the museum in basement storerooms for nearly twenty years, until this showing in 1984.

During the pre-trial discovery process the Museum was obliged to produce for Turkey copies of documents which suggested that its officials had been aware at the time of acquisition that they were buying looted antiquities.[39] The museum settled the case out of court and returned the items to Turkey.

1.3.3.2 The Sevso Treasure[40]

The Zurich office of Sotheby's in 1990 offered for sale a collection of late Roman silverware consigned to them by Lord Northampton, a British peer.[41] Dating from the late fourth or early fifth century A.D., the treasure took its name from its erstwhile owner: a Roman general, Sevso, whose name was engraved on one of the plates. The auction catalogue stated that the treasure was 'said to be found somewhere in Lebanon in the 1970s' and at this suggestion Lebanon instituted suit against Sotheby's in New York (where the treasure was being exhibited by Lord Northampton pre-sale) pursuant to its law vesting ownership of all previously undiscovered antiquities in the State.

The Governments of Croatia and Hungary joined the action, staking their claim to the treasure alongside Lebanon. The action, commenced by Lebanon on 20th February 1990, was not concluded until November 1993.[42] Lebanon withdrew its claim prior to trial after doubt was cast over documents which suggested that the treasure was exported from its territory, and which were central to its claim. When adjudicating the claims of Croatia and Hungary, the jury remained unconvinced by their respective expert testimonies that the treasure had emanated from their territories, and possession of the silver was, almost by default, re-consigned to Lord Northampton. Croatia and Hungary appealed against the decision, but it was upheld.[43]

38 M. Rose, & O. Acar, 'Turkey's War on the Illicit Antiquities Trade', (1995) 48 (2) *Archaeology* pp. 45-56.

39 L.M. Kaye & C.T. Main, 'The Saga of the Lydian Hoard: From Ushak to New York and Back Again', in K.W. Tubb (ed.) *Antiquities Trade or Betrayed: Legal, Ethical and Conservation Issues* (1995, London, Archetype).

40 *Republic of Lebanon v. Sotheby's* 167 A.D. 2d 142, 561 N.Y.S. 2d 566 (N.Y. App. Div. 1990); *Croatia v. Trustees of the Marquess of Northampton* 1987 Settlement, 203 A.D.2d 167 (1994). *appeal denied*, 84 N.Y.2d 805, 642 N.E.2d 325 (1994).

41 Sotheby's, *The Sevso Treasure: a Collection from Late Antiquity* (Auction Catalogue). (1990. Zurich, Sotheby's).

42 See above footnote 41, and C. Renfrew, *Loot, Legitimacy and Ownership: the Ethical Crisis in Archaeology.* (1999, Amsterdam. Joh. Enschede) at p. 35.

43 See above footnote 40, and C. Lowenthal, 'Sevso Case Ended in New York', *IFAR Reports*, November 1994, pp. 4-5.

The case illustrates the difficulty inherent in proving ownership (or origin) of antiquities which have been stolen by means of clandestine excavation. Three and a half years of litigation managed to produce the conclusion that, while the treasure had almost certainly been stolen from somewhere, it should be returned to its current possessor, since precisely which country had lost the treasure could not be proven to the appropriate civil standard.

1.3.3.3 The Schultz Case[44]

Frederick Schultz, then president of the United States National Association of Dealers in Ancient, Oriental and Primitive Art, is quoted as having said at a New York meeting between leading antiquities dealers and USIA officials on 5th February 1998 that:

> The terms of the debate have been cast as if we're all crooks, which is too bad, because there is a wonderful public role played by people who collect art and donate it.[45]

His words were somewhat prophetic. On 12th February 2002 he was convicted of possession of stolen property under the US National Stolen Property Act and on 11th June 2002 he was sentenced to 33 months in federal prison and fined US$50,000.[46] He appealed, but his conviction was upheld by the federal appeals court on 25[th] June 2003.[47]

Mr Schultz claimed to have been sold the Egyptian antiquities in question, valued by the prosecution at US$1.5 million,[48] by British dealer Jonathan Tokeley-Parry who had represented them as having come from an old collection. Mr Tokeley-Parry, however, (who was himself convicted in Britain in 1997 on charges of handling stolen property[49]), gave evidence in the trial of Schultz that the defendant had been aware of the illicit source of the objects and had been party to the production of evidence of the imaginary 'private collection' including the manufacture of false labels to be attached to the artefacts.[50] Mr Tokeley-Parry even gave evidence as to his method of illicit export of the looted antiquities from Egypt, alarming in its simplicity. In the case of the Head of Amenothep III, he dipped it in plastic, coating the head in a veneer which he then painted black, enabling him to pass it off to Egyptian customs officers as a

44 *US v. Schultz* 178 F. Supp. 2d 445 (S.D.N.Y. 2002), 333 F.2d 393 (2d Cir. 2003), 147 L.Ed 2d 891 (2004); See M. Lufkin 'Criminal Liability for Receiving State-claimed Antiquities in the United States: The Schultz Case', (2003) VIII *Art Antiquity and Law* 321.

45 G. Russell Chaddock, 'Art World Wary of New Rules', *The Christian Science Monitor*, 10 February 1998.

46 C. Bohlen, 'Antiquities Dealer is Sentenced to Prison' *New York Times*, 12 June 2002; M.B.G. Lufkin, 'End of the Era of Denial for Buyers of State-owned Antiquities', (2002) 11 *International Journal of Cultural Property* pp. 305-22.

47 *US v. Schultz*, 333 F.2d 393 (2d Cir. 2003).

48 The court accepted this valuation over that offered by the defence, who argued that the value of the antiquities in question was US$70,000. The point at issue is one of mandatory sentencing. The higher valuation carried with it a minimum jail term of 33 months, which would have been avoided had the defence's valuation been found to be correct.

49 *R. v. Tokeley-Parry*, [1999] Crim. L.R. 578.

50 Bohlen and Lufkin, *op. cit. note 46.*

modern-day reproduction. Schultz purchased the head from Tokeley-Parry in 1992 for US$915,000 and resold it to a London collector for US$1.2 million. Tokeley-Parry said in evidence that he had paid around US$7,000 for the piece.[51]

These three cases are among the more prominent of many cases of looted objects appearing on western markets. Demonstrably, there is a market for looted antiquities. Does this include Thai antiquities?

1.4 THE SCALE OF THE PROBLEM SPECIFICALLY: THAILAND

1.4.1 Instances of Looting in Thailand

One of the most noteworthy instances of large-scale looting of Thai artefacts is the story of the pottery discovered in Ban Chiang in the 1960s. Ban Chiang was discovered to be a major archaeological site in which was buried pottery dated by thermo luminescence tests to between 3,500 and 4,600 years B.C. Once word of the deposits at Ban Chiang and rumours of the results of the TL tests got out, the Bangkok art market began to take an interest and organised trips for collectors and dealers to visit Ban Chiang. Three years later, there was no major site within 100 kilometres of Ban Chiang left undisturbed.[52]

Ban Pone Ngam, in the Udon Thani Province of Thailand is a prehistoric site which bears the same type of material as Ban Chiang. During the 1980s, Ban Pone Ngam was entirely looted, such that archaeologists now report that there is "no area left untouched in which to conduct an archaeological dig".[53] The looting was carried out by local villagers who, upon realising the wealth of their soil, dug their own land for objects to sell to small local dealers, or sometimes to larger ones from Bangkok or Ban Chiang.

Ban Prasat and surrounding areas northeast of Bangkok were severely looted in 1982. As Thosarat, an archaeologist with Thailand's Department of Fine Arts, currently working with the 9th Office of Archaeology and Museums in Phimai, explains:

> Looted pots were sold at the Wat Maha That flea market in Bangkok. At that time, no one knew where the pots had come from. In March 1983, the Regional Office of the Fine Arts Department in Phimai found out that they came from Ban Prasat. Six looters came from Suphan Buri, central Thailand, and asked villagers to dig under their houses and gardens...[54]

51 'Art Smuggler Reveals Trade Secrets' *BBC Online World News Service website* at http://news.bbc.co.uk/2/hi/entertainment/1793300.stm (version current at 1 March 2005).
52 C.F. Gorman, 'A Case History: Ban Chiang', (1981) 1 *Art Research News* at p. 10.
53 R. Thosarat, 'The Destruction of the Cultural Heritage of Thailand and Cambodia', in Brodie *et al.*, *op. cit.* note 23.
54 *Ibid.*, at p. 10.

The destruction of contextual information perpetrated during the act of looting is often at its most visible when archaeologists arrive at looted sites and are confronted with what the looters have discarded in their search for items they see as being of a financial value sufficient to merit their removal. At Ban Puk Ree, in Lop Buri province, archaeologists arriving at the site after the "prehistoric mound was entirely looted in 1996 by professionals from Khok Samrong village"[55] found iron tools, bronze fragments, human remains, potsherds and animal bones removed by the looters from their context and thrown away in their search for jade and other stone bangles, semi-precious stone beads and whole pots.[56]

In April 2001, seven stone antefixes from a Khmer temple at Si Sa Ket in northeast Thailand were stolen from the local museum. Three of the thieves were promptly arrested and five of the seven antefixes were seized. A rumour emerged (which cannot be confirmed) that the pieces were stolen in an attempt to satisfy an 'advance order' worth 5 million baht (US$128,000).[57]

1.4.2 Instances of Looted Thai Objects Appearing on Western Markets

Thosarat cites two cases where looted Thai objects have been traced to western market destinations and then claims made for their return.[58] The first is the Vishnu lintel from Phanom Rung in northeast Thailand, allegedly stolen from the site by air force officers using a helicopter. The lintel was broken into two pieces, one of which was recovered from Capital Antiques, an antique shop in Bangkok, in 1965. The whereabouts of the other piece of the lintel was unknown until it was discovered on display at the Art Institute of Chicago in 1973. It was not returned to Thailand until 1988, the negotiations over its repatriation being typically tortuous. Were it not for photographs of the lintel *in situ* taken in 1929 and 1960, its source may have been impossible to prove.

The second case noted by Thosarat is the Phra Sila, a stone sculpture of the Buddha stolen from Sukhothai in 1977 and reported by local villagers to the police but thereafter untraced. On the basis of a letter received by the journal *Arts and Culture* reporting the Phra Sila to be advertised for sale in a Sotheby's catalogue in 1995, the Fine Arts Department sent a delegation to the USA to track down the buyer who had by that time successfully bought the object at auction. With the help of the FBI they found him – an American millionaire who wanted US$2 million in compensation for its return to Thailand. Again there followed protracted negotiations, in

55 *Ibid.,* at p. 10.
56 *Ibid.,* at pp. 10-11.
57 R. Thosarat, 'Thailand Theft', *Culture Without Context: the Newsletter of the Illicit Antiquities Research Centre,* University of Cambridge, 9 (Autumn 2001).
58 Thosarat, *op. cit.* note 53.

conclusion of which the Thai government complied with the buyer's demand. In this case also, the Fine Arts Department had a photographic record of the Phra Sila which aided them considerably in assuring themselves and others of its origin.

1.4.3 Thailand as a Transit State

In late 1998, the remote Cambodian temple of Banteay Chmar, dating back to the twelfth century A.D. was severely looted.[59] The looting, it seems, was perpetrated by the Cambodian military. Witnesses report that several hundred soldiers worked for four weeks with heavy machinery to remove some 500 square feet of bas reliefs.[60] One part of the stolen heritage, a wall inscription, was discovered in December 1998 for sale in a Thai antiques shop by Claude Jacques, a French expert in Cambodian antiquities, who duly alerted the Director-General of the Fine Arts Department. A further 117 of the carvings were discovered in January 1999 when the truck carrying them was impounded in the Prachin Buri province of Thailand. The pieces, valued at 100 million baht, or US$2.6 million, are now stored in the Prachin Buri National Museum although they will be returned to Cambodia by the Thai government.[61] The driver offered up some interesting information to the authorities – that the objects had been stolen to order by the army on the request of a Thai antiquities dealer operating out of the Riverside market area of Bangkok: the dealer used a portfolio of photographs of Banteay Chmar to order specific items to be cut from the temple walls and transported to him for sale.[62]

Thailand, says Thosarat, has for years been the conduit for the export of antiquities from Myanmar and Cambodia as well as Thailand itself: "For Cambodia, the easiest way out of the country is overland into Thailand and the Bangkok market or port for export".[63] Her view of Thailand as the hub of transport routes for antiquities emanating both from Thailand itself and from Cambodia, is corroborated by several sources.[64]

1.5 In Conclusion: How do we Know Thai Objects Currently for Sale on Western Markets were not Looted?

Chippindale and Gill provide a useful analysis of the buying practices of museums, in what they call the "two-stage movement of antiquities out of their countries of origin and into established and public collections in the countries of acquisition".[65] The example

59 K.D. Vitelli, 'Looting and Theft of Cultural Property', *Conservation: the Getty Conservation Institute Newsletter*, 15 (1: Spring 2000).
60 J. Doole, 'In the News: Post-war Cambodia'. *Culture Without Context: the Newsletter of the Illicit Antiquities Research Centre*, University of Cambridge, 4 (Spring 1999).
61 Thosarat, *op. cit.* note 53.
62 Doole, *op. cit.* note 60.
63 Thosarat, *op. cit.* note 53, at p. 14.
64 B.M. Broman, 'Khmer Art in Paris', *Arts in Asia*, March-April 1986, p. 77.
65 Chippindale & Gill, *op. cit.* note 31, at p. 488.

they take is of the private collector who buys an object (stage one) which is then later acquired from his or her collection by a museum (stage two). The essence of their submission is that the private collector who makes acquisitions does so with little but their own conscience to guide them. When the museum makes its acquisition it must abide by relevant codes of conduct and its board of trustees and auditors must be satisfied as regards the legitimacy of the purchase. And:

> ... the free creation of private collections whose contents then find their ways into public collections insulates the public collections from the history of the objects they are thereby acquiring. A public showing and catalogue before a collection is acquired by a public institution in this way "cleanses" the collection.[66]

In other words, history of ownership (provenance) is taken as a satisfactory substitute for evidence of legitimate excavation (provenience) when there is in fact no necessary link between the two. Provenance is important for the question of legal liability in terms of a documented timeline of ownership which would see the object through to the expiry of the relevant statute of limitations that would govern any subsequent claim to ownership by a source country, but it has no bearing on the *de facto* (as opposed to *ex lege*) issue of the original circumstances of excavation of the object. One might argue that public institutions should take the moral high ground and concern themselves with provenience, but as long as the law requires only that they concern themselves with provenance, such requests for museum self-policing seem unrealistic.

There is currently no legal requirement in the market destinations under study here – New York, London, Melbourne – for dealers, collectors or museums to see a valid export certificate, let alone certificate of proper excavation, relating to goods offered for sale to them which appear to originate in Thailand. Where there is evidence of a certain class of Thai antiquities being looted from the ground and disappearing, combined with the appearance of objects from that class of antiquities in western markets, offered for sale without archaeological provenience and with the barest provenance, if any, which alludes to their prior place among the collections of Swiss gentlemen and Belgian connoisseurs, we have enough evidence upon which to act.

That action must take the form of research which offers up suitable suggestions for the implementation of measures that will allow us (collectors, museums, interested scholars, the police) to know that these items we see for sale are not the same as those which we know are being looted, or in the event that they are the same, to

66 *Ibid.*

prevent their purchase. This will involve measures to encourage the recording and publication of provenience and provenance. The aim is to enable buyers who may be (and probably are) geographically far removed from the source of the looting to have access to the information they need to decipher whether or not the item they want to buy has been looted. Just as justice must not only be done but be seen to be done, so antiquities must not only be licitly excavated and traded, but must be *seen* to be licitly excavated and traded.

It is clear, then, that there is a large-scale looting problem in Thailand. The rest of this book will examine how this can be possible in the face of attempted control. This includes investigations of: the form and content of that attempted control; the relationship between the international market and looting; what place buyers in the market play in the problem; and how they deal with and talk of issues of provenance.

In Chapter 2 the interview data are used to provide an overview of the shape of the market. Here too, the views of key participants in the market are presented on a concept of central importance to the movement of illicit antiquities – that of provenance. It is observed that many buyers of antiquities do not care about the provenance of objects they purchase. Those who do care use discursive and psychological mechanisms to give themselves and others the impression that the provenance of their purchases is unlikely to be problematic.

In Chapter 3 I set out and discuss the domestic laws (private and public), the international treaties, and major codes of practice, which currently combine to form the system of regulation governing the market. Here we address the question of how the illicit market can persist; what are the failings of the existing regulation?

In Chapter 4 the laws governing two comparative illicit markets – the wildlife and drugs markets – are examined. This leads both to a debunking of the myth that prohibitive legislation can on its own solve the problems of illicit markets, and to the conclusion that antiquities dealers and collectors can be viewed as members of the category 'white-collar criminals' for the purposes of deterrence initiatives.

Chapters 5 and 6 form my inductive attempt to attribute theoretical structure to the qualitative interview data. Here a sociological and psychological analysis of the discourse of the market is undertaken, following the data presented on the issue of provenance in Chapter 2 with the question "how and why do buyers continue to purchase antiquities with no (or unreliable) provenance when they know these to be possibly (or in some cases actually) looted?" This leads in Chapter 6 to the generation of a theory of 'entitlement to crime' which identifies the use of 'internal balance sheets' by the interview subjects as a medium through which techniques of neutralisation can be manipulated to achieve desired ends.

Chapter 7 concludes the study with a recommendation for a structure of regulation to govern the market. The theory explaining illicit market purchase decisions which in Chapter 6 emerged from the interview data is drawn together with contemporary ideas on appropriate market regulation and the question of deterrence in relation to white collar criminals, to create a 'regulatory pyramid' for the antiquities market.

A methodological appendix is included at Appendix I, and it is recommended that all but the most cursory reader of the book take a moment to review this before proceeding any further. The appendix explains the interview method and data analysis, and puts this process in context by acknowledging the methodological paradigm on which basis the data were collected and used. It is excluded from the main text in the name of fluency of form rather than to suggest that it is in any way peripheral to the research, and readers will most likely find many questions raised by the interview data, as presented in the following chapters, to be answered in the appendix.

Chapter 2

The Antiquities Market – Structure and Key Issues

This chapter will introduce the antiquities market in the words of its members. This view from the inside naturally very quickly gives rise to mention of the issues the market interviewees see as important; issues which take on increasing importance throughout this study. These issues all relate to one theme – that of provenance, and the meaning and susceptibility to investigation of the past history of looted antiquities. The importance of this chapter stems from the significance of discursive forms prevalent in the market. Aside from the obvious relevance of gaining information on the market from those who operate therein, once we acknowledge the constitutive power of discourse in terms of minds and action, an indispensable point of departure for the researcher is to discover how the system perceives and talks of the problem.

The antiquities market is shaped roughly as a pyramid. At the top end are high-level dealers and collectors, relatively small in number, who buy and sell artefacts sometimes individually priced in terms of millions of dollars:

> There aren't that many dealers in the antiquity trade. Active dealers in the antiquities trade, truly active dealers, you have under 100, worldwide. And people let's say that do a couple of million upward, you have a few dozen at the most. And if you talk about a few million upward, you cut it down to maybe ten or twelve dealers. (New York Dealer 4)

This dealer is himself one who 'does a couple of million upward' and is undoubtedly influenced in his opinion of the total number of dealers in the market by the fact that as a top-end dealer he has an élite client base and probably discounts from his calculation dealers which he does not see as up to a similar standard, and therefore as serious. Certainly though, there is a consistent perception that buyers of top-end antiquities are relatively few in number:

> You find that in any given year, 50 percent of your business is accounted for by 1% of your mailing list. One of the main ways I keep in touch with people is I've got a mailing list of 4,500 names who I'm always mailing cards to and saying "come on in" you know, "we still love you and why don't

*you come see us" and that kind of thing. And that's as
effective, or more effective, than an advertisement in the NY
Times, and certainly more cost effective. And at the end of
the day, of the 4,500 names on my mailing list, probably
3,000 of them have never bought a thing, probably more
like 3,500 have never bought a thing. And from that analysis
you find that there are probably 150 names on the list which
account for 80% of the turnover. This is more true, I would
suggest, at the higher end.* (New York Dealer 1)

As we move down the pyramid and the value of the objects traded
decreases, the number of dealers, and their client collectors,
increase. At the bottom end of the market, vast numbers of objects
of small value are traded, as trinkets with historical mystique and
purportedly no archaeological significance:

*A lot of the dealers that you talk to will only be selling to the
very wealthy collectors, but I've got a lot of teenage kids who
absolutely love the stuff; they've grown up with it, they read
the books, they see the pictures, and then to actually own an
ancient Egyptian amulet is the absolute ultimate. I have some
at under $100, so they're sort of over the moon about it. It's
um, yeah, it's a lot of pleasure to sell something to somebody
who's really enthusiastic about it, too. So that's the bottom
and then all the way up, really, depending on the price range.*
(Melbourne Dealer 1)

The two main international centres for the high-end antiquities
trade are London and New York. These two cities house the greatest
concentrations of antiquities dealers in the world. This is
particularly so for southeast Asian and Chinese material. Different
classes of material have their own geographic market signature in
terms of their flow – Paris remains a centre for the sale of traditional
Cambodian material, for example, and much African material moves
through Paris and Brussels:

*When you look at the true money for all of this, the big money
is in America and in Europe. And that's where it's going,
that's where the really big work's going. The pieces that are
being ripped out of the ground, or off the temple, that's where
it's going. And it's frightening.* (Melbourne Dealer 2)

Despite the increasing focus on the trade by interested
archaeologists and legal commentators, there appears to have been
no diminution in levels of business being carried out in these two
international centres. For example the British Antique Trade
Association's annual survey for 2000-2001 shows that, although
there was a generally bemoaned slump in the trade during that
period, the annual turnover among its 380 plus members in fact
increased by 10% in that year. This represented an increase in
turnover for 42% of the survey respondents, no change for 37% and
a decrease in turnover for 22%. Oriental art was the strongest growth

sector. The estimated total turnover of the Association's members was £782 million.[1] The market in antiquities continues to grow, then, some years steadily, some years expansively. Between 1998 and 1999, the world-wide licit trade in antiquities grew by 42%.[2]

There are no special restrictions on who may become an antiquities dealer in any of the jurisdictions studied, beyond any local regulations that may exist to govern all dealers of second-hand goods:[3]

> [What sort of registration requirements are there for dealers in Victoria?]

> None! You just open a business and ... get a second-hand dealers licence, providing you don't get knocked back, if you've got a criminal record, um that's it, but there's no real professional basis. (Melbourne Dealer 2)

Most dealers accept that looted objects enter the market. They do not, however, accept that they might be purchasing these objects.[4] That is the misfortune of other, less scrupulous dealers, they think. The interviewees regularly attributed both the supply of illicit objects onto western markets and their purchase by western traders, to unethical dealers with criminal intent:

> There are dealers who no doubt are very, very active in pieces that are, let's say, stolen ... there are rotten apples in every barrel. There are dealers that I have nothing to do with because I don't trust them or because I know that they smuggle... There are people that make a livelihood out of bringing things across borders, major, major pieces. And we try to keep far apart from that... You have a particular auctioneer in Paris who is extremely unethical. Not a dealer, but an auction expert, who will take consignments of material and I'm sure is directly involved in the importation of antiquities out of Egypt. (New York Dealer 4)

> Where can we start? There are, believe it or not, clean channels and unclean channels. There are dealers in India, for e.g., who are criminals. And they organise digs here, they organise digs there. They even organise thefts and then try and sell those things on the market. But most of my colleagues and myself don't deal with these people. (London Dealer 2)

1 G. Adam, 'British Antiquities Trade: Slackening Off' *The Art Newspaper website* at http://www.theartnewspaper.com/news/article.asp?idart=9392 (version current at 7 May 2002).

2 N.E. Palmer, P. Addyman, R. Anderson, A. Browne, A. Somers Cocks, M. Davies, J. Ede, J. Van der Lande & C. Renfrew. 'Ministerial Advisory Panel on Illicit Trade', December 2000 (hereinafter: ITAP Report) London, UK Home Office Department for Culture, Media and Sport, 51, Annex A, para. 10.

3 In Victoria, for example, these are the Second-hand Dealers and Pawnbrokers Act 1989, the Second-hand Dealers and Pawnbrokers (Amendment) Act 2001, and the Second-hand Dealers and Pawnbrokers (Amendment) Regulations 2002.

4 As we shall see, this reluctance to accept a part in the purchase of looted antiquities rests to a large extent on the very narrow definition of 'looting' held by the interviewees.

> *Of course there are some sleazebags around who are handling hot merchandise.* (London Dealer 5)

> *At the moment there's a lot of seedy operators in this business.* (Bangkok Dealer 1)

Through identifying the flow of illicit antiquities as taking place among 'criminals', the interview subjects were able to reinforce their conviction that they did not handle illicit goods. They also used these 'criminals' as evidence supporting the intractability of the problem of the illicit market:

> *There is always someone at the bottom of the line who is going to do a deal. And that's one of the problems with the whole business – that there isn't an answer to I'm afraid any more than there is in anything else. You know, people selling illegal petrol at petrol stations. There's always something going on somewhere.* (London Dealer 4)

The preferred method of self-protection in the market is to do business only with sources that the dealer trusts. This leads to a market comprised of many small circles of dealing in which relationships are formed based on trust. Through a course of dealing, that trust is established and cultivated. Reputations are formed which sustain trade. To a dealer, the maintenance of a reputation and the goodwill that it brings is of the utmost importance:

> *There is an awful lot of illicit stuff… and you know, the answer is one doesn't know, one can only suspect. And being involved in the marketplace I know a vast swathe of people, and I think off the top of my head I have or will do business with less than 10% of them. Purely because I regard the rest as untrustworthy, to put it mildly. You just don't know where you are with them. You don't know whether there's any integrity there, whether you have title when you buy, and all these things. So it's a sort of crazy world.* (London Dealer 4)

However, highly desirable objects are sometimes offered by sources who are not accorded such trust, and at that stage the dealer must decide whether to buy or to turn the seller away:

> *I try these days to take less and less risks. I try to deal with people who I consider to be reliable, responsible and reputable. But then again if somebody walks in and offers me a great treasure, I'll probably get tempted… especially if it's not too expensive.* (Bangkok Dealer 1)

> *You can make a hell of a lot of money in this business playing it straight, but it's also so easy to be tempted. You can sit here for a week and certainly several times somebody will come in or on the phone or e-mail, offering things for sale. E-mail's a very tricky thing now, you never know where anybody's coming from.* (New York Dealer 4)

Doing business with 'established trade sources' is often used as an example of transacting with people who can be trusted, in contrast with strangers who approach a dealer 'off the street' and might be seen as being more suspicious:

> If we buy from reliable suppliers, if we can then demonstrate to them later on that it was a mistake [i.e. a fake], they will take it back and go and fight with the guy they bought it from. But if you're dealing with some guy who runs in from the jungle with a bag over his shoulder, you're hardly likely to ever see him again and so you have to take your own risks. (Bangkok Dealer 1)

That established traders can be trusted is seen as a legitimate assumption in the face of all the investigation which would be necessary were these trade sources not accorded such trust:

> If I'm on my way back to the subway and somebody offers me something who I've never met, I'm not going to say that's acting in good faith. But we deal with established businesses and dealers in Europe and you know I think that can be construed as good faith, the same way as if you're purchasing any other item, you know travelling overseas, so I don't think for instance in the Schultz case, I don't think it's possible for you to do some kind of background check on people and find out everything you can about them. (New York Dealer 3)

> If you buy an object from a reputable dealer in one of the major countries of Europe, you assume that that person has title to the object because this business is based a lot on trust. (New York Dealer 5).

In fact, however, when pressed on the issue of trust, the dealers admit that there is a general assumption of goodwill in respect of most sellers and that any vetting of the seller is done 'by exception':

> There isn't any requirement to investigate in depth, nor is there any sort of economic method, if you will. The payback for investigation, 90% of the time, is you get nothing. So it's done by exception. (New York Dealer 1)

> I like to believe that most people are straight and that you shouldn't be required to prove that you are. That somebody should be required to prove that you aren't. (London Dealer 8)

This is to say that only in the event of there being something suspicious about the seller or his representations to the dealer will the dealer decline to do business:

> How far can you go in other words? If somebody claims to have done something then you have to take their word. On the other hand if some swarthy guy comes in here offering me something with fresh dirt on it, you know, you grow suspicious. (New York Dealer 4)

I buy quite a lot from the trade, from people that I know. People I don't know who come into the gallery and offer me stuff for sale, I've got to take a view on that. And I do; I take a view. And I would suggest to you that 50% of people who walk through the door with things for sale leave with their things and I don't buy them. Not because I can demonstrate that they're stolen, but because I can't demonstrate to my own satisfaction, and it's a personal thing. I'm uneasy, so I don't buy them. Now the result of that of course is that less and less of these people come to me. You could say "well, they're simply going somewhere else". But I don't think that's true. I think that most people in my field now are watching their backs very carefully. But I will not refuse to buy something just because it doesn't have provenance. (London Dealer 8)

As is indicated by this last passage, dealers who are offered goods which they do not wish to purchase because of their suspicions of criminality on the part of the seller will rarely, if ever, report to the police suspicious approaches made to them. They are much more likely simply to tell the seller that the piece is not for them:

I have seen photographs of work that definitely has been looted, and work that's been shown to me that's been looted, and I've walked away, I've said "look I'm not interested in this. This is not what I'm in – this should be back in the country". (Melbourne Dealer 2)

This non-reporting of suspected or known illegality stands, even in the most blatant instances of apparent wrongdoing by the seller:

Years ago I was rung… and I was offered a gilt bronze horse, life-size, in a major Italian city. And I talked to the person enough about it to find out that they were putting new streetlights on a small road crossing a major road. And they were going to put the streetlight on the left-hand side, say. When they dug down two feet to put the upright in, they discovered the rump of the bronze horse. So being Italians, they immediately found an urgent necessity… to put in a streetlight on the other side of the road, and there indeed was the head. And they wanted to give it to me for $3 million. And I said thanks for the thought mate, but what the hell do you think I would do with a life-size gilt bronze horse, even if it is fantastic? You can't just trawl up with things like this and expect no-one to ask a question. I said the whole bloody world's going to go apeshit. He said what shall I do? And I said, well if I was you, I'd make very careful specific notes of exactly where it is, if you have a family archive or something like that. Things can change in 30, 40 years. Lodge it with a lawyer, probably not in Italy, probably somewhere else, just so that someone in your family down the line does know of it, and if things change, he

> *might be in a position to do something with it then. There's nothing else you can do. And I said, you could ring twenty other dealers and I can assure you that every one would tell you much the same thing.* (London Dealer 4)

The dealer does not report the seller to the police, nor does he offer the advice that he should report his find to the local office of archaeology.

The same process of vetting the seller by exception is undertaken by auction houses in deciding which objects to accept in their sales:

> *Basically there is I think an international situation which is know your client. So assuming the client is one that we know and have had a good long relationship with, and one that we know haven't played games or anything in the past, then we would be inclined to ask the standard question, you know, does this come from anywhere strange, is there a problem with it? And we would generally accept their answers. Unless we felt there was reason not to accept those answers... You know, sometimes it's difficult to say; you just get a bad feeling about it. You think "there's something funny about this" and so you need to check it.* (Hong Kong Auction House 1)

Even if such suspicious circumstances exist, the dealer may still choose to transact. He might at that stage ask for documentation, but in the absence of available provenance information this will probably take the form of a legal assurance of title given by the seller. Dealers are not so naïve as to ignore the possibility that the signature with which the seller vouches his or her title may be applied fraudulently, but their concern being to protect themselves in any subsequent legal inquiry into the transaction rather than to actually attempt to verify the seller's title, they are not much concerned with such fraudulent possibilities:

> *I have to establish that you have the right to sell it to me. If you're a private citizen or somebody I've never met, the best I can do is to, it's usually done by exception, quite honestly, whether it's Sotheby's or dealer number 27, there's an assumption of goodwill and if there's anything that sets off a little bell, you know what is this guy who's just come in in overalls and he's just unloaded fourteen tonnes of gold on my desk, maybe this isn't what I should expect, then obviously you've got an obligation as an intelligent person to look into it and say "okay, where did you get this stuff, can you tell me a little bit". You ask the person, you know, "what can you tell me about this, I'd like to be able to tell the next person if it's from the Smith estate or it's from the Rockefeller collection, has it been published, do you have any background on it", and you listen to what they're giving you, and hopefully you can spot it if it's a yarn, and you can ask for some documentation if it's available. If none of that is there, if they just say "look I bought it from a guy in Chicago and I've*

owned it for ten years and sat on it and at the end of it I'm bored with it, you know and it's not traceable" which is legitimately true for any number of objects, including probably a number of objects in your mother's house, there's nothing nefarious about it, they then need to give me a document. Whether they have a good story or not, I get a document which is a bill of sale in which they state, they sign a piece of paper which says "I have full and clear ownership, no liens or encumbrances, and I agree to sell this to you". It's a very simple, boilerplate kind of thing that they sign off on, and frankly it's if and only if there's a great deal of value or any reason to think there's something funny going on would I go beyond that exercise. (New York Dealer 1)

There is much in the data to support this observed practice of obtaining a signature on a document of title as one way of allaying fears of repercussions when proceeding in a transaction with a suspicious seller. The following story told by London Dealer 4 is one of the more arresting in this regard, as the extraordinary measures he takes to protect himself demonstrate his (quite reasonable in the circumstances) suspicions about the seller. This is particularly interesting as it takes the form of an immediate contradiction to his first assertion that he would probably not deal with anyone he did not trust:

If it is someone you are not 100% satisfied is 100% trustworthy, you probably don't do business with them at all. Secondly, you would insist on a proper written invoice with guarantees etc. So that should there ever be a problem down the line, at least if you're taken to court as maybe part of a chain, you can actually show the judge this. I mean I used to have to buy things from people who preferred not to have paper payment – they preferred cash. And it got to the stage with one person who I did a reasonable amount of business with for large sums of money. But the last time I said look, you don't have to talk to me, but you have to give my bank a bank account for them to transfer into. "No, no, no, I want cash". So I said okay. He was going to meet me somewhere a couple of days later. So I hired a photographer. I went to the bank in question, which had big glass windows, and I said I want you to roll off a roll of film, at three different times of day. Because I don't know yet what time. And if I'm standing just inside the window, counting the money apparently, in which case the other person will be in there too, it is visible who the person is – you don't get glare or reflection or that sort of thing. And it worked absolutely fine. I never told the person this, and it was a good many years ago now, and it's sitting in a solicitor's office somewhere in the world, just in case. Because you know, if there had been a problem on that particular piece, the person of course would have denied selling it to me in the first place, and as there was a cash transaction there would

> *have been no chain of evidence whatever. And when it was coming up for trial, you'd simply say to him very quietly, here's a copy of the photograph – do you still want to go to court? But you know, it's pretty horrible to have to think of your friends like that. But if people want to do extreme things which are not part and parcel of the present world, the modern world, you have to have some sort of protection for yourself, or you don't do the business. And you can't go on just not doing the business. (London Dealer 4)*

One point should be made here about this extraordinary purchase. The dealer went ahead with the transaction even although he was clearly suspicious of the seller, and by implication, of what he was selling. Instead of investigating the provenance of the object for sale, however the dealer tries to protect himself by obtaining evidence that he bought it from someone else (as opposed, one presumes, to being assumed to have stolen it himself, if indeed it turned out to be stolen). Quite what protection in law he thinks he is getting by recording evidence of the purchase is not clear.[5] The very act of recording the evidence in this way might well be taken as proof that he was *not* acting in good faith, having reasonable suspicions about the legality of the object for sale which he did not properly investigate. The confidence among dealers that the act of purchase in some way protects them from the consequences of possession of stolen goods – that it is not their fault for buying stolen property but the seller's fault for selling it – is quite misplaced. This transaction frankly sounds more akin to a drug deal than an open market sale.

London Dealer 9 explains the 'gut-feeling' approach to vetting the seller, so common among dealers, in the context of the British Art Market Federation rules, voluntarily subscribed to by some UK dealers, which require that the identity of the seller be verified and recorded in purchases for more than £2,000:

> *Anything that you buy in terms of antiquities, on your purchase form the vendor is supposed to sign that they are, you know proper. You can't shine the light in their eyes, so therefore you've got to use your own instinct and knowledge. Whether the thing is right or wrong in the market. (London Dealer 9)*

The issue underlying all checks into the seller and his or her title is that of provenance. Has the object been stolen in the past? While dealers feel that the warranties they obtain from the seller as to title protect them in a future inquiry into the transaction, they know that in truth they are not checking the seller's title – and therefore the provenance of the object – with any degree of rigour or certainty:

5 The only benefit to recording the transaction would be an ability to prove the sale took place if the object turns out to be stolen, is reclaimed from the dealer, and he opts to sue the seller for a refund of the purchase price.

We require that they tell us the truth, in every transaction that we do, we want complete and full information, and therefore contractually speaking they have no right to withhold from us. Having said that, we have no way of actually verifying that the information given is the full and open and complete information. So this is a dilemma we face. (New York Dealer 6)

2.1 PROVENANCE – WHERE DOES THIS OBJECT COME FROM?

It's very rare to get something with a provenance, with an actual collection name. Usually it's entirely anonymous, especially in the London and New York trade, just objects for sale in a shop...

[So what percentage of the stuff that you buy comes with provenance, would you say?]

Ooh, a very, very small percent.

[Percentage of acquisitions of yours that come with archaeological information?]

Just tiny. 1%. Absolutely minuscule, yeah.

[And that come with some sort of ownership history?]

That would be a little bit higher. Of course, any pieces purchased from a dealer, they don't pass on any details of where they purchased it from – that's just part of a dealer's policy. Unless it's a famous collection. But if they've bought it from somebody, they won't pass on any of the details. It's the same with anything in the shop here, like nineteenth-century ceramics, we don't pass on who we purchased it from unless it's a well-known family, you know a celebrity or something. It's the same with the archaeological pieces and any auction rooms won't advise that either unless it's from something like the Petrie collection or the Elgin; once again the celebrity factor.

[If you asked what would they say?]

An auction room would point blank refuse – it's part of their policy I think...

[Why do you not ask for details?]

Yeah, just doesn't really seem that relevant. It's, yeah, (pauses to think for a few seconds) we don't, we don't provide that information to our customers, so I don't expect it from whoever I buy it from. Basically I think, yeah, it's the way the antiques trade works, really.

[So it's almost like an unwritten rule of the way things go on?]

Yeah, I guess so. (Melbourne Dealer 1)

Historically, the antiquities market, as with most other goods markets, functioned without the transmission of information relating to the provenance of purchases, and without giving any consideration to that omission. This is perfectly understandable. Why, in the absence of a celebrity provenance, would a buyer care where an object had come from? The climate until the first writings on the subject of looting in the 1960s was generally supportive of the trading and collecting of antiquities, whatever their origin. Provenance was simply not an issue:

> [When someone offers you something for sale, how much do you worry about where it's come from?]

> More now. Before we didn't worry so much... I suppose there are certain things that might just have too high a profile, are too important, maybe ten years ago I would have not thought twice, but now of course one does because of the legal climate. (New York Dealer 2)

> The issue of provenance has become something that people are more aware of in the last five to ten years. (London Dealer 7)

> The whole issue has become so emotional. We've got on the one hand archaeologists saying "all dealers are thieves" and on the other hand you've got dealers saying "well this is ridiculous, everything should be for sale and who the hell cares about any of it". Now not many dealers say that these days. They used to. Things have changed a great deal in the last ten years... I can tell you that I've been dealing in antiquities since the '70s, and in the '70s the world was a completely different place. Guys were turning up in London with suitcases full of stuff every week. Nobody knew that there was a problem with selling antiquities that were illegally excavated. It was not regarded as being a problem in this country. (London Dealer 8)

To be clear about the historical association between lack of provenance in the market and the presence of looted antiquities, provenance was not seen as an issue because looting was not seen as an issue. The purchase of objects dug up by inhabitants of source countries was the norm:

> Let me start somewhere around 1965-1970. No one had any complaints whatsoever when it came to stealing and to plunder of artefacts. The criminology was actually created during that time. Before it was a perfectly legitimate way to acquire objects wherever you wanted and to bring them wherever you wanted and keep them or sell them or whatever. And a few archaeologists had here and there some complaints, but only if their own work was disturbed. Which did happen then, still happens – some cowboys jumping over fences and digging at

night while the archaeologists coming back in the daytime and it's always empty. That kind of chasing the treasure is hundreds of years old, and nobody seemed to make an issue out of it, except if it concerns themselves. Somebody stole out of my hole. It was never political, the issue. And certainly not a national one. (London Dealer 5)

Much has changed over the past 30 years, but the historical indifference of the market to provenance and provenience still casts a shadow over attitudes in the trade. There is more provenance information in the market now than ever before, but objects with provenance still form a small fraction of all the objects on the market. And with a continuing strong market for unprovenanced pieces, there is not much impetus for change:

There's more reluctance nowadays for better material without provenance. There's more reluctance now. I don't think that the market has changed that drastically. There are always collectors that have insisted on provenance. There are collectors that thrive on no provenance. I can think of two major collectors in the US that are absolutely thrilled to find a piece that's just come out of the ground illegally. It's something exciting. They're cheating... And they're known for it. (New York Dealer 4)

[How do you feel as a dealer in terms of your practice? Has it changed recently?]

No. No sort of concrete changes at all. However, obviously I'm aware of these sort of moves off-stage. So you know, one's casting around trying to maybe deal in things which have more obvious provenance and so on. But I haven't done very much about it. (London Dealer 3)

[What sort of information do you get when you buy in Hong Kong, for example?]

Hong Kong rarely you get much information, except you buy it from a dealer you trust... The market in Hong Kong is the same as it was before Chinese handover. It might change one day, I've no idea. But as far as I know there hasn't been any great change in the way that antiquities are sold in Hong Kong. (London Dealer 7)

For most dealers the absence of provenance and provenience is a norm which they purport to accept without question:

[You won't get findspot information when you buy an object?]

No, no... I think you just have to keep a clear head and make your own decisions. (London Dealer 1)

This is particularly so in relation to objects which are not of great monetary value. No provenance is still the norm today even for

objects of considerable worth, but it becomes more of an issue at that level as the chance of the dealer losing the object through a claim for repossession by a true owner increases. Further down the financial scale, the notion that provenance might be passed with an object is seen as a ludicrous proposition. Archaeologically, of course, the market value of the object is of little relevance to the knowledge which its context might offer:

> Who that was [the vendor who placed the item in the auction sale from which it was bought by the dealer], I've no idea at this point. But that doesn't really matter. Anyway, it's only important things that it really matters, because of the sums of money involved with them. As I told you on the phone, you get little black whatever things from Italy, and there are thousands of the bloody things: only the absolute perfect ones are of any interest to anyone at all. But it is just as illegal to buy and sell a piece of crap as something highly important. (London Dealer 4)

Many adopt a strong opposition to the idea that unprovenanced objects should be viewed with suspicion. To them, this is tantamount to condemning most of the goods in the market to be off-limits to the trade. They choose to argue with the fiction that 'all unprovenanced goods are looted' – a fiction that not even the most radical archaeological lobbyist would support. This caricaturing of their opponents' position enables them to dismiss the more sensible and balanced view that *some* unprovenanced objects on the market are probably looted and therefore *all* objects without provenance should be treated with at least a base level of suspicion:

> We are trying to get the government to produce a national database of stolen art, so we're approaching it from the other end. We're assuming things are not stolen unless they're on a register. And I think that's right, incidentally. The thing that I really do take issue with is this idea that something is hot unless it's proved to be cold. I won't buy that, at all, under any circumstances. I feel very strongly about that. Guilty until proven innocent is not acceptable. (London Dealer 8)

For the small minority who see the anonymity of the objects they buy and sell as a troublesome issue, it is still acknowledged as a norm which they are powerless to alter:

> Some of the work I've bought has come from dealers in southeast Asia and in Hong Kong and that work has been predominantly good work, good quality work, and when I've said to them "where does it come from?" they tell you only what they want you to know, okay? That's why it gets back to your own knowledge of what's happening. And that's why I spend so much time up there, because that's the only way I find that I can really know that what I'm getting or

what I'm handling isn't from an illegitimate source. It's very hard.

[There's no documentation that comes with anything you buy?]

Through private collectors, no, but through galleries or dealers you deal with of course there's receipts.

[I mean regarding where it's come from.]

Where it's come from, no. (Melbourne Dealer 2)

We're very careful from whom we buy and we try to know as much as we can, but sometimes it's not that possible. (New York Dealer 2)

What form does what little provenance information as is passed in transactions take? For the most part it is simple word of mouth:

Material gets lost, unfortunately. And a lot of it is apocryphal, a lot of it is "so and so told me that such and such came from somewhere, and he got it from their grandfather" and that's very often the only kind of documentation you have. (New York Dealer 5)

I bought a wonderful piece of sculpture in Paris from an old dealer. He told me it came from an old collection. Fine. How do I prove it? This is the madness of provenance. It's just impossible to prove. (London Dealer 2)

Rarely, there will be some paper documentation to accompany the piece. This might be as little as a sticker with the name of a past collector on it.

You may get a label, like I was saying before, that's nice, or an ink inscription, but otherwise, yeah, a lot of it is verbal. (Melbourne Dealer 1)

I just bought a head from a colleague in Geneva for $340,000. An Egyptian head, with an old auction, the remnant of an auction sheet underneath it, with the name of the original owner; part of the famous family. (New York Dealer 4)

How seriously can such provenance documentation be taken? It seems that while it is *de facto* accepted by dealers as better than nothing, when questioned about its weight they agree that it should be accorded little. Provenance documentation can easily be faked, and genuine documentation can just as easily be lost. Sighting documentation is therefore not an end to the issue of legitimacy, nor is its absence seen in any way as fatal:

[I wonder how hard it would be to fake one of these [the label] because all you would need to do would be to produce a bunch of these and stick them to the bottom either of things you've faked yourself or that have come from somewhere else and say well look, yeah, this is part of that deposit.]

Yeah. Fake provenance is a big problem actually. You'll find quite a few instances of that. (Melbourne Dealer 1)

(Pointing out a letter offering to sell him a batch of antiquities) Here's a collection, antiquities collection, notarised, declaration, no stolen pieces, blah blah blah, whatever, it's probably all smuggled... (and moving on to another matter) Now this is interesting. It's an indication of how provenance can get lost... This group of scarabs was sold by me in 1960. Reverend Nash collection. I bought them from Spinks in London, for 3 shillings each in 1960. And at that time we sold them for $3 to $5 each. And I wholesaled a huge bunch of these to [anonymous] for a mail order business that he had, because he's publishing magazines. And if somebody called me up and said "I have 160 scarabs, are you interested?" I'll say no, I have bags full of them. "But these are from the Reverend Nash collection" – oh my God, provenanced! Suddenly each one of these bears a label. Now if I was clever I could take all of those (unprovenanced), toss them in here and say "hey, these are Reverend Nash". But it's not my way. But it's interesting. Here are pieces I sold over 40 years ago. He bought from me 1,000 pieces, as I recall. What happened to the other 840? How many of those will have a provenance card? Come on! ... There are thousands and thousands of loose scarabs floating around. Almost any auction in England, Bond's or Christie's, you'll find heaps of scarabs.

[So it's really impossible to say what proportion of the material on the market is illicit?]

This is the point. (New York Dealer 4)

The paradox of the current market approach to provenance is this: while an absence of provenance does not necessarily detract from the value of an object, no provenance being the norm, the rare occurrence of a demonstrably unimpeachable provenance accompanying a piece adds to its value:

Ten years ago I never thought of a provenance. Now I'll actually pay more if there's a provenance for the piece... I think that it's fair to say that the prices are higher if something has a provenance – it seems to be reflected in the price that people are willing to pay. (London Dealer 6)

I'm in the trade, I've seen how things have changed. Even when I'm dealing with friends of mine, I'll say to them "that's

> *nice, you know, how about provenance?" Everybody says*
> *that now. "Got your provenance?" Because if it has a*
> *demonstrable good provenance, that helps. It helps with*
> *the selling of it. And very often they'll say to me, "well, not*
> *really, you know, I bought it from a dealer" and that to me*
> *is okay. Because I trust them to buy in the way that I buy.*
> *And I'll say the same thing to them. (London Dealer 8)*

The effect of the focusing of current legal attention on the international market in antiquities has not been to eradicate dealing in unprovenanced objects. It has simply increased the asking price for the minority of pieces which can be proven to have been in licit circulation prior to being sold. In some cases this has dramatically added value to an object:

> *There's not a lot coming from private collections, other than*
> *things like the Newby Venus, which you've probably heard*
> *about, which made 7.9 [million pounds]. As the*
> *underbidder, who is an old friend of mine, said to me*
> *ruefully a couple of weeks later over a glass of wine, he*
> *said "yeah, well about 300,000 for the piece and 7½ million*
> *for the provenance". I think it's worth a little more than*
> *300,000, but the gist was right. (London Dealer 4)*

The absence of reliable provenance information in most transactions means that any attempt to attribute origin to the artefact, both geographical and historical, will have to be done by comparison with similar objects whose provenience can be confirmed. This lends many objects an unfortunate air of uncertainty:

> *I mean you'll see pieces going through the large auction rooms*
> *internationally, and you'll think to yourself hmm, very good*
> *piece, very interesting piece... very beautiful piece, but we*
> *don't know where it's come from. Iconographically, we might*
> *say okay it's of the same style as such and such but actually*
> *did it come from that temple? (Melbourne Dealer 2)*

2.1.1 Auction Houses and Provenance

As the above quote identifies, the decision not to pass on provenance information is a routine one for auction houses as well as for dealers. In addition, however, they give no independent warranty as to the title of the seller, or guarantee that any provenance information they do publish is accurate:

> (having been given the Christie's standard warranty by the interviewee) *[This warranty is only on authenticity.]*

> *Oh, they won't give you anything on provenance.* (New York Dealer 4)

> *Any sort of provenancial information, such as 'from such and such a collection' we actually publish in the catalogue. But we*

would only publish it in the catalogue if we have clear proof of it. So it's sort of its own balance.

[So what the buyer takes away is in effect your catalogue as having been vouching for the provenance of whatever the object is?]

Yes. Absolutely. Although we don't guarantee it. (Hong Kong Auction House 1)

Auction houses simply pass on a warranty of title obtained by them from the seller. In other words, they ask the seller to vouch for his or her title by signing a document to that effect, and then the assurance they give to the buyer at auction is that the seller says that he or she is the owner:

[Do you guarantee title? Or do you guarantee title on behalf of the consignor?]

The consignor guarantees to us that they have title. So we in effect pass that on. We don't guarantee the title. (Hong Kong Auction House 1)

Many jurisdictions, including New York and England, have a form of Sale of Goods Act which imposes a warranty of good title on any seller.[6] Thus, although the auction houses which operate in these jurisdictions do not give such a warranty in their contractual documentation and would probably in the first instance try to refer a buyer who wishes to make a claim to the consignor in terms of the contract, they are careful to obtain an indemnity from the consignor against claims which may be made against them under statute by buyers who know their legal rights. Christie's current standard form consignment agreement states, *inter alia*:

> 5(a) Consignor represents and warrants to Christie's that: (i) Consignor has the right and title to consign the property for sale; (ii) the Property is, and until the completion of sale by Christie's will be, free and clear of all liens, claims and encumbrances of others or restrictions on Christie's right to offer and sell the Property; (iii) upon sale, good and marketable title and right to possession will pass to the buyer... (vii) the exportation, if any, of the property from any foreign country has been in full conformity with the laws of such country and the importation of the Property into the United States has been or will be in full conformity with the laws of the United States... (b) Consignor agrees that such representations and warranties are for the benefit of Christie's and buyers of the Property... (e) Consignor shall defend, indemnify and

6 In England and Wales, this is achieved by s. 12 of the Sale of Goods Act 1979; in New York by s. 2-312 of the Uniform Commercial Code.

hold harmless Christie's from and against any and all
losses, damages, liabilities and claims, and all fees, costs
and expenses of any kind related thereto (including,
without limitation, reasonable attorney's fees), arising
out of, based upon or resulting from (i) any act by or
omission of Consignor or Consignor's agents (other than
Christie's) or representatives relating to or affecting the
Property or (ii) any inaccuracy or alleged inaccuracy... of
any representation or warranty made by Consignor
pursuant to this Agreement...

In effect, therefore, although dealers claim to protect themselves
against the purchase of looted antiquities by 'only buying at public
auction' or buying from 'established' or 'trusted' trade sources which
will include auction houses, the level of protection they obtain in
such transactions is only greater than if they themselves had dealt
personally with the seller and asked her to sign their own standard
warranty of title document in the degree that an auction house
like Christie's might make a more solvent defendant in a legal
claim than an unknown consignor. As regards the likelihood of
having to make such a claim, the level of protection may actually
be lower than in a face-to-face transaction as the dealer has missed
his chance to gauge the apparent trustworthiness of the seller, and
to have his suspicions aroused by unusual conduct.

The truth seems to be that buying from auction houses allows dealers
to profess their confidence in this public method of transacting as a
safeguard against their buying illicit artefacts when in fact many
of them do not hold any real objections to the purchase of many
categories of looted antiquities. The only loss or harm to the buyer
through the purchase of a looted object that is seen as a realistic
possibility by dealers is their loss of the object if it is in the future
claimed back by a source country, and in that event they could
pursue the auction house for a refund, which would then in turn
have to rely on the indemnity given to it by the consignor. Purchase
from public auctions enables dealers to profess reliance upon the
auction houses' provenance-checking procedures when in fact they
know that these safeguards are minimal. Through this pretence
that buying at public auction is one of a few 'secure' methods of
purchase where the possibility of buying looted antiquities is
minimised, they buy unprovenanced antiquities freely:

> Of those 90% of things that I buy that don't have
> demonstrable provenance (by that I mean they've never been
> published) I have to follow my nose. Actually I buy a lot at
> auction, where I'm relying to an extent on their good offices,
> which I think is not unreasonable. (London Dealer 8)

This belief is of course encouraged by the auction houses themselves
who although contractually taking no express responsibility for the
seller's title to what is being sold, are happy to propagate the false

impression that buyers can rely on them as having effectively performed the necessary checks:

> *The onus is on knowing your client, in knowing your sources and in avoiding things which are suspicious. A company like* [Hong Kong Auction House] *has its own legal department, has its network that allows it to cover those bases. And therefore a buyer buying from us can feel that an awful lot of those things – probably much more than they themselves could do anyway – have been done.* (Hong Kong Auction House 1)

A buyer who read the small print would find the actual position to be in contrast with this. For example, Sotheby's current conditions of business state, at clause 3(a):

> Sotheby's knowledge in relation to each lot is partially dependent on information provided to it by the Seller, and Sotheby's is not able to and does not carry out exhaustive due diligence on each lot. Bidders acknowledge this fact and accept responsibility for carrying out inspections and investigations to satisfy themselves as to the lots in which they may be interested.

Dealers *must* know that auction houses cannot be relied upon to the extent that they profess to put this faith in them, since many dealers sell through auction houses as well as making purchases there, and will therefore have experienced the title-verification procedure first hand. One of the interviewees presented an honest answer to the question:

> *[How much checking do you think auction houses do into the right of someone to sell?]*

> *Very, very little. Very little. They have a far more complicated form than I have: they have a five-page legal document that people sign swearing up, down, sideways, that they own the thing and they promise not to do this and they promise that they haven't done that and so forth and so on, but basically all that they do is they sign the bottom line. They don't then hire a private investigator to see if I've misled them in any way. It's all done by exception.* (New York Dealer 1)

Where auction houses do publish 'provenance details' these are generally unspecific and do not extend back past the current consignor. They will normally give only an indication of the category to which the consignor belongs:

> *You do get 'collector' sometimes, or you get 'private owner', that's true. Or you get 'dealer', but you don't always get it, no you don't.* (Geneva Collector 1)

These very general indications of provenance mean little to purchasers, who will buy from auction houses whether or not any provenance is given in the catalogue. Perhaps the naïve trust which dealers and collectors would have us believe they place in the levels of title checking performed by auction houses is in a few cases genuine, but for most lack of provenance is seen as unproblematic because they are happy to buy most looted antiquities. One dealer who spoke of his shopping trips to Hong Kong where he would buy and export recently-excavated Chinese antiquities did not think that provenance was an important issue in auction catalogues since much of their stock, he surmised, came from the same foreign sources as he visited and therefore the objects were recently excavated and would have no provenance:

> In Hong Kong you're buying it from a dealer, and how he got it into the country is not really something you delve too far into. So the most information you're likely to get is where it came from.

> [In terms of?]

> In terms of province, or city, or that sort of thing. The things, as far as I'm aware, almost all don't have previous owners. Previous ownership is not really a sort of issue.

> [And what about the stuff you buy over here? Is there a different attitude towards it?]

> Not necessarily. If you buy at auction, say, if the auction house has provenance then they will normally write it in the thing, or it says 'property of a gentleman' or from such and such a collection. But equally a lot of the stuff in the auction will come through the same routes that I get it anyhow, in which case it's the same. (London Dealer 3)

2.1.2 Museums and Provenance

For dealers, the uncertain past lives of the objects in their galleries can make matters difficult when selling to museums. Museums as public institutions are concerned not to be tarred with the looting brush, and their versions of the warranty of title document mentioned above are considerably tighter than the rather laissez-faire practices of dealers can accommodate:

> ... We have to sign guarantees when we sell to museums.

> [What do you guarantee them?]

> Title.

> [Do you guarantee that it's not fake?]

> Of course. That's the most important thing for us, because we're serious about our expertise. But, you know, we

> *guarantee as little as we have to. But that becomes increasingly more and more difficult. The museums all ask you, they're all hypocritical. They ask you this export, this has been exported legally from its country of origin? This has been imported into the USA [legally]? How do you know how many hands it's passed through? It's just to protect them. They don't want to deal with the issues. The boards of trustees don't want any bad publicity and if they can pass it off on somebody else, on the dealer, they will. And they do. And the dealers are always hard up for money, because these things cost money and they sit around, and dealers often need money and so they sign. And cross their fingers. (New York Dealer 2)*

When museums require dealers to provide them with written assurances of good title and secure provenance, dealers balk. They very often do not have the information required safely to vouch for these matters, and while they may do so anyway it is not without resentment at the perception that museums are passing the buck in terms of provenance investigation and covering themselves while leaving the dealers exposed:

> *I sold something fairly important to a museum. And in due course... I got a one-page A4 disclaimer that I had to sign, which effectively was guaranteeing everything for life, forever... When you're buying something, it doesn't matter what it is, the onus is on the museum as much to do due diligence. They can't just get a dealer to guarantee everything and do bugger all themselves. And they shouldn't be allowed to either. But a lot of them are trying to get away with it. And I think probably a lot of collectors are too. (London Dealer 4)*

It was earlier stated that warranties of title obtained by dealers from sellers, while superficially a valid exercise, in fact take the place of proper due diligence investigations into the provenance of the objects. The signed documentation is taken as a substitute for knowledge of the seller or of the history of the object. Many museums, some of them motivated by their having signed the International Council of Museums' code of ethics, discussed in more detail below,[7] have implemented policies which require even tighter documentary evidence than is sought by dealers. Generally at a minimum this comprises title warranties given by the seller coupled with proof of the object's circulation on the market prior to a given date. In some cases that date is arbitrarily set around 1970 – the date when the UNESCO Convention on the Means of Prohibiting and Preventing the Illicit Import, Export and Transfer of Ownership of Cultural Property was opened for signature. In others it can be as recently as six years ago, that being the limitation period on claims in conversion for the return of chattels in the United Kingdom:

7 Section 3.2.4.1.

People like museums, they'll say "we'd like number 42 in the catalogue" and I'll say 'well I don't think it's secure enough for you to buy it with your terms of reference'. I'm very upfront about that. It doesn't mean that I think it's hot. What it means is it's not secure enough for their purposes. Because some museums have extremely stringent rules. You know, unless it's published before 1970, they won't buy it. Well that writes off 90% of the goods that are legitimately on the market. Well that's their lookout not mine. (London Dealer 8)

The requirement of such assurances by museums, however, conceals discrepancies in practice. As Haines has argued in respect of white-collar crime more generally, the implementation of rules on a group sometimes falls foul of the division Weber observed between formal and substantive justice. Accounting requirements often produce compliant accounts without affecting actual practice.

The demand for formal accountability in regulation may… result in record keeping for the purpose of being *seen* to comply in order to prevent the organisation from being prosecuted or sued. The relationship these formal records have with the reality of organizational life is entirely a separate issue. The use of law and law enforcement by regulators to exact compliance may force changes in formal accountability which can improve procedures, but are equally likely to produce little or counter-productive real effects on behaviour.[8]

This would seem to hold true even for self-imposed rules, voluntarily subscribed to:

Now museums are in a total quandary; they don't know what to do. Some don't care. Some just ask us, I mean this is very confidential, they ask us for paperwork. And I say look sometimes I can't do this. But I'm sure there are plenty of dealers who come up with the provenance.

[So they ask you to make up paperwork yourself to try to trace where it might have come from?]

Yes. To invent paperwork.

[Oh, I see. To cover them?]

To cover them. Because they desperately want the object. (London Dealer 2)

Museums ask provenance questions, then, to comply with the standard they set themselves and hold themselves out as conforming to. To ask the question and receive an answer, even one which the

8 F. Haines, *Corporate Regulation: Beyond Punish or Persuade* (1997, Oxford, Clarendon Press) at pp. 6-7 (her emphasis).

museum knows to have been concocted, is seen as enough by some museums to meet the standards when in reality the exercise is pointless. If this is the middle of the spectrum, at either end are museums which set standards and *do* stick to them, and museums which simply do not care where an object has come from:

> [What do the people who buy from you ask for in terms of provenance information? Do they care or not?]
>
> Museums care, sometimes. Depending on which museum. Basically American museums – some require provenance and some don't. That's the situation at the moment. Collectors don't mind.
>
> [Do they ask?]
>
> They sometimes ask, but when you actually probe you find that they normally mean something entirely different. They might say "does this have provenance?" And you think what do they mean by that. And it turns out they mean "are you sure it's genuine?" or something.
>
> [That it's not a fake?]
>
> Yeah.
>
> [In trying to sell to American museums that ask for provenance, do you find that you can't sell them certain items because you don't have the provenance?]
>
> Yeah. Well they wouldn't actually usually try and buy objects. It doesn't really arise.
>
> [Why not?]
>
> I don't know. I suppose they just assume that if we haven't got provenance then they don't, I don't know. Good question. I don't know. But the museums who don't mind ask, because they'd all rather have provenance. And then if you said "well, I got it in Hong Kong" they'll say "okay". (London Dealer 3)

There appears to be a rough geographical split between museums who require provenance and those that do not. Even among the American purists, however, there are discrepancies:

> Our main customers are American museums, financially at least... they all need provenance... European museums don't even ask. Small university museums ask pro forma and fortunately the things I've sold them all have had a provenance. But they ask more because they were interested where it came from. But the big museums like the [US museum name 1 deleted] can't buy anything. And the [US museum name 2 deleted] has its own politics. They want provenance, but if it isn't there it's not the end of the world

if they want the piece. They seem to be able to deal with that, because it's not a national museum like the [US museum name 1 deleted again] is. So it depends on what level the museum is. You can't have a museum in [US city name deleted] buying stuff which is, well not 'stolen' in that sense, but they won't buy the things that come from Hong Kong etc. Although I know they bought a Chinese piece which I was surprised at because it has no provenance, must have come out of Tibet in the last twenty years by its condition. Must have... I think they just wanted it and they snuck it in. So there's a bit of a, I understand that people don't want their head on a chopping block, and that's normal. (London Dealer 6)

We can see that those museums who do attempt to buy only objects they can be sure have not been recently looted, are perceived to be having trouble finding things that are secure enough to buy. Those museums who have not set themselves such strict standards, or simply do not comply properly with the standards they purport to operate under, will buy unprovenanced objects, but not if they are of such major importance as might draw attention to the museum. That would attract unwelcome criticism and perhaps even a claim for the return of the object by the source country from which it may have been looted and illegally exported:

We were all living from American museums, for the last 30 years. They were buying without asking too many questions. And it was a great time. Today, political correctness in America, provenance is the first issue for any museum curator – it means they can't buy anymore. A couple of museums are still buying, but if it's very important they don't buy it. (London Dealer 5)

2.1.3 Initial Conclusions on Provenance

Overall, then, the interviews confirm the image of the market obtained by a reader of the literature – an object-oriented trading forum which deals in artefacts about whose past little, if anything, is known. Concluding an interview with a major dealer in New York, I pointed to a small head in a display cabinet next to us, which seemed to resemble the Greek God Poseidon. I asked the dealer if, as an example picked by me at random, he could tell me anything about the provenance of this object:

[If I was a person coming in here to buy this object, could you tell me where it came from?]

We don't know. We just don't know. It was bought from an auction in Germany, a public auction, and they weren't able to give us any information and so therefore we have none. We don't know where the findspot was, we're not sure which country it came from. This is the problem. (New York Dealer 6)

Although provenance is becoming more of a talking point in the market, it has only influenced museum buying in the minor ways detailed above. It does not appear to have changed the way most dealers or collectors transact:

> *Private, they don't really care, but that is just something that's creeping up more and more and more.* (London Dealer 6)

By far the most important initial conclusion to reach on provenance is that while its absence in a transaction does not necessarily indicate that the object for sale has been recently looted, this routine lack of passing of provenance information that has been identified as a central feature of the market makes for a system of trading in which it is at times difficult – and often impossible – for a buyer to tell whether the object he is offered is licit or illicit:

> *[What's going to happen to all of the objects on the market which are currently circulating from old collections but have no provenance?]*

> *Well, that's the really difficult question, you know, which of them are from old collections and which of them are the product of looting from within the last, say, 50 years.* (London Museum 1)

2.1.4 Why do Trade Practitioners buy Unprovenanced Goods?

The majority of dealers and other trade members who buy antiquities without provenance or provenience resort to one of four appeals to justify their actions.

2.1.4.1 *A generally-accepted way to maintain competition*

The first appeal is to time-worn practice. This sometimes includes the argument that dealers should be allowed to conceal their sources to keep matters competitive and protect their profit margins:

> *A dealer, they don't want to say where they've got the object. A dealer ingratiates himself to a collector... a dealer ingratiates himself to children of people who've inherited objects. And he buys an object. He doesn't want anybody to know where it's come from. It's like somebody on a hunt... or someone who fishes, and has a little few places in the river where the fish are – he's not going to give it away. So that's one thing that's going to make giving where you bought the object... almost impossible, because people want to keep their source to themselves... If he bought it at auction, at a country auction, he's not going to want the collectors to know that he paid ten and he's asking 50 for it. Hmm?* (Geneva Collector 1)

> *It's an extremely cut-throat business. There are a lot of us doing it. Well, a very small number actually, but in relation*

*to the number of clients and the amount of material that's
available, there are quite a lot of us doing it, so you need to
be discreet, because if you blab, you know I might get a
collector to show me or sell me ten or twelve objects. If I
blab too much about where they came from you can be pretty
bloody sure that somebody else will be in there trying to get
the rest of it. I don't want that to happen. He'll cut me out...
If I bought something at Christie's I'm not going to say I
bought it at Christie's, obviously I'm not going to, because I
don't want people to go and look it up and find out what I
paid for it.* (London Dealer 8).

One might have thought that it would be in collectors' interests to
fight against this process of client and source protection, but they
appear to accept it as inevitable. They even read some benefits into
it for themselves:

*Collectors are hidden from each other by the dealers.
Because they don't want collectors to trade with each other
like postage stamps in a stamp market. There are stamp
collectors and there are stamp dealers and there are stamp
booths at stamp fairs where stamp collectors can trade
amongst themselves and trade with dealers. It doesn't exist
in antiquities. They don't want collectors knowing each
other. They don't want one collector to say "x dealer offered
me this for so much. It's expensive. Did he offer it to you
and for how much?" So the dealers do everything they can
to avoid one collector knowing another collector. And one
collector will not tell the other collector what the dealer offers
him, or how much the dealer offers something for. He wants
to keep his advantage – what he thinks is a privileged
relationship with a dealer; makes him believe he's a
privileged collector. So it's individualist.* (Geneva Collector
1)

2.1.4.2 Protection of the seller

The second appeal is to the rights of sellers to remain anonymous.
This appeal usually involves the example of the landed aristocrat
who must sell his collection to fund the upkeep of the family
residence, but who does not wish his family or perhaps prying
neighbours to know that he has fallen on hard times. The point, of
course, is that it is then left entirely to the buyer's sense of judgment
to decide whether the story he is being told is true or is simply part
of a ploy to sell looted or otherwise stolen goods:

*You see some people might sell objects totally anonymously
and want to be that way. Either way, it could be for totally
reasonable reasons – they just don't want people to know
they're flogging things – or it could also be probably that
they're trying to conceal something, but it could be either
way. And again, it's not limited to antiquities. I know of*

*people selling things who just don't want people to know
that they're selling things that are on the market and so
quite often dealers won't want to, because they've been
asked not to, won't want to divulge that information.*
(Melbourne Museum 1)

*We obviously protect the identity of our seller – we're not
going to go around shouting that this belongs to Mr X, partly
because Mr X may be having to sell because he's in
financial difficulty and doesn't want anyone to know about
it. That sort of reason* (Hong Kong Auction House 1)

*I have bought things in the past from the heads of aristocratic
families who were flogging stuff off to repair the roof and
didn't want the rest of the family to know it. And part of the
deal with me was that I would not divulge their names.
Now that's a legitimate thing.* (London Dealer 8)

The privacy accorded to sellers is an extension of the privacy
accorded to possessors of antiquities. Justifications for privacy in
respect of holdings extend from protection against criminal interest
to tax avoidance. Some arguments here clearly are more ethically
sound than others:

*When for example you're looking at catalogues and "the
property of, from an old English collection" or something.
And Colin Renfrew's been batting on about this. "People
should be transparent". "Let their names be known". But a
case in point in Britain: in many instances, they don't want
the neighbours to know that they've got to sell the family
silver. Or if it's a big house: "ooh, Lord so and so, did you
see in the sale room, he's sold off that statue"... people
don't want their names bandied around... Take for example,
in respect of antiquities, most of the learned societies in
this country do not publish a list of their fellows or members.
Because again, such is the world that the burglars or
whoever say "oh, that's handy". A list for example of the
fellows of the Royal Numismatic Society. "Ooh, they belong
to that, they must have coins on the premises"... So again, a
lot of the argument is that such transparency can be a
burglar's charter.* (London Dealer 9).

In many countries, people do not like to register anything of value
that they own. It's not because they want to hide from archaeologists.

[It's because they want to hide from the government?]

It's a taxation issue.

[That's not a good reason though, is it?]

Of course. (New York Dealer 6)

The 'burglars' charter' argument is contradicted by the reality that many of the major collectors of and dealers in antiquities do publish their holdings in catalogues and temporary exhibitions. As we shall see, the desire to achieve public recognition through collecting antiquities – a form of immortality which will enable the individual to survive in the world after their physical death – forms one of the main attractions for the committed buyer. The dealer who produced this 'burglar's charter' argument made clear his personal desire to remain free from all forms of scrutiny and assumed an intractable position which he supported with many different appeals. His position is made clear in an exchange between him and London Archaeologist 1:

> London Dealer 9 to London Archaeologist 1: *Well, let me ask you a leading question: Have you got any antiquities and a collection?*
>
> London Archaeologist 1: *Me personally? No I haven't.*
>
> London Dealer 9: *I do have and I'm known in particular areas, and I would not have my name public.*

Ultimately, it seems a truism that some members of the market will not countenance change of any real magnitude: the old ways are the best and carry with them a weight of historical repetition which renders them apparently inevitable. Secrecy is, and always has been, a function of the market and those it attracts:

> *People who deal in art – and it's not only antiquities, people who deal in art generally – tend to be individualist, loners, and rather discreet. That's part of the reason why they do what they do. It attracts people like that* (London Dealer 8).

2.1.4.3 Lack of provenance does not necessarily indicate anything sinister

The third appeal is to the presence of legitimate, but unprovenanced, antiquities in circulation on the market. It must be the case that there are many objects on the market which are licit. These include objects that were excavated and exported prior to the passing by the relevant source State of a law vesting ownership of all undiscovered antiquities in the State, or a law restricting export of the class of antiquity in question. They will also include objects in breach of these conditions which have become legitimated through the operation of limitation laws in the market State. In that case, after the passage of a prescribed period of peaceful possession of the object, the dispossessed owner is time-barred from making a claim against the current possessor for recovery of the object. The presence of licit objects on the market, coupled with the absence of mechanisms to distinguish between licit and illicit objects offered for sale, enables dealers to opt for an assumption of legitimacy when buying:

> *I think that there are so many antiquities on the market that don't have provenance information that dealers will try and*

exploit that and say "well, you can't be sure that these don't come from old collections and therefore we should say that they're okay". (London Museum 1)

[Do you think there's a need for regulation in the antiquities trade?]

Yes, definitely. Yep.

[Do you think people can regulate themselves?]

No, I'd say definitely not.

[Because of the nature of the people in the trade? Because there are some bad apples?]

No, I think it's too easy to turn a blind eye to things. However well intentioned you are, you know, if they came along with something knocked of a temple somewhere, and they said it was from their family collection or something, it's very easy to believe it. (London Dealer 3)

The 'blind eye' which this dealer suggests his colleagues turn to the presence of looted antiquities in the market is evidenced by the following remarkable exchange with a dealer in Melbourne. After stating with conviction that it is impossible to tell whether any given object has been looted or not, he proceeded to show me an object sitting on the desk where the interview was being conducted which *had* been looted, or so he thought! The irony inherent in the fact that after complaining about not being presented with suitable evidence to distinguish looted from non-looted artefacts, he had in any event purchased an obviously looted pot, was apparently lost on him:

[We've talked about provenance. What would it take for your suspicion to be aroused that something was stolen or illegally exported?]

Depends what you mean by stolen. I think that's one definition we should come to. If it's come from a museum collection, that's what I'd define as stolen...

[Okay, let's do both of them.]

... and that would be very very hard to work out, to tell you the truth. Like I was saying before, a lot of pieces have a collection number on them, but they've been de-acquisitioned. How can you tell? You've got no way of telling. So I doubt that I'd ever know if I did have something. And, er, what was the other part?

[Looting and then illegal export from a source country.]

Once again, pretty well impossible. Antiquities do change over time, once they've been taken out of the ground. You know, patination, like a nice old piece of furniture. When

it's new, it had sharp edges, everything was smooth, but with a bit of time the edges get a little bit worn. There are all these subtle signs. It's a lot to do with being an antique dealer – you look for these subtle signs to look for age. Now something that's freshly brought out of the ground does look different to something that's been out of the ground for years. Woodwork, like if it's a painted piece of wood, the colours might fade a bit. Yeah, it definitely does change with time. Pottery, I don't know what it is about pottery, but somehow that changes too. If it's something that's been handled, you get, obviously the oils from the skin get into the piece and you get a beautiful lustre appearing, especially if it's wood, or stone too, stone polishes beautifully over time. So you look for something like that. And sometimes you do get a piece that looks very fresh, but that may just be because it was kept in a cabinet on a stand. Certainly with the Chinese pieces, for example this pot (picks up pot off desk), you've got dirt in the crevices. That hasn't been out of the ground for long, so that's a recent, you know within the last five years I'd say that one's been dug up. (Points to striped indentation on the pot) You can see that that's where the spade hit when they dug it.

[So they don't even clean it? They just give you it covered in dirt?]

That's right! Yep, they just pass it on and pass it on. Some farmer's dug that up, somewhere in remote China and it's funnelled down through Hong Kong and into the marketplace. (Melbourne Dealer 1)

Some market professionals go to extraordinary lengths to keep track of circulating objects for themselves, but these conscientious 'annotators' are the exception rather than the rule. If the tracking of provenance necessitates this level of sustained diligence, it will always be the remit of the few rather than the many:

Carlos Picón, who's the curator of the Metropolitan, I mean Carlos is the most efficient annotator of catalogues, and he's a very good personal friend of mine, and sometimes I have dinner with him in his apartment. And I say Carlos, that piece sounds good. And he'll go and get a catalogue out and hand it to you. And it will have nine pencil annotations of previous sales that it's come up in. And he still has time to do that. He's pretty remarkable that way. You know, there's an awful lot of stuff that has been around and around and around. (London Dealer 4)

2.1.4.4 Chance finds

The fourth appeal is to the preservation of chance finds. This is an appeal so central to the issue of looting that it merits a reasonably extensive examination.

What do you do when somebody is not looking for something and discovers it? (New York Dealer 6)

Where no provenance or provenience accompanies objects sold in the market, it is impossible to tell whether an object for sale is the product of a chance find or an illicit dig. Technically of course, most source countries having passed laws vesting title of all undiscovered antiquities in the State, the extraction of a chance find is illicit. There is usually therefore no legal distinction between chance finds which are retained rather than surrendered, and looting. Even in the face of these laws, however, the market distinguishes between the two types of excavation. The concept of the chance find gives trade members an opportunity to see all unprovenanced objects (apart from those assumed to have been in circulation for some time) as the products of such fortuitous discovery. It even legitimates to some extent a bit of post-discovery digging around by the 'finder' by providing for its innocent beginning and acknowledging the curiosity inherent in our human nature:

> *Now, I do believe that most things are chance finds, although following the chance find, the guy may dig around to see if there are other objects. So it could be that chance find becomes illicit dig. And probably does.* (Geneva Collector 1)

The notion that most antiquities are discovered by chance rather than by deliberate searching helps antiquity buyers in the west to dissociate their act of buying from the destruction of context which accompanies the unlawful excavation of artefacts. If things are found by chance, they are not being deliberately sought out by diggers motivated by the thought of the price their find will fetch on the market. Coupled with this, as is to some extent apparent in the collector's quote above, is a different argument: that due to the naturally inquisitive nature of the human condition, locals in source countries would dig up antiquities whether a market existed for them or not. And if they are digging them up anyway, the market argument goes, what harm comes from our buying them:

> *My personal view is that if people know that they have fairies at the bottom of their garden, they'll dig them up. They'll dig them up irrespective of whether they can sell it or not. It's human nature that you will go treasure hunting. And I use treasure not in the monetary sense, but in the sense of discovery. People love to do it.* (London Dealer 8)

The first above-mentioned disavowal of a cause and effect relationship between market purchase and looting denies that the antiquities on the market have been discovered through active searching. Rather, it prefers to see them as chance finds. The second disavowal of cause and effect in the market does see the discovery as intentional, but still declines to place market purchase as a relevant causal factor. A combination of these two lines of thought leads to the following view of

the discovery of antiquities, prolific in the market: "Most discoveries are chance finds. I am not responsible for their discovery, but I preserve them by ensuring that there is a market for them once they are accidentally unearthed. Those antiquities that are not chance finds are the result of digging by curious local treasure hunters who would be digging whether a market existed or not. Therefore it is not my purchase of the goods they find which encourages them; it is inherent in their nature to dig". Through the employment of such apparently comprehensive thought processes (comprehensive because they cover both the situation in which the discovery of the object is intentional and that in which it is not), at no point does the buyer of an unprovenanced antiquity have to consider whether it may be the product of an organised looting project.

The pervasive argument that the market ensures the preservation of chance finds will be dealt with in more detail in Chapter 5 under the heading 'The market is a 'good''. That chapter will examine in more depth the use to which the argumentative strategies described in this chapter are put by market participants. We might here simply note the overwhelming presence of this argument in the interview data, and an example of the form that it takes:

> I have a friend who has a house in Greece, whose neighbour found a pot. They were terrified. They were tempted to destroy the pot, because if they got caught with it, you know, I think people should be thankful for the market in a way: that if someone finds something and it's gold then he's not going to melt it down as it has a value and it has a monetary value that's higher outside the country than it has inside the country. And that encourages people to take it outside the country. They take it out. We don't take it out. They smuggle it. We don't smuggle it. (New York Dealer 2)

Importantly for our analysis at this stage, in the average transaction there will be no objective basis on which to infer the intention of the original finder of the antiquity. There is no way to know at point of purchase whether the object was stumbled upon and 'saved' or was the product of a more sinister and dedicated project. The buyer is simply presented with an object, and possibly a story by the seller, which he may or may not choose to believe. Doubtless some antiquities on the market are the results of chance finds. Given evidence of looting recorded by source countries and the archaeologists, both local and foreign, who work there, however, it would appear to be unreasonable to assume without evidence that most newly surfacing objects on the market have come from chance finds. Interestingly this is precisely the assumption that the market makes:

> But really the vast majority of pieces that I've seen have really been – and I'm talking now about genuine pieces of course – have really been pieces which have come (I would have thought) more from accidental discovery than people

going out there and going to a temple site and looting it. (Melbourne Dealer 2)

You never know how something is found, and even if archaeologists tried to do an excavation, they will not be able to do it any more efficiently than someone who does it by chance. Because most of these are chance finds. (New York Dealer 6)

Sometimes, interviewees made their views explicit. Chance finds do not fall within their definition of looting:

If, for instance you come across something, let's go back into the mind of the person that's looking for it, well not looking for it, discovering it. Let's just say we've got a farmer. It's 1974, or 1980, it doesn't matter. He was originally a doctor or a teacher or whatever, and he's now working in the fields in Cambodia... He's digging in the field. He's been told by the Khmer Rouge he's got to plant crops, he's got to do this, he's got to get the rice going, he's got to do this all the time. He's ploughing away, he hits a piece of rock, he digs it up and he finds it's a torso, or a female figure. He looks at it. To him it's probably of no interest at all. He's seen these things in books, but never even been to the temple sites, because it's just not part of their existence. He's got four children, a wife, they're all working, or the kids are doing whatever they can. He tells people what he's discovered. Someone says we can get you enough rice to last you a month if you can let us have that piece. He then says of course – it's not important to me, I'll be lucky to survive six months. He then hands it on. That person who's bought it for a sack of rice might know someone in the military. And this is only fanciful, but I'm pretty sure that this is what happens. And then the piece travels and you end up finding it in Hong Kong or in Bangkok or wherever. To me that's not looting. If it's a piece that's kept people alive, if it's not of major significance (and how do we ever know if it was or wasn't – that's another question, but that's again, you can debate that till the cows come home) then really it's not looting. It's a providential find. But just as important is that the man has been able to live because of his discovery, other people up the chain have been able to have life, and also suddenly a piece has come to light that no-one may ever have found. (Melbourne Dealer 2)

[Let me ask a very straightforward question. Are you against people going out and deliberately digging around looking for antiquities under the soil?]

Yes, yes I am.

[Are you against people going to sites of archaeological interest, temples and things like that, and ripping bits off them?]

Absolutely, that's totally out...

[Now chance finds. Chance finds are to you different from that kind of looting?]

Well of course! You're ploughing your field, you're putting irrigation in, you're building a road, you're building a highway, you're building a dam, you're building an airport; the economic development is colossal. So you go underground for the foundations, and obviously in some countries you can barely go underground without hitting antiquities. Or testimony of the past – ancient art. That's a chance find. Now that chance find is immediately destroyed, just to avoid problems. I can go into all of the problems, but you can guess what they are or imagine them. And if one of the workers, one of the contractors, one of the foremen, whoever it be, knows that these have a value, then they are taken out of the ground, they're hidden and then they follow a route that leads them abroad eventually, although some can be sold locally. (Geneva Collector 1)

Here we might split buyers in the market into three classes. Class 1 buyers have no qualms about buying most looted antiquities. Class 2 buyers will buy chance finds, which they do not classify as looted, but will try not to buy other looted antiquities. Class 3 buyers are the imaginary angels of the market, who will do everything in their power to avoid the purchase of an illicit antiquity, whether chance find or product of an intentional illicit dig. No evidence of this class of buyer was found in the interview sample.

Those interviewees with the widest definition of looting included therein organised illegal digging, along with theft from an architectural structure above the ground. These are Class 2 buyers. Many interviewees employed a much narrower definition of looting which covered only theft of parts of monuments above the ground. These are Class 1 buyers. The notion of 'saving heritage' implicit in the use of the concept of the chance find affected these Class 1 interviewees so strongly as even to lend legitimacy to intentional exploratory digging insofar as that brings objects out of the ground which might otherwise have gone undiscovered. This, in fact, is an approval of action which forms the classical definition of 'looting'. Geneva Collector 1 who above stated that he disapproved of intentional digging pulls back from that position when questioned further, to reveal that only if archaeologists have discovered the site and rendered it 'official' does he disapprove of its unauthorised excavation:

I don't approve of digging in an official archaeological site. That's absolutely out. But where a farmer, or someone who thinks there's a little mound over there, I'll dig it, and it's out in the countryside, not within an archaeological site, that in a way is quite different.

[Well, presumably an archaeologist would say in relation to that mound that it would be an archaeological site if they knew about it.]

No. Because there's far too much. They'd think it wasn't worthwhile. They wouldn't dig it. As happened with the third mound, the most important one at Sipan: it's been surveyed by archaeologists and discarded... (Geneva Collector 1)

Perhaps surprisingly, many Class 1 buyers were found among the trade interviewees. In some interviews, while never expressed outright, throughout the course of the interview it became apparent that although the interviewee spoke of chance finds, or used the imagery of farmers digging in fields, he would quite happily buy objects discovered less through chance than through intentional digging, so long as they were not architectural. An example is this exchange with a dealer in Chinese antiquities:

I think when they [source governments] say that things that they don't even know exist are theirs, you know things so far undiscovered, that seems to me not an easy thing to claim. And you very easily get confused between real theft and that kind of theft... I mean I think to take something from an archaeological dig falls within a completely different category than a farmer who happens to be digging and finds something in a field. That's where I stand but I know that a lot of countries seek to make those things both to be the same...

[So you think there should be a differentiation between chance finds and the destruction of archaeological sites?]

I think they should be considered in a very different light indeed. I mean, where I personally draw the line is with damage to structures. I don't want to make a big moral thing about it, but... damage to immovables of any kind really.

[That's more in the nature of depredation than things taken out of the soil?]

Yes, yeah, that's what I agree.

Does that happen a lot in China?

Er, yes, yep. (London Dealer 3)

Some Class 1 interviewees were frank enough to make their willingness to buy the product of intentional digs plain:

There's nothing wrong with what they're doing (diggers), as long as the goods are not stolen, and all the goods we have today will eventually one day end up again in Thailand or in Cambodia or wherever, when they have found oil or whatever, or in 300 years they've won a world war, you know, whatever. (London Dealer 5)

I don't like fragments taken off walls, heads off figures, whatever, I think that's avoidable and you won't see any in the gallery here. We try avoiding fragments, because in the end if you buy it from an old collection, that's one thing, but if you would go to Hong Kong and you see a head there for sale then you just know it's ripped off something and that's stupid. Whereas if it's a Tang horse, or the things that I tend to buy, I mean the three things that I bought in Hong Kong in the last ten years was a Tang Horse, a Han dog and a large Han horse, all of which come from some grave which has been underground, smashed, put together. So it doesn't occur to one, I don't know if you understand that. They're in some grave, smashed, we're all going to be dead in 30 years, so I have no interest that they're there – I've enjoyed them and I couldn't give a hoot if they've been on the list[of objects which China does not wish to be exported] or not. I've sort of enjoyed the objects and I think one has to realise that. The tragic thing is if you get an imperial grave, or you get a grave which is of great historical value and that's looted and the stuff is destroyed, then that's a pity, because the history is destroyed with it. Manuscripts can get destroyed. Old silk can get knocked about. If it's just sort of normal, run of the mill, like millions of Etruscan graves in which people found them, then we're enjoying the art now. Why not, you know? I don't think it's the end of the world compared to what we have to deal with in everyday life. Also mentality changes, because we accept certain things. Maybe we accept like someone having an affair on holiday, but would never accept it at home, in the little town you live in. I think that's where you have exactly the same thing with mentality, you know, you'd never accept something being taken from an English grave and sold on the market, but you know, it's an exotic place and it's just one of those strange things, somehow things function. (London Dealer 6)

Khmer, … as I see it, there are two or three very clearly distinct types of item which come into the market. There's things which have been in the market since the French dug them up and took them away decades ago. And then there are things which are dug up today. And those two I think can be considered fair game, mostly. And then of course there is very great chunks of art which have been chopped off Angkor Wat or Bantaey Chmar, which obviously are not fair game, which are part of an above-ground existing national monument.

[Is it easy enough to tell the difference between the two?]

Very difficult, in many cases. That's one of the problems. People claim they can do it. In some cases it's very obvious, because the thing is documented as being in place a couple of years ago and now it's not there and here it is somewhere else. That's obviously easy to document…

[… How then does the stuff come onto the market? How does it come to you? Do people just come and offer it to you?]

Yeah, people come and offer things. And we try and be discriminating. I mean I don't feel any qualms about buying something that's obviously just been excavated. But if it's got evidence of recent worship and stuff then you have to be a lot more careful. That doesn't necessarily mean that it's not a legitimate buy. I mean it could be that it's from somebody's private personal home collection and in that case, if you can verify that, that I think is okay. But obviously if it's been knocked off from the local temple it's very much not okay...

... I mean there are certain things I simply won't buy. I don't like to buy heads, for example, Buddha heads. I'll buy a head if it's obviously excavated and I'm really sure (you can easily tell by the wear on the break and so on) but if it's freshly sawn off, I absolutely won't touch it. But a lot of other people will.

[Why are there so many heads on the market?]

It's because they're easier to move... and you'll find that years ago there were lots of heads on the market and now the heads are all sold, and now the bodies are coming on to the market. Because people are now taking the trouble to pick the whole thing up and bring it. And hopefully at some point in the remote future, some of the bodies will get re-united with their heads... I find that rather sad. (Bangkok Dealer 1)

Although some of the Class 1 buyers among the interviewees would see some category of excavated material as problematic (usually that taken from a scheduled archaeological site in a clandestine raid), the chance find argument can be used – as it is by Class 2 buyers – to allow them to buy all excavated goods that they are offered without having to breach their purported standards:

If for any reason, economics, cultural or otherwise, an existing monument is damaged, the world should have very important punishments for this. To that I agree, I subscribe, I will support, I will do anything. Because I want to be part of this preservation effort. On the other hand, if somebody finds a jar of coins and it's a chance find, you have to have a scenario worked out. (New York Dealer 6)

[When we were looking at your pieces downstairs you were pointing at them and saying 'this one's a chance find'. How do you know that's a chance find? How does the information get to you that it's a chance find?]

Ah, well I said I thought that most of my objects are chance finds. They're obviously all not chance finds. But one gets a feeling, if you go to a museum and see and read, in the old days and locally where things come from, how they're found, how they come, I think one can get a pretty good feeling. Now I may be inclined to think that more of my objects come from chance finds than actually do, but that is a weakness of human nature. (Geneva Collector 1)

The reality of course is that the lack of provenance in the market means that, just as there is often no way to know how long an object has been out of the ground, there is no way to know whether it was found by chance or by organised looting:

> At the moment anything can be a chance find. There are things that are on the market that could have been on the market for the last 50 years of course, or fifteen years or five years. There are things that might come from a chance find, there are things that might come from an illicit dig, there are things that might come from a temple. (London Dealer 7)

This recognition of the market discourse regarding chance finds leads us to see the looting problem as defined by dealers as something external to them, for the most part. Individual dealers may choose to define their purchases in terms of the preservation of chance finds, thereby avoiding the issue of looting in their minds when making these purchases. All of the dealers and collectors interviewed were, as would be expected, aware of the issue of looting generally, but they did not see it as of particular relevance to their practices. This merits further exposition.

2.2 IN CONCLUSION: HOW THE MARKET TALKS ABOUT LOOTING

The mechanisms employed by the trade to justify their unsecure purchases (by which is meant any purchase the object of which does not have a verifiable provenance) to themselves, and to inquisitive others, such as the use of the concept of the chance find, represent the personal interaction of the individuals with the issue of looting: 'I do not buy looted artefacts.' How, though, is the looting problem thought of more generally by those in the market? When not pressed to speak about their own trade practices, how do dealers, collectors and museum representatives describe the phenomenon of the looting of antiquities in source countries?

Occasionally the practice of looting is denied altogether, more through ignorance it appears than attempted deception. An example is this conversation with an Asian art dealer who was fairly active in buying antiquities from throughout southeast Asia, but was not aware, or so it seems, that looting was a problem in Thailand:

> The sites that you're talking about [looted sites] haven't really occurred as far as I'm aware, in the parts of southeast Asia that I'm talking about. It's very much an Italian thing, with the tomb robbers there. They know that there are grave sites under the ground. They literally get earthmovers in, they dig up the graves, they destroy everything just to get vases or whatever out. Very much in Italy. Very much I believe also too in South America, where they know where things are. But for instance... not so much Thailand, because Thailand's got very strong rules on it, which are quite good. (Melbourne Dealer 2)

More often the practice of looting is acknowledged, but the interviewees shrug off the idea that anything much might be done about it. Like their unwillingness to question the lack of provenance in the market, discussed above, a similar reason is given for their unwillingness to question the continuing work of looters – it has simply always been this way:

> Frankly this has been going on for centuries. You can read literature about tomb robbers in pre-dynastic Egypt. It's not a new idea. It's something that's always been with us. (New York Dealer 1)

> Most of the pieces that you do see on the market have been dug up by a farmer somewhere, or organised groups which go looking specifically for things, and then they go onto the marketplace and they get sold and of course their scientific value is lost, which is a bit of a problem of course… it's just a basic sort of theme which wealthy people have always wanted to collect beautiful things like that, and that's fuelled the demand for the trade. (Melbourne Dealer 1)

Some interviewees did not have any problem with the concept of looting – they thought that as a practice it was alright, and that the arguments against it had been overstated. Much more common, though, was a statement of general disapproval of looters and looting on the part of the interviewee, followed by a 'but…' which sought to focus on the positive outcomes of the activity. The two main positives are the economic benefit to source populations and the very discovery of the objects which might otherwise never be known to humanity. These perceived benefits of the market and of looting will be examined further in Chapter 5.

The conclusion to the present chapter is stark and simple. There is very little provenance information in the market. Those in the market could change this, but they do not. They offer reasons for this, such as fair competition, seller protection and the weight of precedent. They suggest that most objects have been around for years, or are chance finds. All of their reasons, arguments, excuses and justifications form the seemingly insuperable wall within which operates a trade protected from scrutiny. Some of these justifications seem reasonable enough at first blush; as they must, otherwise the wall would crumble. Others, however, are less secure. Transactions are based in 'trust' but where there is no verifiable or objective basis for this trust such as reliable evidence of provenance, it amounts to a straightforward decision to buy what is available without reference to the looting problem. What have lawmakers done to regulate activities within these system walls?

CHAPTER 3

THE CURRENT STRUCTURE OF REGULATION IN
THE ANTIQUITIES MARKET

In this chapter I shall set out and examine the relevant laws affecting the international movement of antiquities. In section 3.1 we look at the domestic laws of Thailand as a source country and the United States and United Kingdom as market countries. These include import/export laws, which can be seen as 'barrier' control, as well as laws internal to those barriers. The Australian import laws are also mentioned for comparative purposes.

In section 3.2 we move to a broader analysis of the main implements of international regulation. These are the UNESCO and Unidroit Conventions; documents which attempt to establish an ethic of care for source countries and their antiquities, but which fail, for reasons that will be explored, adequately to do so.

In section 3.3 the question is asked "how well does the norm of civil actions by source countries for the recovery of their antiquities illicitly taken abroad work to control the problem of the international market in illicit antiquities?" To conclude, the level of protection afforded to Thai-sourced antiquities by the law is assessed.

3.1 DOMESTIC ANTIQUITIES LEGISLATION

3.1.1 Thai Legislation Governing Removal at Source

Thailand's Act on Ancient Monuments, Antiques, Objects of Art and National Museums, B.E. 2504 (1961), ('the 1961 Act') as last amended by the Act on Ancient Monuments, Antiques, Objects of Art and National Museums (No. 2), B.E. 2535 (1992) sets up a system of registration of monuments and relics, controls dealing, prohibits export, makes all excavations subject to a licensing procedure (whether on public or private land) and requires all finds to be reported.[1] These controls placed on excavation of antiquities are matched by sections in Thailand's Minerals Act and its Petroleum Act which require persons licensed to prospect for or exploit these resources to report any 'antiques' which may be found.[2]

[1] A certified copy English translation of the 1961 Act as amended is available at the Office of the Council of State website at http://www.krisdika.go.th/home.jsp (version current at 1 March 2005).

[2] L.V. Prott, & P.J. O'Keefe, *Law and the Cultural Heritage, Volume 1: Discovery and Excavation.* (1984, Abingdon, Professional Books).

Additionally, the National Executive Council Announcement No. 189, 23 July B.E. 2515 (1972) prohibits the search for archaeological and historical objects in areas designated by the Minister of Education.

It is worth detailing the most important provisions of the 1961 Act here. The Director-General of the Department of Fine Arts has, under section 7, the power to cause any ancient monument, and such area of land around it as he thinks fit to be its compound, to be registered. Once such registration has taken place, building on the land may only take place with a permit from the Director-General (section 7(2)). Modification, demolition, removal and excavation of any part of an ancient monument or its compound may similarly not be undertaken without a permit, under section 10.

In relation to individual antiquities (i.e. not forming part of a monument), section 14 gives the Director-General the power to cause antiques and objects of art not in the possession of the Department of Fine Arts to be registered if the object is of 'special value in the field of art, history or archaeology'. What we are here referring to as antiquities appear in the Act mainly under the headings of 'antiques' and 'objects of art'. 'Antiques' are defined in section 4 as archaic movable property, whether produced by man or nature, or being any part of an ancient monument or of a human skeleton or animal carcass which, by its age or characteristics of production or 'historical evidence', is useful in the field of art, history or archaeology. 'Objects of art' are defined in the same section as things skilfully produced by craftsmanship which are of high value in the field of art.

Power is also given to the Director-General to deem certain objects to be conserved as national property, in which case their trade is barred other than by licence. Once registered, certain obligations attach to the possession and transfer of an antiquity. Repair, modification or alteration may be undertaken only with a permit (section 15), deterioration, damage, loss or removal must be notified to the Director-General within 30 days (section 16), and all transfers of ownership must be reported (section 17).

Vesting of title to undiscovered antiquities in the State is effected by section 24, which states that:

> Antiques or objects of art buried in, concealed or abandoned within the Kingdom or the Exclusive Economic Zone under such circumstances that no one could claim to be their owners shall, whether the place of burial, concealment or abandonment be owned or possessed by any person, become State property.

Finders of antiquities who report their discoveries are entitled to a reward of one third of the value of the object or objects found under section 24 if they deliver the objects to a competent official. This system of reward appears to offer little incentive to a finder to leave

the object in the ground and leave the surrounding area undisturbed. Although such prospecting is outlawed in and around ancient monuments under the provisions detailed above, a person who happens upon an antiquity outside such restricted areas would seem entitled (and indeed well advised) to dig up what he can in order to claim his finder's fee on as many objects as possible.

Penalties for breaches of the various provisions of the Act are set down in section 31 *et seq*, and currently range from a maximum prison term of three years and/or a fine not exceeding 300,000 baht (US$8,000) for a breach of the section 10 prohibition on excavation (section 35) to a maximum prison term of ten years and/or a fine not exceeding 1 million baht (US$26,000) for damage to a registered ancient monument, antique or object of art (sections 32 and 33).

There is no special group of enforcement officials in Thailand allocated with the responsibility of enforcing the provisions of the 1961 Act, although employees of the Department of Fine Arts sometimes try to perform a policing role. In terms of security of sites, apprehension and arrest of lawbreakers etc., the responsibility lies with the Thai police.[3]

This is the law as it appears on the books. The law as it is applied in practice seems much more lax:

> *[Do you foresee a time where there might be a crackdown by the Fine Arts Department?]*
>
> *No. Because all the top, top people in government would have artefacts which are illegal.*
>
> *[Really?]*
>
> *Oh, yeah.*
>
> *[So everybody's a collector to some extent?]*
>
> *They collect Buddhas, mostly.*
>
> *[Why do they do that?]*
>
> *It's just the Thai way...*
>
> *[They collect Buddhas for religious importance?]*
>
> *Yes.*
>
> *[So we've got a system of law which is incredibly restrictive on the books, but which doesn't actually do anything?]*
>
> *Doesn't work at all.*

3 R. Thosarat, 'The Destruction of the Cultural Heritage of Thailand and Cambodia', in N. Brodie, J. Doole & C. Renfrew (eds) *Trade in Illicit Antiquities: the Destruction of the World's Archaeological Heritage.* (2001, Cambridge, McDonald Institute for Archaeological Research).

[And even the people who are supposed to be responsible for drafting and enforcing those laws are themselves breaking them by collecting objects?]

Yes. The officials of the Fine Arts Department, some of them have been buying and selling...

[What about the police? Are they interested in this at all?]

Oh, they were very interested. They were arresting the people coming out of these burial sites, confiscating the goods and then re-selling them. They get a low salary (Chiang Mai Collector 1).

There appears to be ample opportunity for illegal excavation of antiquities in Thailand, and no reluctance on the part of locals to buy the objects which come out:

They found these burial sites about fifteen years ago with fabulous things. We couldn't compete with the big dealers, but we got a few pieces.

[Direct from where they were finding them?]

Direct from where they were finding them, yep. We stood there and watched them dig them up (Chiang Mai Collector 1).

When the police do exercise the powers they are given to enforce the provisions of the 1961 Act, they arrest those at the digging end of the chain of supply rather than the socially superior major dealers who buy the products of illicit digs and move them onto the international market:

The ones that we get is always on the lower level. We never get closer to the top. And I believe that the top one is very high powered and this might link to the higher level people in society, and you never get close to that network.

[In Thailand you don't?]

In Thailand, and I believe in a lot of countries in southeast Asia as well. What you get is oh, villager. Police arrest like 50 people. That is the end product, the bottom, not the real stuff (Bangkok Archaeologist 1).

While some members of the Fine Arts Department do know who these 'high powered' dealers are, they feel powerless to involve the police for fear of losing the only method at their disposal in tracking down the more important of the looted Buddhist images – asking for help from the dealers and hoping that they will deign to assist:

When all the things come to Bangkok we cannot do anything much, because they are underground. We don't know much.

But some people in Fine Arts Department in archaeological division, they know who sells the objects.

[They do?]

But they can help just only a little bit, like some temples that have some Buddha image, the whole objects, if it was stolen and report, they can ask for help from some of these people. They know they have some links, but not much.

[They could never report them to the police?]

No, otherwise they have no connection (Bangkok Archaeologist 2).

3.1.2 Thai Export Control

Section 22 of the 1961 Act prohibits the export of antiquities in the following terms:

> No person shall export or take out of the Kingdom any antique or object of art irrespective of whether it is registered or not, unless a licence has been obtained from the Director-General...

The section 22 export prohibition does not apply to relevant objects five years old or less and those in transit – it is only Thai-sourced antiquities which are restricted.[4] Antiques or objects of art may be temporarily exported (for example for the purpose of display abroad) under licence from the Director-General if adequate security is deposited with the Fine Arts Department under section 23, and there is also a provision permitting export for the purposes of education (section 23(2)).

Export of an antiquity in violation of the section 22 licence requirement renders the exporter liable to imprisonment and/or a fine under sections 38 and 39. Currently, the penalty for export of a non-registered antique or object of art is a maximum prison term of seven years and/or a fine not exceeding 700,000 baht (US$18,000). The exporter of a registered antique or object of art without licence is currently liable to a mandatory prison term of one to ten years and to a fine not exceeding 1 million baht (US$26,000).

3.1.3 US Import Control

Restrictions on the import of illicit antiquities into the United States, as elsewhere, come in different forms. The import of stolen goods is unlawful under the National Stolen Property Act (the 'NSPA') 18 U.S.C. section 2314. The goods must be known to have been stolen at the

4 This has made Thailand an attractive transit route out of the region for looted antiquities from neighbouring countries, notably Cambodia.

time of import. In *United States v. McClain*,[5] the Supreme Court had an opportunity to consider the issue of State declarations of ownership. Mexico had, under Article 27 of its Federal Act on Monuments and Archaeological, Artistic and Historic Zones 1972 declared all archaeological monuments, movable or immovable, to be the property of the nation. The US Supreme Court decided that such property was capable of being stolen from the nation, having never been reduced to the possession of any individual owner as such, and was therefore covered by the NSPA. The recent case of *United States v. Schultz*[6] reached a similar conclusion in relation to objects smuggled out of Egypt in breach of that country's declaration of State ownership. In fact, in that case the Judge sentencing Schultz, Judge Rakoff of the Federal District Court in Manhattan, seemed comfortable in dismissing any suggestion that the case involved legal peculiarities difficult to resolve, describing the defendant as "an ordinary thief in every conventional sense of that word" and explaining that "the court was convinced by the evidence in the trial that the defendant knew he was stealing, in every sense of the word...".[7]

The United States imposes restrictions on the import of cultural property on what is almost a case-by-case basis. One manifestation of this is its interpretation of the UNESCO 1970 Convention as requiring the existence of a bilateral agreement to have been entered into between the United States and the source country before action will be taken by the US to restrict import of the goods which form the subject of that agreement. This idiosyncratic implementation of the 1970 Convention will be discussed at greater length in the course of this chapter. Another example of such relatively specific restrictions is the Regulation of Importation of Pre-Columbian Monumental or Architectural Sculpture or Murals of 1972 (19 U.S.C. sections 2091–2095), which was passed in response to pressure on the United States from archaeologists such as Clemency Coggins[8] to take measures to protect pre-Columbian sites in South America from escalating damage caused by looting. The Act effectively requires a certificate of authorisation from the source country to be produced on import into the United States of any cultural property originating in the various South American countries covered by the legislation.

Thailand's antiquities currently have no such protection. Thailand has no bilateral agreement with the United States under UNESCO 1970 (indeed at the time of writing Thailand is not a signatory to that Convention) and neither is there any domestic US legislation requiring a certificate of legal export from Thailand before an object

5 593 F.2d 658 (5th Cir.), cert. denied, 444 U.S. 918, 100 S.Ct. 234, 62 L.Ed.2d 173 (1979).

6 *Ibid.*, section 1.3.3.3. 178 F. Supp. 2d 445 (S.D.N.Y. 2002), 333 F.2d 393 (2d Cir. 2003), 147 L.Ed 2d 891 (2004).

7 C. Bohlen, 'Antiquities Dealer is Sentenced to Prison' *New York Times*, 12 June 2002.

8 C. Coggins, 'Illicit Traffic of Pre-Columbian Antiquities'. (1969) *Art Journal*, Fall, pp. 94-8; 'The Maya Scandal: How Thieves Strip Sites of Past Cultures', (1970) *Smithsonian*, October, pp. 8-16; 'An Art Historian Speaks Out', (1971) *Auction*, January, p. 33.

will be allowed to be imported into the United States. Objects which are recognised as stolen from the Thai State under its 1961 vesting legislation might be the subject of restricted import into the United States under the NSPA, then, but other than that there will be no restrictions imposed on the import of Thai antiquities. And we can temper even the effect of the NSPA with the recognition that in the absence of a general requirement for Thai export documentation it will be very difficult, if not impossible, for US customs officials to recognise any given item as looted (and therefore stolen).

Of course, there exists legislation giving powers to customs officials to control imports of antiquities in the absence of any specific cultural heritage legislation or the need to invoke their powers under the NSPA in relation to traffic in stolen goods. Prott and O'Keefe in their summary of international cultural heritage legislation list some of these general US customs powers as provisions on: smuggling (18 U.S.C. section 545); entry of goods by false statements (18 U.S.C. section 1001); fraud and false statements (18 U.S.C. section 1001); failure to declare (19 U.S.C. section 1497); loading or unloading of merchandise or baggage without permit (19 U.S.C. section 1453); and false descriptions on ocean bills of lading (46 U.S.C. section 815).[9]

A relatively recent example of the enforcement of these customs powers, which exist in isolation from both the NSPA and the powers of import restriction consequent upon the US's implementation of UNESCO 1970, is *United States v. An Antique Platter of Gold*.[10] The case involved the seizure in 1995 from the home of a New York antiquities collector of a fourth-century gold phiale. In the District Court of New York, forfeiture of the phiale was ordered by the court after evidence was heard that the US purchaser's agent conducted his import of the object into the United States in such a way that strongly suggested he had knowledge that the item was stolen (from the Italian State which had passed vesting legislation in Article 44 of its law of 1 June 1939, No. 1089) and therefore the phiale could be confiscated under section 2314 of the NSPA, mentioned above. On appeal, however, the forfeiture of the phiale was upheld, but on the basis of a contravention of the United States Customs Code 18 U.S.C. section 545 which, as stated above, prohibits the making of false statements in customs declarations. The customs form which accompanied the imported phiale had stated the country of origin as Switzerland, from where the dealer had imported it, rather than Italy, its original source. The Court of Appeals therefore found it unnecessary to rule on the question whether the phiale had been stolen, and consequently on the knowledge of the purchaser and his agent, as forfeiture could be ordered on the basis of the mis-statements on the customs import form.

9 L.V. Prott, & P.J. O'Keefe, *Law and the Cultural Heritage, Volume 3: Movement*. (1989, London, Butterworths) at pp. 600-601.

10 991 F. Supp. 222 (S.D.N.Y. 1997), aff'd 184 F. 3d 131 (2d. Cir. 1999), cert. denied 1205 S. Ct. 978 (2000). See M. Lufkin 'Forfeiture of an Antiquity Claimed by Italy: the Steinhardt Case' *(2000)* V *Art Antiquity and Law* 57.

In the absence of the discovery of some element of fraud (such as amounts to smuggling) or deception (such as misdescription), however, the import of a looted Thai antiquity is unlikely to be challenged. In the *Antique Platter* case, there was evidence to support the contention that the buyer's agent had gone considerably out of his way to ensure the phiale was imported from Switzerland rather than Italy. The price of the object was also fraudulently misdescribed on the customs form as US$250,000; the purchase price was US$1.2 million. It is important to note that these misdescriptions did not raise the suspicions of the US customs officers who processed the import. The purchaser had the object on display in his home for three years before his possession was interrupted by the Italian Government's claim. Even when import requirements are in place in art market countries, then, their efficacy is subject to considerable doubt. In the more regular course of events, however, where a (say) Thai object is looted and illicitly exported to a transit port such as Hong Kong, there will be no problem getting it from there into the United States. A dealer from New York describes this simple process of exporting an object from Hong Kong and importing it into the United States:

> There's a great deal of buying in Hong Kong; they have to get some kind of little stamp duty kind of okay from the Government: "yes you may send this out". They record who it was bought from, what it is and what was paid for it, who bought it, and say "fine, off you go". Then it comes to US customs with the same list, same invoice, and basically their question is "is it over 100 years old?" We've got a documented invoice of who sold it and who bought it, so is it over 100 yrs old? And then it comes through clear of customs. That's the exercise. It's not very complicated (New York Dealer 1).

3.1.4 UK Import Control

The current system of UK import control was introduced by the Import of Goods (Control) Order 1954, an Order made under the Import, Export and Customs Powers (Defence) Act 1939 as amended by the Import, Export and Control Act 1990. The Order requires all goods imported into the United Kingdom to have a licence. In practice, however, the Department of Trade and Industry grants an Open General Import Licence which permits the import of all goods from all sources unless specifically excluded.[11] Currently no items of cultural property are the subject of such an exclusion, and so all are free to be imported. The exception to this rule occurs under the Dealing in Cultural Objects (Offences) Act 2003, which creates a criminal offence that applies, *inter alia*, to the import of a 'tainted' cultural object.

Prior to the introduction of the 2003 Act, which will be discussed in more depth in section 3.1.6.2 below, the lack of import controls on cultural property entering the United Kingdom was acknowledged

11 Prott and O'Keefe, *op. cit.* note 9.

by the House of Commons Culture, Media and Sport Committee in their report on the illicit trade in cultural property.[12] Antique firearms might be subject to restriction, they noted, but cultural property generally attracts no special treatment. They are explicit in their conclusion that "in consequence, it is not an offence to import into this country cultural objects which have been illicitly excavated in or illegally exported from their countries of origin".[13] Closer examination reveals a flaw in this statement, however. Handling stolen property is an offence in England and Wales under section 22(1) of the Theft Act 1968. The section reads:

> A person handles stolen goods if (otherwise than in the course of the stealing), knowing or believing them to be stolen goods he dishonestly receives the goods, or dishonestly undertakes or assists in their retention, removal, disposal or realisation by or for the benefit of another person, or if he arranges to do so.

Under section 24, 'stolen goods' can include thefts outside England and Wales. Therefore, insofar as import of a stolen object involved possession within the jurisdiction of England and Wales, it would seem to be covered by the second half of the section 22(1) offence, provided the import was for the benefit of someone other than the importer himself. In their memorandum of evidence submitted to the House of Commons Committee mentioned above, HM Customs state that there is no customs prohibition on the import of goods known or believed to have been stolen overseas.[14] They also say that where they had such information they would liaise with the police, suggesting that while they acknowledge a possible offence, they see themselves as powerless to seize incoming goods stolen abroad. This interpretation of their own powers is quite wrong, however:

> The offence of handling would include the case of someone who imports a stolen object into this country. The police also have powers under the Police and Criminal Evidence Act 1984 (PACE) to seize and detain any object that is evidence of a crime. Similar powers are conferred on HM Customs.[15]

This statement must be qualified. The offence of handling is committed under the second half of the section 22(1) offence if the import is for the benefit of another. Import of stolen property for one's own benefit does not constitute handling. The case of *R v. Tokeley-Parry*,[16] applies to that situation, however. It was there

12 House of Commons Culture Media and Sport Committee 'Cultural Property: Return and Illicit Trade', *1999-2000 session, seventh report*, July 2000.
13 *Ibid.*, at para. 103.
14 HM Customs and Excise, 'Memorandum of Evidence submitted to the House of Commons Select Committee on Culture, Media and Sport', April 2000.
15 K. Chamberlain, 'UK Accession to the 1970 UNESCO Convention', (2002) VII *Art Antiquity and Law* pp. 231-52.
16 [1999] Crim. L.R. 578.

acknowledged that where a foreign State has passed a suitable vesting declaration, illegal export of vested antiquities will constitute a theft recognised by English law. Where, therefore, such antiquities are imported for the benefit of the importer, those objects will be 'evidence of a crime' recognised by England under section 24 of the 1968 Act and therefore could be seized by HM Customs or the police.

The offence created by section 1 of the Dealing in Cultural Objects (Offences) Act 2003 will now cover both types of import-related handling; for the benefit of the importer and for the benefit of another. Section 4 gives HM Customs and Excise the power to institute proceedings in relation to the offence. The new offence is to be welcomed in relation to the clarity it brings to the matter of illegal import, but it remains to be seen whether this newfound clarity is enough to generate an increased level of control. At the time of publication of this text the Act has been in force for over a year and has yet to form the basis for a prosecution, import-related or otherwise.

That the 2003 Act has not resulted in a flood of prosecutions consequent upon seizure at the border might have been predicted on the basis of statements made prior to its enactment to the House of Commons Committee. In considering the implementation of an import control system for cultural property, the Committee looked to evidence provided by HM Customs and Excise by way of the above memorandum. It made clear that they would require a system based on hard practicality, which would probably take the form of import licences linked to verification of legal export, together with the provision of clear and unambiguous definitions of goods that require a licence. Without such a licensing system, "HM Customs considered that a prohibition on importation of certain categories of cultural property "would not be terribly effective" because there would be little evidence ascertainable by the Customs service to lead it to detain a consignment".[17]

Further, even if a licensing system were imposed for the control of the import of cultural property into the United Kingdom, HM Customs indicated to the Committee that "in the absence of specific intelligence or reasons to target a particular consignment, we would have no means by which to routinely enforce an import system on movements from within the European Community".[18] Earlier in this book the position of transit States in the flow of antiquities to their destination market was mentioned. Neither Switzerland nor Hong Kong is of course a member of the European Union, but Belgium – a popular transit State for antiquities – is. The free movement of goods, which is one of the pillars of the European Union, therefore can be seen to provide considerable problems for those who would

17 Report of House of Commons Culture Media and Sport Committee *op. cit.* note 12, para. 105.
18 *Ibid.*

try to control the flow of illicit antiquities. The power of EU Member States to exclude illicit goods from their territory is to some extent only as strong as the import controls of its most *laissez-faire* Member in respect of goods entering the external borders of the Community.

As with the US customs law, there are provisions allowing seizure of an object by HM Customs in the case of misdescription or undervalue. Objects properly seized under these provisions will be declared forfeit to the crown. However, an interview with a London dealer confirmed his understanding of the low likelihood of having an incoming shipment inspected at the UK border. Only if there was an obvious discrepancy in the documents accompanying an incoming shipment would it have an appreciable chance of being stopped, he thought. Even then, he was not concerned with the possible consequences for himself, for he makes sure that he is in no way associated with the import of an illicit shipment. In this way he can feign ignorance of the contents of the shipping crate and escape the possibility of further action against him by UK authorities:

> The shipments that have been stopped here in England were all shipments with dodgy invoices. I had a shipment of value $200,000, and they write $1,600... ridiculous! The freight cost was higher than the invoice value! Things like this, coming out of the country, straight out of Pakistan for example, where the English customs know that they have a law which says that you're not allowed to export anything older than 100 years. So that invoice, country of origin Pakistan, declared as handicraft? Let's check it out. Open it, stone relief, call up the British Museum, guy comes and says market value today $200,000. First person to be contacted is the person who it was sent to, the person in England: "I have no idea. They send it to me. I don't own it. They sent it to me. Contact the Pakistanis". (London Dealer 5)

By way of contrast, it is instructive to note that while the United Kingdom has, in effect, no explicit restrictions on the import of antiquities from foreign source countries other than the new offence in the 2003 Act which applies only to stolen - not illegally exported - cultural objects, it prohibits the export of its own antiquities without a licence. The doctrine of sovereignty of course dictates that what might be interpreted as a 'one rule for us, another rule for them' approach to border control is a perfectly normal paradox. Export of antiquities and works of art is controlled in the United Kingdom by the 'Waverley' rules.[19] The system requires would-be exporters of works of art above a minimum age and monetary value to apply to a Reviewing Committee on the Export of Works of Art for a licence to export. The Committee then determines whether the object is of

19 So called after their creation by a committee under the Chairmanship of Lord Waverley. appointed in 1949 by the Chancellor of the Exchequer.

such national importance that its export should be prevented. If it decides that the object is not of such a level of national importance, an export licence will be granted. If the object is of such a level of importance, the Committee will delay the granting of an export licence for a specified period of time, to allow British collectors and public institutions to make offers to buy the object at a fair international market price.[20] In this manner, national treasures can be retained in the United Kingdom without artificially depressing the price the seller may receive.

Unfortunately, the system does not perform as effectively in practice as its design might suggest. If no offer is received by the seller within the time limit specified by the Committee (and there is no prospect of a fair offer materialising in the near future, in which case the Committee has power to extend the period) an export licence must be granted. An historical view of the operation of the system suggests that British collectors and museums often cannot raise the funds necessary to acquire national treasures destined for export – figures for the decade 1987-98 show that an average of around only 50% of the cases recommended for deferral by the Committee were in the end retained by the United Kingdom.[21] That the inefficiency of the system in protecting the UK's most important cultural heritage from export is a continuing trend is confirmed by the most recent annual report of the Committee in which it regretfully admits that "through a lack of funding, the system has failed totally to achieve this objective".[22] Waverley items deferred for export in 2001-2002 to allow UK buyers to match the international sale price numbered 31. Of these, twenty were ultimately acquired by UK institutions. However, these items were all at the lower end of the price scale. The 20/31 ratio conceals the reality that in financial terms the United Kingdom succeeded in retaining objects only to the value of £3.1 million out of a total pool of £19 million.[23]

3.1.5 Australian Import Control

Australia's federal Protection of Movable Cultural Heritage Act 1986, section 14, provides for import controls to be applied to "any protected object of a foreign country", defined in section 3(1) as an object "forming part of the cultural heritage of a foreign country". Such wording leaves generous scope for debate over precisely what might

20 M. Polonsky & J.-F. Canat, 'The British and French Systems of Control of the Export of Works of Art', (1996) 45 *International and Comparative Law Quarterly* 557.
21 UK Department for Culture Media and Sport, 'Forty-fifth Report of the Reviewing Committee, Export of Works of Art 1988-99', Part I.
22 Home Office Department for Culture Media and Sport 'Export of Works of Art 2001-2002: 48th Report of Reviewing Committee on the Export of Works of Art' *DCMS website* at http://www.culture.gov.uk/cultural_property/export_art.htm (version current at 1 March 2005). M. Bailey, 'Little Success in Saving Major Art: an Export Reviewing Committee Report Shows that Few Expensive Works are being Kept for the Nation' *The Art Newspaper website* at http://www.theartnewspaper.com/news/article.asp?idart=10690 (version current at 1 March 2005).
23 Bailey, *ibid.*

be included. The offence of unlawful import is created by section 14 of the Act, which provides for a fine of up to AUD$100,000 or up to five years imprisonment, or both, and may result in forfeiture of the item.[24] Part V of the Act gives powers of search, seizure and arrest to police officers. These powers may seem routine, but importantly they allow official capture of prohibited imports after they have passed through the customs barrier, something that was difficult under the previous legislative structure (the Customs (Prohibited Imports) Regulations 1956).

In common with the perception of the London interviewee quoted in the previous section that there is a low likelihood of adverse repercussions from the import of illicit antiquities, a Melbourne interviewee explains that while 'checks' are sometimes performed on his incoming shipments by Australian customs agents, he doubts whether they would have enough knowledge or interest to tell whether the shipment contained anything illicit:

> As far as importing goes I've never had any issues with anything that's come in.
>
> [How do things come in? Do you know what the mechanics of import are?]
>
> Well our goods just come in in a big shipment. We're over on a buying trip in England at the moment, so we'll have a big 30-foot container arriving in probably about two months time. Included in that will be quite a quantity of antiquities. There's a manifesto with all the description of each object and customs goes through that.
>
> [And if they think there's anything they want to check, they check it?]
>
> Yep.
>
> [Do you know if they check it as a matter of course, or is it just if something is flagged up?]
>
> Um, we've certainly been checked, yeah. Quite often, well you can imagine, with a big container full of stuff, they'll send an agent down when the seal is broken and as we unload they just sort of stand there and amuse themselves, check everything out. So to find an actual object that they might have noticed is quite difficult sometimes.
>
> [Do you get the impression that they're there to make sure you're not offloading heroin, or...]

24 Forfeiture provisions have provided difficult questions of statutory interpretation for courts hearing cultural property cases (for further information on this, and on the Australian import provisions more generally, see P.J. O'Keefe 'The Use of Criminal Offences in UNESCO Countries: Australia, Canada and the USA' (2001) VI *Art Antiquity and Law* pp. 19-35.).

Yeah, yeah.

[Do you think they would know anything about the antiquities that you're bringing in?]

No, not at all.

[It's not like somebody would say...]

Ooh, that's Chimu! No, I doubt there'd be any expertise within the customs at all (Melbourne Dealer 1).

3.1.6 Legal Controls on Possession and Sale in Market Countries once the Antiquities have Passed their Customs Barriers

When illicit antiquities escape their country of source and penetrate what import controls there might be in market countries, what further controls on their trade are in place in those market countries? We shall focus here on the two largest market destinations for Southeast Asian antiquities: New York and London.

3.1.6.1 USA

How do market States interpret legislation passed by source States which vest all antiquities discovered after a certain date in those source States? Two US decisions from the 1970s are notable for their acceptance of such legislative declarations as providing the basis on which a case for recovery can proceed. They are *United States v. Hollinshead*,[25] and *United States v. McClain*,[26] mentioned above. Both cases involved the criminal conviction in the United States under the National Stolen Property Act (NSPA) of defendants charged, respectively, with taking a stone stela from a Mayan Temple in Guatemala, and beads and pots from Mexico. In both cases, the US courts were prepared to treat removal from the foreign countries as theft after a declaration of ownership of all undiscovered cultural property by those countries. The *McClain* case formed the basis of the 2001/2002 prosecution of New York antiquities dealer Frederick Schultz for possession of Egyptian antiquities illegally excavated and exported from Egypt under Egyptian Antiquities Law 117 of 1983. The issue in that case was recently decided in line with *McClain*, and Schultz was convicted of possession of stolen goods under the NSPA.[27]

The recognition by market countries of foreign source country laws vesting ownership of all antiquities in the State, is highly objectionable to the antiquities market. This view is found regularly in the literature, and was particularly true of the New York interviewees. It amounts, they say, to an unwarranted dilution of American sovereignty in its criminal lawmaking – it allows foreign

25 495 F.2d 1154 (9th Cir. 1974).
26 545 F.2d 988 (5th Cir. 1977), 593 F.2d 658 (5th Cir. 1979), cert. denied, 444 U.S. 918 (1979).
27 M.B.G. Lufkin, 'End of the Era of Denial for Buyers of State-owned Antiquities', (2002) 11 *International Journal of Cultural Property* pp. 305-22.

governments to tell Americans what they should see as stolen and what they shouldn't:

> The heart of the Schultz decision, it seems to me, was that Egyptian law should govern the determination of whether or not property is stolen property in American courts. And I think that that would have a chilling effect, certainly, on the art market. On any exchange of second hand property, if you will, to the extent that any dictator in any country can stand up and say: "Everything that's over 100 years old that's in my country belongs to me and anybody who takes it out is a thief" and American courts, or British courts for that matter, decide to recognise in local law that definition of stolen property, I think we're all up the spout. It's a very, very bad precedent... I don't think we have any right to tell any country what their laws should be. I also don't think any country should have a right to tell us what our laws should be (New York Dealer 1).

This argument is one of those most strongly put forward by the market against the conviction of Schultz, but despite being viewed as a strong one by the market, it is rather obviously flawed. Foreign countries are not dictating American law; American courts have simply chosen to apply the foreign definition of a theft in making their own law. This is of course no diminution of American sovereignty, and no departure from the everyday workings of any country's courts in which foreign laws are routinely applied where they appear proper to the issue. Further and more specifically, foreign government legislation nationalising a commodity is nothing unusual, and it is by no means extraordinary for a western government to acknowledge a theft from a foreign State in this instance as no different from a theft from an individual resident in that foreign State – both may routinely form the basis of a criminal prosecution of a handler of that stolen property in western courts:

> [In relation to the NSPA and applying foreign definitions of 'stolen', is that something that happens in the US regularly with other stuff apart from cultural property?]

> The Government would say that in certain instances it does. If nationalised objects were stolen, if somebody had a consignment of oil barrels that came out of Kazakhstan, they would be stolen and this is like any other nationalisation and usually you give effect to these things, or often you give effect to these things.

> [And in relation to things that are stolen from private individuals in foreign countries?]

> Well, private is, but that's stolen in the common law sense. There's no objection on our side to stolen in the common law sense.

[And that kind of thing happens routinely?]

Well, it would, but that's the easy case. (New York Lawyer 2)

The advocates for the market are trying to mark out theft from a State as different in kind from theft from an individual (what they choose to term 'common law theft') and within that distinction, to mark out theft of antiquities from a State as different in kind from theft of any other commodity. These distinctions were wholly rejected in the *Schultz* case.[28] Based on that, therefore, the current position is that theft of antiquities from a foreign State which has nationalised antiquities will be treated as a statutory theft in New York and the domestic criminal law applied accordingly.

This area is one in which much was put forward by the interviewees by way of neutralisation of the criminal acts of Schultz in his purchase of looted Egyptian antiquities; of another dealer, Haber, who was involved in the *Antique Platter of Gold* case[29] the facts of which are set out in the section on US import control above; and of the collector who bought the looted antique platter from him, Steinhardt.

How could Schultz have been expected to know that Egypt had a vesting law and an export restriction on antiquities, the interviewees ask? This would appear to be a problematic line of argument. Schultz was a respected dealer in antiquities and president of NADAOPA: the National Association of Dealers in Ancient, Oriental and Primitive Art. I came to this subject in 2001 with no knowledge of antiquities legislation, and within around two weeks was aware that Egypt, Turkey, Greece, Italy and others had laws prohibiting the excavation and export of their antiquities. I would at least know to check whether the country from which I was offered antiquities had such a law. The Egyptian law came into force in 1983. Could Schultz have traded for over fifteen years in ignorance of its existence? In any event, there is an almost incontrovertible argument that businessmen should make themselves aware of the laws which affect their trade,[30] and that *ignorantia iuris neminem excusat.* Yet this ignorance of the law was one of the main lines of argument put forward by Schultz's lawyers in his defence, and one which some of the interviewees supported doggedly:

> *What the district attorney tried to do, and made the case, he had conscious avoidance, in other words he intentionally did not pay attention to their laws. The only problem with that is that, as it turns out, there are no translations of that law in*

28 *Ibid.*
29 Above, note 10.
30 This general rule was acknowledged in the specific case of those in the antiquities trade by the Nova Scotia Court of Appeal in Canada in *R v. Yorke* (1998) 166 N.S.R. (2d) 130 at 143, who noted that the increased duty of inquiry placed on businesses is not unreasonable, given their "access to consular offices, customs and police officials and other traders in the foreign lands".

English in any law library in the United States. So even if he wanted to know about it, the American Law Library in New York I think is one of the biggest ones in the country, it's not on the books. And if you deal with the material from 30 countries, how do you know with which ones it's okay and with which it's not okay and when did it come out and when did it not come out? (New York Dealer 5)

Schultz was convicted on the basis of McClain, *pure and simple. There were a couple of troubling aspects to the* Schultz *decision. The jury was charged, called a general charge, that you can convict Schultz if you knew either that he actually knew that he was dealing in materials that had been purchased from the antiquities police, or that he was dealing in objects that had been exported in violation of Egypt's law, but you can also find that he knew that he was dealing in objects exported in violation of Egypt's law if he consciously avoided learning the requirements of Egyptian law. In other words, he wilfully turned a blind eye. So the conscious avoidance theory was again this degradation or watering down of the mens rea requirement. Scienter – what's the threshold of scienter? If you knew Egypt had some law? How are you supposed to know the requirements of that law? What it says? What it prohibits? What it permits?* (New York Lawyer 2)

Other interviewees were more sceptical of this rather spurious line of argument, while still supporting Schultz and his illicit purchases:

If anybody was to tell me that Fred Schultz, who is a very, very nice guy, very well educated, that he doesn't know the laws of Egypt, then I don't understand the trade anymore, okay? He's been manipulated by this sleazebag here from England. And then there's a part of greed, and a part of this and a part of that. And then the sleazebag here got knocked off his sentence here a couple of years, by starting to talk. That's how it is. And the Americans tried to make an example out of him. And unfortunately that example is jeopardising the position of a lot of powerful people in America. (London Dealer 5)

The fault, it is thought, lay much more with Tokeley-Parry, the seller of the goods, than with Schultz as buyer.[31] Schultz wasn't bad; he was just 'stupid', and the victim of the penal whims of a harsh judge:

The fact that Fred Schultz might have done some stupid things in not getting good information from the guy who was offering him things on consignment for sale and the fact that the guy who was offering things on consignment for sale was a clear crook and a nutcase, you know that's out

31 See above, p. 75.

there for anybody to, if you're buying a used car or you're buying art, then you have to protect yourself in that situation. (New York Dealer 1)

In Fred's case, I can't agree with the idea that if he purchased something in good faith that he should be punished for it. And it would be bothersome to see him go to jail for that. If it could be proved that he conspired to remove something from a country, I mean I think there is an obligation, dealers do have an obligation to educate themselves on the laws of countries from which the material comes from that they handle. So I think he should be aware of the laws, but that's a far cry from accusing him of being guilty of stealing something. It's clear that the person that he bought the item from who had it before him was a crook. So I don't think that necessarily makes him guilty. (New York Dealer 3)

I think it depends entirely on whoever the judge is. I mean this fellow Schultz, I'm told that he came up in front of a man called Rakoff, who's a known absolute bastard. Seriously tough, unbending, I mean extreme right Republican attitudes, I'm told. And of course he's now out of the case, so I don't know what'll happen in the Schultz case. I'll be very sorry if he goes to jail, because he's basically a decent guy. (London Dealer 4)

He's a pathological liar [Tokeley-Parry] and I met him on several occasions when Fred was dealing with him and I mean he was just a nutter. Fred was stupid, but that should not be an imprisonable offence. (New York Dealer 5)

You're probably familiar with the Fred Schultz story? He was stupid. He actually did something criminal in that they faked paperwork and so on. But what they actually did, the thing that they dealt with, was not that immoral or evil or didn't do anyone any harm. (Bangkok Dealer 1)

This stupidity excuses Haber's illegal import of the looted antique platter into the US as well as Schultz's purchasing decisions:

I don't think the serious people in the art market behave badly. I mean one or two of them behave extremely stupidly, but as we were talking about the person in New York going to Sicily, it was a track record of extreme stupidity from beginning to end. Everything they did. (London Dealer 4)

What do the interviewees mean when they talk of 'stupidity'? It appears to be a euphemism for criminality. It is not an excuse based on any property of the *act* itself, although such excuses do figure as well. It is more a dismissal of the *intent* behind the wrongdoing in question – an inference of naivety on the part of the criminal which led to his being taken advantage of and spelt his downfall through no real fault of his own. It removes the *mens rea* from the offence, and

therefore leaves a picture of an inadvertent wrongdoer without criminal or otherwise malicious intent. It is one indication of the use of what we shall come in Chapter 6 to call 'psychological fronts' by the interviewees, to play down in their minds the presence of illegality at the respectable end of the market. Acknowledging the presence of this illegality would lead them to the unpleasant truth that they are all at similar risk of prosecution:

> *I think that he's just one of many that could have gone down...*
> *I mean I can't guarantee that the pieces that I have weren't*
> *exported illegally, so there's no reason why, you know, I*
> *couldn't be ostracised like that too.* (Melbourne Dealer 1)

It is this use by the interviewees of psychological fronts that enables them to dislocate themselves from the application of the law. Schultz was 'stupid' because he bought something too high-profile from a seller whom most of the interviewees thought was plainly not to be trusted. He took a chance on a risky transaction, and his stupidity landed him in prison. The interviewees decline to acknowledge that they indulge in precisely this form of stupidity in their day-to-day trading, perhaps on a less grand scale.

3.1.6.2 England and Wales

In 1997, in response to a question in the House of Lords by Lord Renfrew, the relevant Minister replied:

> It is not an offence to import into this country antiquities
> which have been illegally excavated in and exported from
> their countries of origin.[32]

The answer conceals broader issues. As mentioned above, section 22 of the Theft Act provides for the offence of handling stolen goods, which will apply to the import into England and Wales of goods known to have been stolen, for the benefit of another. Further, under the first half of the section 22(1) offence, a knowing receiver of the stolen goods in England and Wales is also guilty of the offence of handling. The implication of the Minister's answer is that if it is legal to import illegally excavated and exported antiquities, it would also be legal to sell them in England and Wales. Yet section 22 provides for the offence of handling both in respect of a knowing receiver and a knowing abetter of the sale of such goods; the second half of the section 22(1) offence can even result in the conviction of someone who has 'arranged for the disposal of the goods' which includes circumstances in which he has falsified documents.[33]

It is therefore (unsurprisingly) illegal knowingly to receive stolen goods in England and Wales. Proving that the accused had knowledge

32 Lord Inglewood, 'Written Answer: Antiquities', *House of Lords, Official Report*, 17 February 1997, Col. WA 34.
33 UK Sentencing Advisory Panel, 'Handling Stolen Goods: Advice to the Court of Appeal'. March 2001.

or belief of the illicit nature of the goods can be difficult. This is particularly so in relation to antiquities which have been illegally excavated and exported from a foreign country.

As mentioned above in section 3.1.4, any lack of clarity surrounding the application of the handling offence looks to be in the process of being resolved by the Dealing in Cultural Objects (Offences) Act 2003. The UK Government in May 2000 established a Ministerial Advisory Panel on the Illicit Trade in Cultural Objects under the chairmanship of Professor Norman Palmer to examine the place of the United Kingdom in the international market in illicit cultural objects, and recommend action. The Panel (hereinafter 'ITAP' – the Illicit Trade Advisory Panel) published a report on 18th December 2000 containing sixteen recommendations, including the creation of a new criminal offence explicitly to deal with such circumstances.[34]

In respect of England and Wales, this recommended offence has become enshrined in the 2003 Act, which originated as a Private Member's Bill. The Bill received the Royal Assent on 30th October 2003 and entered into force on 30th December 2003.[35] The Act in section 1 provides for a sentence on conviction on indictment of up to seven years' imprisonment and/or a fine where a person:

> dishonestly deals in a cultural object that is tainted, knowing or believing that the object is tainted.

Under section 2 of the Act, a cultural object is 'tainted' if it is excavated, or removed from a monument or other building or structure of historical, architectural or archaeological interest, and such excavation or removal constitutes an offence. It is stated to be immaterial whether the excavation or removal was done in the United Kingdom or elsewhere. The intended effect of this piece of legislation is therefore (a) to close the current loophole in the handling offence so as to cover the case of an importer of stolen property who does so for his own benefit, and (b) to remove any doubt surrounding the *Schultz*-type of situation as it applies to England and Wales, preventing dealers from arguing that the fact that the excavation or removal of the object was contrary to the local law of the source country should not result in penal consequences under the English criminal law for a buyer there. The Act adopts a wide definition of 'dealing' for the purposes of the offence, including acquisition, disposal, import and export (for which powers of action are given to HM Customs and Excise), and being part of an arrangement under which someone else does the actual 'dealing' in the tainted object.

The offence created by the Act retains the strong element of *mens rea* in its construction contained in the offence as proposed by the ITAP

34 N.E. Palmer, P. Addyman, R. Anderson, A. Browne, A. Somers Cocks, M. Davies, J. Ede, J. Van der Lande & C. Renfrew, (2000) 'Ministerial Advisory Panel on Illicit Trade', (December 2000 London, UK Home Office Department for Culture, Media and Sport).
35 The Act is reproduced below at Appendix IV.

report. This will present a continuing significant evidentiary hurdle to prosecutors. To obtain a conviction in terms of this offence, the Crown must prove not only that the dealer (say) bought the tainted object, but that he knew or believed that it was tainted. It is not enough to argue that he *should have had* such knowledge or belief. Actual knowledge or belief must be shown. Proving the knowledge or belief of an accused is in ordinary circumstances rather difficult, but in a market where there is no routine exchange of provenance information on purchase, it would seem very easy for a dealer to excuse his tainted purchase with a simple denial of knowledge or belief that it was anything out of the ordinary. Further, once knowledge or belief has been proven, it must be shown that the accused *dishonestly* dealt in the object. It is hard to fathom what this means, and what it will require of prosecutors by way of evidence. In most cases, dishonesty may be implied; if the dealer knows or believes that the object is tainted, then any further dealing in it on his part might be seen as constituting dishonesty, unless perhaps, fearing it will be lost or destroyed, he acquires it with the sole aim of returning it to its source.

Our conclusion here should be that given what we know about the mechanics of transactions in the antiquities market, we should not expect an offence which requires proof of knowledge or belief in the illicit status of an antiquity to be much used. While the offence might be useful in the prosecution of gross and obvious cases of smuggling or illicit trading, it will not affect the ordinary systemic workings of the market, which we have identified as themselves being greatly problematic.

3.1.7 The Practical Effect of Export Restrictions on Cultural Property

Export restrictions on cultural property are in many cases a fairly recent trend, most dating back 50-100 years. They became popular as a response to the post-Second World War phenomenon of the dispersal of masterpieces from the economically-ravaged nations of Europe into the hands of wealthy buyers in countries such as the USA and Japan. Laws were passed by source countries, including England and Wales, to restrict the outflow of their 'cultural patrimony'. As Paul Bator has already noted, however, the effect of these export prohibitions is often contrary to that which was intended.[36] Restrictive cultural patrimony export laws in source countries leave the seller of embargoed art or antiquities with two choices, one legitimate and the other illegitimate. He can go the legitimate route of selling to a national museum or domestic collector who has enough funds to purchase the item. The price offered for such a purchase is likely to be a fraction of the item's worth on the international market. The reasons for this include the broad economics of market scale – i.e. the more potential buyers in a market to create competition for an

36 P.M. Bator, *The International Trade in Art* (1983, Chicago, University of Chicago Press).

item, the higher the price it is likely to fetch in a public sale, particularly for those source countries with weak economies – and the fact that a domestic buyer too will not be able to sell the item internationally, his future sale price therefore being similarly restricted by the export prohibition and discounting the amount he will be prepared to offer to purchase the item. The illegitimate route therefore seems much more lucrative to our seller; arrange for the item to be sold internationally on the black market in breach of the export conditions imposed upon it by the seller's national government:

> *Now, the Italian rule is that you may not sell it outside Italy, you may only sell it to Italy. The sums of money involved, that the Italians are prepared to pay, are probably less than 10%. So anyone who's got anything which they know to be valuable on the international market is going to think hard, and think, 'I'm going to send this to Switzerland or wherever the hell and get an international price'* (London Dealer 4).

> *A huge amount of material comes out of Egypt, and has been coming out. It's been illegal since 1984 to bring anything out of Egypt, but probably more has been brought out illegally than what was brought out legally before. One thing about these prohibitions is that they encourage smuggling* (New York Dealer 4).

Murphy makes the point in relation to China's export restrictions:

> Embargo or retention legislation is toothless without the resources to enforce the laws, and meaningless unless there exist the means to preserve, catalogue, and display the relics that the state means to protect.[37]

He follows a respectable line of commentators[38] who have argued that artefacts should be ranked by the source country in order of cultural significance; those at the bottom of the ladder being released onto the international market in an effort to make effective the source country's attempted retention of those at the top:

> What is required is a process of judicious selection that may result in the export of all but the most culturally significant items. A country's comparative poverty becomes an argument against, rather than for, stricter national controls ... The income from the sale of excess relics can be made available to finance preservation of the most culturally significant pieces, training of curators, and scientific exploration efforts. Once international demand is satisfied by the creation of a sizeable licit market, the profit is cut out of illicit trafficking and the

37 J.D. Murphy, *Plunder and Preservation: Cultural Property Law and Practice in the People's Republic of China* (1995, Hong Kong, Oxford University Press) at p. 155.
38 Among them, Bator; see P.M. Bator, 'An Essay on the International Trade in Art', (1982) 34 *Stanford Law Review* 275 at p. 322.

concomitant anti-social behaviour is reduced ... This sort of approach, which has at its core the substantial relaxation of export controls in accordance with the application of a scheme of values that would dictate the retention of only the most significant objects, would achieve the stated objectives of embargo legislation better than embargo legislation itself.[39]

The problem with this apparently sensible line of argument is that western collectors, museums and dealers are unlikely to be satisfied with artefacts classified at source as of an 'expendable' standard:

> I've yet to see any sign that they would ever be willing to let anything, even of almost no significance, out of the country. And that's certainly not going to satisfy, for instance a museum in a country like the US, to say you can have a bit of a roman lamp or something and we should be happy with this. (New York Dealer 3)

> Don't expect the source countries to suddenly sell great works of art. They only sell third-rate things. Nobody wants third-rate things as the expression of a culture. You want a few first rate things. (Geneva Collector 1)

The rarest and most important pieces retain their allure. All that is likely to occur if this course of releasing objects deemed unimportant is put into practice by source countries is the legalisation of a portion of the trade which is currently illicit, without an appreciable reduction of the illicit trade in high end objects. The income obtained by the source country through the (presumably State-controlled) sale of objects of a lower standard might well be channelled into the protection of important sites as Murphy suggests, but source countries such as China and Thailand have many pressing fiscal needs, and without reducing the level of demand for the most precious antiquities in market nations, it is questionable how far situational crime prevention measures at source can in fact guard against the theft of highly expensive objects.

By way of analogy, the international market in diamonds is carefully controlled by the few organisations who operate the world's mines (De Beers and Rio Tinto are two names which will probably be familiar). The flow of licit diamonds onto the market is regulated so as to ensure that the market is not flooded, keeping prices high by ensuring an appropriate correlation between supply and demand. Yet diamonds are still stolen – at source and at many points along the chain of supply – sometimes to be traded illicitly and sometimes to be inserted into the licit market.[40] The United Nations has estimated that 20% of the world's rough diamond trade is illicit in

39 Murphy, *op. cit.* note 37 at p. 157.
40 R. Tailby, 'The Illicit Market in Diamonds'. (2002) *Trends & Issues in Crime and Criminal Justice No. 218,* January 2002. (Canberra, Australian Institute of Criminology).

nature.[41] While a demand exists which thieves can exploit for profit, an interest in devising ways to link a supply to that demand is created.

The desire to avoid such a black market-effect led the United Kingdom to design a slightly less strict version of this type of blanket export prohibition (the Waverley Rules, mentioned above). For items that are classified as national cultural treasures in terms of its legislation, an export permit is withheld temporarily to give British museums and individual citizens a chance to make offers for the object at or above what is considered to be the price which would be fetched at an international sale. If no suitable offers are received within the timeframe, an export licence must be granted. The UK provisions are often touted as a model of fairness, but not all source countries are home to museums and collectors wealthy enough to compete with the international market. We have seen that even the United Kingdom can afford to retain only around half of what is recommended by the Waverley Committee; much less if we use financial value as our indicator rather than number of objects.[42] The international market has much more money at its disposal for the purchase of antiquities than even a relatively rich nation such as the United Kingdom can match. Were Thailand to implement similar export rules, the result would certainly be a large (and legal) outflow of its national treasures, for want of sufficient domestic buyers who could afford to pre-empt the international market in this way.

If we accept the argument that high sale prices on the international market, due to healthy levels of demand from relatively wealthy consumers, provide impetus for the illicit excavation of antiquities by citizens of source countries, we are therefore led to the conclusion that export prohibitions implemented by those source countries – whether total (as in the case of Thailand) or partial (as in the case of the United Kingdom) – will not create the social and economic circumstances necessary to stop looting. There appears to be no reluctance in the market to buy illegally-exported goods:

> *I think, to answer your question, according to the laws of today, a great part of my collection has been illegally exported. But to really know if the individual items were illegally exported, I would have to know when the laws came into being for each of the countries from which I have objects.* (Geneva Collector 1)

This finding of the current research is supported by the anecdotal evidence of another commentator:

41 United Nations (2000) 'Expert Panel on Sierra Leone', *Report of the Panel of Experts Appointed Pursuant to Security Council Resolution 1306 (2000), Paragraph 19, in Relation to Sierra Leone. S/2000/1195*, December. UN.

42 Home Office Department for Culture Media and Sport 'Export of Works of Art 2001-2002: 48th Report of Reviewing Committee on the Export of Works of Art' *DCMS website* at http://www.culture.gov.uk/cultural_property/export_art.htm (version current at 19 June 2003).

In twenty years as an art market correspondent, I have never met an antiquities dealer who did not happily handle smuggled goods. The nearest I have come was a London dealer who told me that he would not buy from smugglers himself although he considered it acceptable to buy smuggled goods at auction.[43]

As we shall see in the analysis of the international markets in illicit drugs and wildlife to come in Chapter 4, one of the major stumbling blocks of prohibitive legislation in market control lies in its unexpected, and therefore of course unintended, consequences. One such surprising consequence of prohibitive legislation in the antiquities market can be identified here. Antiquities dealers see blanket export restrictions by source countries as so grossly unfair to the free trade goals of the market that not only do they show a lack of respect for these laws in discourse, they go so far as to hold these restrictive pieces of legislation *responsible* for the outflow of material. If source countries are going to draft outrageous pieces of legislation like this, it is said, then they have themselves to blame for the loss of their heritage. Far from trying to abide by the export restrictions of source nations in practice, then, and endeavouring to avoid the purchase of an illegally exported antiquity, the dealers in the sample ironically saw these export restrictions as so unfair that they deserved to be ignored:

> With very draconian sort of laws, they leave the field open to smugglers and also to a lot of undesirable elements in the countries themselves, as well as the officials, who are pretty undesirable I suppose too. And if you've got laws like that without any sort of review, you're going to lose everything. (New York Dealer 2)

> I have a big problem whenever I buy anything in Italy, I say, "please send it to me" and they say, "we can't". They have to travel to Brussels and send it out through a friend of mine in Brussels, or they send it out to me as something else. They just can't send it out. And that makes me crazy. I mean you're literally forced into a situation where you have to evade the law. (New York Dealer 5)

> It's common knowledge that you can export anything you want from Italy. Well, now it's easier because of the EC, but even, you know, once you forbid everything, everything is possible. In Italy they have a wonderful saying "if there is too much rules, then you find a way around it" ... I would never deal knowingly in something if I thought it was stolen. I don't consider things that have been illegally exported stolen... because restriction of exportation, I don't agree with it. I don't support looting. I don't finance looting. I don't

43 G. Norman, 'Bad Laws are Made to be Broken', in K.W. Tubb (ed.) *Antiquities Trade or Betrayed: Legal, Ethical and Conservation Issues* (1995, London, Archetype) at pp. 143-144.

necessarily approve of looting, but I still think that it has a purpose, a function, and sometimes it saves rather than destroys. I mean it might destroy information. It saves the object, which this is what I'm more interested in personally in any case... I mean I'm interested in both, of course, but if at least one of the two is preserved, that's fine. But of course I wouldn't encourage that. (London Dealer 7)

This view that export restrictions could justifiably be ignored when purchasing objects in market countries was echoed both by a dealer and a collector interviewed in Thailand in respect of their approach to the export of antiquities from that source country:

Theoretically you're supposed to apply for an export permit, but in reality it's such a pain in the arse and such a hassle to do that, that it's so much easier just to give it to a shipper and it gets shipped, either as a decoration or something like that. Even if it's a perfectly legitimate brand-new thing, you're supposed to get a permit, but getting the permit is a pain because they haven't got proper systems set up to make it easy. If it was easy, people would do it. But I don't think I've ever heard of anybody on any item bothering to get a permit.

[What's hard about it?]

Just it takes a long time, bureaucracy, you've got to fill in forms, you've got to talk to people who don't know what they're looking at. And if they do know what they're looking at, even if it's a genuine thing, they'll probably try to get you to pay them some money under the table, and it's just not worth doing.

[What are the chances of the shipment being inspected? There's no chance a member of the Fine Arts Department will be opening the crates?]

Nah, very unlikely, highly unlikely. If someone's got a tip-off for some reason, it might happen, but in general, I've never heard of anybody having a problem walking out of the airport. There used to be an Italian that used to come and buy Buddha statues 2- and 3-feet high, and he'd just put them in a bag and walk them out of the airport, and nobody said anything. I've never heard of anybody having a problem, let's put it like that. Although in the letter of the law you're supposed to have a permit and all the rest of it, in practice the law is not followed because (a) it's inconvenient and (b) it's foolish. It's obvious that the issue of religion and national pride and so on comes into the law, so they would find it difficult to just allow people at random to send things in and out, but they're sent in and out at random anyway. So not much can be done (Bangkok Dealer 1).

You just ship them out. If you apply for a licence it'll take ages. You have to get ten copies of everything and it takes

about three weeks to get it, and no-one is here long enough to do it. So you just ship it out as a modern reproduction... about fifteen years ago they found these burial sites up in the mountains where literally tens of thousands of beautiful pieces emerged. And those were almost all exported...

[So basically you just stick it in a shipping container and it goes out?]

Yes.

[Nobody would ever search it?]

No. (Chiang Mai Collector 1)

The conclusion here seems to be that, at least so long as they remain unenforced by market States, export restrictions implemented by source States are something of a red herring in relation to the looting issue. Export restrictions apparently do not stop looting or illegal export. This is not an argument for a free market, however, as neither does the absence of export restrictions, or their liberal use, protect sites in any way.[44] So long as a market for illicit objects exists, looting will persist whether export restrictions are in place or not.

3.2 INTERNATIONAL ANTIQUITIES LEGISLATION

The main thrust of the two international Conventions to be discussed is in relation to what has come to be called 'repatriation'. Rather than 'recovery', which might be undertaken by an individual in a claim for repossession of his property, 'repatriation' suggests some level of reinstatement of a broken link between an artwork and a place. Repatriation of stolen art suggests two strands of analysis. One is the issue of antiquities looted from their sites and fed into the market. The other strand is the issue of the theft and international transport of antiquities which were not taken illicitly from the ground or from an ancient monument of which they formed a part, but perhaps from a museum, church or collector's repository. Here also are covered artworks which do not qualify as 'antiquities', but which do fall within the general definition of 'cultural property'. This head includes the current issue of art looted by the Nazi regime during the Holocaust. Thirteen thousand works of art from Hitler's Linz Museum project have yet to have their owners traced,[45] and a trend is emerging among museums and galleries worldwide to conduct thorough and public checks of the provenance of the works they hold in order to deal with this issue.

44 K.D. Vitelli, 'Response to Merryman's Draft Principles to Govern a Licit International Traffic in Cultural Property', in J.H. Merryman (ed.) *Thinking About the Elgin Marbles: Critical Essays on Cultural Property, Art and Law.* (2000, London, Kluwer Law International) at p. 240; P.V. Domenici, 'Preface B', in G.S. Smith & J.E. Ehrenhard (eds) *Protecting the Past* (1991, London, CRC Press).

45 The Provenance Review Committee of the National Gallery of Victoria (2001) *Draft Discussion Paper.*

Artworks which are stolen and taken abroad, but which are not 'cultural property' are excluded from this analysis, on the basis that (a) they do not possess the necessary cultural link with their place of origin to fall within the scope of a claim for 'repatriation' as opposed to one for simple restitution (and this lack of cultural alignment takes them outwith the scope of this book) and (b) only items of cultural property are affected by the provisions of the Conventions we discuss here.[46] In fact, the division in analysis is more properly defined as a split between claims for repatriation by an individual and claims for repatriation by a State. I work here on the assumption that stolen artworks (including what we will shorthand here 'Holocaust art', that being the most topical example of works in this category) will be claimed from abroad by an individual dispossessed owner, whereas stolen antiquities will be claimed by the source State. This assumption is illustrative only; it is appreciated that of course it will not always be the case.

Much of the talk in this field is of how to secure the return of a cultural object to its proper resting place, whatever that phrase might be interpreted to mean. Museums, however, are key acquirers of cultural objects and are often governed by idiosyncratic pieces of legislation which served to establish them as bodies, and provide restrictions on their powers of de-accession. It is often the case, then, that claims against museums, while found to be proper, are met with the rejoinder that the museum in terms of its constitution does not have the power to divest itself of the object in question, an act obviously necessary for its return. Where, therefore, the statute governing the powers of a museum provides a fetter on its powers of disposal, the only remedy a court may find it can impose in the event that it finds the plaintiff to have made a good claim, will be damages.[47] That museums may not have the ability to return to their rightful owners objects in their possession which have been found by a court to be wrongfully held, is a deficiency of legal design in the drafting of such statutes which should be remedied without delay.

Two Conventions are of prime relevance to the issue of repatriation of stolen art. They are the UNESCO Convention on the Means of Prohibiting and Preventing the Illicit Import, Export and Transfer of Ownership of Cultural Property of 1970 and the Unidroit Convention on Stolen or Illegally Exported Cultural Objects of 1995. The former is an instrument of the United Nations Educational, Scientific and Cultural Organisation, while the latter was produced by an organisation formed to work towards the harmonisation of international private law.[48]

46 This is not such a broad exclusion as at first it might seem. The definition of 'cultural property' in both Conventions to be discussed is of such breadth that it is capable of including most works of artistic merit.
47 Palmer *et al.*, *op. cit.* note 34.
48 The full text of these Conventions is reproduced as Appendices II and III to this book.

3.2.1 The UNESCO Convention on the Means of Prohibiting and Preventing the Illicit Import, Export and Transfer of Ownership of Cultural Property

3.2.1.1 The worth of the Convention in terms of the recovery of art (including Holocaust art) which falls within the definition of cultural property, by an individual

As its title suggests, the Convention applies only to issues surrounding 'cultural property', which it defines in very broad terms in Article 1. An item is 'cultural property' if it is defined as such by the State in which it resides. It must belong to one of a number of categories. Article 1, category (g) covers:

> items of artistic interest such as pictures, paintings and drawings produced entirely by hand on any support and in any material ..., original works of statuary art and sculpture in any material, original engravings, prints and lithographs and original artistic assemblages and montages in any material.

With appropriate designation by the source State, then, such artworks will fall within the scope of the Convention.

For all the breadth of inclusion of different types of artwork, however, the Convention is all but worthless to individuals from whom art is stolen. Its main operative provision is Article 7, an examination of which reveals that the Convention is concerned with regulating the international movement of items of cultural property belonging to the source State or its institutions. Article 7(b)(i) requires the market State to "prohibit the import of cultural property stolen from a museum or a religious or secular public monument or similar institution...", but not from an individual. Article 7(b)(ii) imposes an obligation on the market State, "at the request of the State Party of origin, to take appropriate steps to recover and return any such cultural property...". The wording 'any such cultural property' must refer back to Article 7(b)(i) and cover only cultural property stolen from institutions of the State.

There appear to be only two items in the Convention of relevance to an individual from whom cultural property has been stolen. The first is incidental and the second is jurisdictional. Neither provides an enormous amount of help to the dispossessed individual who would probably have title and interest to sue in tort for the return of his or her stolen property anyway, without the aid of the Convention.

The provision of incidental importance to a dispossessed individual is Article 7(a), which requires market States:

> to take any necessary measures, consistent with national legislation, to prevent museums and similar institutions within their territories from acquiring cultural property originating in another State Party

which has been illegally exported after entry into force of this Convention, in the States concerned [and] wherever possible to inform a State of origin Party to this Convention of an offer of such cultural property illegally removed from that State after the entry into force of this Convention in both States.

If, therefore, the item of cultural property is one on which the source State has placed export restrictions owing to its cultural importance, or perhaps simply because the State prohibits the export of any stolen property as a matter of principle, the individual dispossessed owner might gain some comfort from the fact that museums in a State Party abroad will be discouraged from buying his property. Individuals abroad, however, might still do so.

The provision of jurisdictional importance to an individual is Article 13(c), by which:

> the States Parties... undertake, where consistent with the laws of each State ... to admit actions for recovery of lost or stolen items of cultural property brought by or on behalf of the rightful owners.

This provision may give a dispossessed individual title to raise a civil claim for recovery of his or her artwork in a country in which he otherwise would not have been able to do so. The words "where consistent with the laws of each State" confuse matters terribly, as it might well be argued that where the laws of the State in question deny jurisdiction to a certain class of claimant it is inconsistent with those laws to give that class jurisdiction and the clause is rendered inoperative *ab initio*.

3.2.1.2 The worth of the Convention in terms of the recovery of looted antiquities by a source State

The Convention operates on two levels here: in relation to cultural property illegally exported from the source State, and in relation to such property stolen from it. Let us deal first with the issue of illegal export.

The significance of the Convention here could have been great, in providing a novel solution to a time-worn problem. Courts do not routinely enforce foreign claims based on laws prohibiting export; in the absence of a treaty or other special legal provision, the source nation seeking the return of a cultural object that is legally obtained but illegally exported may find itself limited to diplomatic or executive channels.[49] The non-enforceability of export restrictions abroad can

49 *King of Italy v. De Medici Tornaquinci*, (1918) 34 T.L.R. 623 Ch.; *Attorney-General of New Zealand v. Ortiz*, [1983] 2 W.L.R. 809,H.L., affirming [1982] 3 W.L.R. 570, C.A. (remedy denied in action by New Zealand to recover illegally-exported Maori carving: see note 52, below). On these cases and others, see J.H. Merryman, 'The Retention of Cultural Property', (1988) 21 *University of California Davis Law Review* 477; P. Gerstenblith, (2000) 'Museums, the Market and Antiquities' *University of Chicago Cultural Property Workshop website* at http://culturalpolicy.uchicago.edu/workshop/gerstenblith.html (version current 4 December 2003).

be seen as an application of the principle of private international law that courts of one nation will not enforce claims based on the public law (as distinguished from claims based on private rights, like ownership) of another nation. The principle has been the topic of a good deal of scholarly discussion,[50] and while far from settled, is often invoked in cultural property cases. So the Convention provides mechanisms for the international enforcement of domestic export prohibitions.[51]

Unfortunately these mechanisms do not go so far as might have been hoped. As detailed above, Article 7(a) of UNESCO 1970 requires States Parties:

> to prevent museums and similar institutions within their territories from acquiring cultural property originating in another State Party which has been illegally exported...

but it places no similar requirement in relation to individual collectors or dealers who may wish to acquire such property. These buyers of course play a sizeable role in the market and any regulation which fails to acknowledge that fact restricts its goals unnecessarily. Article 7(a) also provides only for the prevention of acquisition – there is no mechanism for the return of illegally-exported property to the source nation.[52]

50 See, for example, G.A. Bermann, 'Public Law in the Conflict of Laws', (1986) 34 *American Journal of Comparative Law* 157; F.A. Mann, 'The International Enforcement of Public Rights', (1987) 19 *New York University Journal of International Law and Politics* 603.

51 Art 7(a), mentioned above.

52 Even had the United Kingdom been a signatory to the Convention at the relevant time, its provisions would therefore not have helped New Zealand in its attempt to recover a looted Maori carving from Sotheby's, London (holders of the carving for the defendant, the dealer George Ortiz) by appeal to its protective domestic legislation which provided for the automatic forfeiture of illegally- exported cultural property, making the State the owner (and therefore legitimate pursuer) of the property. See *Attorney-General of New Zealand v. Ortiz* [1983] 2 W.L.R. 809 (H.L.). A case detailing the utterly tortuous process of civil litigation necessary to recover a looted or illegally exported artefact, the decision reveals the many inadequacies in the current reliance on existing systems of repatriation when used in the case of cultural property. After jumping, fortuitously, through the many hoops of proving erstwhile possession of the looted Maori carving by matching a photographed shovel mark made in the object on its accidental discovery with an identical mark on the carving then before the court, the New Zealand counsel were ultimately confounded by the ruling of the English court that forfeiture in terms of the New Zealand protective legislation should be interpreted as requiring actual seizure of the object, which having escaped the country without such seizure could not now be the subject of a State claim to ownership. This decision might be classed as a tactical refusal by the House of Lords to enforce New Zealand's export laws, by interpreting those laws in such a way that the court did not have to rule on whether it could or would enforce them or not. By insisting that New Zealand's export laws required seizure – a seizure which had not taken place – the House of Lords put itself in a position which deemed it improper, in terms of New Zealand's own legislation, for the English court to rule on the delicate issue of the status of the foreign export legislation of a friendly Commonwealth country in English law. In fact, Lord Denning in his prior judgment when the case came before the Court of Appeal had ruled, following Dicey and Morris, *The Conflict of Laws*, 10th edn (1980), vol. 1, p. 90, rule 3, that an English court would not enforce foreign export laws, just as it does not enforce the penal or revenue laws of foreign States. This decision was deemed *obiter* in the House of Lords.

In the case of cultural property stolen from a source State, rather than merely illegally exported, such a mechanism is present. This is set forth in Article 7(b)(ii). The mechanism of return, however, appears to refer only to cultural property which falls within the bounds of Article 7(b)(i), i.e. that 'stolen from a museum or a religious or secular monument or similar institution...' This serves heavily to restrict the impact of the provisions of the Convention even in relation to the already narrow issue of stolen State property.

Many source States have passed legislation which vests title to all cultural property within the bounds of the State to them, as of a certain date. This includes property in the ground, as yet undiscovered. Market States have traditionally been ambivalent about the enforcement of such 'universal declarations of ownership' without some form of real action on the part of the source State to back them up. For items undiscovered at the time of their taking, as is the case with many antiquities buried in the ground, source nations of course find these requirements difficult to accomplish. Without such a degree of practical implementation by the source State, its legislation runs the risk of being viewed by the courts of market nations as being contrary to certain inalienable rights, such as the rights of finders or landowners to own property which the market nation would legally view as theirs. The self-vesting legislation of source States is therefore capable of being cast as falling within the 'public policy' exception to the requirement under international private law for one nation to enforce the private laws of another.

The current status of the western legal treatment of source State declarations of ownership is disputed, and therefore the importance of its position in any case of this sort is difficult to quantify. The cases of *Hollinshead*,[53] *McClain*[54] and *Schultz*[55] discussed above provide a chain of support for the acceptance of source State vesting legislation by the United States, but the validity and appropriateness of this line of authority is hotly disputed by the dealers' lobby.

Recently, lawyers from the firm which represented Turkey in its claim for recovery of a collection of coins named the Elmali Hoard,[56] have described the issue as settled, relying on the authority of *McClain*:

> The United States courts have long held that claims for the recovery of artworks or antiquities arising under national laws that vest ownership of previously undiscovered antiquities in the State will be honoured, just as private ownership rights are. For, it is a tenet of international law to provide recognition to a sovereign

53 495 F.2d 1154 (9th Cir. 1974).
54 545 F.2d 988 (5th Cir. 1977), 593 F.2d 658 (5th Cir. 1979). cert. denied, 444 U.S. 918 (1979).
55 178 F. Supp. 2d 445 (S.D.N.Y. 2002), 333 F.2d 393 (2d Cir. 2003), 147 L.Ed 2d 891 (2004)
56 *Republic of Turkey v. OKS Partners et al*, No. CIV. A. 89-3061-RGS (D. Mass. Jan. 23, 1998).

nation's laws governing interests in property found within
its territory.[57]

While we must treat such flat assertions with due caution, coming
as they do from a team of lawyers regularly employed to barrack for
source nations, the fact that the issue was argued and won by the
source nation in the recent *Schultz* decision does give cause
tentatively to propose that the issue is becoming more settled, in the
US courts at least, and that so long as the sovereign claimant
instituted national ownership laws pre-theft which operate with the
precision required to satisfy the court of a market State, it will at
least overcome the first hurdle of establishing title to sue in a case
for repatriation. In the United Kingdom, similar authority is available
in the form of *R. v. Tokeley-Parry*[58] in which English law recognised
the right of a State to assert ownership over antiquities in its territory
and was prepared to view their illegal export as theft.

Although US courts seem to have established a trend towards the
acceptance of such source laws, and the United Kingdom is moving
towards this position - the 2003 Act being a significant step - the
perpetuation of the alternative state of affairs is unfortunately effected
(to an extent implicitly) by the restriction of Article 7(b)(i) of UNESCO
1970 to cover cultural property stolen from a museum or religious or
secular monument of the source State, "provided that such property
is documented as appertaining to the inventory of that institution".
Bare legislation is therefore not enough in terms of the Convention
to vest title in a source State. Cataloguing is necessary, and if the
item stolen does not form part of an inventory under Article 7(b)(i), it
will not fall within the scope of Article 7(b)(ii). The result is that, in
respect of stolen cultural property which is not documented as
appertaining to an inventory of a State monument or institution,
there will be no obligation on the market State to 'take appropriate
steps to recover and return such cultural property' in terms of Article
7(b)(ii). The protection afforded by the Convention to source States is
so narrow that it seems the US courts and the UK legislature have
moved beyond it of their own accord.

How is a source State to compile an inventory of all of the cultural
property within its territory when an indiscernible proportion of it
lies undiscovered? How might it finance such a thing if the
undertaking itself were possible? Don't many items of cultural
property exist *in solo* without any link to a museum or monument?
Why do these not deserve similar protection under the Convention?

These issues and others gave rise to the perceived need for a new
international Convention to fill in the gaps left by UNESCO. That
Convention materialised as Unidroit 1995.

57 H.N. Spiegler & L.M. Kaye, 'American Litigation to Recover Cultural Property: Obstacles,
 Options, and a Proposal', in N. Brodie, J. Doole & C. Renfrew (eds) *Trade in Illicit Antiquities:
 the Destruction of the World's Archaeological Heritage.* (2001, Cambridge, McDonald
 Institute for Archaeological Research).

58 [1999] Crim. L.R. 578.

3.2.2 The Unidroit Convention on Stolen or Illegally Exported Cultural Objects

3.2.2.1 *The worth of the Convention in terms of the recovery of art (including Holocaust art) which falls within the definition of cultural property, by an individual*

The right of a dispossessed owner to sue in the courts of another country for the return of his property is already established. Rights of ownership established under the law of one nation will normally be recognised and enforced by the courts of another nation.[59] There are many examples of this happening routinely; in relation to the legal systems of developed western nations the rule is settled. So what does Unidroit do for pursuers of stolen cultural property beyond their existing rights in law?

The answer appears to be not much. Certainly, the Convention provides a mechanism in international law for individuals to sue for the return of their stolen cultural objects. Article 3(1) declares that any such stolen property shall be returned. But unlike existing remedies in law, Article 4(1) gives the good faith possessor of such a returnable object the right to compensation from the claimant. Claimants must therefore buy back their stolen cultural property.

The compensation provision is confounding, as it gives the innocent purchaser of cultural property who finds that he has not acquired a good title a right of recovery from the dispossessed owner which he would not have had in many systems of western law. While some countries (mainly those with civil law roots such as France and Italy) insist that a good faith purchaser be so compensated, common law systems such as those which pertain in Australia, the USA and England do not give the good faith purchaser such an entitlement. In those systems, the remedy of the innocent purchaser is to recover from the party who sold him the object.

This has the interesting effect that if the claim comes within the applicable domestic limitation periods (probably those prescribed by the *lex situs*), the dispossessed owner would in many cases do better to sue under the pre-existing law which may (depending on the State in question) not require him to 'buy back' his object in this way. Article 9(1) preserves the right of a Contracting State to apply any rules more favourable to the restitution or the return of stolen or illegally exported cultural objects than provided for by the Convention.[60]

59 Subject of course to the possible rights of good faith purchasers in terms of the operation of statutes of limitation or rules of prescription, and the difficulties encountered by States who have passed universal legislative declarations of ownership, already mentioned.

60 Such a course might not be open to a claiming source State (as opposed to an individual citizen) owing to the possible reluctance of market nations to recognise source declarations of ownership in terms of existing international private law, already mentioned. For stolen items which were not the subject of private ownership, the claiming State might have to take the route prescribed by the Convention and pay compensation to a good faith purchaser. This is because of the necessity of relying on the recognition of State-vesting legislation in Article 3(2) in order to get over the initial hurdle of proving ownership on which to base the claim. See the next section.

3.2.2.2 The worth of the Convention in terms of the recovery of looted antiquities by a source State

As with the UNESCO Convention, we can divide the effect of Unidroit under this head into its provisions on illegal export of cultural property from a source State, and its provisions on the theft of such property from the source State.

In respect of illegal export, as elsewhere, Unidroit goes further than UNESCO in providing for the return of illegally-exported cultural property to the source State. Unidroit provides for such return in Article 5(1), but only under certain circumstances, specified in Article 5(3). Given the terms of Article 5(3), a market nation will be under no obligation to arrange for the return to its country of origin of all but a very small proportion of cultural property. The section is worth quoting here in its entirety:

> 3) The court or other competent authority of the State addressed shall order the return of an illegally exported cultural object if the requesting state establishes that the removal of the object from its territory significantly impairs one or more of the following interests:
> a) the physical preservation of the object or its context;
> b) the integrity of a complex object;
> c) the preservation of information of, for example, a scientific or historical character;
> d) the traditional or ritual use of the object by a tribal or indigenous community,
> or establishes that the object is of significant cultural importance for the requesting State.

In terms of (3)(a), the source State requesting the return of its object is likely to be met with the rejoinder that museums and collectors in market nations are able to provide preservative conditions for artworks that are superior to those to which a source State working on a limited budget can stretch. As far as context goes, unless the object in question were part of a temple or other structure, in which case it would fall within (3)(b) anyway, the context is likely to have been destroyed when the artefact was looted and will no longer be open to preservation. A similar criticism may be levelled against (3)(c); the scientific or historical information to which an antiquity can give rise is predominantly captured in its findspot, i.e. its immediate surroundings. Once removed by a looter, that information is gone and the return of the object from abroad will do little to aid the preservation of such information. If the section intends to aid the preservation of information that is immanent, i.e. to do with the object itself rather than its archaeological context, there is no apparent reason why that information should be endangered simply because the object has come into the hands of a museum or a collector in the market State. In fact, quite the reverse would seem to hold.

Leaving aside (3)(d) as applying to items currently in use, and therefore being irrelevant to antiquities which are buried, we are left looking at the bones of the section. These are that only items removed from a monument (similar to the situation under UNESCO 1970) and other objects of 'significant cultural importance' are likely to form the subjects of valid requests for recovery by a source State. It is not easy to predict how courts will interpret the standard of 'significant cultural importance', but the phrase has the potential to take on a very narrow meaning.

It is in relation to property stolen from the source State that this Convention has its really important effect, going much further than UNESCO. Article 3(2) tries to get around the 'lack of market enforcement of source State universal declarations of ownership' problem by acknowledging these 'thefts' from the source State in the case of illegal excavation. Viz: "... a cultural object which has been unlawfully excavated or lawfully excavated but unlawfully retained shall be considered stolen, when consistent with the law of the place where the excavation took place". No requirement for steps beyond the legislative declaration of State ownership is stated (such as the inventory requirement in UNESCO).

Items of cultural property which form part of an inventory are given another form of preferential treatment, however. Article 3(3) introduces a special limitations rule for claims falling within the scope of the Convention. The rule is weighted very much in favour of the dispossessed owner. It states that:

> any claim for restitution shall be brought within a period of three years from the time when the claimant knew the location of the cultural object and the identity of its possessor, and in any case within a period of fifty years from the time of the theft.

The benefit accorded to documented items is set out in article 3(4), which removes the fifty-year longstop for such objects:

> ... a claim for restitution of a cultural object forming an integral part of an identified monument or archaeological site, or belonging to a public collection, shall not be subject to time limitations other than a period to three years from the time when the claimant knew the location of the cultural object and the identity of its possessor.

If these appear to be significant steps in the right direction, though, we should note that the compensation provisions in Article 4(1) apply to claims made by a source State in the same way as they do to individuals, and therefore source nations are similarly required to 'buy back' their stolen heritage.[61]

61 A similar compensation provision is included in UNESCO 1970, Article 7(b)(ii). Whether the claim is made by a source nation under UNESCO 1970 or Unidroit 1995, then, compensation is in both cases required to be paid to the innocent purchaser of stolen cultural property who does not acquire good title as against the true owner.

Both the UNESCO and the Unidroit Conventions may seem, on the surface, to be simply about the return of artefacts to their countries of origin (in the case of antiquities) or to the dispossessed owner (in the case of art theft). At first blush they appear to have little to do with addressing the question of the initial theftous acts which took these objects from the ground or from their owners. In the case of antiquities, these theftous acts involve the destruction of context and the archaeological and historical knowledge which that context can reveal to the trained excavator. There is a deeper logic at work, however, in the assumption that retention and/or recovery by source countries or individual dispossessed owners in those countries will have an effect on consumer choices in market States – a collector or institution will be less likely to buy an unprovenanced antiquity, it is thought, if it is likely that it will be reclaimed. Whether this is still the case if the purchaser is assured of receiving compensation to the tune of the purchase price, or better still (as is debated) to the market value of the object upon its return, is unclear.

What the Conventions do not do is relieve national governments of the task of enforcing their provisions:

> Although States have co-operated to create international legal rules e.g. the UNESCO Convention, they have not been able to agree on international enforcement procedures... There is no international enforcement agency endowed by States with the jurisdiction to prosecute cultural heritage offences, nor any international tribunal with jurisdiction to try and punish them.[62]

Relying as they do on systems of civil recovery involving huge and potentially irrecoverable expenditure by source nations (in the case of UNESCO) or worse, by individuals (in the case of Unidroit), the financial and administrative hurdles inherent in the mechanisms contained in these treaties may provide such a disincentive to litigation, or an obstacle to success if indeed a claim is made, that they give even a bad faith purchaser more security than he deserves. We shall elaborate on the suitability of the civil litigation mechanism to this area of cultural property ownership and possession in section 3.3 below.

The UNESCO Convention entered into force in 1972, after being adopted in the Organisation's 1970 general meeting. Currently, 102 countries have become States Parties to the pact, with only a few developed market nations yet to join the list: most notably Germany.[63] In 2001, a resolution at a U.N. General Assembly was adopted urging fuller ratification of the Convention, and Japan was singled out as being a storehouse for stolen cultural property. Japan responded to

62 L.V. Prott, & P.J. O'Keefe, *Law and the Cultural Heritage, Volume 1: Discovery and Excavation.* (1984, Abingdon, Professional Books) at p. 87.
63 A continually updated list of States Parties to the Convention is available at http://www.unesco.org/culture/laws/1970/html_eng/page3.shtml (version current at 1 March 2005).

this pressure by taking steps to seek parliamentary approval for the ratification of the Convention. Approval was duly obtained and the Convention came into force in Japan on 9th December 2002.

While the Convention has many States Parties, its power is limited. There exist no sanctions under public international law for Parties who choose not to abide by their obligations. In fact, then, we might see the Convention as containing no obligations as such; merely imprecise and unenforceable guidelines for State action. States Parties can choose which parts of the Convention to introduce into domestic law, and how to introduce them. Without domestic implementing legislation the Convention has no real effect and will not be enforced by the domestic courts of the country in question.[64]

At the time of writing, only 22 countries have signed the Unidroit Convention. It has been ratified by eleven of these, and nine others have acceded to it. None of these groups include the USA, the United Kingdom, Australia or Thailand.[65]

In fact, Thailand has not yet signed or acceded to either the UNESCO or the Unidroit Conventions, but its archaeologists hold out hope that it will do so in respect of the former in the foreseeable future.[66] As far back as 1986, Thailand acknowledged that, while it had some reservations concerning the UNESCO Convention, and therefore did not intend at that time to ratify or accept it, it in fact already abided by many aspects of its terms.[67]

Two of the main difficulties with the UNESCO Convention detailed by the Thai representative at the UNESCO Regional Seminar on the Moveable Cultural Property Convention in Brisbane in 1986 were stated to be in respect of Articles 7(b)(ii) and 10(a). In relation to Article 7(b)(ii) (which as detailed above is one of the central operative provisions of the Convention), the delegate questioned the requirement that the State requesting the return of its cultural property "pay compensation to an innocent purchaser or to a person who has valid title to that property":

> How can a developing country like Thailand pay such money to retrieve her cultural heritage?[68]

64 K. Chamberlain, 'UK Accession to the 1970 UNESCO Convention'. (2002) VII *Art Antiquity and Law* pp. 231-52.

65 Unidroit 'Status Report: Convention on Stolen or Illegally Exported Cultural Objects' *Unidroit website* at http://www.unidroit.org/english/implement/i-95.htm (version current at 1 March 2005).

66 R. Thosarat 'Report from Southeast Asia'. *Culture Without Context: the Newsletter of the Illicit Antiquities Research Centre, University of Cambridge.* 8 (Spring 2001).

67 M.C. Subhadradis Diskul, 'Reports on National Protection Measures in the Region: Thailand', in L.V. Prott & J. Specht (eds) *Protection or Plunder? Safeguarding the Future of Our Cultural Heritage: Papers of the UNESCO Regional Seminar on the Movable Cultural Property Convention.* (1986, Canberra: Australian Government Publishing Service).

68 *Ibid.*, at p. 63.

Article 10(a) requires States Parties:

> as appropriate for each country, [to] oblige antique
> dealers, subject to penal or administrative sanctions, to
> maintain a register recording the origin of each item of
> cultural property, names and addresses of the supplier,
> description and price of each item sold and to inform
> the purchaser of the cultural property of the export
> prohibition to which such property may be subject.

Note this is not a publicly-held register, rather a register kept by
each dealer. The delegate stated that, even though they were not
(and still are not) signatories to the Convention, Thailand had:

> tried to comply, but rather unsuccessfully, with the terms
> of Article 10(a) because we do not have enough officials
> dealing with this matter in the Department of Fine Arts.[69]

It is clear, therefore, that international legislative mechanisms for
the 'protection' (read 'repatriation') of cultural property have been
framed in terms which render their implementation and use difficult
for source countries such as Thailand, which find that they are
prevented from taking advantage of the terms of these instruments
by internal funding and resource deficits.

3.2.3 Implementation of the UNESCO Convention

3.2.3.1 The US implementation of UNESCO 1970

The Convention on Cultural Property Implementation Act 1983, 19
U.S.C. section 2601 ('CPIA') was the route chosen by the United States
to implement the 1970 UNESCO Convention. It provides, in response
to what the United States sees as the main operative provision of
UNESCO 1970 – Article 9 – for the mechanism of bilateral agreements
as a prompt to US action in restricting import of items of cultural
property. Countries whose cultural heritage is under severe threat
are invited to apply to the United States for such a bilateral (or in
theory, multilateral) agreement, which, if concluded, would form an
undertaking by the United States that their customs will implement
import restrictions on incoming objects which fall into the agreed
categories of protected property. These import restrictions come with
powers of seizure and forfeiture (section 2606). The requesting State
must show that its cultural patrimony is in jeopardy and that it has
taken measures to protect it (section 2602). The Act also provides for
emergency powers, allowing for the implementation of import
restrictions without a concluded bilateral agreement where
important finds are "in jeopardy from pillage, dismantling, dispersal
or fragmentation which is, or threatens to be, of crisis proportions"
where the implementation of such import restrictions would reduce
the incentive for that pillage, etc. (section 2603).

69 *Ibid.*, at p. 63.

By and large, the United States has viewed the requirements of UNESCO 1970 that States Parties act to facilitate the return of stolen or illegally-exported cultural property as being in its case satisfied by the possibilities of litigation initiated by source countries. An exception to this is found in section 2607 of the CPIA which implements the first part of Article 7(b)(ii) of UNESCO 1970. The section provides that no article of cultural property documented as appertaining to the inventory of a museum or religious or secular public monument or similar institution in any State Party which is stolen from such an institution may be imported into the US. Stolen foreign property (including, after the *Hollinshead*,[70] *McClain*[71] and *Schultz*[72] cases, unlawfully exported items of cultural heritage to which the government of the source state has claimed ownership) is covered by the US *National Stolen Property Act* and so the only real effect of section 2607 of the CPIA is to give powers of seizure to US customs in the particular case of inventoried items.[73] Both the NSPA and the CPIA provide alternatives to a civil claim for recovery of possession and authorise the United States Attorney, rather than the national claimant, to bring suit for the forfeiture of the object. Which Act is used in the prosecution of the possessor of stolen cultural property will therefore depend upon two main concerns: (a) whether the claimant nation has a concluded agreement with the USA or can invoke the crisis provision, and (b) whether the property in question was documented as appertaining to the inventory of a museum or religious or secular public monument or similar institution in the claimant nation. If one of these provisions is not satisfied a criminal case against the US possessor would have to proceed under the NSPA, as was the case in *Schultz*.[74]

Peru is one of the few countries which currently have an extant bilateral agreement with the United States.[75] In 1998, Susan McIntosh, an anthropologist at Rice University in Houston and a member of the eleven-member Cultural Property Advisory Committee which helps negotiate bilateral agreements under the 1983 Act, explained why the agreement with Peru had been entered into:

> The public doesn't realise how ravaged some of these prized areas are. Some sites in Peru look like lunar landscapes after encountering an asteroid belt. They are destroyed before we can map them, inventory them, or learn anything about the culture.[76]

70 495 F.2d 1154 (9th Cir. 1974).
71 545 F.2d 988 (5th Cir. 1977), 593 F.2d 658 (5th Cir. 1979), cert. denied, 444 U.S. 918 (1979).
72 178 F. Supp. 2d 445 (S.D.N.Y. 2002), 333 F.2d 393 (2d Cir. 2003), 147 L.Ed 2d 891 (2004).
73 L.V. Prott, & P.J. O'Keefe, *Law and the Cultural Heritage, Volume 3: Movement*. (1989, London, Butterworths) at p. 797.
74 *Supra*, note 72.
75 The relevant agreement is Import Restrictions Imposed on Significant Archaeological Artifacts from Peru, 19 CFR 12.104(g), 55 FR 19029 (May 7, 1990), amended 62 FR 31713-31721 (June 11, 1997).
76 G. Russell Chaddock, 'Art World Wary of New Rules', *The Christian Science Monitor*, 10 February 1998.

Other countries that have successfully concluded relevant agreements (which are extant at the time of writing) with the United States under the procedure in the CPIA are: Italy, Cyprus, Bolivia, Honduras and Nicaragua (which hold bilateral agreements); and Mali, El Salvador, Cambodia and Guatemala (which initially negotiated emergency protection, now replaced with bilateral agreements).[77] Thailand has no extant agreement with the US (US Department of State, 2003), and as such its antiquities are not subject to any special US import restrictions, making them effectively freely importable into that country.

3.2.3.2 Australia's implementation of UNESCO 1970

Sections 3 and 14 of the Australian Protection of Movable Cultural Heritage Act 1986 make unlawful the import into Australia of an object which is part of the moveable cultural heritage of a foreign country and the export of which is prohibited by that foreign country's law. The unlawfully-imported object will be forfeited, and where the unlawful import was made with knowledge, the importer may be prosecuted. The Act therefore both restricts the import of the protected cultural heritage of other countries and, through the Protection of Movable Cultural Heritage Regulations 1988, regulates the export of Australia's cultural heritage by means of a Control List which sets down categories of protected Australian artefacts in accordance with Article 1 of UNESCO 1970.

This linking of Australian import controls to the export controls of source nations seems a positive step, particularly when compared to the reluctance of other market nations such as the United Kingdom and the United States to enforce foreign export restrictions, at least without special provision for such enforcement as, for example, in the case of US bilateral agreements under the CPIA. We have seen from the Melbourne interview data, however, that in practice dealers see the likelihood of any suspect shipment being stopped as very low.

3.2.3.3 The United Kingdom and UNESCO 1970

Following the recommendation of ITAP,[78] the United Kingdom ratified the 1970 UNESCO Convention, with full accession being achieved on 31st October 2002. Ultimately in the ITAP deliberations, it seems that the UNESCO Convention's weaknesses became its strength. Compared to the more tightly-worded Unidroit Convention, the

77 US Department of State (2003) 'Chart of Current and Expired Import Restrictions Under the Convention on Cultural Property Implementation Act' *Bureau of Educational and Cultural Affairs website* at http://exchanges.state.gov/culprop/chart.html (version current at 1 March 2005). See also H.N. Spiegler & L.M. Kaye, 'American Litigation to Recover Cultural Property: Obstacles, Options, and a Proposal', in N. Brodie, J. Doole & C. Renfrew (eds) *Trade in Illicit Antiquities: the Destruction of the World's Archaeological Heritage.* (2001, Cambridge, McDonald Institute for Archaeological Research).

78 Palmer *et al.*, *op. cit.* note 34, at 12, 23.

UNESCO Convention's loose non-specific un-legal drafting made it an attractive solution for a Panel which had to come up with something, but nothing too drastic; the recommendations had to suit all of the range of interests comprising the Panel. Implementation of the UNESCO Convention by the United Kingdom has allowed it to show its allegiance to the cause of the protection of culture and the taming of the illicit market, without in substance requiring any great changes in its domestic law or any new institutional or policy arrangements for the detection and cessation of the illicit trade in London. Kevin Chamberlain, the legal adviser to ITAP, notes that:

> it was the opinion of ITAP that United Kingdom acceptance of the UNESCO Convention could be achieved without new legislative provision

calling the provisions of the Convention "fairly vague and non-specific".[79] The eventual ratification by the United Kingdom therefore comes as something of a hollow victory for supporters of the Convention, involving as it does no implementing domestic legislation.

Quite how loosely the UK has chosen to interpret the Convention is demonstrated by Chamberlain's commentary on what needs be done to bring the country in line with the spirit and terms of the document. In effect, this is nothing at all. He sees the existing provisions of the Theft Act 1968 as enough to satisfy the requirement of Article 7(b)(i) that States Parties 'prohibit the import' of cultural objects stolen abroad.[80] Yet, as we have seen, HM Customs is, despite that statute, unaware of its powers of seizure and therefore takes the view that such import is not prohibited. Also problematic, and not addressed by Chamberlain, is the Scottish position; the Scots law in relation to handling of stolen property is called 'reset' and does not currently accord to a Scottish court jurisdiction in respect of property stolen outside the United Kingdom.[81] The United Kingdom may have subscribed to the Convention in principle, but changes in practice are required. The Dealing in Cultural Objects (Offences) Act 2003, part of a package of measures designed to complement accession to the UNESCO Convention, might actually best be seen in the same vein as that accession itself: an attempt by Government to signify concern and 'action' which is manifested in a flurry of symbolic legislative activity followed by a sharp decrease in the prominence of the issue on the policy radar. As mentioned previously, the 2003 Act does not appear to have been adopted with

79 K. Chamberlain, 'UK Accession to the 1970 UNESCO Convention', (2002) VII *Art Antiquity and Law*, 231 at p. 239.
80 *Ibid.*, at p. 246.
81 K.V. Last (2002) 'Implementation of the 1970 UNESCO Convention: Implications for Scots Law'. Published as proceedings of the conference *Implementation of the UNESCO 1970 Convention.* Department for Culture Media and Sport, London, Institute of Art & Law and Art-Law Centre, Geneva.

energy and enthusiasm by HM Customs as a tool for the prohibition of import of stolen cultural objects, and neither does it apply to Scotland, where parallel legislation is still to emerge. Its effect in complementing accession to the Convention may therefore emerge in practice as severely limited.

Even where no law currently governs the market practice, it is thought that self-regulation codes devoid of sanction satisfy the Convention. Article 5(e) contains a requirement that a Contracting Party should undertake:

> establishing, for the benefit of those concerned (curators, collectors, antique dealers etc.) rules, in conformity with the ethical principles set forth in this Convention; and taking steps to ensure the observance of these rules.

The United Kingdom's system of self-regulation where most of the relevant professional associations such as the International Council of Museums, the Museums Association, the Institute of Field Archaeologists, UK Institute of Conservation and dealers' associations now have codes of conduct, is likely to satisfy this requirement. One weakness of the system is that there are no effective sanctions for non-compliance with the codes, other than to expel the member from the organisation concerned, a sanction that is rarely enforced.[82]

We shall now examine two of the major international self-regulation codes, to which many UK dealers and museums subscribe, highlighting their inadequacy as tools of market governance.

3.2.4 Other Sources of International Regulation – Codes of Practice

3.2.4.1 ICOM

The International Council of Museums' Code of Ethics, first adopted in 1986 and most recently revised on 6th July 2001, contains instructions to its signatories regarding proper acquisition procedure. Paragraph 3.2 instructs that:

> A museum should not acquire any object or specimen by purchase, gift, loan, bequest or exchange unless the governing body and responsible officer are satisfied that a valid title to it can be obtained. Every effort must be made to ensure that it has not been illegally acquired in, or exported from, its country of origin or any intermediate country in which it may have been owned legally (including the museum's own country). Due diligence in this regard should establish the full history of the item from discovery or production, before acquisition is considered.[83]

82 Chamberlain, *op. cit.* note 78 at p. 244.
83 'Code of Ethics for Museums' *ICOM website* at http://icom.museum/ethics_rev_engl.html (version current at 1 March 2005).

This is a relatively stringent requirement compared to the language of the international treaties discussed above,[84] and if adhered to rigidly by museums would block one of the conduits of disposal of looted antiquities. The problems, however, are threefold:

1. The illicit and undetected nature of the looting of antiquities and their illegal export, when combined with the routine lack of provenance information and documentation available to buyers of antiquities, makes the requirement a difficult one practically to abide by. Such difficulty is illustrated in what Colin Renfrew calls the 'round Robin' procedure [85] practised by museums, of writing to likely source nations asking if a piece the museum intends to acquire has been stolen from them. This procedure often amounts to little more than a superficial exercise in the museum covering its own back, since source governments find it extremely hard to verify in the short timescale required that an object which was buried in their territory – and accordingly of which they have no record – has been stolen. ICOM publishes a 'Red List' of items reported as stolen by source governments,[86] but like the Art Loss Register this List cannot contain reference to items lost in the normal course of looting from unpatrolled and perhaps unknown rural sites – indeed the list itself acknowledges that it cannot claim to be exhaustive;

2. Museums exist to some extent in competition with private collectors, at least insofar as both are offered antiquities for sale and make bids for them at auction. Generally the buyer who can offer the highest price will be able to take ownership of the object. Museums exist to showcase objects of historical importance and educational value and there must exist substantial temptation to interpret the ICOM Code relatively loosely when operating in a market with private individuals who are not so constrained, so as to ensure the continuing proper performance of their *raison d'être*;

84 And indeed even when compared to the Archaeological Institute of America's ethics code which requires its members to 'refuse to participate in the trade of undocumented antiquities and refrain from activities that enhance the commercial value of such objects'. Undocumented antiquities are those that are not documented as belonging to a public or private collection before December 30, 1970, when the AIA Council endorsed the UNESCO Convention on Cultural Property, and show no evidence of having been excavated and exported from the country of origin in accordance with the laws of that country (Archaeological Institute of America (2002) 'AIA Code of Ethics' available as a pdf file through the Archaeological Institute of America website at http://www.archaeological.org/ (version current at 1 March 2005)).

85 C. Renfrew, Loot, Legitimacy and Ownership: the Ethical Crisis in Archaeology. (1999, Amsterdam, Joh. Enschede) at p. 39.

86 At http://icom.museum/redlist/ (version current at 1 March 2005). The List is divided according to geographical focus, the most recent addition being an Emergency Red List of Iraqi Antiquities at Risk, released on 11 June 2003. There is much current focus at the time of writing on the international transit of Iraqi antiquities after widespread reports, conflicting in their portrayal of the scale of the issue, of post-war looting at the Baghdad museum and indeed throughout the country. As an indication of how seriously the matter is being taken, the United Nations Security Council on 22 May 2003 passed Resolution 1483 banning all international trade in Iraqi cultural property exported illegally after 6 August 1990.

3. The Code implements no enforcement procedures for museums which do not abide by its terms.

3.2.4.2 UNESCO Code of Ethics for Dealers in Cultural Property

This Code was endorsed by the 30th General Conference of UNESCO in November 1999. Subscription to the Code is voluntary. Under Article 1, a professional trader is not to:

> import, export or transfer the ownership of [cultural] property when they have reasonable cause to believe that it has been stolen, illegally alienated, clandestinely excavated or illegally exported.[87]

O'Keefe states that 'reasonable cause' requires traders to investigate the provenance of the object in question. It is not enough simply to trade without questions and apply the clause solely "when somehow evidence of the illegality is fortuitously acquired".[88] The clause is breached by most of the interviewees in the course of most of their transactions. Many of them, of course, will not subscribe to the Code, but insofar as it tries to embody standards to which all dealers should adhere, or at least consider, it has achieved no reaction from the interview sample. Many of those in the sample declared their readiness to deal in antiquities exported contrary to source laws. This breach of ethics is excused by the group with reference to the perceived restrictiveness of source country export laws, unfair to the market. Further, in relation to stolen objects, many of those in the sample admitted to the regular purchase of antiquities with no provenance. Any provenance investigations as were undertaken usually turned up general verbal assurances of prior ownership or drew a complete blank, neither of which results, it could be argued, would give a buyer reasonable cause to believe that the object for sale was stolen. In this way, the poor state of provenance information-sharing in the market is functional in allowing dealers to make purchases of objects where the licit or illicit status of those objects is unknown, while purportedly still being in no breach of promulgated standards of ethics.

3.3 HOW WELL DO THE CONTROLS WORK? THE LACK OF PROTECTION OF CONTEXT AFFORDED BY CIVIL RECOVERY

Civil recovery has operated effectively in a few headline cases to retrieve for source countries artefacts which have travelled overseas in breach of export restrictions. Even in these cases, however, we should note that the export restrictions themselves did not operate to prevent the passage of the objects abroad. Neither the international

87 'International Code of Ethics for Dealers in Cultural Property' UNESCO website at http://www.unesco.org/culture/legalprotection/committee/html_eng/ethics1.shtml (version current at 1 March 2005).

88 P.J. O'Keefe, 'Unlawful Traffic in Cultural Heritage and UNESCO', (2001) 6 Media & Arts Law Review pp. 139-41.

conventions, the source country ownership and export laws, nor the increasing number of lawsuits raised by source countries to obtain the repatriation of their cultural property have operated so as to achieve a retention of heritage at source:

> [Is there any way you can tell how much of the market is illicit?]

> What do you mean by illicit?

> [For the moment, taking the strictly legal position, let's work with the source country laws which restrict the movement of objects, putting aside moral arguments and simply taking them as valid, how much of the market do you think is composed of objects which have come out in breach of those regulations?]

> All the good objects. (New York Dealer 2)

We have looked at the reasons for the failure of export prohibitions and the international conventions. Let us here turn to some of the reasons why civil suits for recovery of property by source countries do not achieve a protective effect on cultural property.

3.3.1 Problems for Source Countries in Obtaining Successful Outcomes

3.3.1.1 Proof of origin or identity of object

Here we find a most intriguing dynamic between legal claims for recovery of looted or illegally-exported objects by source countries and the issue of provenance. What is a stumbling block to source countries is a safeguard to possessors of antiquities in the market. Provenance information is wilfully obscured by market participants in order to reduce the chance that a claim might be made against them for repossession of the object by the country which they have named as its source:

> [Would it be fair to say that if the information was available, where the object was found, that would be of interest to you?]

> Of course it would be of interest to me, and I desperately want to give it, but I would have to caution it with "said to be" or "allegedly from" because otherwise I could lose it. It's obvious…

> [What you can do, I think, is improve your mechanisms for recording and passing on provenance information.]

> I've tried and I get hit for it. I've destroyed some of it out of fear. (Geneva Collector 1)

This results in something of a Catch-22 situation for source countries and for those legal commentators and practitioners who

would, through advocating civil suits for recovery of possession by source countries, try to encourage the open passing of provenance information in the market through highlighting the perceived danger of litigation for the buyer. Where no provenience information is available it is very hard for claimant governments to prove that the object came from the soil of their country. Where exact provenance information is given, this task may be considerably easier, but will discourage future identification of origin in the market generally, precisely through fear of such legal action. These civil suits are themselves one of the causes of the lack of open provenance and provenience information in the market.

3.3.1.2 Limitation periods

Limitation periods affect whether an owner of a chattel, dispossessed by theft or some other wrongful act, will be successful in a civil law suit to recover the chattel from the party who now possesses it. They can, through the simple passage of time, preclude a claim for the return of a stolen antiquity.

Different jurisdictions employ different limitation rules. The justification for such rules lies in the promotion of speedy litigation, such that buyers of property need not harbour eternal uncertainty as to the validity of their title, and therefore commercial transactions are in some degree granted reliability. Through their sometimes harsh operation, however, the English Law Commission has recently offered a view of limitations law as outdated, complex, uncertain, and often unfair to relatively innocent parties.[89]

Australia, along with other common law jurisdictions such as the United Kingdom and the USA, premises its limitations laws on the maxim *nemo dat quod non habet*, which translates as 'no-one can give that which he does not have'. A thief cannot therefore pass good title to a buyer. That basic rule, however, is misleading as the law can – and often does – effectively give title to the third-party buyer by time-barring a claim for the return of the item of property by the dispossessed owner. In relation to civil claims for recovery of stolen chattels, the operation of limitation periods in this manner can cause a claimant considerable difficulty.

For civil claims heard in Australia, the relevant statutes of limitations vary between Australia's States and Territories and can range from three[90] to six years.[91] In general, a plaintiff cannot sue once six years has run from the accrual of the cause of action. The cause of action accrues from the date of the theft and time runs

89 Law Commission of England & Wales (1998) 'Limitations of Action: Making the Law on Civil Limitation Periods Simpler and Fairer', *Discussion Paper No. 151* and 'Limitations of Actions', *Report No. 270*, April 2001

90 E.g. in the Northern Territory; see Limitation Act 1981 (NT) s12(1)(b).

91 E.g. in Victoria and New South Wales; see Limitation of Actions Act 1958 (Vic) s.5; Limitation Act 1969 (NSW) s.14.

whether the plaintiff knows the identity of the defendant possessor of the stolen work or not,[92] unless that identity is concealed by fraud.[93] Presently, then, a plaintiff source State which sues for the return of its artefact and finds that Australian limitation rules govern the claim (as will be the case if the object has been sold in Australia, remains there, and the case is heard by an Australian court) will find that the claim is barred if the requisite number of years has passed since the date the State was dispossessed. This will be the case even if the current possessor of the artefact bought it in suspicious circumstances. That is to say there is no 'good faith' requirement on a purchaser in Australian limitations law.[94] A system such as this, which places no good faith requirement on buyers, might be seen to prejudice dispossessed owners. It certainly does nothing to encourage buyers in the secondary art market to ask for details of a work's provenance when buying.

Queensland's Law Commission has recently recommended a break from the six-year limitation norm, proposing a general limitation period of three years from the date on which the plaintiff knew, or in the circumstances ought to have known, that the injury had occurred, that it was attributable to some other person, and that it warranted bringing proceedings. They also recommended a longstop period of ten years from the date on which the conduct giving rise to the claim occurred.[95] Similar proposals have been put forward in Western Australia.[96] There, the Law Commission has recommended a three-year 'discovery limitation period' – which in the case of stolen or looted antiquities would revolve less around the date of the theft and more around the gathering of the information necessary to raise a suit for recovery – backed up by a longstop limitation period of fifteen years. These recommendations for reform, however, have at the date of writing still to be implemented, and there is no telling when, if ever, that might happen.

The limitations law of England and Wales is slightly different. By section 4 of the Limitation Act 1980, the short limitation period of six years does not run against a thief, rather it starts on the first good faith conversion of the chattel. A stolen or looted antiquity which finds its way into the hands of a buyer in England will therefore be recoverable by its dispossessed owner – in terms of the rules on limitation of actions at least – unless the object was purchased in good faith more than six years ago. In that case, the good faith purchaser and his successors in title will find themselves protected;

92 *RB Policies at Lloyd's v. Butler* [1950] K.B. 76.
93 Eg Limitation Act 1969 (NSW) s. 55(1)(b).
94 A.T. Kenyon, & S. Mackenzie, 'Recovering Stolen Art: Australian, English and US Law on Limitations of Action' (2002) 30 *University of Western Australia Law Review*, pp. 233-50.
95 Queensland Law Reform Commission (1998) 'A Review of the Limitation of Actions Act 1974', *Report No. 53*, September.
96 Law Reform Commission of Western Australia (1997) 'Limitation and Notice of Actions', *Report No. 36(II)*. January and (1999) 'Review of the Criminal and Civil Justice System'. *Report No. 92*.

under section 3(2) of the 1980 Act, the original owner's title is extinguished upon the expiry of the six-year limitation period. Good faith is not, however, presumed: it is for the possessor to establish a good faith purchase outside the six-year limitation period.[97] English law will not give effect to a foreign limitation period which would offend UK public policy;[98] for example it has been suggested that it would not recognise the limitation laws of an Australian State or Territory which favoured a buyer not in good faith.[99]

What puts a purchaser in good faith? As a general rule, the purchaser should undertake all investigations into the seller's title to the chattel as a reasonable man *in his position* would undertake. The emphasis is to draw attention to the implication that the standards required of a dealer or collector of antiquities can be higher than those required of an average consumer purchasing miscellaneous goods in the marketplace. This view was taken in *De Préval v Adrian Alan Ltd*[100] a case concerning a claim for the return of antique candelabra stolen from the claimant ten years prior to the commencement of proceedings.[101] The defendant dealer had purchased the candelabra more than six years previously, and argued that he was protected as a good faith purchaser. Arden J. held that, as the stolen candelabra were unique, the defendant (being a dealer and hence supposedly experienced in such matters) should have been on notice in regard to checking their provenance and should not have bought them without first verifying the vendor's title. He had not done so, neither had he resorted to checking electronic registers of stolen artworks, and as such he failed to establish the good faith necessary to time bar the claim.

Changes to the six-year basic limitation rule have been proposed in England and Wales, as they have in Australia.[102] The proposals are for a three-year short limitation period to run from the date the claimant discovered, or reasonably should have discovered, the cause of action, the identity of the defendant and, in cases of conversion, the location of the property. The short limitation period would be backed up by a ten year longstop which, in cases of theft, would run from the date of the first good faith conversion.[103] Such a period might appear relatively favourable to a source State suing an English possessor for the return of its looted artefact, but the effect of the longstop would mean that an

97 Limitation Act 1980, s. 4(4)
98 *Per* Moses J. in *City of Gotha and Federal Republic of Germany v. Sotheby's and Cobert Finance SA* QBD Case No. 1993 C3428 and 1997 G 185. Foreign Limitation Periods Act 1984 s. 2(1) and (2).
99 K. Chamberlain, 'UK Accession to the 1970 UNESCO Convention', (2002) VII *Art Antiquity and Law* 231 at p. 241.
100 Unreported, Eng High Court, Q.B.D., Arden J., 24 January 1997.
101 Noted by R. Redmond-Cooper in (1997) II *Art Antiquity and Law* 55.
102 Law Commission of England & Wales (1998) 'Limitations of Action: Making the Law on Civil Limitation Periods Simpler and Fairer', *Discussion Paper No. 151*; and 'Limitations of Actions'. *Report No. 270*, April 2001.
103 Law Commission of England & Wales 2001 Report, above note 102, at paras 3.145, 4.67.

action raised more than ten years after the initial looting or illegal export of the property would be time-barred.[104] Ten years may seem like a long time, but given the difficulties inherent in discovering the looting of an artefact, the presence of which was in all probability unknown to the source State until someone alerted the relevant governmental body to its presence on the international market, let alone the problems in some developing nations of managing to initiate and retain enough sustained bureaucratic impetus actually to achieve the raising of an international court action, the time may well have expired before much is done.

Approaches to limitations in the United States vary between states, running the gamut from the plaintiff-friendly 'demand and refusal' rule to the more common 'due diligence' rule. While the due diligence (also sometimes called 'reasonable discoverability') test is the more common in the United States – under which time will start to run against a dispossessed owner from the moment he should reasonably have discovered the location of the object and the identity of the possessor had he been making reasonable investigations into the theft[105] – New York has adopted the demand and refusal rule. The demand and refusal rule operates just as it sounds; time will not start to run against a dispossessed owner under a statute of limitations unless that owner has not only discovered the location of the object and the identity of the possessor, but made a demand of the possessor for the return of that object which has been refused. It is at that point that the New York courts feel the dispossessed owner should consider his rights in litigation, and lose those rights if he delays in commencing proceedings beyond the stated time limit. In cultural property terms, a major case evidencing this approach by New York courts is *Guggenheim v. Lubell*,[106] in which the museum managed to recover a Chagall painting from a good faith purchaser more than twenty years after it was stolen, having in the interim taken virtually no steps to try to track down the work. As this case and others[107] evidence, there is no duty of diligence implied into the demand and refusal rule, although the doctrine of laches can in some cases provide relief for a defendant

104 Unless the countries involved were both signatories to the Unidroit Convention, which imposes its own scheme of limitations on the recovery of cultural property.

105 A good example of such an approach to limitations is the case of *Autocephalous Greek Orthodox Church of Cyprus v. Goldberg* 917 F 2d 278 (7th Cir. 1990), a decision much cited in commentaries on stolen and looted art and antiquities, and on which more will follow in this section; see also the earlier first instance decision *Autocephalous Greek Orthodox Church of Cyprus v. Goldberg* 717 F Supp 1374 (SD Ind. 1989). The plaintiffs in this case had made substantial efforts to discover the location of stolen mosaics and to notify relevant authorities. Thus their action was in the event not time-barred, as the court in Indiana held that time did not start to run until the plaintiffs discovered the mosaics' location in the US nearly a decade after their theft in northern Cyprus. Crucial to this finding were the efforts made by the plaintiffs to seek to locate the mosaics once they had discovered that they were missing.

106 *Solomon R Guggenheim Foundation v. Lubbell* 567 NYS 2d 623 (CA 1991).

107 E.g. *Golden Buddha Corp v. Canadian Land Co. of America* 931 F 2d 196 (2d Cir. 1991); *Hoelzer v. City of Stamford* 933 F 2d 1131 (2d Cir. 1991).

who can prove that he has been prejudiced by the plaintiff's unreasonable delay in choosing to exercise his rights to sue for the return of the object.[108]

Limitation laws, if known and understood in their content and operation by art market practitioners, can be used to encourage desirable behaviour by buyers in the art market and by the victims of theft and looting. They are currently little known or understood by those in the market, however, and therefore rather than influencing the conduct of market transactions, they come as something of a surprise to market practitioners when they become embroiled in litigation and consult their lawyers.[109] Art and antiquity dealers are educated and intelligent people and there is scope for publicising the existence of limitations rules as a mechanism of encouraging good faith (including provenance checking) in transactions.

If the rule is 'demand and refusal' there is little incentive for dispossessed owners to chase up their missing artworks with an expeditious energy; their claim for recovery will still be 'live' if and when they eventually track down the new owner. Conversely, rules such as that currently in operation in Australia which award good title to thieves, bad faith purchasers and good faith purchasers of artworks alike six years after the date of the theft provide scant incentive to buyers to take steps to put themselves in good faith, which might include the checking of international listings of lost and stolen art such as the Art Loss Register.[110] This is a missed opportunity for market steering; it is much easier for a buyer to take steps to investigate the origin of the object in that manner than it is for a dispossessed owner to track down the missing work through the regular searches of international auction catalogues that such services also offer.

Neither of these two positions seems ideal. It is not my intention here to propose a new scheme of limitations for stolen artworks (or indeed for all stolen property) although it would certainly be possible to devise a scheme which in theory would provide justifications for diligent investigation by both buyers and dispossessed owners. As became apparent from both the core and the supplementary interview data, few of the interviewees had any knowledge of the existence of limitations laws in their own country, let alone the content of those laws or their diversity internationally. Currently, then, limitations laws do little, if anything, to guide the actions of buyers in the trade. They may have a greater effect on the actions of dispossessed owners, simply because when a theft is discovered an owner might consult a

108 R.E. Lerner, 'The Nazi Art Theft Problem and the Role of the Museum: a Proposed Solution to Disputes over Title', (1998) 31 *New York University Journal of International Law and Politics*, 15; R. Schwartz, 'The Limits of the Law: a Call for a New Attitude Toward Artwork Stolen During World War II', (1998) 32 *Columbia Journal of Law and Social Problems* 1.

109 Kenyon & Mackenzie, *op. cit.* above, note 94.

110 www.artloss.com

solicitor who would then advise them on their possible duty of reasonable diligence in searching for the object. It should be noted that owing to the fact that generally the *lex situs* will determine the limitation law to apply to a claim by a dispossessed owner,[111] that owner must, in order to protect his interests, search for the missing object with due diligence in case that object subsequently surfaces in a jurisdiction in which time starts running from the date a person searching with reasonable diligence would have found the object. At risk of stating the obvious, if the dispossessed owner is indeed searching with reasonable diligence, then the point in time when a reasonably diligent searcher would have found the missing object will be the point in time when the object is actually discovered by the owner. If he is not searching with reasonable diligence, he may find himself time-barred if the court thinks he should have discovered the whereabouts of the object sooner, and the stated limitation period has run between that time imputed by the court and the date when proceedings were in fact commenced.

The point here, in summary, is that to get the best of limitation laws dispossessed owners must always be duly diligent, whereas in many countries buyers need not be. This requirement of diligence on the part of owners stems from the international nature of the market in stolen art: although the owner's domestic jurisdiction may prefer to support the rights of dispossessed owners over purchasers of chattels, such an approach may not be mirrored by the jurisdiction in which the object is ultimately discovered. In effect, then, dispossessed owners would be well advised to be as diligent as possible in the search for their chattel in case the issue of their title falls to be decided according to foreign limitation rules that decide questions of extinction of title with reference to the owner's activity, such as the reasonable discoverability test prevalent in the United States, mentioned above. Where the law gives title to a bad faith purchaser, the effect on the dispossessed source State seems unduly harsh. Where the law requires good faith to start the clock running, buyers unaware of this requirement will not be encouraged to perform the requisite provenance checks to satisfy the law. Even when provenance checks *are* made by buyers, these often take the form of electronic searches on web databases such as the Art Loss Register which will rarely contain antiquities looted from the ground, as the victim source State will have no record of these objects to register. Without a publicised requirement of serious and relevant provenance checking, the current structure of these laws – unknown to most buyers and in any event often superficial in their current tests for good faith – therefore does little to dissuade the purchase of unprovenanced antiquities.

111 The English authority for the rule that the court will apply the *lex situs* to the transfer of property (i.e. the law of the place where the transfer occurs) except where public policy dictates otherwise is contained in *Winkworth v. Christie Manson & Woods Limited & anr.* [1981] Ch. 496 at 513.

For the small subset of antiquities buyers with the legal sophistication to know and exploit limitation periods, we might identify one reason a notable number of antiquities offered for sale are the 'property of a Swiss gentleman/lady', in addition to Switzerland's *laissez-faire* attitude to import and export documentation. Swiss law is relatively favourable to a good faith purchaser in terms of its laws on the limitation of actions. A good faith purchaser of a stolen article in Switzerland obtains an unchallengeable title to that article after the expiration of five years from the date of the theft under Article 934 I of the Swiss code, the Zivilgesetzbuch. The standard of diligence required of a good faith purchaser is quite high in Switzerland,[112] but if that standard is met the purchaser obtains a comparably high level of protection. If, within the five years when a challenge to the buyer's title can be made by the dispossessed owner, the buyer is required to return the article, he or she must be paid compensation by the claimant, by virtue of Article 934 II of the ZGB. This requirement for compensation is absent from most common law systems, notably for our purposes Australia, the United Kingdom and the USA. Purchasers in these States are therefore not offered the same protection as Swiss buyers; generally they will be required to return the object to its rightful owner and seek redress from the person who sold it to them.

Some defendants who have made purchases in Switzerland and then are subject to claims for restitution of the object in their home countries have tried to claim that Swiss law governed their good faith purchase of the object under the *lex situs* rule and they should therefore be paid compensation upon its return to the original owner, or alternatively that the Swiss limitation period, running as it does from the date of the theft rather than the date of the good faith purchase or any discoverability rule, should apply to their purchase and that the claim being made against them should be time barred. Such was the plea in the much-discussed US case of the Kanakaria mosaics; *Autocephalous Greek-Orthodox Church of Cyprus and the Republic of Cyprus v. Goldberg & Feldman Fine Arts Inc, and Peg Goldberg.*[113]

In 1988 Peg Goldberg, an Indiana art dealer, purchased four of the looted mosaics in the duty free area of Geneva airport for US$1,080,000 and took them back to the United States. Alerted by the J. Paul Getty Museum, to whom Goldberg offered them for sale, Cyprus filed a civil action in the Indiana courts for their return. Evidence emerged that the mosaics had been stolen between 1976 and 1979, and Goldberg argued that the Swiss limitation period had long expired and the claim should therefore be time-barred. The Federal District Court for the

112 See the Swiss case of *Insurer X v. A*, referred to in Lloyd Goldenberg 'New York State Law Initiative, Part II', (1999) No. 6. Spoils of War 12-16 at 15, available online at http://www.lostart.de/pdf org.php3?pdf name=texte%2Fforum%2Fsow6.pdf (version current at 1 March 2005).

113 717 F. Supp. 1374 (S.D. Ind. 1989), aff'd 917 F. 2d 278 (7th Cir. 1990).

Southern District of Indiana, in a decision upheld by the seventh Circuit Court of Appeals, held that Swiss law was not applicable. The law of Indiana was the governing law, as it was the law with which the parties to the case were most closely connected. None of the parties had any connections with Switzerland. The court found support for its decision in an analysis of the Swiss choice of law rules – for objects in transit, Swiss law applies not its own law but the law of the destination to the purchase of the object.

The outcome of the case seems fair, legally at least, but it is interesting to consider whether it might have been decided differently if the facts were not so stacked against Goldberg's central contentions: that Swiss law should govern the question of limitation and that she was a good faith purchaser. The link with Switzerland in this case was about as tenuous as could be imagined – the mosaics were in Switzerland for only four days before they were removed to the United States, and it appears that they did not leave the compound of the airport. Had Peg Goldberg been able to argue a presence in Switzerland through a place of business there, however small, or perhaps shown evidence of a partnership or other looser business arrangement with a Swiss dealer to whom the antiquities had been passed for temporary storage, the outcome of the jurisdictional decision might have been different. Even had Swiss law been held to govern the question of limitation, it is clear that Goldberg would still have fallen at the 'good faith' hurdle. As Gerstenblith summarises the position:

> the court concluded that the dealer did not act in good faith because she knew little about the people with whom she dealt; the little she knew indicated their questionable backgrounds; she completed the transaction with considerable haste; she possessed virtually no knowledge of Byzantine art; and she failed to consult with various governments involved and international agencies which track stolen art.[114]

Goldberg's is, therefore, something of an extreme case, and although Switzerland's limitations laws are not as relaxed in practice as they are often supposed to be, it would perhaps be a mistake to take what could be described as a textbook example of bad faith as an assurance that more routine and less sensational purchasers on the borderline of wilful blindness would be denied title.

Limitations law is the remit of lawyers rather than dealers and collectors in the art and antiquities markets. Whether Goldberg had any understanding of the Swiss laws on limitation prior to consulting her lawyers is unknown, but doubtful. Museums are more likely to be aware of limitation rules than private dealers or

114 Patty Gerstenblith 'Museums, the Market and Antiquities' (2000) *University of Chicago Cultural Property Workshop website* at http://culturalpolicy.uchicago.edu/workshop/gerstenblith.html (version current at 1 March 2005).

collectors, since they will (the larger ones at least) have legally-trained staff to advise on this. The promulgation of limitations laws throughout market States which encourage due diligence in provenance and/or provenience checking as a component of good faith exercised by the purchaser of an antiquity would, if these laws were made more generally publicly known, encourage market participants to investigate the origin of their purchase.

Currently, however, laws such as those of many Australian States and Territories which limit the right of recovery of a plaintiff source State after a short number of years irrespective of the bad faith of a purchaser, do little to combat the illicit market in antiquities. In the case of the looting of cultural heritage, limitations laws advise museums, dealers and collectors to question not the origin of the objects they buy but rather prior periods of temporary possession by other members of the trade; information often passed on by way of very general verbal assurances or at best signed warranties, but usually unsupported by documentary proof. This state of legal affairs facilitates the insertion of illicit antiquities into the market by granting buyers good title to acquired property after relatively short periods of time and with little (or sometimes nothing) in the way of due diligence performed. In the case of the due diligence required of museums, the standard required of them to ensure the acquisition of good title under limitations law is substantially less stringent than the requirement of ICOM's Code of Ethics, mentioned above, that they verify the full history of an object from discovery before acquisition is considered. This supports an assertion that the law of limitations, a general law which applies across most categories of property, in our specific case lags behind current ethical standards in the movement to protect sites against looting.

3.3.1.3 Cost

Some writers ask whether civil litigation is the best tool for resolving disputes over the ownership of works of art. For example, Norman Palmer has suggested the forensic difficulties and complex questions of fact and law which lead to massively expensive litigation make it tempting "to ask whether anyone, other than a State, a State-supported party, an oil company, or a private individual of enormous wealth, could seriously contemplate litigation" for the return of stolen art across international borders.[115]

Presently the claimant in an action for the recovery of a looted or otherwise stolen antiquity, be they an individual or a nation State, must bear the initial costs of the civil court action. Given the often high value of reclaimed antiquities, such proceedings are likely to be commenced before the highest civil court in the land. There will be court fees for lodging the summons and fees charged by lawyers or other officers of the court for serving the summons on the defendant. Small administrative expenses will be encountered

115 N.E. Palmer, 'Recovering Stolen Art', (1994) *Current Legal Problems* 215.

throughout the course of the action, for the lodging of motions and other procedural documents, the fixing of diets of debate and the costs of the courtroom and a shorthand writer for the main hearing.

These incidental costs are, however, a mere fraction of the overall expense to a litigant of court proceedings. Lawyers specialising in international law and versed with a familiarity with art recovery cases must be employed to represent the claimant. These must be lawyers licensed to practise in the courts seized of jurisdiction in the matter; in most cases the courts of the State where the object is now located. The claimant or his representatives must engage in meetings with his lawyers, involving the expense of multiple trips to that jurisdiction, or else the costs of long-distance communication. The lawyers will of course charge for their time in considering the matter, attending at telephone calls, writing letters, drafting documents, lodging those documents, appearance in court (including time spent waiting to appear) and all other incidental expenses. Witnesses must be paid at a standard daily rate of expenses for each day they attend the hearing, whether they are called to appear or not. The hearing itself will likely involve complex issues of proof of ownership, examination of limitation periods, evidence of the circumstances surrounding the purchase of the antiquity, and perhaps expert testimony on the matters of international law involved (experts must of course be paid for their appearance too, and at a higher rate than lay witnesses). A complex hearing such as this may last for anywhere between three days and several weeks.

There are many such complex hearings to be resolved and a limited number of judges, so having a hearing date allocated takes time. It is not unusual for civil actions in higher courts to last for two to three years, from the date of raising of the action to its conclusion. Generally, throughout this time the lawyers will be engaged in some stage of process, be it drafting, negotiating with the opposition, or attending minor hearings to iron out debated issues of law so that when the hearing date finally arrives the facts themselves can be the focus.

Three years of civil litigation costs a magnificent sum. If the claimant is successful, he, she or it (in the case of a State government claimant) will receive a court order for the return of the antiquity, plus an award of costs. These costs, however, will not recompense the claimant for all of the above-mentioned expenses; typically they will receive somewhere in the region of one-half to two-thirds of their outlays. In a court action that has cost several hundred thousand pounds to finance, the deficit can amount to a considerable loss. There is always the chance that the claimant will not be successful. In that event an order of costs may be made against them, such that in addition to bearing the whole costs of their own side of the litigation, they will have to pay the defendant a sum equal to one-half to two-thirds of their outlay. It is a considerable risk to take.

For this reason, most actions are settled by negotiation between the parties before the matter reaches proof, where the preponderance of the legal costs are accumulated. Many litigants simply run out of money, or back down from their principled stances, horrified at the cost involved in obtaining justice. Concluded proofs are, in truth, the remit of only the richest or most bullish of litigants. Most others, however convinced they are of their having been wronged, will settle for a less than satisfactory outcome so as not to expose themselves to the huge financial penalties our system of civil litigation imposes even on the successful claimant.

3.3.2 Do 'Successful Outcomes' in Civil Litigation Translate into Better Protection of Sites?

The United States, particularly New York, is one of the world's biggest markets for antiquities. Under private international law a dispossessed State that wishes to sue for the return of its object which has travelled to New York must do so before the courts of New York. And in order for that claim to be satisfied, the New York court will require evidence in respect of all of the legal issues discussed above, and more. Protracted and expensive international litigation for the return of looted antiquities is unquestionably less impressive both in terms of the preservation of stratigraphic context and the promotion of an ethically healthy marketplace than measures which ensure that antiquities do not leave the ground, let alone the source country, in manners other than those authorised by its government.

Civil recovery proceeds broadly upon the principle of *restitutio in integrum*; that the wronged party should be put in the position that he, she or it was in before the wrong occurred. Often this is done by an award of financial damages, but in terms of the recovery of objects of special importance such as looted antiquities, this is interpreted by the courts of market States straightforwardly as the return of the object(s) in question, together perhaps with an award of costs to cover some of the expense of the claimant's having to litigate. Once we take into account the archaeologists' argument regarding the destruction of context inherent in the act of looting, we see that there is no provision in the prescribed mechanism of civil recovery which might adequately compensate the claimant State for this element of its loss. Further, unless there is a demonstrable general deterrent effect to buyers in the market from their knowledge of successful cases of recovery by source nations, the procedure cannot provide satisfactory protection to either of the system points mentioned above, i.e. to context or to the market. Returns to source will ameliorate the destruction of context caused by looting only if they discourage prospective purchasers from buying illicit antiquities, thereby providing a disincentive to looters *before* the objects are taken from the ground. The interview data suggest that currently market buyers feel no such deterrence.

3.4 IN CONCLUSION: WHAT LEVEL OF PROTECTION DOES THE LAW AFFORD THAI ANTIQUITIES?

Thailand is a signatory to neither the UNESCO Convention of 1970 or the Unidroit Convention of 1995. It cannot therefore claim as of right any of the protection for its antiquities recommended by those documents. Consequently, it does not have a bilateral agreement with the US for import restrictions to be imposed on its illicitly-exported antiquities. Perhaps Thailand's decision not to become party to the Conventions is driven by a desire to protect its position as a transit point for the worldwide export of antiquities from Southeast Asia. As strong a reason for not signing up, however, might be the lower levels of protection afforded by the Conventions to artefacts that do not form part of an inventory, and their requirements that compensation be paid to innocent purchasers required to return illicit antiquities. Without the finance to conduct significantly higher levels of archaeological excavation and inventorying than is currently possible, and to reimburse buyers from whom antiquities are claimed, becoming party to the Conventions would do little for Thailand beyond heightening awareness of the looting and illicit export of its antiquities among the customs officers of market signatories such as the United States and the United Kingdom. This in itself would be worthwhile, given the testimony provided in this chapter of both HM Customs in the United Kingdom and the interviewees in the market that the chances of an illicit antiquity being intercepted on its route into the market country are currently perceived as slim.

At the level of domestic law, we can observe that the US NSPA is of no help if the country of origin of an illicit antiquity and the fact of its recent theft cannot be proven to the criminal standard. This is the same problem as was listed above[116] for civil suits, only it is amplified here owing to the higher standard of proof required by the criminal law. Most Khmer objects surfacing on western markets, for example, could have come from one of several countries in southeast Asia, and an unidentifiable proportion will have been freely circulating for years without having been documented anywhere.

Finally, the new criminal offence in England and Wales is phrased in a way that immediately rules out its application to most of the routine illicit purchases in the market. Requiring a buyer to have knowledge or belief of an object's illicit status may seem appropriate, given the standard requirement of a combination of *mens rea* and *actus reus* in the commission of a criminal offence, but in this particular market it results in no liability for most buyers who, like the interview sample, occupy a middle ground short of *scienter*. That is to say, while they may have no knowledge or belief that an object offered for sale is illicit, neither do they usually have knowledge or reasonable grounds for belief that it is licit.

116 In section 3.3.1.1.

An appropriate summary of the regulatory approach presently taken in the antiquities market might be that too many cooks spoil the broth. The size and complexity of this chapter, which has attempted simply to categorise and briefly explore the major aspects of the controls in the market, is testament to the complexity of the web of control created. There is, however, a lack of density to this web. Consisting as it does of different strands of control, it creates gaps between the strands which can be exploited by those who wish the market in illicit antiquities to continue. What is required is a single, unified, research-based approach to the regulation of the market which draws together the strands of the web of regulation to create a more solid structure that is more amenable to detecting and processing the illicit movement of antiquities.

While large in number, the current strands of the regulatory web each have individual failings. We have seen that the international Conventions rely on implementing legislation by signatories, and so are effectively open to manipulation in their ambit by the countries which choose to apply them. The United Kingdom, for example, has moved under the umbrella of the UNESCO Convention without any significant alteration to its law, other than the new criminal offence which appears on its face to be problematic. The United States has taken multiple approaches to the issue of illicit antiquities, but in the absence of a bilateral agreement under its CPIA, or a criminal prosecution under the NSPA, a source country must fall back on conventional civil litigation in order to combat the illicit trade of its artefacts.

The gaps in the web of control are apparent in the failings of each mechanism, each strand, examined in this chapter – from the discovery of the antiquity at source to its purchase in the market. Prohibitions on excavation are seen as irrelevant by finders, and the threat of punishment is minimised by corruption and apathy among enforcement officials. Export prohibitions and licensing requirements exist widely, but remain just as widely ignored by local exporters and unenforced by importing nations. Civil litigation for the return of stolen property is a general tool, not refined to suit the individual facets of the international trade in illicit antiquities. The gaps in this part of the web are therefore routinely exploited by traders in market countries who, as the data have shown, wilfully destroy and otherwise obscure provenance information in order to reduce the chances that a source State might prove the object to have been looted and illegally exported from their territory.

We therefore need to move away from a reliance on general legal mechanisms which combine to create a web full of holes. What is required here is a system of regulation that is straightforward, cohesive, and targeted to the control of this particular illicit market. To that end, it would seem productive to conduct an examination of the systems of control governing other illicit markets. This forms the subject of the next chapter.

CHAPTER 4

THE PLACE OF PROHIBITION IN MARKET GOVERNANCE -
TWO COMPARATIVE ILLICIT MARKETS

The ramifications of acknowledging that the movement of looted antiquities from source to consumer is best analysed as a market system are set out in the more important of the recent additions to the literature on the looting problem.[1] These include:

- the pull effect that the supply and demand dynamic exerts on antiquities, moving them from source to market nations;
- the ineffectiveness in the face of such market forces of source country laws which attempt to prohibit the outflow of antiquities;
- the smuggling networks which must evolve or adapt to handle the large-scale traffic of illicit antiquities from point of supply to point of demand;
- the political and other official corruption which must accompany such trafficking networks in order to ensure their survival; and
- the place of transit ports as functional in allowing illicitly-excavated and exported antiquities to assume the appearance of legitimacy and therefore to be openly traded in the consumer markets which are their destination.

The importance of this new approach to the problem should not be underestimated. It takes its point of departure in the quite reasonable proposition that where the antiquities market parallels other illicit markets (and note this is not in all respects) we might do well to study the regulatory interventions made into those other markets, and the large amount of literature evaluating those interventions, in order better to consider what strategy might work to best regulate the antiquities market. Strategies of prohibitive legislation similar to those developed and developing in the antiquities market have been tried and tested elsewhere, along with other less formal and more inventive attempts at intervention. For the most part, they have failed to achieve their goals and we need to ask both (a) why? and (b) what does this failure tell us about the way forward in

1 Notably J.D. Murphy, *Plunder and Preservation: Cultural Property Law and Practice in the People's Republic of China* (1995, Hong Kong, Oxford University Press); C. Alder, & K. Polk, 'Stopping this Awful Business: the Illicit Traffic in Antiquities Examined as a Criminal Market', (2002) VII *Art Antiquity and Law* 35.

our own project? The parallel markets we shall study here are the illicit international markets in wildlife and drugs.

4.1 The Illicit International Movement of Controlled Wildlife

Ranking third to gun and drug running, the trade in illicit wildlife has been valued by the World Wildlife Fund at US$20 billion annually, with some animals being worth more, ounce for ounce, than cocaine.[2] By way of comparison, the global *licit* art market was valued at US$20.56 billion in 1999, with the worldwide trade in classical antiquities forming an estimated £58.7 million of that figure.[3]

Similar themes to those which are problematic in the control of illicit antiquities emerge here. Brazil's National Network against the Trafficking of Wild Animals (RENCTAS) reports that around 38 million wild animals are stolen from its forests every year, and cites widespread poverty, lack of education and the temptation of high profits despite often great risk as primary reasons for Brazilians entering the animal trafficking industry.[4] These impoverished locals provide the items for a market which transports them to the source of consumer demand. The biggest buyers include the United States and the richer Member States of the European Union. All of this sounds familiar to a student of the antiquities market. RENCTAS also estimates that only 0.45% of animals smuggled out of the country are successfully intercepted by Brazilian police.

One of the main reasons for regulating wildlife transactions is to ensure that the international trade does not endanger the survival of certain protected species of animal in the wild. This purpose is a close parallel to the driving force behind the call for effective control of the market in illicit antiquities; to protect the source, and the context, of the commodities.

The constraints of space militate against as thorough an examination of wildlife laws as was undertaken in relation to antiquities laws in Chapter 3. Australia, one among many market countries for illicit wildlife, is recognised as a world leader in terms of its laws addressing this trade. We shall therefore take the example here of the smuggling of a protected animal from Thailand to Australia, and examine the structure of the relevant laws governing its movement.

4.1.1 Thai Export Controls on Restricted Wildlife

Thailand has over the last fifteen or so years been the focus for much international attention owing to its lax wildlife laws. It has

2 A.M. Roberts, 'The Trade in Drugs and Wildlife', (1996) 16(5) *Animals' Agenda* pp. 34-5.

3 N.E. Palmer, P. Addyman, R. Anderson, A. Browne, A. Somers Cocks, M. Davies, J. Ede, J. Van der Lande, & C. Renfrew, (2000) 'Ministerial Advisory Panel on Illicit Trade', (December 2000 London, UK Home Office Department for Culture, Media and Sport) at pp. 40-41.

4 BBC 'Wildlife Smuggling Rises in Brazil' *BBC Online World News Service website* at http://news.bbc.co.uk/hi/english/world/americas/newsid_1653000/1653034.stm 13 November 2001 (version current at 1 March 2005).

been a Party to the Convention on International Trade in Endangered Species ('CITES') since ratification in 1983, but its lack of co-operation with the implementation requirements of CITES led the Secretariat in 1991 to recommend a ban on its members' trade with Thailand in any specimens of species included in the CITES Appendices. Thailand responded to this ban by passing legislation in the form of the Wild Animals Preservation and Protection Act 1992, B.E. 2535, ('the 1992 Act') and the recommended ban was lifted in 1992. Article 100 of the 1992 Act prohibits trade in wildlife unless that wildlife is the product of captive breeding operations. The Ministry of Agriculture and Co-operatives is charged with enforcing the Acts and in the case of export violations can issue fines of up to 40,000 baht (US$1,000) and/or imprisonment of up to four years.

Prior to 1992, the only piece of legislation to govern Thailand's wildlife trade had been the Wild Animals Preservation and Protection Act 1960, amended in 1972, a loose and easily-circumvented statute which contributed in part to Thailand becoming the centre of the illegal wildlife trade in Indochina. Even after the enactment of tighter legislation in 1992, commentators continue to view Thailand as a conduit for illicit trade. A recent study of Thailand's place in the illegal tiger trade uses official CITES data to conclude that as well as 58 shipments of tiger parts being intercepted between 1977 and 1997 after export from Thailand en route to Europe, Australia, New Zealand and the Philippines, some tiger-based derivatives in fact originate in China and travel to Thailand before export to their destination markets.[5]

Any CITES-listed wild animal or wild-animal product to be taken out of Thailand must be licensed or certified by the Wildlife Conservation Division of the Royal Forestry Department, a subsidiary of the Ministry of Agriculture. The 1992 Act also imposes an export ban on certain species of wildlife that it deems to be rare and protected. However, the Royal Forestry Department contends that it has too few staff adequately to carry out its responsibilities.[6] Despite the controls introduced by the 1992 Act, the illegal trade continues in many parts of the country, one of its most visible faces being the weekend Chatuchak market in Bangkok where restricted species, live, in parts and often in the form of medicines, are openly sold.[7] One of the core interviewees, Bangkok Archaeologist 2, noted during the course of the interview that Thai antiquities were also sold at the Chatuchak market, often purchased by international buyers and taken overseas.

Acknowledging that the Royal Forestry Department has been fighting a losing battle in trying to suppress the illegal trade in wildlife, the

5 D. Banks, & F. Doherty, 'Thailand's Tiger Economy' *Environmental Investigation Agency website* at http://www.eia-international.org/Campaigns/Tigers/Reports/thailand/thai00.html 2001 (version current at 17 April 2002).

6 D. Swartzentruber, 'Wildlife at Weekend Market' *Bangkok Post*, 5 February 2002.

7 *Ibid.*

Thaksin administration has decided to offer an amnesty to operators of wildlife-smuggling businesses and those who have protected endangered species in their possession. Under the amnesty, those who illegally possess wild animals will not be prosecuted provided they come forward and register the restricted animals in their possession and pay a token registration fee ranging from 20 to 2,000 baht (US$0.50 to $50) per animal. The Ministry of Agriculture sees this as an opportunity for wildlife traders to make a new start and move their businesses away from illegal trading and into legally approved practices of commercial breeding.[8]

Whether the amnesty will achieve the intended results remains to be seen. A similar amnesty was implemented with the coming into force of the 1992 Act and seems unfortunately to have been less than successful. Commentators complain that in 1992 government officials did not check the numbers of animals held by traders in the run-up to the implementation of the amnesty programme, which left the less scrupulous traders free to intensify their hunting in that period in the knowledge that their illegal captures and kills would soon be legitimated.[9] The main difficulty with this proposed panacea is, however, economic. Commercially-bred animals must be sold at a price which illegal hunters and traders can easily undercut. As long as buyers remain willing to purchase illicitly-obtained goods then, amnesty or no amnesty, it seems likely that the illegal trade will continue, particularly when the likelihood of prosecution remains low. Rational choice theory, with its 'criminal calculation' based on likely profit weighed against projected estimation of the chances of apprehension[10] tells us that much. In a country where officials are open to bribery in lieu of prosecution, poverty levels are high in many regions, and nature produces goods which are amenable to trade for profit, an amnesty might work, but only in combination with other initiatives.

4.1.2 Australian Import Controls on Restricted Wildlife

In order to meet its obligations as a signatory to CITES, Australia enacted the Wildlife Protection (Regulation of Exports and Imports) Act 1982 (Cwlth). On 29th June 2001, this legislation was integrated within the Environment Protection and Biodiversity Conservation Act 1999 ('the 1999 Act') by the Environment Protection and Biodiversity Conservation Amendment (Wildlife Protection) Act 2001 ('the 2001 Act'), resulting in a piece of legislation hailed by Traffic

8 The Nation, 'Thaksin and the Call of the Wild' Editorial from *The Nation* 16 November 2001, available at The Wild Animal Rescue Foundation of Thailand website at http://www.war-thai.org/editorial.htm (version current at 18 April 2002).

9 *Ibid.*

10 R.V. Clarke & D.B. Cornish, 'Modelling Offenders' Decisions: a Framework for Research and Policy', in M. Tonry & N. Morris (eds) *Crime and Justice: an Annual Review of Research*, Vol. 6. (1985, Chicago, University of Chicago Press); D.B. Cornish & R.V. Clarke, (eds) *The Reasoning Criminal: Rational Choice Perspectives on Offending* (1986, New York, Springer-Verlag).

Oceania, WWF Australia and Humane Society International as a new benchmark, and which not only implements Australia's international obligations under CITES but now goes several steps further.[11]

Under CITES, a system of species classification is implemented. Australia's system of wildlife control is thus based on a licensing model, providing for a range of licensing categories corresponding with a classification of species, from those which are viewed as requiring the lowest level of protection to some species which are prohibited from possession under any type of licence. Through this mechanism, all agents and transactions are monitored and traced. Failure to comply with licensing requirements constitutes an offence, punishable by fines and/or imprisonment.

In order to import wildlife into a signatory country, a permit or certificate from the country of export must be issued and presented on import. The Australian Customs Service has principal responsibility for the enforcement of the legislation at the border, and such prosecutions of illegality under the legislation as take place are conducted by the Australian Nature Conservation Agency.[12]

In addition to the Commonwealth legislation, each State and Territory has implemented its own legislation, peculiar to its own jurisdiction. Some factors, however, are common to all such jurisdictions:

- Licence holders are required to keep and maintain up to date records of all transactions and changes in stock;
- All licence holders submit regular returns to the regulatory authority;
- Strong penalties apply to failure to comply with record-keeping requirements and submission of returns;
- Strong penalties apply to the provision of false or misleading information in license applications, documentation, or in response to queries by authorised officers;
- Strong penalties apply to unauthorised taking from the wild.[13]

It is the new Commonwealth legislation which sets the pace for the control of dealing in wildlife in Australia, however, and it is on the principles of this which I will focus rather than describing at length the idiosyncrasies of individual State and Territory legislation.

Schedule 1, Part 1, section 11 of the 2001 Act inserts a new Part 13A after Part 13 of the 1999 Act. This new Part 13A "sets up a system for regulating the international movement of wildlife specimens". Unless otherwise stated, the following section numbers refer to the new sections inserted into the 1999 Act by section 11 of the 2001 Act.

11 'New Australian Wildlife Bill Sets World's Best Practice Standards' TRAFFIC website at http://www.traffic.org/news/australia2.html (version current at 29 Nov 2001).

12 B. Halstead, Wildlife Legislation in Australia: Trafficking Provisions (1994, Canberra, Australian Institute of Criminology).

13 Ibid.

CITES classifies protected wildlife species into three categories, listed in its Appendices I, II and III ('CITES specimens'). The 2001 Act makes it an offence to export or import a CITES specimen unless the exporter or importer holds a permit, or an exemption applies. A permit can be issued on application to the Minister under section 303CG. Under section 303CG(3) and section 303CH, an import permit will only be granted by the Minister in the case of the two least-protected categories of CITES specimen (II and III) if, *inter alia*, the source country has a relevant CITES authority and permission to export the specimen from that country has been given by a relevant CITES authority of that country. We therefore see that for a CITES II or III specimen, legal import into Australia is dependent on the consent of the controlling body in the source country. For the most protected species, CITES I, there are even more stringent requirements, which do not need to be detailed here. Interestingly, section 303FB(c) provides for the possibility of a permit being issued where the import of the animal is for the purposes of exhibition.

It is also an offence to import other 'regulated live specimens' (i.e. regulated otherwise than by CITES) unless the importer holds a suitable permit; section 303EK. A register is to be kept of applications for all classes of permits, and decisions made thereon, in terms of section 303CK. It is to be published on the Internet.

Possession of a specimen which was imported in contravention of these rules is an offence under section 303GN, attracting a penalty of five years imprisonment or 1,000 penalty units, or both. Provisions are also made for the regulation of the movement of native Australian species, but with our concern being Thai animals imported into Australia, these provisions will not be examined.

The penalties for illegal import of restricted specimens are considerable. Under section 303CD(1), the importer of a CITES specimen without a permit faces imprisonment for ten years or a fine of 1,000 penalty units, or both. Under section 303EK(1) the penalties for import of other regulated live specimens without a permit are the same.

Authorised officers (notably, for our purposes, customs and police officers) are given quite invasive powers where they have reasonable grounds to suspect that an animal is being, or has been, illegally imported. The following powers are given to them by sections 26-28 of the 2001 Act, which insert them into the 1999 Act:

- To ask questions, which must be answered on pain of a penalty on conviction of a fine of up to ten penalty units (section 443A);
- Powers of seizure (section 444A); and
- Automatic forfeiture of the specimen after the expiry of a designated period post-seizure if matters do not proceed to the stage either of a prosecution or a claim by the owner for return of the specimen (section 444H).

After the incorporation of its new provisions into the 1999 Act, in its Schedule 2 the 2001 Act repeals the Wildlife Protection (Regulation of Exports and Imports) Act 1982, thus clearing away the old statute and leaving the 1999 Act, newly amended, as the governing piece of legislation.

4.1.3 How Well do the Controls Work?

While Thailand is struggling to control the export of its wildlife, as it is its antiquities, for anyone interested in designing regulation to govern the antiquities market via control at the demand end, the Australian legislation is of great comparative interest both in its system of local licensing of possession of wildlife and its border controls which link the granting of an import licence with the holding of a permit by the importer and the sight of an appropriate export certificate from the source State. These surveillance mechanisms, coupled with the giving of authority to a non-police domestic Australian organisation to pursue criminal prosecutions under the 2001 Act, are control factors missing from the antiquities trade. It is too early to tell whether Australia's enhanced system of control will be as effective as is hoped, but its mixture of recording and reporting requirements coupled with deterrent criminal penalties and the threat of licence revocation in the case of breach, seem sensible ingredients for a successful regulatory mix.

4.2 THE ILLICIT INTERNATIONAL MOVEMENT OF CONTROLLED DRUGS

Again, we must restrict ourselves here to a single example of the movement of a controlled drug from source to market. This is not as restrictive as it sounds, since in fact the structure of drug prohibition is similar across many market nations. Any of the three market nations in our study would be appropriate examples to analyse here. I wish, however, to avoid a focus on Australia which might lead the examples in this chapter to be seen as idiosyncratic or parochial. We shall therefore take as our case study here the export of heroin from Bangkok, Thailand and its import into London, UK.

4.2.1 Thai Export Controls on Restricted Drugs

The Royal Decree on Narcotics 1979 ('the 1979 Act') deals with the import, export and possession of controlled narcotics, imposing restrictions on those acts which vary with the categorisation of the drug. The most heavily controlled are Type 1 and 2 narcotics, the import, export and possession of which are the subject of general prohibition in Thailand. Heroin is classified as a Type 1 drug for the purposes of the 1979 Act and export of heroin from Thailand is therefore prohibited in terms of that piece of legislation.

Penalties for breach of these prohibitions are harsh. Conviction for export of a Type 1 drug such as heroin merits life imprisonment

under section 65(1) of the 1979 Act. If the offence is committed for the purpose of dealing, then the death penalty applies under section 65(2). The intent to deal is implied in respect of the export of pure substances of 20 grams or more, by virtue of section 15(2).

4.2.2 UK Import Controls on Restricted Drugs

Import of controlled drugs into the UK is regulated by two main statutes, the Misuse of Drugs Act 1971 ('MDA') and the Customs and Excise Management Act 1979 ('CEMA'). The former defines a series of offences, including unlawful supply, intent to supply, import or export (all these are collectively known as 'trafficking' offences), and unlawful production. It also prohibits unlawful possession. To enforce this law the police have the special powers to stop, detain and search people on 'reasonable suspicion' that they are in possession of a controlled drug. Trafficking and production (the supply offences) have stronger maximum penalties than possession.

Drugs are categorised according to how harmful they are thought to be. Class A contains such substances as heroin, cocaine, LSD and ecstasy. Maximum penalties on indictment are seven years' imprisonment and/or an unlimited fine for possession; life imprisonment and/or a fine for production or trafficking. The Crime (Sentences) Act 1997 created for England a minimum seven-year custodial sentence for a third Class A drug trafficking offence. In respect of Class B drugs such as cannabis, the maximum penalties for possession are lower (five years and/or a fine) than for Class A, as are the penalties for trafficking (fourteen years and/or a fine). Class C (less potent stimulants and tranquillisers) has the lowest penalties – two years and/or a fine for possession; five years and/or a fine for trafficking.

Although an analysis of drug-sentencing statistics reveals that these maximum penalties are rarely resorted to in the reality of sentencing drug offenders, that is because the majority of drug convictions are not in respect of cross-border trafficking, but possession. Nearly all drug offences are 'triable either way' in England and Wales, which means that they can be tried either before magistrates or a jury in the Crown Court. In practice, this means that less serious offences are usually dealt with by magistrates' courts, where sentences cannot exceed six months and/or a £5,000 fine, or three months and/or a fine for less serious offences. Eighty five per cent of all drug offenders are convicted of unlawful possession. Nearly three quarters of fines are £50 or less. When the offence in question is the smuggling of drugs through the UK customs barrier, however, an English case will almost certainly be heard before the Crown Court where there is no financial limit on the fines which may be imposed, apart from the ability of the offender to pay.

The maximum penalties under CEMA are the same as for other trafficking offences, except that fines in magistrates' courts can

reach three times the value of the drugs seized. The offences under this Act are detected and prosecuted by Her Majesty's Customs and Excise, as opposed to the anti-drug smuggling measures in the MDA which are used by the police. The vast majority of drug smuggling offences are prosecuted under CEMA, which contains very wide provisions designed to impact upon all participants in the chain of supply. Ship crews and vehicle drivers who transport drugs into the United Kingdom as well as shipping packers and handlers are targeted, along with those who store the drugs and of course the organisers of the operation.

The Drug Trafficking Act 1994, a statute which consolidated the Drug Trafficking Offences Act 1986 and several other pieces of legislation under the one Act, also contains punitive provisions in respect of breach of UK import controls. It allows for the seizure of assets and income that cannot be shown not to have come from the proceeds of drug trafficking, by means of a confiscation order. 'Drug trafficking offences' under section 1 of the Act include drug smuggling and possessing or knowingly carrying or concealing controlled drugs on ships. The Proceeds of Crime Act 2002 amalgamates and strengthens existing criminal asset recovery powers in one Act, as well as introducing a civil recovery scheme applicable to all crimes, not just drug offences. Asset confiscation is, under the Proceeds of Crime Act, to be the task of the Assets Recovery Agency (ARA), a body of financial investigators with power given to the Director to sue in the Crown Court to remove offenders' wealth accumulated through criminal activity.[14] New asset-tracing powers are given to investigators, including the power to require banks or other financial institutions to provide transaction details of specified accounts, power to require banks to identify any accounts held by a person under investigation and to restrain property at the beginning of a criminal investigation to avoid the dissipation of assets – a step which previously could only be taken by a prosecutor when a charge had been brought or was about to be brought. Other powers given to ARA investigators include the power to compel a person to answer questions, provide information and produce documents.

The United Kingdom Government set as its manifesto target the doubling of receipts from criminal asset seizures from £30m in 1999/2000 to £60m in 2004/2005.[15] The most recent figures published on the Home Office website[16] are for the year 2002/2003, when it is stated that recovered funds amounted to £40m.

14 Proceeds of Crime Act 2002, section 6.
15 Home Office (2001) "Tough New Powers to Search and Seize Criminal Cash Announced" UK Home Office website at http://www.homeoffice.gov.uk/proceeds/press/press.htm (version current at 9 April 2002).
16 http://www.homeoffice.gov.uk/crimpol/oic/proceeds/crimassets.html (version current at 1 March 2005).

4.2.3 How Well do the Controls Work?

In 1999 there were 6,571 seizures of heroin in Thailand, amounting to 419.93 kg. Additionally in that year, there were 39 seizures of heroin destined for foreign markets, amounting to 186.60 kg.[17] In the same year, the United Kingdom seized 38 kg.[18] What does this mean? To measure the success of enforcement in any one year we need to know what proportion of the total amount of heroin smuggled was seized. The production, traffic and consumption of heroin being illicit, this kind of information is not as reliable or accurate as we might wish, but official estimates of production and consumption of illicit drugs are available and from these we can infer increases or decreases in global trafficking. What we can say is this. While statistics on heroin use and smuggling do experience peaks and troughs depending on various factors, enforcement activity in any given year is only one among many causes of these variations. For example, globally, heroin seizures increased by 44% in 2000, which reflected the flooding of the market by the bumper crop harvested in Afghanistan in 1999.[19] It is estimated that this equates to the seizure of 21% of all heroin produced in 2000 (up from 15% the year before), although that figure will be seen to be very rough in light of the fact that much of Afghanistan's 1999 production would still be reaching the market in 2000.[20] By contrast, in July 2000 the Taliban authorities banned the cultivation of opium poppy throughout Afghanistan, and this ban was widely complied with. The result was that in the 2001 season cultivation of opium poppy there dropped by 91%.[21] Figures detailing how this drop in global heroin production affects seizure statistics have yet to be released at the time of writing, but we might reasonably imagine that the number of seizures will fall.

While it does seem from figures available that police and customs crackdowns achieve spectacular intermittent success,[22] when evaluating current international drug trafficking initiatives we must acknowledge that it is not possible to sustain these special levels of attention to drug movement in the long run. Over time, it does not seem that prohibitive laws governing import, export and possession have significantly reduced the amount of drugs being smuggled. Over the decade 1990-2000, global heroin seizures rose at approximately 8% per annum. Throughout that decade fluctuations in projected global heroin production have been more marked, sometimes rising or falling as much as 30% in a year, but

17 'Statistics' *Office of the Narcotics Control Board of Thailand website* at http://www.oncb.go.th/e1-frame06.htm (version current at 10 April 2002).

18 United Nations Office for Drug Control and Crime Prevention *Global Illicit Drug Trends.* (2002, New York, United Nations) at p. 85.

19 *Ibid.*, at p. 75.

20 *Ibid.*, at p. 78.

21 *Ibid.*, at p. 45.

22 For example the heroin drought experienced by Australia in 2001 as the result of successful law enforcement operations, including the dismantling of a trafficking ring which had for many years moved heroin from southeast Asia to Sydney (*Ibid.*, at p. 239).

overall rising by approximately 25% throughout the whole decade.[23] It might be that prohibitions have operated to minimise the growth of an escalating problem that would expand in scale exponentially if the prohibitions were removed. Yet in terms of effectiveness at stopping the traffic, prohibition and its enforcement fail. Even with the large rise in heroin seizures in 2000 to the 21% figure mentioned above, 79% of all heroin produced in that year reached its destination unchecked. In 2000, in a continuing trend, more countries reported increases than declines in drug use.[24] Overall, then, while seizures of heroin (as with most drugs) are increasing globally, excluding the outlying year of 2001, so is global heroin production and drug use in most countries. Prohibition as an approach to the international market in illicit narcotics has been criticised widely and consistently, but it remains the central strategy of choice of the governments of major market nations in the face of this criticism and of an associated absence of ameliorating effect on the problem.[25]

In common with other international illicit markets, in the drugs market we see the facilitation of illicit transport by means of the corruption of officials, both bureaucratic, and those employed by enforcement agencies and the military.[26] Even without this corruption to facilitate the movement of illicit commodities across borders, the protection of borders against unwanted imports or unlawful exports is a massive task which seems destined only to achieve limited results. Lack of manpower dictates that not every metre of the border can be patrolled. Even at official ports of entry, there is not enough manpower to search more than a minimal proportion of the shipping crates that enter any given country:

> This DEA official noted... that most of the discoveries of drugs in containers were the result of informant tips, not high-tech surveillance. "Unless you have an informant providing definitive information that a shipment has cocaine in it," he stated, "it usually goes right through".[27]

Commercial expediency militates against the imposition of additional searches, even if the treasury could stretch to funding them:

23 *Ibid.*, at pp. 47, 49 and 76.
24 *Ibid.*, at p. 222.
25 The literature on this subject is enormous, but examples of various shades of criticism across the last decade can be found in S.B. MacDonald & B. Zagaris, *International Handbook on Drug Control.* (1992, Westport, CT, Greenwood); L. Tullis, *Handbook of Research on the Illicit Drug Traffic: Socioeconomic and Political Consequences* (1991, New York, Greenwood); L. Tullis, *Unintended Consequences: Illegal Drugs and Drug Policies in Nine Countries* (1995, Colorado, Lynne Rienner Publishers Ltd); R.F. Perl, *Drugs and Foreign Policy: a Critical Review* (1994, Boulder, CO, Westview Press); P.B. Stares, *Global Habit: the Drug Problem in a Borderless World* (1996, Virginia, Donnelly & Sons); N. Dorn, L. Oette & S. White, 'Drugs Importation and the Bifurcation of Risk: Capitalization, Cut Outs and Organized Crime', (1998) 38 *British Journal of Criminology* pp. 537-60; P.J. Green, *Drugs, Trafficking and Criminal Policy* (2000, Winchester, Waterside Press); J. Healey, (ed.) *Drugs and the Law* (2002, Rozelle, NSW, Spinney Press).
26 Tullis, 1991, *op. cit.* note 25, at p. 64.
27 J.B. Treaster, 'Bypassing Borders: More Drugs Flood Ports' *New York Times*, 29 April 1990, 1.

> ... if interdiction efforts along the border were significantly stepped up, there would be a massive disruption in the flow of trade... Customs officials estimate that even if they had the personnel, they could never search more than 10% of incoming containers without extensive disruption of trade through US ports.[28]

In the case of our hypothetical import into the United Kingdom of heroin from Thailand we can produce specific figures to support the assertion that border controls are an ineffective form of protection against the movement of illicit commodities. Of the heroin seizures made by UK enforcement agencies in 2001, 99% were made by the police and only 1% by HM Customs.[29] The lesson for the regulation of the antiquities market is clear: laws that empower an informed and dedicated local police force to search out illicit commodities within their jurisdiction, seize them and charge their possessors, are markedly more effective than laws which depend upon the interception of illicit commodities at the border by customs officials.

4.3 THREE PHASES OF INTERNATIONAL ILLICIT MARKETS

To say that the antiquities market is just that, i.e. a market, may seem trite. To say that it is a market *system*, perhaps less so. Luhmann developed a theory of social systems, wide ranging and controversial in scope.[30] Central to his thinking, and relatively free from contention when extracted from the complex web of his thoughts on autopoiesis and his theory more generally, was a view of social systems as isolated, singular domains constituted by communications. It is helpful to view the antiquities market as a single, bounded, social system. In this, we acknowledge that whereas this particular market – insofar as it involves the traffic of illicit material – might have many parallels with other market systems with illicit elements, there will be elements of the antiquities market system which are very much its own. Comparisons with the illicit markets in drugs and wildlife will therefore prove useful – many lessons can be learned from a study of these markets, not least that of the historical ineffectiveness of techniques of control based on prohibitive legislation both at supply and demand – but the idiosyncrasies of the antiquities market must remain in our thoughts as we indulge in such a cross-system analysis. The strongest interpretation of the data gathered at interview is that there are elements of the discourse of the antiquities market which

28 C.J. Johns, *Power, Ideology and the War on Drugs: Nothing Succeeds Like Failure* (1992, New York, Praeger) at p. 38.

29 J.M. Corkery, & J. Airs, 'Seizures of Drugs in the UK 2001', *Findings 202* (2003, London, Home Office Research, Development and Statistics Directorate) at p. 4.

30 N. Luhmann, *The Differentiation of Society* (1982, New York, Columbia University Press); 'Insistence on Systems Theory: Perspectives from Germany - An Essay'. (1983) 61 *Social Forces* pp. 987-98; *Social Systems*, tr. J. Bednarz Jr & D. Baeker. (1985, Stanford, Stanford University Press); *Ecological Communication*, tr. J. Bednarz Jr. (1989, Cambridge, Polity Press); *Essays on Self-Reference* (1990, New York, Columbia University Press).

are linked to thought constructions that give actors positive definitions of the purchase of illicit goods, and that this discourse is unique to the antiquities market. With this in mind we can consider the lessons available to us from such a comparative analysis of illicit markets. It will be useful to categorise the observations to follow in terms of three stages which appear common to all international illicit markets: supply, demand, and the transport of the illicit goods between the two.

4.3.1 Supply

Thai villagers who are implicated in the supply of illicit antiquities onto the market are, like their counterparts in other major source nations, generally very poor. Their levels of education are low and, partly for this reason, they see underground cultural heritage in very different terms than do archaeologists. It can provide them with an income:

> Professional looters come to the village and pay 200 baht (£3 sterling) per one-by-one metre square to the landowner in the northeast and up to 2000 baht (£30 sterling) in Lop Buri. Looters take what they want ... Villagers may dig in their own property and sell objects to dealers. A complete pot is worth 400 to 1,000 baht. Stone adzes, spindle whorls and clay pellets are ten to twenty baht per piece. Some villagers are dealers themselves.[31]

A Thai archaeologist in the core sample confirmed that looting is currently prolific in Thailand. Sometimes, she says, the looting follows a chance find, but on other occasions the looters use the archaeological survey of the Fine Arts Department as a basis on which prospectively to dig promising sites. The archaeological survey is in essence an overview of sites of interest throughout Thailand. Sites are surveyed prior to being dug by the archaeologists of the Fine Arts Department, and as there is not enough funding to support digging on all sites of interest, many of them remain surveyed but untouched until the looters begin their work:

> *In Lop Buri, once the news spread that we'd found artefacts, or people dig their yard and they found something and then the dealer went there right away and they rent the land or pay the land for digging by square metre, things like that. They get the stuff two ways. One way is they get the people to dig the stuff and then they buy it above the ground. Another way that they do is they rent the land to dig the graveyards. We see it a lot in central Thailand.*

31 R. Thosarat, 'The Destruction of the Cultural Heritage of Thailand and Cambodia', in N. Brodie, J. Doole & C. Renfrew (eds) *Trade in Illicit Antiquities: the Destruction of the World's Archaeological Heritage*. (2001, Cambridge, McDonald Institute for Archaeological Research), at p. 13.

[Where are the archaeologists in all of this? Do you dig a small part of it and then people hear about the thing?]

Most of the time we follow them. After it has been looted already. I think that a lot of case, this is by accident, where the villager found the stuff and the rumour spread and that thing happened. And this is done by the whole group of looters; they open an academic archaeological textbook or something like that, and they say "ah, this site is really interesting". And most of the time they have the location of the site exactly. If they have the GPS, they can go to this latitude and this longitude and "sure, we're going to find something". So that's another way. Our textbook or our technical report is the map for the looter (Bangkok Archaeologist 1).

Increasing the supply of legitimate antiquities onto the market has been offered by some commentators as a way to fight the black market in looted and illegally exported objects.[32] This relaxation of control at the supply end would satisfy the demand in the market for a time, they argue, and allow other initiatives the breathing space to set to work on the looting problem. Source countries are generally resistant to such suggestions, being unable, or unwilling, to see them as anything other than a legitimisation of the further loss of national cultural heritage:

[It's not unthinkable that things could be sold overseas and the money could come back to Thailand to be used by the Fine Arts Department to protect sites, maybe, or to do more work on them, to give to archaeologists?]

I don't think that this will happen under the Thai law, to sell stuff and bring the money back. Replica, to make a replica or the fake one of the masterpiece maybe is more likely to happen, in my opinion.

[Why do you think that the Thai government wouldn't be happy for things to be sold?]

In my opinion I think that we don't have much left. Most of it has been gone. So to really sell them out, we would not have anything left. The most beautiful ones are already out of the country. We teach the student how to do the excavation about the civilisation in the past in Thailand, but we excavate the stuff that is the really by-product of the looter. All the classic stuff like beautiful pot or something like that, right now is very few of these because we excavate only the broken one, or the human bone is scattered all over like this, we never get the whole skeleton.

32 J.H. Merryman, 'The Retention of Cultural Property', (1988) 21 *University of California Davis Law Review*, 477; 'A Licit International Trade in Cultural Objects' (originally published in (1995) 4 *International Journal of Cultural Property* 13), in J.H. Merryman (ed.) *Thinking About the Elgin Marbles: Critical Essays on Cultural Property, Art and Law.* (2000, London, Kluwer Law International).

[You just get what the looters have left behind?]

Yes, yes. So I think to us it's important to have it in our country. To have it outside, maybe we can have a permanent loan or something like that, why not? For the educational purpose and for the world to know about our culture, I think that it's fine to have the permanent loan, but to sell, we have very few left (Bangkok Archaeologist 1).

As with the illicit international markets in antiquities and wildlife, it is generally true to say that in the drugs market the consuming nations tend to be rich whereas the producing nations tend to be poor.[33] The corollary of this is that whereas the major western economies are in no real measure dependent on the drug trade for their stability, in many impoverished drug-producing nations the cultivation and sale of drug crops is a means to financial stability for the local farming population for which there is "hardly any other viable income replacement".[34] Producing other viable income replacements has been an aim of supply-reduction initiatives in drug cultivating countries, along with debt forgiveness and other forms of aid given to third world producer nations by the west, particularly the United States.[35] The point of these interventions is to try to alleviate the poverty under which source populations struggle, and provide those populations with realistic choices to pursue other income streams besides the cultivation of drug crops. The difficulty with proposing that this scheme of international support be transferred into the antiquities field in an attempt to reduce the 'production' of that illicit commodity, is one of incentive. The major damage caused by the international drug market is to the market State, in the form of damage to the health and social fabric of its society. This provides a motivation for the market State to give financial aid to source nations to fight the problem. The major damage caused by the international market in looted antiquities, however, is to the science of archaeology and to the source nation in the form of the loss of its heritage. In respect of both of these harms, the latter even more than the former, there is little to encourage a market nation to intervene with income-replacement strategies at source.

4.3.2 Transport

4.3.2.1 Antiquities smuggling – personal indulgence or commercial enterprise?

If we accept that antiquities are leaving Thailand and other source countries in breach of national export restrictions, we might then

33 L. Tullis, *Unintended Consequences: Illegal Drugs and Drug Policies in Nine Countries* (1995, Colorado, Lynne Rienner Publishers Ltd).

34 L. Tullis, *Handbook of Research on the Illicit Drug Traffic: Socioeconomic and Political Consequences* (1991, New York, Greenwood) at p. 59.

35 R.W. Lee III, *The White Labyrinth: Cocaine and Political Power* (1990, New Brunswick, Transaction); L. Tullis, *op. cit.* note 33.

further ask how this happens. Two possibilities present themselves. The first is that antiquities are smuggled on an individual, or small-hoard, basis by dealers who transport them abroad for sale on international markets, on what we might call a 'disorganised' basis, i.e. without much in the way of an underground support network to assist in the smuggling operation. A dealer in Bangkok describes his entry into the trade in such terms. He does not see his export and sale out of the country as smuggling, but that is precisely what it is, occurring as it does after the passing of Nepal's laws forbidding export of antiquities without a licence:[36]

> I got to Kathmandu in 1970, thinking I would just spend a short time there and while I was there, I had a little bit of money and I started finding – I mean I was trained as an electronic engineer, so this was a big leap – I started finding interesting looking things for sale mostly on street markets and stuff like that. And at some point in around 1971 I went back to England and I took some of these things to show [name omitted], and he gave me an idea of what he thought they might be worth in England, and the lights went on! And I went back again to Asia, better prepared and with some more money and started becoming an antique dealer.
>
> [Did you know anything about the objects?]
>
> Nothing at all. In the beginning, no. The first thing I bought was a fake. I learned hands-on. And then I had a shop in London (Bangkok Dealer 1).

The second possibility is that there are in fact criminal groups who operate on a more 'organised' basis illegally to export antiquities out of source countries to buyers abroad.

There is evidence for the existence of the second category of organised criminal groups. Italy provides a good example. Claims are made with reasonable regularity by the Carabinieri as to their breaking of so-called 'antiquities smuggling rings'. In 1997, four warehouses in Geneva belonging to an Italian businessman and containing 11,000 Italian antiquities were seized.[37] In Sicily in 1998, 10,000 antiquities estimated to be worth US$35-60 million were seized in the hands of another 'criminal organisation'[38] and the domestic press reported the arrest of the leaders of yet another antiquities smuggling gang based in Puglia and again possessing over 11,000 Italian antiquities, mostly Etruscan and Apulian.[39]

36 See section 13 of the Nepalese Ancient Monuments Preservation Act 1956 (2013) as amended 1964 and 1970, and the Notification of the Ministry of Education concerning the exportation and movement of historical, archaeological or artistic objects, 7 April 1969.

37 P. Watson, *Sotheby's: the Inside Story* (1997, London, Bloomsbury) at pp. 113 and 126.

38 E.H. Minchilli, 'Antiquities Gang Busted', *Art & Auction*, 15 February 1999, pp. 8-10.

39 'Va a segno l'operazione Athena, tre arresti' *Il Tempo*, 18 March 1999, p. 2.

How are such looted antiquities smuggled across borders? Giovanni Pastore, Comando Carabinieri for the Tutela Patrimonio Aristico in Rome summarises the findings of the Italian police as follows:

> Objects are usually transported in trucks with refrigerated compartments. As they contain perishable goods, these vehicles are only rarely checked... Ancient vases, especially if coming from places with a present-day production of ceramics which are similar to ancient models, can be exported stowed among hundreds of modern replicas in confined spaces where they are difficult to identify. Some objects are broken into small pieces so as to take up as little room as possible and are transported in personal luggage.[40]

This exposition covers only those methods discovered by the police. How many other (successful) methods are practised cannot be known. There is much evidence that organised criminal groups exist worldwide, and that among their competences is the movement of illicit goods across borders. Often, the same group will be involved in the movement of several categories of illicit commodity, among them antiquities.[41]

The interview data suggest that the first category of illicit movement of antiquities is more usual than the second. The movement of antiquities from source countries to market countries is seen as rather mundane by dealers, who in many cases simply go on buying trips to source countries or transit ports every year or two, fill up a container with their purchases, and ship it back home. The susceptibility of illicit antiquities to open sale in market countries allows such traditional methods of import, unlike the comparable market in illicit drugs. Heroin is not usually trafficked by Fed Ex, although this was the method of shipment recommended to me by an antiquity dealer I spoke to on Hollywood Road.

Constant, routine supply is a necessary limb of the market in illicit drugs. Habits must be formed among customers, and then fed. At the high end of the antiquities market, however, shops in London and New York often have very small amounts of stock, consisting of high-value items which are sold relatively infrequently. At this level, a few sales per year are enough to keep the dealer afloat, and therefore his need for a supply of antiquities is much less routine than that of a comparable drug dealer.

Regulatory moves which target the cross-border transit of illicit antiquities therefore have to combat both the disorganised international transport of objects by individuals and the organised

40 G. Pastore, 'The Looting of Archaeological Sites in Italy', in Brodie *et al.*, *op. cit.* note 31.
41 S. Mackenzie, 'Organised Crime & Common Transit Networks', *Trends & Issues in Crime and Criminal Justice No. 233.* (2002, Canberra, Australian Institute of Criminology).

transport of objects by criminal groups. Neither is easy to do, necessitating substantial funds dedicated to surveillance and manpower. Disorganised smuggling by individual dealers seems infrequent as compared to the constant channels of supply in other illicit markets, and therefore we can propose that border surveillance is not the most effective way to target that smuggling. In the case of organised criminal groups, the forging of more integrated control strategies in respect of the cross-border movement of drugs, arms, antiquities and other illicit commodities would seem sensible.

It would, however, seem much more profitable in terms of the control of the flow of illicit antiquities in both the disorganised and organised categories – economically and in terms of results – for both source and market States to pursue the development of systemic regulatory solutions which treat the market as a single entity and combine to target it with end-to-end initiatives affecting market gearing so as to remove the profit incentive for traffickers, be they individuals or groups. This book will recommend suitable initiatives to achieve this end.

4.3.2.2 International transport as a mechanism of legitimation

In markets where provenance is accorded a weight which it does not deserve and provenience is routinely ignored, the import of an antiquity from a port such as Hong Kong accords the object (let us assume here that it was looted from Thailand, or China for example) with a documented history which might be enough to persuade a buyer in London or New York that it was not recently looted. After all, it has come from one of the centres of the Asian art and antiquities trade. Hong Kong's soil is not rich in antiquities, and even if it were, is so small in area that it would be ludicrous to assume that any sizeable proportion even of just the Chinese antiquities sold in its arcades and auction houses originated there:

> *The things we've sold in the last couple of years, they've all come either from auction where I buy quite a lot – but a lot of the auction material comes straight from Hong Kong – or they come from old collections. Or I've bought them in Hong Kong. But the last time I was there was five years ago, so I really don't do that deal. But a lot of dealers go there several times a month. So they are dealing with looted stolen goods in a humungous scale, yes, and all the major dealers dealing in Chinese art are doing that quite legally. So we have a different case there. If you were doing the same thing with Egyptian stuff, you'd be in jail now and you'd have a million people hovering around you. So there's no fairness to this, but that's just how things are. And that will also change. It's like if you're dealing in Khmer, you can't import it into America; you can get prosecuted if you do.*[42] *It's just at the*

42 On 19 September 2003 the United States signed an agreement with Cambodia under the 1970 UNESCO Convention, restricting import of certain categories of Khmer archaeological material ranging in date from sixth to sixteenth century A.D.

> *moment in time that Chinese is accepted, even although we all know that it's not growing off the trees in Hong Kong but being dug up wherever in China, destroying a number of graves.* (London Dealer 6)

Almost all the antiquities sold in Hong Kong will have come from somewhere else, but buyers in New York and London do not feel that they should investigate this. The import requirements of New York and London share some of the blame here – an export certificate from Hong Kong will allow passage of an object into those cities. This export certificate will take the place of a valid certificate of export[43] from the source country, which of course will not exist for looted and illicitly exported antiquities:

> *[At the moment for western dealers (buying in Hong Kong) there's no system of seeing an export licence? There's nothing that ever comes with what's being sold?]*
>
> *You get export licence from Hong Kong, for example.*
>
> *[But if it was a Chinese piece the dealer would never give you an export certificate from China?]*
>
> *No.* (London Dealer 7)

In Hong Kong, I visited several antiquities shops on Hollywood Road. In one the dealer, a keen salesman, prompted me to ask him any questions I might have about an old-looking Chinese statue on display. I asked him whether there would be any problems getting it to the United Kingdom. He assured me that there would not be. He could send it there for me by Federal Express, in which case it would arrive within four days, or by shipping container, which would take longer but was charged at a flat rate and would therefore allow me to fill up the container without any increase in shipping costs. I asked him where it came from (China, as expected) and how he got it into Hong Kong from China. His reply was evasive but revealing: "There are people who know how to get things out."

Hong Kong has very liberal rules on import; whatever the obstacles to illicit export from the source country, getting a looted and illegally-exported antiquity into Hong Kong is not difficult:

> *As far as I'm aware, in antiquities, there is no requirement to show country of export in order to import into Hong Kong.*
>
> *[And then to export from Hong Kong you don't need anything?]*

43 It seems common for antiquities exported from Thailand to be misdescribed to Thai Customs and to receive an export manifest from Customs in terms of that misdescription: 'stone object' or 'wooden handicraft' for example. These official export documents will ease the passage of the antiquity in question into a market nation. They do not, however, amount to lawful export of the antiquity, which would require an export licence to be obtained from the Department of Fine Arts; an altogether different document to a Customs manifest.

> *No. There's no requirement as to export at all, although there
> are some countries that we import to that require an export
> declaration from Hong Kong, so in fact we now do always
> get an export declaration because pieces often go to the UK
> or America or wherever. So we provide that when we export
> things ourselves.* (Hong Kong Auction House 1)

The result of this movement through a transit port is the
transformation of objects illegally excavated in and exported from
their source country into *ex facie* legal and freely tradable goods:

> *There are pieces which are coming out today which are
> evading and avoiding laws which are in place to stop the
> looting of material. But you take China for example, which
> has 120 statutes on the books against the removal of
> antiquities, and there's floods of material. It comes through
> Hong Kong, where it can be legally exported from Hong Kong.
> It's smuggled from the mainland to Hong Kong, and then it's
> sanitised by being exported legally.* (New York Dealer 5)

It is important to clarify, however, that although *ex facie* legal (i.e.
having the appearance of being legal), the status of these objects in
reality is no different from if they had never passed through Hong
Kong, or another transit port. They do not lose their status as having
been taken illegally from their resting place in the source country
whether that be underground, as part of an architectural monument,
in a museum, or in private hands. According to the law of the source
country they are stolen, and they remain so despite their
international transport. Market countries may not enforce the export
restrictions of source countries, but they have in the past used
source laws to convict purchasers of looted antiquities under the
national domestic criminal legislation of the market country.
Hollinshead[44] and *McClain*[45] are examples of such convictions in
the United States, followed recently by *Schultz*.[46] What transit ports
such as Hong Kong do, however, is to allow objects to take on a
mask of legitimacy, which operates on two levels. Firstly, this
appearance of open purchase and proper export (evidenced by
documents provided by the transit port) decreases the chance of
any inquiry into the history of the object when it enters a western
market. Secondly, even if such an inquiry took place, the purchaser
in the west could argue that he was fooled by the mask in the same
way as anyone would be, and that therefore he should be excused
from the penal consequences of his illicit purchase, it being
unreasonable for a court to expect him to have known of the defect
in the object's title. These effects of transit through Hong Kong apply
equally to museums, which may find themselves able in terms of

44 495 F.2d 1154 (9th Cir. 1974).
45 545 F.2d 988 (5th Cir. 1977), 593 F.2d 658 (5th Cir. 1979), cert. denied, 444 U.S. 918
 (1979).
46 178 F. Supp. 2d 445 (S.D.N.Y. 2002), 333 F.2d 393 (2d Cir. 2003), 147 L.Ed 2d 891 (2004).

their internal constitutive rules to buy illicit antiquities simply because the export documentation from Hong Kong gives them the appearance of having legitimate provenance:

> *Chinese is a very interesting example because, of the source countries, it's the country that has exported the most gigantic number of objects. And we're talking probably millions: (a) because there was a huge amount of tombs that were never opened because of superstition; (b) because the Chinese were never interested in their, in the last 100-150 years they actually methodically destroyed most of their artistic heritage. Especially during the Cultural Revolution. So there's very little of it exists above ground, actually. So a lot of the market is in antiquities, because there's no furniture and very little porcelain left after all this cultural suicide that they've done for so many years. So there's been thousands and thousands of objects being exported to Hong Kong on a very organised basis. This happened because the army has lorries with which they can transport the objects. Money went into the politicians' pockets, into the Museum Director's pocket, into the archaeologist's pocket; anybody was getting a cut. The customs people, the military. And these things would all come to Hong Kong where they were sold with an invoice from Hong Kong. And every museum in the West would buy it, because they were all out of Hong Kong. And the Chinese were very happy about it, because they were all getting black money. If there was a group of people that didn't work with the establishment, they were shot in the public square. But that was just to make the world know that they were looking after the things. Now at the same time China is very pragmatic and they have the most organised archaeological structure in all these Eastern source countries. They look after their museums, they dig in many sites, and now that Hong Kong is part of China, what they do is they are now sending a lot through Beijing and through auction, and anything you buy at auction which hasn't got an asterisk can leave the country... At the same time there's still a very big so-called black market where things are brought through Hong Kong which is still a free market, free port, and things are sold through there. And legally, museums say "well, we've got export papers... we can buy." But it's all hypocrisy.*

> *[And that's still the case?]*

> *And this is still the case, oh absolutely. So the number of contradictions is gigantic.* (London Dealer 2)

Although the senior representative of the auction house interviewed in Hong Kong dismissed the idea that many, if any, looted artefacts passed through its sales, expressing confidence in the company's procedures and adherence to lawful standards of practice, there is reason to see his assurances as more in the nature of marketing

spin than honest evaluation. Auction houses in Hong Kong demonstrably do sell looted antiquities, although how many we cannot tell. An auction at Christie's Hong Kong Ltd on 28th October 2002 entitled 'Imperial Devotions: Buddhist Treasures for the Quianlong Court' was found when investigated by Chinese authorities to contain many lots looted from the Eight Outer Temples of the Forbidden City in Beijing. A spokeswoman for Christie's Hong Kong is reported to have called the incident 'an isolated case', and the collector who had consigned them to the auction house for sale said in his defence: "those people who sold me the antiques never said that these treasures were stolen. Instead they said that they had inherited them from their ancestors. I wouldn't have bought them if I knew they were of questionable origin." The subsequent investigation revealed that he had bought the items from an official at the Eight Outer Temples.[47]

Interestingly for this study, Bangkok shares these legitimating properties for stolen goods in transit. Even with Thailand's strict stance against the export of its antiquities, antiquities in transit are granted an exemption from its framework of prohibition under section 22 of the Act on Ancient Monuments, Antiques, Objects of Art and National Museums (1961), mentioned above. Thus antiquities which enter Bangkok having been looted from neighbouring source countries can leave freely under legal export papers which will then be produced in the market nation to assure a buyer that the object for sale is not illicit.

4.3.3 Demand

While demand for a commodity remains after the implementation of prohibitive legislation in a market State, a comparative analysis of the drugs and wildlife markets and the literature surrounding them shows that – in the absence of further supporting measures taken on a social steering level – the market will adapt in criminal ways to meet that demand. The criminalising of a commodity imposes artificial constraints on the market which suppliers must circumvent, with undesirable results for society:

> To undermine, circumvent and otherwise overcome the market barriers established by law enforcement, suppliers are... likely to resort to bribery and other corrupt practices. Because those in the supply chain have no legal recourse if 'contracts' are broken or their inventory is stolen, prohibition encourages the use of physical intimidation to deter such activity and violent sanctions to punish it.[48]

47 J. Pomfret, 'China Uncovers Looted Buddhas: Relics Sold by Christie's in October Hong Kong Auction' *Washington Post Foreign Service*, 28 May 2003, A11.

48 P.B. Stares, Global Habit: the Drug Problem in a Borderless World (1996, Virginia, Donnelly & Sons) at p. 48.

4.3.3.1 Do international market purchasers see their buying decisions as relevant to the continuing supply of illicit antiquities?

Or to turn the Elia/Renfrew war cry into a question for study, are collectors (and dealers and museums) the real looters?[49] The interview data present the strong indication that they certainly do not see themselves in these terms. Looting would continue whether I bought its excavated products or not, says the market:

> People in Iraq are going to do the way people in Iraq think is acceptable to them. If you want to modify their behaviour, you don't try to modify the American behaviour, you go there and you try to educate them, or you get the government's support in education processes. None of this are [sic] being done. (New York Dealer 6)

> [What about Lord Renfrew at the archaeological institute in Cambridge, who says that collectors are the real looters, because by providing a market for antiquities that have come out of the ground contrary to source country laws they are providing an economic impetus for people to go out and start digging around looking for things?]

> Yeah, well I know he says that. I mean it's rhetoric really, and to pin the responsibility on one particular group seems arbitrary, to my mind. Um, that's what I think about that. (London Dealer 3).

Is this belief truly held by the interviewees, or is it in itself simple rhetoric? Is their denial of the link between their operations and the production of the goods which supply those operations disingenuous? It must be. We have already seen in Chapter 2 that many of the more frank interviewees stated their willingness to buy most categories of looted antiquities, with the exception of fragments of registered monuments. This is evidence of a supply and demand relationship between buyers and looters, although those at the demand end often still seek to deny it. Here is one example of such a flat denial, followed by an explanation which shows that the dealer has interpreted 'looting' to mean theft from an architectural structure rather than from the ground. Theft from the ground must of course be included in any acceptable definition of looting since this is where the loss of contextual information is greatest for archaeologists. Such selective definitions of the problem, which are then used to support a denial of the supply and demand relationship,

49 It is interesting to note by way of background that Lord Renfrew was once on the receiving end of this style of accusation from Elia (C. Renfrew, 'Collectors are the Real Looters', (1993) 46(3) *Archaeology*, pp. 16-17; R.J. Elia, 'Ricardo Elia Responds', (1993) 46(3) *Archaeology*, p. 17). He is now an arch-critic of the market in unprovenanced antiquities. His strong opposition to the market was treated with disregard by many of the interviewees, the less diplomatic of whom suggested that his arguments should be discounted as the new religion of a hypocrite and turncoat. Clearly, this is most unfair.

make for good emphasis of the responsible attitudes of dealers, until we remember that the dealer has not considered the more important matter of unlawfully excavated objects:

> The archaeologists are saying, bluntly, since years, that the art world in the west is encouraging looters in source countries to plunder archaeological sites and temple sites. Absolute nonsense... For one simple reason. If you chop off the head of a Buddha statue, anywhere from a temple site above ground, not even inside of Indonesia or inside of Thailand can you sell it. Because every dealer sees it. It's a totally different skin. It's a skin above ground. And nobody wants to touch a piece from above ground, because it means it's stolen. (London Dealer 5)

There is also evidence in the data that further contrasts with the denials of this link between market purchase and the encouragement of supply at source. Some interviewees acknowledged a possible relationship between supply and demand in the market, while declining to consider amending their actions in light of this relationship:

> The idea that you create an incentive for people to dig freelance is no doubt correct, but it ignores, or chooses not to face the fact, that people already have an incentive to dig, thank you very much. There's plenty of incentive to dig. Because they're human beings, because they want to see what's under there, because they have found beautiful things in the past, because they know that there is, you know, pleasure and reward to be found there... I don't have the answer to the looting question. And I don't either have the will to say that I or the rest of the people who live in New York should deny themselves the art market on the grounds that it might encourage a peasant in wherever, China or Italy, to go hunting. (New York Dealer 1)

Some interviewees went beyond describing a general relationship between a market of buyers and the encouragement of supply, to identify in some instances a direct link between an individual buyer and the act of looting he has caused:

> If a collector wants a particular piece, a collector wants a particular piece. That's why you'll find a lot of these sort of works are literally going to an end collector who might have employed a dealer to start doing the work, the searching for them. For instance, a person might say look, they want a Mayan head, they want this, this, this, and this. And then they'll go off and they'll ask dealers and a dealer will know someone who knows someone, and the next thing one gets pulled away. (Melbourne Dealer 2)

It is my conclusion from an analysis of the data gathered that most international buyers of antiquities are aware of the cause and effect

relationship between supply of and demand for illicit artefacts, and that those who did not admit to this were simply trying to defend their position in the market. Those who did acknowledge the presence of the relationship appeared to neutralise their part in it by way of the same appeals as were used to neutralise the possible illicit nature of goods without provenance; broadly that they are saving chance finds, and that people would dig for interesting and valuable objects whether the market bought them or not:

> *It is true that the presence of a market is an outlet, and is a stimulation for illicit digging, but it is also a saving for all the chance finds that would have no outlet. And my theory and my conviction is that the contribution of saving far surpasses the stimulation to illicit goings on... people look at it as a sport. It's been through history that people like to find things. It's exciting, it's fun.* (Geneva Collector 1)

4.3.3.2 The Internet

Visit http://www.antiquetica.com/index.html (version current at 1st March 2005) and you will come across several pictures of sumptuous Asian antiquities, a search engine that allows you to search out your desired purchase by era, country of source or object type, and the following sales print:

> AntiqueTica aims to be the center of Asian Antiques and Asian Art on the Internet, we provide various kinds of Asian Antiques and Asian Art for collectors, dealers, scholars, curators, and connoisseurs around the world. Feel free to contact us for more details about the Asian Antiques or Asian Art pieces that interest you. Should you are looking for a specific item, we are here to locate it for you through our networks of communications located in Thailand, China, Hong Kong, Vietnam, Japan, Taiwan, Philippines, USA, UK, Belgium, and Germany.

Based in Rivercity, Bangkok, AntiqueTica is the website of Hong's Antiquities, run by Tara Sae-Be, a Thai dealer in art and antiquities. Customers view digital images of Hong's antiquities on the web and are able to order them electronically, making payment with their credit card, rather in the manner one would buy books from Amazon's online bookstore. Shipment costs in respect of the Thai items for sale are stated to be payable by the buyer 'at actual cost', but nowhere is it suggested that the item bought may not by law be allowed to leave Thailand. Is an application made to the Department of Fine Arts in respect of the sale and export of each of these items? If so, does Hong's Antiquities bear the cost of such applications? There is nothing on the website to suggest that such an application is needed, or that it may involve cost, although Section 22 of the Act on Ancient Monuments, Antiques, Objects of Art and National Museums (1961) as amended in 1992, demands an application to the Director-General of the Fine Arts Department for a licence in respect of the export of

"any antique or object of art irrespective of whether they are registered or not", and states that the licensee must pay such fees in respect of the licence as are fixed by Ministerial Regulation. What happens in the event that the application is made and refused? The buyer has already paid for the object.

There are many examples of such traders who offer antiquities for sale over the Internet. Another is http://www.thailandtradenet.com (version current at 8th December 2003) which advertises itself as a company run by American and European e-commerce professionals, based in Chiang Mai. The company describes itself as 'an exporter and wholesaler of Asian art, antiques, porcelain, silver, jade [and] terracotta arts', among other things. No warranty is given as to 'age, origin, condition or for any other reason'. *Caveat emptor,* then. They state that all their advertised Asian Treasures "come directly from mines and factories therefore our prices are low...'". What mines are there in Thailand which offer up antiquities for sale by local-based foreign-owned companies to buyers outside Thailand's borders? None but those dug by looters.[50]

The Internet gives collectors and dealers a means to reach a wide audience of buyers with minimal advertising expense. At www.sellatonce.com (version current at 1st March 2005) collectors can list items they wish to sell along with their e-details and simply wait to be contacted by interested buyers. Prices are often not listed, rather they are to be negotiated once a buyer has expressed interest. These websites offer up the potential for antiquities to be bought and sold in what are effectively very private transactions, with no requirements for publicity or information-recording being imposed upon the parties to these sales.

The flow of advertising information and the ability to make contracts for sale across national borders in this manner makes it very simple for dealers and collectors in the west to purchase antiquities from other dealers anywhere in the world. If those sellers are based in the source country, the artefact sold will be posted out of that country direct to the buyer. In transactions such as these the responsibility for detecting the illegal export of antiquities falls primarily to the domestic postal service of the source country and the customs officials who operate in association with that postal service (if any) rather than its customs officials at ports of human exit.

As an ethereal domain of communications where operations under aliases are standard even in channels as mundane as email, these 'virtual galleries' provide a new challenge to law enforcement officials. Some do not provide the places of business of the seller, or

50 This section was written on 8th December 2003. A visit to www.thailandtradenet.com on 1st March 2005 to update the link for this publication revealed Thailandtradenet to have reinvented itself as seller of Asian wood furniture. The examination of the website in 2003 described here should therefore be read as historical observation.

indeed any contact details aside from an email address. Some do not give the name or head office of the controlling company; something that would, for instance, be required by law in any company correspondence in the United Kingdom under the Companies Act 1985. Unlike the traditional visibility of the High Street shop, online trading entities can use the Internet as a barrier to scrutiny which adds a further element of privacy to the sale of antiquities. Buyers may know little about the seller other than perhaps their ability to produce high quality antiquities, as evidenced by a prior course of dealing. Sellers, in turn, will know nothing of their buyers other than the ability of their credit card company to provide funds. And if law enforcement officials wished to inspect the premises of the seller and its contents, they would first have to discover the true identity of the person or persons behind the corporation and the whereabouts of the premises.

Some of the interviewees had used the Internet to buy antiquities, but for serious buyers of costly items use of this method of purchase is self-limiting. The risk of purchasing fakes is perceived as being so high even in face-to-face transactions that purchase on the basis of an online photograph is seen as increasing that risk to an unacceptable level. E-bay and other online sites continue to sell huge quantities of antiquities, however. Clearly many dealers feel that the risk is acceptable.

4.4 IN CONCLUSION: CAN A PROHIBITIVE APPROACH ACHIEVE HARM-REDUCTION IN THE ANTIQUITIES MARKET?

To what extent can we draw together the points raised in this chapter to produce a 'theory of illicit market structures'? What are the similarities between the antiquities market and the other illicit markets studied, and what are the differences?

Similarities across these illicit markets seem concentrated at the source end of the chain of supply. Here we see poverty and corruption. We see understaffed and underfunded protection agencies (compare the Thai Royal Forestry Department in the case of wildlife with the Fine Arts Department in the case of antiquities; the problems caused by low finance and staff levels are apparent in each). We see harsh prohibitive legislation in respect of the production and export of narcotic drugs which, as is the case with antiquities, struggles to achieve control of the problem.

The most obvious difference between the antiquities market and the two comparative markets studied here is in the manifestation of demand. Illicit antiquities, particularly those which travel though transit ports, are perceived to run a very low risk of interception upon import into a market nation. Once in the market nation they are sold openly. The pattern for both drugs and wildlife is different. These commodities, when smuggled through entry points into market

countries, are more likely to raise suspicion if detected. They are therefore much more likely to be intercepted. White powder, or a bag of snakes, will raise questions in the mind of a customs officer, where an old vase might not. If the border controls are evaded, illicit drugs and wildlife cannot be sold openly in the market nation (in the latter case because of licensing and reporting requirements).

Consequent upon the stricter acknowledgement of illegality in import and possession of illicit drugs and wildlife, we have seen that tighter controls emerge in market nations in respect of these activities. An export permit from the source CITES authority is required to import protected wildlife into Australia. Monitoring and tracing provisions exist to control the movement of that wildlife once it enters Australia. A dedicated prosecuting authority exists in Australia with title to raise court proceedings in respect of breaches of wildlife law. In the United Kingdom we have seen a similar dedicated authority, the ARA, in respect of the confiscation of the proceeds of crime; powers used with regularity in illicit drug trafficking cases. There is no system of tracing of products in the antiquities market, and there is no dedicated authority to control trade.

Given this major difference in the 'pattern of consumption' and its treatment, perhaps there are implications for the success of deterrence strategies targeted at demand for antiquities in market countries? Certainly the open sale of antiquities in market countries lends the commodity we wish to control an element of visibility, and therefore susceptibility to detection, which is absent from the other illicit commodities considered. It might be argued that the disguised nature of possession of drugs and wildlife in market countries is a direct result of more sophisticated attempts to control those commodities by lawmakers and enforcement agencies. However, there are good reasons to believe that attempts to control the antiquities market, correctly applied, will not drive the trade underground. Publicity has traditionally been inherent in the sale mechanism, for example through the use of the auction method to maximise return on sale through the encouragement of competitive bidding. The collection of antiquities has also traditionally been linked to social prestige, which depends for its acknowledgement on a degree of publicity in relation to the objects possessed.

Deterrence through criminal sanctions as an initiative has, as we have seen, been notably unsuccessful in respect of the consumption of illicit drugs, but we should not condemn the strategy as useless in the antiquities market until we have given thought to its applicability to the particular nature of consumerism in our market. I shall consider this further now.

4.4.1 Antiquities Dealers and Collectors as White-Collar Criminals?

From 1940 onwards, the pioneering criminologist Edwin Sutherland sought to draw some attention away from the day-to-day street-level crime of the relatively poor which was (and to a large extent still is) the staple of official criminal statistics, and bring into view the previously socially concealed crimes of the powerful.[51] Traditionally, the first obstacle to the study of white-collar crime has been in its definition. In an early attempt at definition, Sutherland stated that, "White-collar crime may be defined approximately as a crime committed by a person of respectability and high status in the course of his occupation".[52] Later studies have tried to refine this definition, for example with the proposition that white-collar crime should include "economic offences committed through the use of some combination of fraud, deception or collusion".[53] The term white-collar crime therefore applies to a wide variety of types of wrongdoing, but generally involves either offenders of middle to high status or offences committed in the course of trade, or both.[54] Often these offences involve some abuse of trust, for example where a privileged position of control over funds or information has been abused. The trust that we place in businesses to conduct their affairs properly is sometimes misplaced and its abuse is often not amenable to surveillance by traditional institutions and methods of social control, which tend to rely on public reporting of legal infringements and so focus disproportionately on more visible forms of wrongdoing.[55]

Whether an act is criminal or not depends upon vagaries of legislative or common law definition, and whether or not an individual will be officially labelled a criminal turns also on evidentiary issues: has the defendant contravened a law and is there enough evidence to prove it? The market lobby would no doubt argue that most antiquity dealers and collectors should not be seen as white-collar criminals as they are committing no crime in their countries of residence, and this is for the most part correct; in the United States and the United Kingdom, the act of purchasing an unprovenanced antiquity might not amount to criminality for want of knowledge or belief that the object has been looted, or if such knowledge or belief does exist, for want of the prosecutor's ability to prove it. Nevertheless, questions of law aside, it is still instructive to view the market interviewees as white-collar criminals since it appears that they do *in fact* buy looted antiquities,

51 E.W. Sutherland, 'White Collar Criminality', (1940) 5 *American Sociological Review* 1-12; 'Is "White Collar Crime" Crime?' (1945) 10 *American Sociological Review* 132-9; *White Collar Crime* (1949, New York, Dryden Press).

52 Sutherland (1949) , *op. cit.* note 51, at p. 9.

53 S. Wheeler, D. Weisburd & N. Bode, 'Sentencing the White Collar Offender: Rhetoric and Reality', (1982) 47 *American Sociological Review* 641 at p. 642.

54 A. Freiberg, 'Sentencing White Collar Criminals', (1992) *Australian Institute of Judicial Administration, Sentencing of Federal Offenders* 1-19.

55 S.P. Shapiro, 'Collaring the Crime, not the Criminal: Reconsidering the Concept of White-collar Crime', (1990) 55 *American Sociological Review*, 346-65.

there is *in fact* a relationship between the purchase of looted antiquities in the market and the destruction of context at source, and the purpose of this work is to explore what we can do to change this.

4.4.2 Deterrence Through the Threat of Criminal Sanctions

The hypothesis on which deterrence rests can be broadly stated as the idea that decisions of actual or possible offenders (specific and general deterrence, respectively) can be influenced by raising the probable costs of offending, namely the severity of the sanction or the likelihood of prosecution.[56] This hypothesis is, largely because of its breadth, one of the most disputed propositions in the field of criminology and has found differing levels of empirical support in the many studies which have tried to test it. The bulk of those studies have, however, been concerned with the deviance of juvenile delinquents and other disempowered offenders. The lack of success of punitive criminal law strategies for the possession or use of prohibited drugs in market countries illustrates the weakness of the philosophy of deterrence in the face of offenders with little personal freedom, who are part of the long-term unemployed and who have no property to be put in jeopardy. For the reasons made clear by rational choice, control and labelling theorists, deterrence through criminal punishment is unlikely to work for most law violators who come to the attentions of the police. These are street criminals who have little investment in society and little therefore to put at risk; little pleasure in life to balance against the perceived pain of punishment.[57]

Deterrence through the threat of criminal sanctions stands on much firmer ground when applied to white-collar criminals, however, other than when the known probability of detection for the offence is low. White-collar crime is seen as a highly rational form of criminality,[58] in which the risks and rewards are carefully evaluated by potential offenders, the risks being that much more salient for the white-collar criminal owing to his or her stake in conformity.[59] Polk notes this important distinction when comparing the likely success of strategies of deterrence through criminal punishment at the demand end of the illicit markets in stolen goods and antiquities:

> Antiquities buyers are by definition individuals or organisations of wealth and position. Such individuals, especially when it comes to the relatively rational

56 R.A. Posner, 'An Economic Theory of the Criminal Law', (1985) 85 *Columbia Law Review* 1193-231.

57 K. Mann, S. Wheeler & A. Sarat, 'Sentencing the White-collar Offender', (1980) 17 *American Criminal Law Review* 479-500.

58 S. Wheeler, K. Mann, & A. Sarat, *Sitting in Judgment: the Sentencing of White-Collar Criminals* (1988, Yale, Yale University Press).

59 J.Braithwaite & G. Geis, 'On Theory and Action for Corporate Crime Control', in G. Geis (ed.) *White Collar Crime* (1982, Lexington MA, D.C. Heath).

market behaviour involving the purchase of antiquities, can be seen as theoretically amenable to "deterrence" approaches to prevention. In the case of burgled goods, however, the purchasers are highly likely to be deeply intwined in the same circumstances as the burglar, and in fact a major conduit for burgled goods is through drug dealers. Since these individuals occupy the same devastated social and economic position as the burglar, it is not likely that direct demand side sanctions can either reach the buyers or have much purchase on the market. Stevenson and Forsythe[60] speak bravely about attempts at moral persuasion, but to date that has not seemed to be an effective strategy for addressing markets as deeply enmeshed in a criminal way of life as seems to be the case with these burglars and drug users/dealers.[61]

As mentioned above, the concept of deterrence is divided into two parts: specific deterrence, which involves the likelihood of the individual who is subject to the punishment re-offending; and general deterrence, which involves the effect on the population at large of the threat of punishment (and indeed its practice against others). Studies of corporate sanctioning provide some evidence for a specific deterrent effect in relation to white-collar crime,[62] but specific deterrent effects against individuals are debated.[63] The likely reason can be found in terms of damage to bonds to conventional society. For white-collar criminals who are convicted of an offence and perhaps sent to jail, these bonds are stretched, if not broken. Status and prestige are lost. Employment opportunities might suffer after a conviction in relation to one's trade.[64] Rather than being deterred from committing a similar offence in the future, it is reasonable to project that white-collar individuals subjected to such bond-breaking are strongly affected by the process of punishment and come away from the experience with a feeling of dislocation. They will have slid somewhat down the ladder towards the street-criminals with little to lose, for whom specific deterrence has been proven a dubious proposition.

60 R.J. Stevenson & L.M.V. Forsythe, *The Stolen Goods Market in New South Wales: An Interview Study with Imprisoned Burglars*, (1999, Sydney,NSW Bureau of Crime Statistics and Research).
61 K. Polk, 'Illegal Property Markets', published as proceedings of the conference *3rd National Outlook Symposium on Crime* (23 March 1999, Canberra, Australian Institute of Criminology).
62 S. Simpson & C.S. Koper, 'Deterring Corporate Crime', (1992) 30 *Criminology*, 347.
63 D. Weisburd, E. Waring & E. Chayet, 'Specific Deterrence in a Sample of Offenders Convicted of White-collar Crimes', (1995) 33 *Criminology*, 587.
64 It should be noted here that there is a scientific difficulty in relation to the assertion that specific deterrence does not work effectively in relation to white-collar criminals. This may be the case, but it may also be that any sample of convicted white-collar criminals sentenced to jail will be loaded with the more serious offenders. Since, statistically, white-collar criminals are proportionately more likely to be fined or subject to other forms of civil sanction than 'blue-collar criminals', it is reasonable to assume that it is only the worst white-collar offenders who get jail terms (or those most incompetent, and therefore most likely to be caught). This will unduly weight a study of recidivism in favour of those most likely either to re-offend, or to re-offend and get caught.

While specific deterrence is debated, then, and the notion of stemming recidivism among individual white-collar criminals through the assignation of prison sentences does not have a solid foundation, general deterrence is a different matter. White-collar criminals, both potential and actual-but-unconvicted, are ideal grist for the general deterrence mill, for precisely the reasons which make them unsusceptible to specific deterrence. Their strong and socio-economically- fruitful bonds to their trade and their families and loved ones are useful sites of persuasion which, if threatened by a real possibility of their loss as a result of prohibited behaviour, are likely to exert a considerable pull towards conformity.

For these reasons, there is seen to be a greater fear of imprisonment by white-collar criminals than by street offenders.[65] By way of illustration, in October 1989 the House of Representatives Standing Committee on Legal and Constitutional Affairs published a report on insider trading in Australia in which it argued for the retention of imprisonment as a sanction for that offence, using a quote from a prominent professional at a recent AMBA insider trading conference: "five years in denim to anybody in this audience would seem like the death penalty".[66] The increased likelihood of publicity which goes along with convictions in regard to offences which are above the average of everyday street crime in terms of media interest is also seen to provide a deterrent effect on white-collar criminals.[67]

In fact, insider trading provides a useful study of deterrent measures employed against potential white-collar criminals. It is possible to make such huge amounts of money through a course of dealing which constitutes insider trading, that fines imposed on the standard criminal scale of penalties may be absorbed as little more than licence fees in respect of unauthorised trading. As with asset forfeiture in the case of illicit drugs traffic,[68] the penalty would provide little deterrent if it did not present a serious risk of depletion of the profits available to the criminal. A possible solution to this problem was implemented in the United States with a 1984 amendment to section 21(d)(2) of the Insider Trading Sanctions Act providing for a civil penalty, enforceable at the suit of the Security Exchange Commission, of up to three times the profit gained or the loss avoided by insider trading. As Polk and Weston note, this makes possible "huge penalties which constitute real threats to insider traders".[69] Although mechanistically a civil penalty, this level of fine is highly punitive and indeed more practically akin to a form of criminal sanction in its

65 S. Wheeler, K. Mann & A. Sarat, *Sitting in Judgment: the Sentencing of White-Collar Criminals* (1988, Yale, Yale University Press) at p. 135; R. Tomasic, *Casino Capitalism? Insider Trading in Australia* (1991 Canberra, Australian Institute of Criminology) at pp. 100-101.

66 SCLCA 'Fair Shares for All' (1989, Canberra, AGPO).

67 Wheeler *et al.*, *op. cit.* note 65 at pp. 136-138.

68 S.B. MacDonald & B. Zagaris, *International Handbook on Drug Control.* (1992, Westport, CT, Greenwood).

69 K. Polk & W. Weston, 'Insider Trading as an Aspect of White Collar Crime', (1990) 23 *Australian and New Zealand Journal of Criminology,* 24 at p. 26.

threat to the career of the defendant, particularly if coupled with the threat of licence revocation.[70]

Insider trading is of course an area, like the illicit antiquities market, in which investigation is made difficult by institutional organisational structures which obscure the regulatory gaze. The truth of the matter is that if the insiders (who often function in small groups) remain tight-lipped about their activities there is little chance of successfully prosecuting them, even if an irregularity in dealing is discovered. The high level civil fine works well here in breaking up these networks:

> ... given that insider trading involves individuals motivated fundamentally by their self-interest in profits, it can be seen that the threat of huge penalties works as a strong inducement for an individual under investigation to cooperate, and thus reveal the facts necessary to proceed against others in the trading network... the US case studies reveal that time and again, confronted with the enormous consequences of civil penalties, the individual insider trader would collaborate with the prosecution, reducing whatever penalties he faced at the expense of exposing his fellows in the network to the full weight of civil and criminal prosecutions.[71]

Do antiquities dealers act on similar motivations? Certainly, the secretive nature of the trade[72] and the fluid networks formed between dealers and clients mean that the co-operation of an insider might prove invaluable in any investigation into the movement of illicit objects. The prosecution of Frederick Schultz would have had a substantially lower chance of success were it not for the co-operation of Jonathan Tokeley-Parry, the English antiquities smuggler who carried the head of Amenhotep III and other objects out of Egypt and sold them to Schultz.

While for the most part undoubtedly attached to their trade by an interest in the art they sell, it is not unreasonable based on the interview data to agree that dealers, being men and women of business, are also "motivated fundamentally by their self-interest in profits" to adopt the terms of Polk and Weston. Those in business must make money to survive. Once we accept that rather banal truth, we might expand Polk and Weston's thesis in stating that for any business men and women, the threat of substantial penalties, be they financial or

70 Many categories of corporate crime now attract such enormous potential fines and physical penalties, for example antitrust violation in the US where current sentencing guidelines provide for a fine of the greater of twice the corporation's pecuniary gain or twice the victim's loss, asset forfeiture and the making of restitution for corporations guilty of such a violation, and sentences of up to three years in prison for individuals: C. Jones, D.S. Lee, & A. Shin, 'Antitrust Violations', (2001) 38 (3), *American Criminal Law Review*, 431.

71 Polk & Weston, *op. cit.* note 69, at p. 34.

72 P.M. Bator, 'An Essay on the International Trade in Art', (1982) 34 *Stanford Law Review* 275 at p. 360.

carceral, works as a strong inducement for an individual under investigation to co-operate.

4.4.3 Deterrence Through *Appropriate Use* of the Threat of Criminal Sanctions

Freiberg, among others, notes that "analysis of statecraft must go beyond the power to punish",[73] by which he means that compliance with the law might best be obtained by a variety of regulatory mechanisms which combine to create a climate of compliance. Also a proponent of this climate-setting approach is another Australian criminologist, John Braithwaite. He identifies the obligations of regulatory agencies as "to use their resources strategically to find the least cost ways of maximising regulatory objectives while respecting the legal rights of alleged offenders".[74] "We have a greater chance of efficient and effective regulation", he states, "if we have a regulatory culture where regulation reviewers and consumerists actually listen to each other and respect the concerns of the other; we have a lesser chance of cost-effective regulation if these two constituencies see their mission as to destroy the other...".[75]

Braithwaite proposes what he calls a 'regulatory pyramid' as an effective way to approach the constitution of a 'dialogic regulatory culture' (simply a climate in which the regulated and the regulators talk to each other). Self-regulation schemes sometimes work better than government regulation because the industry is more committed to them and because they are more flexible than the law. Often, though, they fail. What is needed, Braithwaite thinks, is a self-regulation scheme (the bottom layer of our pyramid) which can be made to work through the building in of incentives. "Incentives for effective self regulation come from other players... signalling to the industry that they will press for an escalation of regulatory intervention up the pyramid if self regulation is not implemented with energy and results".[76] Higher up the pyramid (the narrowing in height symbolising fewer people exposed to the escalating penalties) we find warning letters, civil penalties, increasingly harsh criminal penalties, and where appropriate to the profession, licence suspension and possible revocation. In this way, the reward for effective self-regulation is a drawing back by the State and the giving of independence in regulatory decisions to the trade itself. Freiberg has termed such a system of reward 'the jurisprudence of the carrot'.[77]

The detection, capture, prosecution and imprisonment of criminals is a costly and time-consuming business for organs of the State,

73 A. Freiberg, 'Reward, Law and Power: Toward a Jurisprudence of the Carrot', (1986) 19 *Australian and New Zealand Journal of Criminology* 91 at p. 94.

74 J. Braithwaite, 'Responsive Regulation in Australia', in P.N. Grabosky & J. Braithwaite (eds) *Business Regulation and Australia's Future* (1993, Canberra, Australian Institute of Criminology) at p. 83.

75 *Ibid.*, at p. 87.

76 *Ibid.*, at p. 93.

77 Freiberg, *op. cit.* note 73.

and ultimately this cost is passed on to the taxpayer. As Braithwaite, Freiberg, Polk and Weston and many others recognise, it is productive on all counts to use methods of persuasion to ensure that system participants can themselves control the practices within their system in line with prevailing legal norms. And given what has been said about deterrence as an option for controlling white collar criminals, we might do well to look at appropriate criminal penalties as the top part of our regulatory pyramid in respect of the manoeuvring of the antiquities trade into a position in which it can for the most part effectively regulate itself.

The law has a declaratory power which is sometimes enough in itself to dissuade citizens from breaches of its terms, such is the prescriptive force of this form of rule. For those who do not feel such a reluctance towards legal infringement, the threat of penalties can persuade them to obey. Further, in the antiquities market, where reputation is vital, the threat of public destruction of a hard-earned regard from one's peers and clients is in itself a considerable deterrent. The relational links that combine to form whole networks have elsewhere been identified as of central importance in the study of those networks[78] and the projected social stigma emanating from these bonds after a breach of group norms has been argued to be a great conforming influence – greater than that from legal sanctions,[79] although the two of course are themselves related. In the antiquities market, the livelihoods of dealers depend upon their management and exploitation of their personal sets of relational links, and threats to those links through damage to reputation seems a suitable site for productive regulatory intervention. The accumulation of personal capital[80] by antiquities traders is central to the success of their enterprise in establishing a network of avenues of disposal of their stock. Claims have been made that potential loss of personal capital is an important consideration in the rational choices of 'marginal offenders' – those whose self-control is not so high as to virtually preclude offending, nor so low that they would offend regardless of the inducements or disincentives.[81] For our subjects, whose personal capital extends beyond the usual networks of family and friends and into their business lives, a threat to this capital by way of damage to reputation consequent upon

78 N. Coles, 'It's Not What You Know - It's Who You Know That Counts', (2001) 41 *British Journal of Criminology* 580.

79 H.G. Grasmick & R.J. Bursik, 'Conscience, Significant Others and Rational Choice: Extending the Deterrence Model', (1990) 24 *Law and Society Review* 837.

80 R.J. Sampson & J.H. Laub, 'Crime and Deviance Over the Life Course: the Salience of Adult Social Bonds', (1991) 55 *American Sociological Review* 608; 'Crime and Deviance in the Life Course', (1992) 18 *Annual Review of Sociology* 63; *Crime in the Making: Pathways and Turning Points through Life* (1993, Cambridge, MA, Harvard University Press); J.H. Laub & R.J. Sampson, 'Turning Points in the Life Course: Why Change Matters to the Study of Crime', (1993) 31 *Criminology*,301.

81 M. Gottfredson & T. Hirschi, *A General Theory of Crime* (1990, Palo Alto, CA, Stanford University Press); D.S. Nagin & R. Paternoster, 'Personal Capital and Social Control: the Deterrence Implications of a Theory of Individual Differences in Criminal Offending', (1994) 32 *Criminology* 581.

criminal, trade, or non-legal public sanction might prove to be an important choice-influencing constraint. Such a constraint is currently absent. Although there are clear legal prohibitions against the possession of stolen goods in both London and New York, the data show that the dealers there do not think of themselves as criminals and therefore do not make the requisite mental connection between their actions and punishment. Certainty of punishment has been found to be central to effective deterrence,[82] and that certainty is currently not present in the minds of the interviewees in our core sample.

Prohibitive laws targeted at the market therefore show great potential to dissuade those who currently purchase illicit antiquities. These laws, however, will only achieve this deterrent effect if their application is perceived by any given buyer to be of sufficient certainty as to heighten the level of risk involved in an illicit purchase to an unacceptable degree. We have in this and the previous chapter looked at the deficits of the legal structure that reduce the certainty of detection and punishment (or an adverse ruling in a civil suit) among dealers, collectors, museums, importers and exporters in the antiquities market. In the remaining chapters we shall examine in detail the social and psychological (as opposed to legal) reasons for the breaking of the link between the purchase of illicit antiquities and the prohibitive stance of the law. We move towards a recommendation for *effective* prohibition in the final chapter which draws together all of the legal, sociological and psychological observations and arguments made, to form a singular targeted solution to the problem of illicit antiquities in the market.

82 D.S. Nagin, 'Criminal Deterrence Research at the Outset of the Twenty-first Century', in M. Tonry (ed.) *Crime and Justice: a Review of Research*, Vol. 23. (1998, Chicago, IL. University of Chicago Press); D.S. Nagin, & G. Pogarsky, 'Integrating Celerity, Impulsivity, and Extralegal Sanction Threats into a Model of General Deterrence: Theory and Evidence', (2001) 39 *Criminology* 865.

CHAPTER 5

THE SOCIOLOGY AND PSYCHOLOGY OF THE ANTIQUITIES MARKET

PART 1: DATA

The aim of this chapter is to provide a structure for the analysis of the discourse of the market, to take place in Chapter 6. This structure is found in a dichotomous separation of the functions of the market – and the characteristics of its participants – into 'good' and 'bad'. In the next chapter, I build a theory of decision-making around the dichotomy identified and explored here.

The antiquities market as a system is comprised of communications. From the mêlée of communications in the system, among which number communications emanating from and received by the interviewees in the core sample, we can discern patterned fragments of discourse. Poststructuralist discourse analytic theory sees discursive patterns in language as regularities through which the generative power of discourse constructs objects, or phenomena. The importance of recurrent patterns in communications is, as Willott and Griffin state, that "institutions and social practices are both supported by and support particular discursive patterns".[1]

This is true of the antiquities market. Rather than view the statements made by the interviewees as definitive indicators of what they 'really' think, we can identify their responses as making use of argumentative strategies which the market has made available to them:

> [Discourses are] recurrently used systems of terms used for characterizing and evaluating actions, events and other phenomena... organized around specific metaphors and figures of speech.[2]

Through the use of these strategies, which appear in the form of what Sykes and Matza have called 'techniques of neutralisation',[3]

1 S.A. Willott, & C. Griffin, 'Wham Bam, Am I a Man? Unemployed Men Talk about Masculinities', (1997) 7 *Feminism and Psychology* 107 at p. 109, citing M. Foucault, *Discipline and Punish* (1977, London, Allen Lane) and S. Walby, *Theorizing Patriarchy* (1990, Oxford, Blackwell).

2 J. Potter, & M. Wetherell, *Discourse and Social Psychology: Beyond Attitudes and Behaviour* (1987, London, Sage) at p. 149.

3 G.M. Sykes, & D. Matza, 'Techniques of Neutralisation: a Theory of Delinquency', (1957) 22 *American Sociological Review* 664.

the discourse of the market has been a mechanism in the production of action on the part of the individual market members, and through their use of that discourse the mechanism is reproduced. This chapter will detail the discursive patterns identified in the language of the interviewees. In the next chapter I move on to explore this choice-influencing mechanism in greater depth.

There are a variety of ways in which people might discursively transform problematic behaviour into unproblematic behaviour. One of these is the recognition of a problematic element to the behaviour, but an appeal to the overall view that the action does more good than bad – thus the problematic element can be ignored, or 'neutralised'. Sometimes also the standpoint of critics is attacked. Both of these tactics were evident in the data. The discursive appeals used by the interviewees can therefore be categorised under two major headings: (i) the market is a 'good', and (ii) those who would try to stop the market are bad. Some of the discursive appeals used do not stand the test of sustained investigation; they are insubstantial arguments, their 'truths' easily brought into question. Importantly, this does not affect their ability to act as neutralisations for the wrongdoing of the interviewees. As Parker has said, paraphrasing Foucault:[4]

> Discourses do not simply describe the social world, but categorise it, they bring phenomena into sight. A strong form of the argument would be that discourses allow us to focus on things that are not 'really' there, and that once an object has been circumscribed by discourses it is difficult *not* to refer to it as if it were real.[5]

The power of the patterned forms of neutralisation which the discourse of the antiquities market makes available to its members is in their ability to subsist through repetition and use, without any need to be incontrovertibly true. The discourse itself constitutes them as real for the purposes of influencing the buying decisions made by our choice-making subjects.

5.1 THE MARKET IS A 'GOOD'

Several lines of argument are led by the market interviewees (the dealers, the collectors, the museums and the auction houses) based on the perceived value of the market to society. These are divided here into four main groups. It was strongly felt that the market was a provider of international cultural education, a long term protector of culture, a device for the preservation of chance finds, and a provider of economic support for local source populations. I shall expand upon these in this section.

4 M. Foucault, *Discipline and Punish* (1977, London, Allen Lane); *The History of Sexuality I: an Introduction* (1981, Harmondsworth, Penguin).

5 I. Parker, 'Discourse: Definitions and Contradictions', (1990) 3(2) *Philosophical Psychology* 189 at p. 191.

5.1.1 'A Provider of International Cultural Education'

> *If we were not to see these things out of context, we wouldn't*
> *see them at all. We wouldn't see them, our children wouldn't*
> *see them, our children's children wouldn't see them, and*
> *so on and so forth down the line. We have to decide whether*
> *it's better to see an object and have to put it like a piece of*
> *a jigsaw puzzle that's loose, try and put it together back as*
> *information from that, or not see that piece of the puzzle at*
> *all. And the archaeologists obviously say that the piece of*
> *the puzzle should not come out until the whole puzzle is*
> *exhumed and if then we think what the free market in*
> *antiques and cultural property is saying is that where*
> *everything's come from, let them come out because they can*
> *be appreciated by people and at least part of the puzzle is*
> *able to be seen.* (New York Dealer 5)

The market ensures that objects travel globally, fulfilling their potential as cultural ambassadors, this argument goes. They find homes where they will be well looked after, and articulate to the world secrets about the cultures they represent. A point made repeatedly, which speaks both to the international educative function of the antiquities market and its long-term preservation of the objects, is that most antiquities end up in museum collections sooner or later:

> *In general I would say that about 60% of all major collections*
> *end up at the end of their day in a museum. That's why*
> *nearly every museum has been founded on the basis of a*
> *big donation. Even the British Museum.* (London Dealer 5)

> *... my sense is that they're [i.e. collectors] probably fairly*
> *serious and fairly responsible about conserving and the odds*
> *are that it probably would end up in a museum as opposed*
> *to going back onto the market.* (New York Museum 1)

> *They end up in museums eventually. It may take 100 years*
> *but they'll end up in some museum or small school.* (New
> York Dealer 4)

> *It calls to mind who owns culture? I mean there are people*
> *that are caretakers, but does anybody really own anything?*
> *I mean collectors really just take out a long lease on the*
> *object. When they die, it either goes to their heirs, or, in*
> *actual fact, most collectors their most ardent wish is that*
> *their material go into a public collection to be seen by other*
> *people. In the back of their heads everybody thinks 'well*
> *I'll build up a good enough collection so that someday*
> *everybody will want to see this'.* (New York Dealer 5)

> *The majority of the private collectors, in the US as opposed*
> *to other countries, acquire antiquities for more or less the*
> *same purposes as the museums do in the US, which is for*
> *the enjoyment, preservation, as well as in 90% of the cases*

they hand it over to museums and it falls into the public domain. And that in my opinion is one of the best things that can actually happen to it, to any work of art from ancient cultures, because that in turn becomes available to students, scholars, the general public, even to archaeologists, to further study it and to further investigate. And here in the US, in particular, there is this extraordinary civic duty and responsibility where people pass on the things to museums, more than any other place in the world. And that serves the public interest quite well. (New York Dealer 6)

The argument that the market is the facilitator of education is not foolproof, we should note. The market ensures that the flow of antiquities from poor countries to richer countries is substantially greater than the flow in the other direction. Consequently while a visitor to a British museum might learn much about southeast Asian culture by studying the exhibits there, a visitor to a southeast Asian museum will almost certainly not be presented with the same opportunity to study Anglo-Saxon culture. Surprisingly, they also might very well not be presented with the same access to Southeast Asian cultural objects as western museum-goers enjoy. When in Thailand, I visited the museum in Chiang Mai (the so-called 'National Museum') to find very few exhibits, generally rather uninspiring, housed in a small building. I discovered why the museum was so poorly stocked when interviewing a local collector:

It's illegal to collect if the Fine Arts Department decide that what you're collecting is art historical or of artistic value and you don't give it to them. It's so broad it's not possible to enforce it. Almost all Thai people wear an amulet round their neck, which are usually old. And therefore they are criminals as well. So the law is so broad that it's really not applicable.

[Does that mean that the police really don't care about it at all? The Fine Arts Department do nothing about it?]

Yes. But the negative thing that it means is that the job of curators in most museums is to make friends with collectors, so that they will leave or donate or give their pieces to the museum. Here, since we're all criminals, no-one ever, ever gives anything to the museum.

[Really? Because if you were in touch with the museum they might report you?]

Yes, yes. It's a very self-destructive piece of legislation...

[If the museum here doesn't have any contact with collectors or dealers, where does it get the stuff from?]

The museums here? They don't. They've got awfully bad collections. (Chiang Mai Collector 1)

The diffusion of art around the world which market proponents see as one of its most positive aspects therefore rather ironically leaves museums in source countries who have passed laws to try to protect their heritage without collections to display.

5.1.2 'A Long-Term Protector of Culture'

One of the most powerful arguments for an international market in antiquities is in relation to the protection and preservation of the objects themselves. We have seen that protection of context is a different matter, which is positively endangered by the existence of an international market; at least one which is prepared to deal in illicit objects. What is incontrovertible, however, is the superior preservative conditions that wealthy collectors and museums can provide over the sometimes below-standard best efforts of financially struggling museums in source countries such as Thailand.

More important than that, disasters, natural and man-made, threaten the preservation of cultural objects. The most effective way to ensure the longevity of representative samples of ancient art is to spread those samples around the world. Western institutions may claim superiority in the safeguarding of the world's cultural heritage, but after the terrorist attacks on the World Trade Center in New York on 11th September 2001 which destroyed many priceless works of art, including a collection of Rodin sculptures kept in the offices of the bond trading firm Cantor Fitzgerald, we see that nowhere can be certain of its capacity to safeguard historical objects. The destruction of the Bamiyan Buddhas by Afghanistan's Taliban Islamic purists along with their systematic ransacking of repositories of artwork, including priceless Buddhist and Gandharan statuary in the National Museum in Kabul,[6] and heavy rains in Bolivia which threaten to forever damage ancient adobe pre-Hispanic burial towers built by the Aymara and Inca civilisations high on Bolivia's altiplano,[7] are but two examples of such harmful incidents:

> *You look at what the museums do, and at what the museums did, I mean they took whole temple sites away. And really if you think about it, all the Gandharan pieces now around the world that are being sold, and people would say 'look most of those have been looted', it's the only record now we've got, the pieces that are actually out of Afghanistan, because everything there's been destroyed.* (Melbourne Dealer 2)

Other examples of destruction highlight the unpredictable nature of the occurrence of natural (and man-made) disasters. On Monday 27th May 2002 the Axum obelisk, a 24-metre Nigerian granite monument looted from that country by invading Italian forces in

6 C. Bohlen, 'Cultural Salvage in Wake of Afghan War' *New York Times*, 15 April 2002.
7 'Bolivia's pre-Hispanic Burial Towers Endangered', *Museum Security Network Email Bulletin*, available through their website at www.museum-security.org, 19 March 2002.

1937 under the command of fascist dictator Benito Mussolini and kept in Rome ever since, was subjected to damage when it was struck by lightning in a heavy storm. Several pieces from the top of the monument were dislodged and fell to the ground. The irony of such damage by act of God is that, despite continuing negotiations between the Italian and Nigerian governments since the 1940s, during which time Italy has on several occasions stated its commitment to secure the return of the object (an undertaking eventually fulfilled in 2003), in January 2002 Italy's deputy minister for cultural heritage, Vittorio Sgarbi, said that Italy could not give its consent for a monument which is well-kept and has been restored to be returned to a 'war zone' and left there at risk of being destroyed.[8] Unforseeable though the damage was, on 27th May 2002 at least, the obelisk would have been safer in Nigeria.

The argument that the market spreads antiquities around the world, helping protect them against natural disasters, has flaws, however. While the market is portrayed by the interview sample as a disperser of antiquities for safekeeping, the reality appears somewhat different. We have heard from the interviewees both that the number of buyers of seriously important antiquities in the market is small and that for many of them their main clients are the larger western museums. In fact, then, far from dispersing objects around the world, the market concentrates them in specific locations, the main two of which are New York and London. The Metropolitan Museum, for example, is a product of the operations of the international market in antiquities, including gifts and bequests of course. And it would be a disaster for humanity on a grand scale if that museum were blown up by terrorists, destroyed by fire, earthquake or flood, or otherwise razed by forces unforeseen and outwith the control of its owners and operators. On a theoretical level the argument is sound, but in this case theory does not accord with practice.

Aside, then, from the obvious advantages for education and cultural edification of the world's population in the ways and history of their and other cultures, the maintenance of deposits of cultural material in museums and collections around the world is a necessary function of the risk-spreading approach which we must use to hedge our bets on the wheel of fortune that dictates the global incidences of forces of destruction. The market performs this function, but on a capitalist basis which concentrates many antiquities in a few major international centres. Ignoring this grander aspect of protection, the interviewees concentrate on the perceived ability of the market to supply optimal conditions for the preservation and restoration of individual objects.

8 N. Bhalla, 'Storm Over Ethiopian Obelisk Lightening Strike' *Addis Tribune newspaper website* at http://www.addistribune.com/ (version current at 3 June 2002).

5.1.3 'The Preservation of Chance Finds'

The issue of preservation as applied to chance finds is qualitatively different from the long-term care of the objects mentioned above. The preservation talked of here is the preservation not from deterioration attributable to lack of proper care over the years, but from a much more immediate threat. Chance finds would be destroyed upon discovery were they not bought by the market, it is said:

> One point that has come up from time to time is unless you are talking about an object that has intrinsic value – a gold or silver bowl for example – if a farmer comes across it while ploughing his field and he doesn't have an easy outlet for it, it's a ceramic pot let's say, he doesn't have any incentive really to keep it. And that, I think, is the potential that this stuff would be lost. He knows that if he alerts the government as he's supposed to do, that it could have an impact on his livelihood because the site might have to be excavated. (New York Museum 1)

> There would be no incentive to save objects, if there is no monetary value. Value helps art or antiquity to be preserved. If there is no value attached to it, then they will not be preserved, because people would consider them headache. Without any economic incentives. (New York Dealer 6)

Even for objects that do have an intrinsic value because of the precious materials from which they are constructed, it is thought likely that destruction would follow discovery were it not for the value placed on the object by the art market, higher than the value of its constituent gems or metals:

> The Sevso treasure, that's created such a colossal scandal; from what I know it is a chance find. From what I know, once the chance find was made, it was dug. And we're talking about a huge amount of money. Not huge compared to Van Gogh, but a huge amount of money. What would happen if there were no market? It was only saved because it had a possible large economic value as an antiquity. Otherwise it would be melted. Melted for the silver content. Silver's worth $5 an ounce. It weighs a lot of kilos. A lot of kilos. (Geneva Collector 1)

The attribution of market value to antiquities therefore ensures their preservation, the argument goes. This very attribution of value also, however, provides an impetus for looters to search out antiquities. The moral strength of the argument therefore hinges upon our accepting that most illicitly excavated antiquities are chance finds. Otherwise it is an admission that the antiquities market encourages looting. Are most illicitly excavated antiquities chance finds? As with all arguments, if the adherent to one side wishes to find evidence to support her beliefs, evidence can indeed be found. A

good example is the representative of London Museum 1, who describes the results of the pilot Portable Antiquities Scheme in England. The Portable Antiquities Scheme encourages the reporting of finds to a local archaeological office, which records details of the place and circumstances of finding. The finder may be rewarded. The museum representative here points out that most of the objects recorded have come from chance finds:

> The other issue about metal detecting in this country, and the report illustrates this quite well, is that 90% of the objects that have been recorded through the scheme, it's with the analysis of data at the back here, 90% of the objects recorded come from cultivated land. That's this chart here. Now what this is illustrating is that it's actually the arable land, the ploughed land, that is the most popular terrain and the most productive terrain for metal detectorists.

> [Because the ploughing turns stuff up?]

> Exactly so. And what they were actually doing – and this is controversial with some archaeologists, but I think increasing numbers are willing to admit this – the detectorists who do go onto cultivated land, ploughed land, are actually very frequently recovering objects from contexts that have been destroyed by the ploughing. And they're actually salvaging objects which would in fact be at risk of deterioration through the chemicals that farmers put on land, or being knocked by the plough the following season. And a lot of the objects which are recorded in fact are broken and have been broken in modern time. The area that produced the highest volume of finds is the one that has the greatest amount of cultivated land. (London Museum 1)

Although the introduction of the Scheme has resulted in a significant increase in the reporting of finds, it is still the case that only a very small fraction of antiquities excavated by non-archaeological personnel in Britain are reported to the Scheme offices. The Museum representative chooses to see the reported finding circumstances of this minority of excavated objects as indicative of the trend for all excavated objects. There are very good reasons why this choice may be mistaken. Reporters of excavated objects may untruthfully tell the office that their find was on ploughed land to avoid the disapproval they might know would be visited upon them by the office were they to admit to having dug an uncultivated site. In any event, if it is accurate to say that 90% of all reported objects were found on ploughed land, this may tell us more about the characteristics of those diggers who report their finds than about the circumstances of the excavation of antiquities more generally. Hobbyist metal detectorists who find antiquities in cultivated fields may be significantly more prone to report their discoveries than more dedicated looters whose intentions are less innocent. It is

therefore unfortunately not possible to say from such a small sample of voluntarily reported objects that most excavations are chance finds on ploughed land, as the museum representative does here.

5.1.4 'A Source of Income for Local Populations'

It's obviously really bad to go knocking things off other people's temples. It happens as much in Greece and Italy – icons get stolen out of churches and things like this. But to me at least, in my thinking it's not that bad that people dig up things out of the ground that have been there for over 900 years or more, and some poor farmer can get some extra money out of something he finds in his field, then jolly good luck to him. (Bangkok Dealer 1)

The revenue gained by locals from illegal digging in source countries is frequently touted as a beneficial outcome of the market by western buyers. If you asked the diggers, the market view goes, they would prefer to be allowed to dig than not. And when the sums offered to them to work with archaeologists are lower than the price they obtain from the local buyer for the objects they find, it is obvious which method of digging they prefer:

I knew a young man who went for his doctorate in archaeology and as his thesis he studied the impact of the archaeological trade on the diggers in one of the middle American countries: I think it was Guatemala or El Salvador. These are the descendants of the Indians; basically they are Indians. They would dig in between planting seasons. Whatever they would find there was word out that there were guys that they could call in one of the big cities who would come over and give them x amount of money for the object. And the amount of money that they would get would be in point of fact considerable, up to the entire cost of their crop if they lucked out. So in many of these places they view it as manna from their ancestors, giving them the ability to get over a lean period, when there was a drought or something. Whereas the archaeologists would come in and hire them as day labourers and pay them however many pesos a day, and take the material and move it to either the national museum where they would never see it… or take it to a foreign museum. And he found out that there was much stronger feeling and bias against the archaeologists than there was against the people that were coming in and buying from the, they call them huaqueros, they're the people that dig: a huaqua is a hole and the huaqueros are the diggers. (New York Dealer 5)

Although it is acknowledged in the interview data that local finders in source countries only receive a fraction of what the international market will finally pay for the piece, this is not seen as unfair to them. They are grateful for the small amount they are given, it is

said, because it seems large to them. The fact that dealers overseas will make much more in profits from their sales than finders receive is not seen as inequitable, and certainly not as exploitative:

> *Smuggling is a wonderful business for small people, for poor people. You're concerned about let's say Thailand or Cambodia. These people sell pieces for $50 or $100: that's, you know, a month's wages. Sometimes several months' wages. And that $100 goes to $1000 through the local heavy, to $10,000 outside: I mean the escalation of the prices is sometimes incredible.* (New York Dealer 4)

5.2 THOSE THAT WOULD TRY TO STOP THE MARKET ARE BAD

The market interviewees see archaeologists and source governments as their foes. Here I set out their criticisms of each group. In terms of classic criminological theory, these criticisms are forms of 'condemnation of the condemners'.[9] I shall further explain and expand upon this theory in Chapter 6. First, it is important to illustrate the presence of these critical lines of discourse in the data. In respect of archaeologists, it is said that they, as well as looters, cause destruction; that they are not sufficiently well funded to ensure the expeditious removal of antiquities from the soil; that they often do not publish their work; and that they have no appreciation of the aesthetics of the objects they find. In respect of source countries, it is said that they do not properly care for their heritage; that they deal poorly with chance finders; that they are corrupt; and that they own the objects through geography rather than affiliation. I shall examine these arguments in more detail in this section.

5.2.1 Archaeologists

> *As it stands for example in Italy, if a farmer finds something in a field, ploughing, and he finds it in the field, he has to stop ploughing and call the archaeological department. He has to wait for them to come, and then they decide on the importance of the object or the context, and he then either gets reimbursed or not for the time lost. And then they take over, and then they dig and he can't use that field until such time as they finish their dig. So he has a choice of burying the object again, calling someone to sell it to, calling the archaeological department, or just even breaking it up and pretending that it never happened, because it represents a real loss of income for these people. There's also another instance where a lot of these people that the archaeologists say are very angry over the loss of their cultural patrimony are in point of fact much angrier at the archaeologists than*

9 G.M. Sykes, & D. Matza, 'Techniques of Neutralisation: a Theory of Delinquency', (1957) 22 *American Sociological Review*, 664.

at the people that come down there and buy the material for the free market. (New York Dealer 5)

Archaeologists do not have a good reputation among the dealers and collectors in the market. Even museum representatives fall into using the anti-archaeologist discourse which pervades the market from time to time. The more radical end of the spectrum of market opinion holds the only worth of archaeologists as being their capacity to find new items for the trade, and this is a function which they are not seen as performing very efficiently. Certainly not as efficiently as looters:

> *What very often happens is initially it's a chance find. Some farmer is out there ploughing his field, he runs across something interesting. Probably he gets very little money for it, but then it gets filtered back to the market, somebody recognises it as something good and then they trace it back to where it came from. And then if they think there's a likelihood of other things being there, they will organise digs. For example the whole north east of Thailand has been thoroughly covered with metal detectors. The Americans probably provided the American detectors in the Vietnam War. And they've found some quite interesting things without the assistance of archaeologists.* (Bangkok Dealer 1)

Some at this end of the spectrum of opinion deny that the archaeologists' project is worthwhile. Context, it is thought, is rarely of importance. So rarely, in fact, as to make pointless the safeguarding of sites, for the looters in all probability are doing no damage:

> *How much knowledge is lost? Some types of knowledge are lost. If you're interested in what kind of pollens were found in a certain tomb, or that kind of archaeology, or what people ate, well... How much does it tell you, how much does context tell you about the thing itself? Most of these contexts are pretty similar. I mean if you find an Etruscan something in a Spanish tomb, that's of interest, but... most of these contexts are pretty mundane and similar... depending on the period of time and how people buried their dead.* (New York Dealer 2)

> *It's a bit questionable how much context one gets from a large percentage of these archaeological sites and certainly I worked on a number of sites that I think very little of any value was learned from. So I think it's something the archaeologists tend to use because it shocks people and because it conjures up images of temples being torn apart and things being broken and it's sort of very violent and disturbing, but the reality is very different I think.* (New York Dealer 3)

> *We have the graves, and I hate to be trite about it, but once you've found a few graves, you've found all of them. In other*

words, there's literally very very little that could be found excavating Cycladic tombs, except finding more of the figures in the burial lots. It's a shame that they're all done illicitly, but it doesn't add to [he means detract from] our field of knowledge of the Cycladic age that heavily. (New York Dealer 4)

Although held by some members of the trade, it would be misleading to paint this viewpoint as that of the majority, other than in a more diluted form that demands recognition that context is not the only important knowledge associated with ancient objects:

When an object is not discovered by an archaeologist, some certain amounts of context are lost, but the work that remains is a fantastic evidence of its culture; or if its period or if context is known, maybe it doesn't have all the context that it would if an archaeologist had recorded it, but the work is not really useless. You can learn about the work through context, but also you can learn about the work by observing the work itself. (New York Dealer 6)

Most archaeologists now are trained to see things solely in terms of cultural context, archaeological context, to the point where they really don't look at the object in terms of its aesthetic qualities. Its intrinsic value as just a beautiful object is completely subsumed and is completely secondary to the fact that it was found in strata A next to this pot, next to this, you know, extinguished fire, which shows us that it was from this particular period, which is very, very important in putting the puzzle together, and is relevant, but is not the only picture. (New York Dealer 5)

The flaws of the stronger version of the argument – that looting should be excused because in the majority of instances it does no harm to context – are obvious, even to colleagues in the market:

I can see that's quite a clever argument, but I think it is in the end self-serving… I think that the argument that the graves which these objects are in… are much the same is really tendentious because how do you know that that one from which that object came was the same or something completely different? And in fact the way a lot of archaeology works, and I'm sure a lot of archaeologists would say this, is not spectacular finds, but looking at how people lived in ancient times. And it's looking at the 99,000 burials and looking at those and analysing them and looking at the remains of the individuals… Although it might be true that an individual grave might not give you any fantastically new piece of information, archaeology's really about amassing lots of data, and looking at patterns… I think dealers have this Indiana Jones view of archaeology; it's about, you know, making another Tutankhamen type discovery, and of course it isn't. (London Museum 1)

Some members of the market revealed a misunderstanding of the very nature of context, the most important of arguments levelled against their buying practices, which leads one to wonder whether they have listened with any degree of care to the case against them:

> Most chance finds have no context. They're just found in the ground. Context are the official temples and things...
> (Geneva Collector 1)

Although we move away from this radical, and in some cases uninformed, position as we examine the majority of trade practitioners' views, the feeling that archaeologists do not have an appropriate platform from which to criticise the trade remains prevalent. This anti-archaeologist discourse takes four standard forms (in addition to the denial of the importance of context mentioned) which we shall examine now.

5.2.1.1 "They cause destruction too"

Firstly, archaeologists are thought to cause destruction which the interviewees see as comparable to the destruction caused by looters. One group is, then, no better than the other:

> A trained archaeologist cannot excavate a site without damaging the site. It's an inevitable thing to some degree. I'm surprised that someone hasn't come along and pointed out that we are violating graves all over the place and isn't it more civilised to let these people lie. (New York Dealer 1)

> If you're interested in a Greek level, but you have to get through the Byzantine level or the Renaissance level, or whatever else above that, you just dig through. With the potsherds, a friend of ours in Mexico is a good guy, he's an archaeologist. He's sent up on the hills to find these potsherds and then they find the potsherds and then they dump them in big pits and bury them because they don't want to deal with them. You know, they might look through and see if there's something interesting, but they just dump them. Boardman, you know, at Oxford, said archaeologists do more damage, and he may be right, than anyone in the market place. Because they're interested in only what they're interested in. They have to get to it. And how do you get to it? You have to dig through other things, and those things, you can't have it all. (New York Dealer 2)

5.2.1.2 "They are not sufficiently well funded"

Secondly, archaeologists are noted to have little funding. Therefore, the argument runs, they cannot protect sites effectively owing to their inability to maintain a presence at all places where important deposits of cultural heritage lie. To an extent, then, it is thought that they bring the looting upon themselves through their inability to protect their sites. For the criminologist, this tactic can be recognised as blaming the victim for his or her misfortune:

[The Sipan treasure], *yeah, that was big big plunder. But we all know why, what and how. Gold always makes you a bit crazy. But the funniest thing, just as an example, the mound of Sipan is known for more than 100 years, okay? It was not a new discovery. And everybody knew what was in there. How come nobody excavated it? Especially not the Americans who had the rights. So the poor guy had one night to dream that tomorrow is the day, and he went in, and bingo, that was the day. And now everyone's screaming...*

They don't want to protect it. [In Pakistan] *they're all Muslims. I mean if you are stealing in Pakistan an Islamic tombstone, they shoot you, they stone you and they chop you into pieces. Because it's a religious thing, of their religion of today. But the Buddhism has died in Pakistan 1,500 years ago. They have no connection to it whatsoever. Sure, they have a couple of colleges there which are worldwide known, but they are so busy in other things they have very, very, very, very limited funds to excavate more of what they have already... What they mainly do is try to find some money to get their own house in order, their own museums in order, because there are older chattels in real serious condition... It's absolutely crazy. Everywhere in Asia is really, really bad.* (London Dealer 5)

A more tenable line of argument put forward under this head is that insofar as archaeologists – who have no funding themselves to excavate many sites – resist the unauthorised excavation of antiquities by others, this position endangers the underground heritage, placing objects at risk of deterioration as chemicals used in farming seep down into the soil, or at risk of loss through natural or man-made disasters:

The Three Gorges Dam project is going to submerge I think 50,000 archaeological sites within the next three or four years. They have a budget of I think something like $8-10 per archaeological site. And what I've heard from some people is that there's de facto agreement with the regional government that people that are going to be displaced can dig whatever they can find and they can sell it and use the money... Now aside from the enormous result of the Three Gorges Dam, which I think is going to end up being as big an ecological disaster as the Aswan dam - it's going to be awful for the ecology - we're going to lose forever 50,000 of these sites dating from 5,000 B.C. to 1,300 A.D. Is it better not to see any of the stuff? Is it okay? Do we just let it all go and let it get buried? If you follow the logic that the archaeologists are propounding... then no, we don't need to see any of the stuff, we don't need to learn anything, piecemeal though it may be about the objects – let it get flooded. (New York Dealer 5)

> *My experience for example is that bronze objects found in the UK before the Second World War are invariably in much better condition than bronze objects found now. And the reason for that is chemical farming. So the archaeologists who say 'well actually you should simply ban it because everything should remain under the ground': in 50 years time this stuff won't exist at all. It'll have been corroded away. And deep ploughing damages a hell of a lot too. And sooner or later the stuff will just go. And it's never going to be found by proper rigid archaeological methods – there is no chance.* (London Dealer 8)

Here we hark back to the image of the market saving objects which might otherwise be damaged or destroyed, and performing its role as cultural educator:

> *There were some archaeologists a generation and a half ago who would go around and sit with the dealers in Paris and London and the US and see what they got from where and talk about it, and would have an example that was from a similar context from a museum in Oslo, and they'd say this is very likely from the same site, and they'd try to elicit information from the people, you know: 'do you know where you got it from?' and people that were getting the material, let's say in Shanghai or Beijing in 1936 would speak to their people if they were careful and say 'where did you get this' and they'd say 'well I got it in a field right here'. So there was some information to be gleaned, that in conjunction with the scientific excavations help, I think, to add to the picture. It doesn't diminish the picture. It may make the picture a little harder to put together in its entirety, but again it's a matter of money. Archaeologists are not getting the capital to get these digs together. I mean a lot of this stuff would never be seen.* (New York Dealer 5)

As is evident here, the perceived reactionary bent of the many modern-day archaeologists who refuse to examine, authenticate, value or discuss unprovenanced antiquities in the market which they know or suspect to have been looted, is not welcomed by traders. Those who, however misguidedly, see their role as protector of culture do not take kindly to such snubs and see archaeologists as biting the hand that has in the past fed them:

> *If they're trying to antagonise many of the benefactors who sponsor the digs, out of their love for antiquity and out of their love for history, how are they going to get more funding? If a lot of collectors often provide a lot of funding for archaeological digs and they give money directly or indirectly to universities? The moment that you begin to have adversarial relationships with people who actually love this field, you're shooting yourself in the foot. And this is one of the things that archaeologists haven't quite understood.*

> *Interests of archaeologists is best served by people who love them, who will allocate them resources.* (New York Dealer 6)

That dealers and collectors are not shown due appreciation for their 'love' does not seem to give them pause for thought over their actions, but rather the lack of thanks for the good deeds the market performs is attributed to failings of the archaeologists involved, such as professional rivalry, jealousy and a small-mindedness when it comes to acknowledging the work and expertise of the trade:

> *They've all got their own little patch to protect and their little reputation and so on. I think they're intensely jealous, also. There's a lot of jealousy. Because they see things being bought and sold for huge amounts of money and obviously dealers getting rich and getting fat and happy, and they're struggling away with no budget and they desperately would love to have the money to go out to Cambodia or wherever, Tibet, and do some serious archaeology. And they can't because they don't have the money. So I think there's a lot of envy involved.* (Bangkok Dealer 1)

> *[So the Fine Arts Department, they know who you are?]*

> *Oh, yes.*

> *[What level of interest do they take in you?]*

> *They refuse to acknowledge that I exist. They've written on the subject and they refuse to acknowledge my books. Once in the last twenty years, one person has very reluctantly come here to look at my collection.* (Chiang Mai Collector 1)

Overall, the feeling among members of the market is that antiquities are better out of the ground than in it, however this transition occurs:

> *It's useless if - it doesn't serve a purpose if it's in the ground and it doesn't serve a purpose if it sits in the basement of a museum in India. It just gathers dust and mould or whatever.* (London Dealer 7)

Source countries and their archaeologists do not have enough finance to attend to this efficiently. That the lack of funds inhibits excavation and the pursuit of archaeological knowledge is a point which archaeologists themselves will willingly concede:

> *[What sort of funding do you have as archaeologists? Do you have a lot of money to spend on digging?]*

> *Not much, not much. Very, very few.*

> *[The money comes from the government?]*

> *Yes.*

[And for universities, where does their money come from?]

Comes from government also. From outside, from foundation or something, very, very rare. Very few. Most of the budget we spend preserve the monument, not for the archaeological find. Not for the knowledge. Last year we got only 100 thousand baht for one site excavation. We can excavate only one site. One pit. And we have to survey. Last year we can do it for 10 sites, that's all.

[10 sites in one year? For survey or for dig?]

For survey.

[And dig only one?]

Yes. (Bangkok Archaeologist 2)

There is little sympathy for the archaeologists' predicament to be found in the market, however. Over and above the chemical damage argument that is sometimes employed by traders, there is a general feeling that if local archaeologists cannot find the resources or impetus to institute a vigorous programme of excavation, it is fair for the local population to take matters in hand:

The archaeological sites, for guided or proper archaeological digs, in general, have always been found, I would say up to 90%, have always been found by diggers. The archaeologists were always second. Or have you ever seen an archaeologist walking around trying to look out for a new excavation site? No. It's always the digger who digs the first hole, and then the archaeologists hear that some great object came out and then they jump on it and they do the excavation. So if you abolish from now on any digger in this world, I believe honestly that the archaeological flow will in a couple of years start to come to a point of standstill. (London Dealer 5)

I think the metal detector guys are doing most of it. Like in Britain for instance, and people should be thankful to them in some ways, if they do it properly they have to register, bring the things in, then it can be sold or the government can have a chance to decide, but there are seeing a lot more objects and a lot more coins particularly than they ever would have if they just relied on the archaeologists. I mean really, there's a sort of sanctity about archaeologists that is just unrealistic and hypocritical. (New York Dealer 2)

5.2.1.3 *"They don't publish their findings"*

The third standard form of anti-archaeologist argument is that what little information as is assumed to be gathered from the limited amount of excavation archaeologists are able to perform on their restricted budget, often remains unpublished. What good is this to humanity, it is asked?

... storerooms which have boxes from 1800 which until today have not been opened because the guy died. He's been paid by the museum to make an archaeological survey. He digged, he gathered all the goods. And they're all very secretive, they don't talk to their colleagues, and then he dies. So five years of work is lingering in the storeroom. (London Dealer 5)

They don't relate to objects, they think it's all historical documentation. They don't understand they're looking at something more. It's not money, it is to me the soul of the world... but apart from that they think that the world has to wait for them to intervene. And this doesn't happen because there's not enough funding, because there are countries at war, because there are floods and acts of God. And they're sitting on their work and bickering most of the time. I've worked with archaeologists on other matters. It's mad. Because the only way they can show off is through their work. They're very secretive. They rarely share what they find. They're incredibly slow, and I think quite ineffective. (London Dealer 2)

In law, objects discovered (and undiscovered) often belong to the State, for whom almost all archaeologists in source countries work, whether directly or through universities. It therefore seems peculiar to these State employees that anyone would question their claim to a monopoly right of access to the objects. Much archaeological work is published, in one form or another, and the fact that information is not generally shared with a trade which archaeologists see as to a large extent being responsible for the propagation of the looting problem, is not seen as problematic:

By law everything that's under the ground belongs to the State. So we have to study and we have to do the data inventory and things like that. And so basically that is the case and they might be right that we don't let anyone else study. (Bangkok Archaeologist 1)

5.2.1.4 "They don't love the art"

Fourthly, and finally, it is generally offered that archaeologists do not see the aesthetic value of the objects which are the subject of their project. They care only about context:

The people who should be the scholars of society, the archaeologists, treat it just as data and not as art. (Geneva Collector 1)

This point, while being difficult to substantiate or indeed to believe, is also rather confusing in its logic. At one level, shifting the priority from context to object enables traders to see themselves as saviours of what is important and possessors of their own brand of knowledge, which should be celebrated:

> *Some of the professional archaeologists and art historians get incensed that anybody else has the temerity to get involved. In fact, many professional dealers by the nature of their business and the number of things they handle and the fact that they have to know what they're doing otherwise they can't do business, many of them know at least as much and in many cases more, I would say, than some of the professional archaeologists, who are in some cases restricted because of lack of budget to studying previous material and stuck in some room somewhere.* (Bangkok Dealer 1)

At a lower level, however, this line of thinking seems to amount to a simple trade argument that "if they don't care about what we care about [aesthetics], why should we care about what they care about [context]?" As archaeologists look out for their own interests with little regard for those of the trade, this justifies the trade in doing similar:

> *People seem, particularly the archaeologists, to have an interest in currying favour with the regime that is running Egypt or Italy or Nigeria or wherever, so that they can pursue their goals. Their goals may or may not be in the best interests of the people in Nigeria or the people in New York.* (New York Dealer 1)

> *I think a lot of people in the trade would be struck by the hypocrisy of all of this. You know, the rhetoric that has been used because the agenda is that the archaeologists would like to secure their own patch much better and you know, look good with the government of China or Pakistan or whatever.* (London Dealer 1)

> *What is important is the object. And that's what people went looking for. [Archaeologists] they're interested in issues, they're interested in abstract issues, and they're not interested in the objects. And just a few people are... Archaeologists couldn't give a damn about art. So they say that any information is important information and any information lost is important to their research. Oh well.* (New York Dealer 2)

We might conclude this documenting of views on the practices of archaeologists by quoting one of the lawyers interviewed. This lawyer, as will be evident, is staunchly pro-trade. He explains the archaeological position in what he thinks are honest terms. An objective reader will, however, find his portrayal of the archaeologists' position to be an exaggeration, crossing the line from description into caricature. He simplifies the many arguments against the trade to the point that they become impossible to support, and this makes it easy for him to suggest that they should be dismissed. His thoughts typify the unbalanced way in which the trade represents archaeologists and their interests in its discourse:

Then there's the archaeologists' view, and the archaeologists say that "we love foreign export controls because we think that every object is potentially critical to understanding the archaeological database. If you take anything out of context, other than pursuant to a scientific excavation supervised by a trained American archaeologist, an archaeologist I like from another peer university, me, unless the object is excavated scientifically, you're stuck with a pot that speaks only for itself and you lost this huge penumbra of scientific information that will tell us more about what we need to know about the entire historical and cultural and anthropological and archaeological context in which the culture that generated this object", I forgot the verb that should end that sentence. So their position is that every site is sacred, every object is sacred to the site, nothing should be removed and although foreign blanket export controls may be defective and counter-productive, we like them because our primary goal as scientists is to protect our potential database. And oh, by the way, yes we acknowledge that there have been objects that have existed in private hands and out of context above the ground for thousands of years, but you know what, that trade really should be banned because it just encourages an insatiable lust for newer fresher objects. So the entire trade in antiquities really just encourages site looting, and indeed the biggest, most prestigious collectors are nothing more than willing accomplices to tomb looters. They are criminals one stage removed, because they're willing to turn a blind eye to the whole sordid trail of illegal excavation. So that's what the archaeologists say. They care about stopping the trade by whatever means they can, in order to protect their database. (New York Lawyer 2)

5.2.2　　Source Countries

Archaeologists, therefore, are the subject of significant criticism by the market, and this criticism is composed of common threads of argument. These arose with surprising regularity among the variety of market interviewees. Source countries also were criticised in like manner.

Buyers frequently fail to inquire about the origins of the pieces they are purchasing, even when it is obvious that laws must have been violated to get the objects from the source-country to them. Collectors justify their purchases of illicit antiquities by claiming that they will cherish and study these objects in a way that the source country would not, because of negligence or corruption.[10]

Condemnation of source countries, and in particular their governments, ranges from allegations of an official lack of interest

10　　J.E. Conklin, *Art Crime* (1994, Westport, CT, Praeger) at p. 188.

in the proper management of the countries' antiquities, through their unfair treatment of finders of antiquities and allegations of official corruption, to the arbitrary nature of their claims to ownership of antiquities. Examples of this 'condemnation of the condemners' follow, compiled under these four headings.

5.2.2.1 "They don't properly care for their heritage"

Museums in source countries stockpile objects in conditions which are less than optimal for their preservation. They do not display many of these, instead keeping them in warehouses, uncatalogued and largely unknown to the world. So goes the view of the market interviewees:

> Were they to have the will and the wherewithal to dig up all this stuff, they got no place to put it. They got no place to care for it. Not only that, it would be completely redundant. Therefore in Peru in the National Museum you have these... pots from one particular culture that have heads and various scenes on them, and they've got them stacked fifteen in a row. Some of them are generic and some of them are individual, but you literally have fifteen in a row. Now is it necessary to have fifteen of the same object in an area that's earthquake prone...? (New York Dealer 5)

> There's so much in the country of origin – so much, unkept, uncared for, unloved, in cellars, rotting, unrestored, unpublished – that you can't criticise the British Museum for the things they have, the way they exhibit things. (Geneva Collector 1)

> The Italians do have a problem, but they don't help themselves. There's a major vase collection of Greek vases in Paola. I think I've been there nine times now. It has never ever been open, over twenty-odd years. I haven't been there in a few years. The last time I was there, there was a large notice on the door written by I don't know who, probably a furious academic who wanted to go and see them and had been told he couldn't, saying that these belonged to - and this is the name and address of - the sovrintenza. If you want to get in, you have to speak with him. And you know, exclamation mark, question mark, exclamation mark. (London Dealer 4)

> [Thai museums] do have, as I say, these things off sunken junks for instance, they've got rooms full of those. But they're just all muddled up. You go down to the basement of the museum here and the bags they're put in are broken and they've all got mixed up and so on. (Chiang Mai Collector 1)

If source countries cannot find the resources or will to house, protect, restore and display objects which they have found, what will become of those antiquities still underground?

> When I studied Egyptian art our teacher stated, and this
> was twelve or fifteen years ago, that only either 4 or 6% of
> the material that's of archaeological nature has been dug
> up in Egypt. So there's 94% still in the ground. I believe that
> the Egyptian government now stated that they have no
> capacity to handle any more objects. They've got about 2
> million objects recorded and they can't handle any more.
> They can't house it, they can't restore it, they can't show it,
> I mean what are they going to do with it? So that means that
> the archaeologists still want to dig, but what do they do
> with the stuff? (New York Dealer 5)

The artefacts, objects of desire for dealers, collectors and museums
in market nations, do not hold any real interest for source
governments, it is alleged. They see them only as vote-winners –
as means to shoring up national sentiment among the populace.
The claims for return of items of national heritage by source
countries are international soundings for respect and the
reinforcement of sovereignty between nations, rather than anything
to do with an affinity for the objects themselves, it is thought:

> I think what's happened to archaeology now is that it's
> become really nationalist. Elgin Marbles, prime case. Is
> Greece really that concerned with them or do they just want
> to make a little point? It's all turned into politics. Rather
> than looking at it as humanity's past it's become really
> nationalist. (Melbourne Dealer 1)

> If all the antiquities went back to the countries of origin, they
> simply could not accommodate them. (London Dealer 9)

What is perceived by the market as the rampant nationalism
underlying policies of retention and reclaim, is portrayed in an
unfavourable light. Such is the radical and unreasonable nature of
source countries as seen by the market, that their restrictive
approach to the movement of cultural heritage is thought to condone
looting so long as the objects are not exported:

> You may find that Greece may claim everything in the
> ground, but certain private collectors have licences to collect;
> the Prime Minister... he bought all the looted stuff. Mrs
> Goulandris, she made a museum. She bought all the looted
> Cycladic stuff. The Greeks never bothered to do an
> archaeological dig in those areas, so she saved it. I mean
> it's great what she's done, she's built a beautiful museum
> full of wonderful things and presented this material, but
> it's all looted. Looted from themselves. It's only when
> someone else buys it out of the country that they talk about
> looting, but it's all looted. It doesn't come from any place
> but a grave. (New York Dealer 2)

> A lot of major Thai politicians and police, certain notorious
> police generals, collect the stuff. So they're not really very
> intent on cracking down. (Bangkok Dealer 1)

Even on the rare occasion that some of the more liberal elements of the government attempt to sell surplus patrimony, they are prevented from doing so by the weight of national sentiment manifested through other powerful figures in the country:

> *The Egyptians in the '70s proposed to sell a bunch of inventory on the public market so that they could pay for the conservation of the stuff they wanted to keep in the national museum, but that got shouted down.* (New York Lawyer 2)

Several interviewees mentioned their feeling that consultation with a source government before the purchase of an antiquity which appeared to have originated in that government's territory was futile. This was so because the government would rarely, it was thought, give an answer which would meet the buyer's needs. Three types of response (or lack of it) to such enquiry seem to be popular on the part of source governments. Often there would simply be no reply. Sometimes the object would be claimed to be the property of the source government without apparent investigation on its part. Finally, it was possible that the government would come back uncommitted, saying that while it did not have any evidence that the object had been looted from its territory, it retained the right to make a future claim if any such evidence were to arise:

> *What they do, they write to the country of origin. The Met had a very good system. They gave a month and a half, 45 days, to the archaeological survey to come back with any problems. This is in Pakistan. If they didn't come back with any problems in a month and a half, which they never did, it would buy the piece. With India, if you write to them and you have a piece which was given as a present to Queen Victoria and you say "we'd love to buy this" then they'll say it's been stolen from India. They have a prefabricated letter. So you're not really getting anywhere.* (London Dealer 2)

A dealer in New York explains why he no longer bothers to consult source countries prior to purchasing objects. He was offered a collection of gold pieces, received an unsure reply from the Greek Ministry of Culture, bought the gold and was later sued in the New York courts by Greece in a claim for the recovery of the gold which the Greek government alleged had been looted from a gravesite in its jurisdiction. The case was settled out of court and the treasure was returned to Greece:

> *You know I was sued by the Greek government, for instance? Well, that was a real experience. I bought a group of gold objects, I had an exhibition, we published them in a catalogue... I mean we used to send letters to foreign countries: we sent letters to Greece about this gold, to the Ministry of Culture, sent photographs, asking if they knew of this material. They said they didn't know of it, but it*

could turn out to be theirs and there could be a claim. But at least we made them aware of this material. And we stopped doing that after this case, because these countries can do anything they want. Basically. In the United States no one is protected from even outlandish claims. They just do it.
(New York Dealer 2)

5.2.2.2 "They deal poorly with chance finders"

Legislation vesting all undiscovered antiquities in the State requires to be coupled with a dynamic and well-funded program of archaeology in Source countries if unfairness to the finders of antiquities is to be avoided. Otherwise, it is argued, chance finders of antiquities on their land can be greatly inconvenienced by the investigations of the findspot and surrounding area that will follow their reporting of the find, and the delay that must be endured before these investigations take place. The following passage illustrates this view, set among various other points common in the anecdotes circulating in the market, which the reader will by this stage recognise as familiar:

I come from Italy. I lived in Italy until ten years ago. I was always confronted with this problem, even as a kid, because Italians are sitting on one of the greatest art treasures in the world. There are very stupid, short-sighted, draconian laws whereby you cannot own anything that comes out of the soil and that is antique. Having said that, the whole of the countryside is full of the stuff. And what was happening in the past, there were no dealers, there were a few pieces, maybe from old renaissance or eighteenth-century Roman collections sometimes on the market, and the sort of intelligentsia, the old bourgeoisie, the dentists, the notaries, the lawyers and stuff, all had a small collection of pots in their study, which they were buying locally from not necessarily art dealers. What was happening was a lot of these pots and things were being destroyed because... there is this obsession in poorer source countries that every site has treasures, or a treasure to be found, so they were breaking vases to see if there were coins inside. Because basically, no farmer in Italy then, or Muhajadeen in Afghanistan now, knows the value, or knows what's good or bad or great or whatever. And therefore the first instinct was to find coins, metal. Either things they could melt or sell, but that have a tangible value. And then of course they found out that there was a market, a growing market, I would say in the '60s probably ,'60s and '70s, and what happened is, if you find a vase in your field, or a tomb or something like that, through the police, the government comes and seals off your field. Forever. I mean it takes years. There's no emergency team to check what the site is all about. So it can take forever. Also because there's very little money involved, not only in Italy but in most of the source countries with art and the safety of local heritage, basically because it doesn't bring in votes or

> *money… And so what happened is, farmers wouldn't go,*
> *because let's not forget initially a lot of the antiquities were*
> *chance finds. So farmers started going to the local, call it*
> *Mafia boss if you like, who would give them money and then*
> *through the network, it's not Mafia, but you know, even the*
> *carabinieri, there's so much corruption all over the place. The*
> *stuff would then go to Switzerland, get a proper provenance*
> *and be sold in the market. This is what was happening then.*
> (London Dealer 2)

Again, we return to the theme of the market as the preserver of objects, specifically those found by chance which, as was detailed above, it is said would very likely be destroyed by the finder in order to avoid the unpleasant consequences reporting might bring. This point, therefore, is simultaneously a condemnation of source governments and archaeologists and an argument in favour of the market:

> *Ninety-nine percent of the countries in the world don't have*
> *any kind of compensation, and worse than that, they have*
> *heavy handed bureaucracy that comes down on poor farmer*
> *number twenty-seven, who made the mistake of honestly*
> *saying "gee I found this in the back yard". They shut down*
> *his farm, they bring in endless numbers of people who have,*
> *either through ineptitude or through corruption or through a*
> *combination of both, a very slow way of developing the*
> *possibilities that might or might not exist under the ground*
> *in his farm. Meanwhile, he's out of business, with no*
> *compensation whatsoever. And the end result might be that*
> *they find something good and it goes in the national museum*
> *to everyone's benefit, or it might be that they find there isn't*
> *much. And they might take just as long in either case. But*
> *that pattern of behaviour, when they hear about what*
> *happened to their friend down the road, gives them a*
> *possible incentive to either destroy the piece and get on with*
> *it, keep ploughing and make sure nobody knows about it,*
> *or to pull it out and not tell anyone about it and try and get,*
> *you know, to a pawnbroker or to somebody to put it in the*
> *chain of the market, to get it out of the way, to their benefit.*
> *So that as long as the governments rely on an oppressive*
> *approach that says "'turn yourself in, and we will punish*
> *you", it seems to me highly unlikely to succeed in the goals*
> *listed by the archaeologists and the national museums and*
> *so forth.* (New York Dealer 1)

The point of course, again, is that there will be no way for a buyer in the west to tell whether what he is offered is the result of a chance find 'saved from destruction' by the value the market has put on it, or the result of looting undertaken in search of objects, inspired by the value the market has put on them.

In Thailand, local criticism of the government and its archaeologists fades into one. It is thought that they seek an unfair monopoly on the country's cultural heritage. It is seen as being unfair because through restricting the rights of individuals to dig up and sell antiquities, they are both interfering with the day-to-day activities of citizens and denying possession of the excavated objects to collectors (both local and international) who would care for the objects. A collector of Thai ceramics living in Thailand gives his opinion on the activities of the Thai Fine Arts Department:

> [What about the point that the archaeologists make about the destruction of context through digging things up? What's your view on that?]
>
> Well the trouble with this is that the FAD here is not knowledgeable enough and is not sufficiently well financed really to be able to do any proper work at all. These fabulous burial sites, which was probably one of the great archaeological finds in the last 50 years in Asia, they didn't dare go there, because they would have had to try to arrest everyone who's digging. And they'd have got shot. So they did nothing there at all. The kiln sites, they've dabbled around and they've dug up a couple of kilns, and then just left them. And it's rained and they've been destroyed. The FAD in Thailand was basically set up to look after Buddhist artefacts, and they're not interested in Thai ceramics. They've done some work on prehistory, and otherwise on Buddhism.
>
> [So their view is that taking these things out of the ground is better than leaving them in the ground?]
>
> Yes. But the farmer, you see, if the farmer finds something on his land, he will immediately dig it up, because if the FAD get their hands on it, it'll be dead land. He won't be allowed to use it; he won't get any compensation.
>
> [They come in and commandeer the find?]
>
> Yes. But then they have no funds, so they don't do anything with it.
>
> [With no compensation to him?]
>
> No. (Chiang Mai Collector 1)

The argument, it will be noticed, often proceeds along the lines of 'if a farmer finds something in his field'. Certainly, policies developed by source countries to deal with situations like this and to encourage farmers who find antiquities on their land during routine activities would seem desirable. England was often touted by the interviewees as an example of a country which had such admirable policies. We should note here two things, however. The first is that England in

its capacity of source country is one of few which have not passed national vesting legislation, taking ownership of undiscovered antiquities. In England, with the exception of treasure (broadly gold and silver)[11] which belongs to the Crown, antiquities found on private land belong to the owner of that land. The number of collectors of antiquities, as has been discussed above, being small, the chances that the owner of the land on which the find is made will want to keep the object are similarly small. Most antiquities found in England are therefore passed on to the market, and to dealers if they are not first acquired by an English museum. This is a situation which we can assume to be pleasing for the interviewees, and therefore can be offered as a strong possible reason for their enthusiasm for the English system over those of other source countries, rather than any real concern for the well-being or civil rights of the owners of the land on which finds are made. The agenda of the market is to ensure the continued supply of objects from source to demand, and the freedoms of finders or owners of land are supported insofar as this accords with the market's goal.

The second point is that the interviewees use the example of the farmer in his field as justification for the market. While the inactivity of source countries and their archaeologists leaves farmers who find antiquities with the stark choice of destroying the objects or reporting them to the government and suffering the adverse consequences, it is thought to be right that the market should offer them a third choice. Illegal excavation, non-reporting and export is therefore seen as justified as the best of three bad options, for it ensures both the survival of the object and of the farmer and his business. Whatever the merits of this argument, it applies to hardly any other category of chance find besides the discovery by the owner of an object on his land, over which he needs constant access in the course of his business. The argument does not work for objects found on public land, other than in the course of a major road-building project or suchlike, which would suffer delay:

> It happens everywhere. Specifically in Italy almost every time you dig, practically anywhere, you find something. Now if you are a digger on a motorway project or something, and a prime bit of marble is found, by Italian law, the contractor is obliged to inform the government and therefore the sovrintenza. What happens? They move in and they close the site down for twelve months while they muck around. Maybe they find something, maybe they find nothing. But is there any compensation to the contractor? None. So the contractors go bust. So what happens is, they either smash the thing up and just bury it under concrete or whatever it is that they're doing. Or, if one of the gang knows someone

11 See Treasure Act 1996

> *they can flog it to... it's at night illicitly shipped off to someone
> or other and they get a bit of spending money out of it.*
> (London Dealer 4)

Neither does the argument work for finds on private land where that
land is not vital to business. It is, however, offered by the interviewees
as a justification for purchasing *any* newly-surfacing antiquity on
the market, working on the assumptions that (a) most such objects
are chance finds, (b) most chance finds are made by farmers or builders
of infrastructure in the carrying out of their normal activities, and
(c) that the fact that the object comes with no provenance or
provenience information is not indicative of anything suspicious,
being simply the normal practice of the market. All of these
assumptions are, in fact, highly contentious.

5.2.2.3 *"They are corrupt"*

Another theme to emerge from the interviews in respect of source
countries was that of official corruption – the interest of some of
those in positions of local responsibility in looting in source countries
and illegal export. These allegations are not peculiar to the interview
data. In the *Schultz* case[12] for example, evidence was led that an
Egyptian Old Kingdom Bas Relief which the defendant was offering
for sale at the price of US$60,000 had been illegally acquired from
corrupt members of Egypt's antiquities police.[13] Several of the
interviewees had first-hand experience of similar official corruption.
Sometimes government officials were implicated in the smuggling
of antiquities out of the country for personal gain:

> *The better things being smuggled out, frankly they can be
> smuggled out anyhow. There's nothing countries can do to
> prohibit the smuggling out of antiquities, basically. As long
> as there's a willing buyer, there's nothing they can do. There
> are always in the market, whether it's a painting or a piece
> of jewellery or anything, there's always going to be a willing
> buyer for contraband. There's no way of preventing it. The
> only way of preventing it is a chain-link fence and people
> standing side by side. There's no way of preventing it. How
> many ambassadorial people do you think smuggle things
> out? I can tell you how many ambassadors or
> plenipotentiaries and all of these have things to sell,
> especially back in the '60s and '70s. A huge amount of
> material coming out. State department people too. There's
> nothing they can do to prevent major pieces being smuggled
> out. (New York Dealer 5)*

> *When you go... to Italy or to Turkey or to Greece, all
> politicians were actively involved in this business, in the*

12 178 F. Supp. 2d 445 (S.D.N.Y. 2002), 333 F.2d 393 (2d Cir. 2003), 147 L.Ed 2d 891
 (2004).
13 C. Bohlen, 'Antiquities Dealer is Sentenced to Prison' *New York Times*, 12 June 2002 (New
 York).

> *antique trade. They were not willing to change the law.
> They're losing out on a very thriving business to facilitate
> the flow of goods. Because they all had these old laws,
> everything which was older than 100 years is property of
> the government, but nobody couldn't care less because their
> museums at that time were already brimming over, and who
> the hell cares. There's another vase or another this or another
> that. (London Dealer 5)*

At other times, knowledge was revealed of widespread official
participation in the smuggling of antiquities, from police and military
personnel to local customs officials who operated under an
institutionally ingrained system of bribery:

> *I cannot really talk about classic antiquities, because it's
> not my world, I just hear it from my colleagues, but I can
> certainly talk about Asia, where I lived myself for more than
> twelve years... I was socially integrated there. I know how
> their heart and their minds tick, and I'm in and out there
> now since 1971. In South and Southeast Asia. Includes
> Pakistan, India, Cambodia, Vietnam, Thailand, Indonesia.
> I know what's going on... the only way how to preserve the
> stuff, and to make some money of course, that's always
> very important factor, the money, they are facilitating the
> transport and export of these objects.*

> *[This is the police or the army or?]*

> *It all depends how big, how fat an object is. The police in
> general in Thailand, Cambodia, Vietnam, Indonesia, does
> not have the facility to transport as military. But in general
> most of the time if you have something big and heavy it's the
> military. If it's something small, you actually don't need
> anybody except for the export. And there is 'stamp duty'.
> You don't get a stamp, you just pay the duty. And that's that.*

> *[And where does it go after that? Hong Kong?]*

> *Wherever. Wherever you want. Wherever you want. In the
> '70s, you would say a customs officer of the middle rank
> who has any kind of say, would make about $200 a month
> (in salary). So you can imagine, if he has from the tenth
> day of the month onwards, he has to start collecting. He is
> charging for anything he is doing. To anybody. Which is not
> slotted only into the art trade, no: anybody. "Give me some
> money". Otherwise he can't survive. Government only pays
> him so little because they don't have taxes. They can't pay
> anything. It's a tolerated system of kickbacks for services.
> Because the government just pays them a token. Whether
> you have a passport extended or your licence for a car
> extended, or you export something or you import something,
> whatever, you have to pay for it. That's it.*

[So when the archaeologists talk about illegal export of antiquities...]

Nonsense.

[It might be technically illegal, but it will have gone through a customs guy who will just take a certain amount of money.]

Everything is taxed. Everything, everything. Because they are more eager to check than a customs officer at Heathrow Airport, because they are checking for their income and not for the law. Here at Heathrow, or in the harbours here, they make these spot checks. Or if the invoice looks dodgy, they check it. But over there in Asia, in general, they check every goddamn box and they know what's in there, unless they get $3,000 before they even open the box. Then it's something big or something important.

[You pay them not to open the box?]

Yes.

[And has that changed now? Has it toned down a bit or is it still the same?]

It is still exactly the same. (London Dealer 5)

In addition to these specific experiences of corruption, much was relayed in the way of general imprecise allegations of source country corruption. The feeling these allegations seem intended to generate in the listener is a lack of sympathy for the plight of source countries in battling the looting problem. They themselves are implicated in the acts of excavation and cross-border transit they purport to outlaw and we are therefore invited to dismiss the notion that we in the west might help solve the looting problem if the source countries who complain about the loss of their heritage are part of that problem. It was often hard to tell whether this was genuine knowledge of official corruption on the part of the interviewees, or simply assumption:

I have it on reliable authority that there's a man in Borobudur who goes out in the middle of the night, breaks of Buddha heads and replaces them with fake heads. And he sells the real ones. If I know that in Australia, how many other people know about it? I should think that there is some official collaboration going on there. Somebody in a position of authority must know. (Melbourne Dealer 2)

I stopped dealing in Southeast Asian and Chinese art back in the late '80s, because I saw what was happening. Material coming out. In 1993 I believe it was, I went to Beijing and had meetings with the head of the antiquities department, the head of publications, and I prepared some exhibition catalogues for them. And as I'm preparing the

> *catalogues I find that the Chinese dealers in New York, London and Brussels were selling pieces that came out of those very finds. In other words, as things were being excavated, things were being spirited out of the country. And with the complicity no doubt of the excavators and the museum curators. This is a known thing. The things that have gone on in China are horrifying. The same thing started happening in Southeast Asia in general.* (New York Dealer 4)

> *You need people to physically protect the site, which is almost impossible because of corruption. And that's the third big problem. I mean everybody in poor countries tries to survive in any way they can. And a lot of the ways are basically illegal.* (London Dealer 2)

> *I have sent pieces back to Egypt which I had discovered to be stolen, and I've seen them on the market again six months later… What is changing is that pressure from archaeologists particularly in Britain and the United States, and Switzerland and wherever, is forcing our countries to enforce their laws* [i.e. those of source countries], *because they won't enforce them for themselves. Now I think that's wrong, personally. This is not a judicial point of view, it's a moral point of view. I just think it's wrong, if they make no real attempt to enforce their own laws. I mean they know who these people are. The Chinese do shoot people from time to time, hah, but on the whole they're making too much money out of it.* (London Dealer 8)

It seems true that there is much official corruption in source countries. A recent investigation into Thailand's illegal economies revealed widespread corruption involving many forms of wrongdoing for financial gain:

> Those whose responsibility it is to make the law and uphold the law are involved in breaking the law, for very high financial returns.[14]

It is, however, questionable to what extent this should count against those in government who legitimately do want to stop the looting of their country's antiquities. Although the Thai archaeologists in the interview sample confirmed their impression of corruption on the part of the domestic police force, we can still perhaps have sympathy for their plight in trying to stop the looting of Thai sites. It seems rather simplistic to equate the corrupt actions of some police and military with the broader governmental and legal processes by which the interests of Thailand and other source countries are represented on an international level. The argument that 'they can't protect

14 P. Phongpaichit, S. Piriyarangsan, & N. Treerat, *Guns, Girls, Gambling, Ganja: Thailand's Illegal Economy and Public Policy* (1998, Chiang Mai, Silkworm) at p. 5.

their own heritage' is used by the market interviewees as a reason why it would be pointless for the market to try. It does not occur to them that in the face of such levels of corruption at source, reducing demand for looted antiquities in the market might be an appropriate means of protecting sites. Certainly, the local situation is one over which archaeologists in Thailand feel relatively powerless:

> *They use tractors to destroy the stupa, then they dig upper chamber, then they destroy the stone and dig underground.*
>
> *[So for archaeologists when they come, there's a mess left and all the good stuff has gone?]*
>
> *Yeah.*
>
> *[Do the police try to stop this?]*
>
> *Police also. Why not them?*
>
> *[I see. Do they get money from it?]*
>
> *Yeah.* (Bangkok Archaeologist 2)
>
> *[Do you know what part the police play in all of this? Do they try to crack down on it?]*
>
> *Well, do you know, I don't think they are really serious about it, because I think that even though we have a law, but the punishment of the law itself is not that strong, like you sell drugs or something like that. So when you get caught you pay only a few baht and then you get out and then you can do it again, so it doesn't matter. The enforcement is not really strict. I'm not sure, but there are people that I know. Some of the policemen really play an important role on this as well.*
>
> *[Because they are part of it?]*
>
> *They are part of it, yes.*
>
> *[How much corruption is there in Thai bureaucracy?]*
>
> *Probably a lot.*
>
> *[Do they take money to get things done?]*
>
> *Yes, I think so.* (Bangkok Archaeologist 1)

1.2.2.4 *"They own the objects through geography rather than affiliation"*

Source countries have no right to restrict the movement of cultural heritage discovered under their soil, or otherwise resident in their territories, the market thinks. Territorial boundaries have shifted over time, it is observed, and why should a country own all of the antiquities buried under them when those objects might possess no link to the current culture or cultures which occupy the country:

Every country's got to keep its stuff? But in what measure is it its stuff? Take Turkey. What antiquities are Turkish stuff? What's found in Turkey? Armenian antiquities? Where they kicked out the Armenians in a bloodbath and a genocide? Greek antiquities, where they did the same to the Greeks? Byzantine antiquities, when it's a Muslim country? And take even Neolithic antiquities, from the plateau of Turkey. The heart of Turkey. Do they have anything to do with the local inhabitants, except they're found where the local inhabitants live? All the inhabitants of Turkey are descendants of the Muslim invasion of the tenth-eleventh century. So what relation do the descendants of this Muslim invasion have with Neolithic Turkey, with the Anatolian plateau of 5, 4, 3 thousand years B.C.? So we're just talking about geographic property. Religions have changed, races have changed, frontiers have changed. (Geneva Collector 1)

Use the example of Khmer. Just because a piece is Khmer, it might have been discovered on Thai soil, or on Vietnamese soil – who then is the owner? Thai? Vietnamese? Khmer? (Melbourne Dealer 2)

You have claims being made by countries that weren't remotely in existence at the time these objects were made... the material that is identified as having to do somehow with their national past, simply by accident of geography for the most part. (New York Dealer 1)

The peoples who are inhabiting a nation now may not be the same peoples who created the object that's being protected. You remember the Sevso treasure? There were Croatia, Hungary and Lebanon I think, and the pieces were basically Roman, so it's hard to know where they belong. (New York Museum 1)

The flaw in this argument is its clash with another fundamental belief of the market in respect of claims to ownership of antiquities: that owners of private land should have the right to own antiquities found on their property, and sell them for profit. Why should individuals have the right to own antiquities on their land, but not source countries? The answer would appear to be because individuals seem likely to sell the objects they find, whereas source countries do not. The market cares about the civil (read 'property') rights of finders only insofar as those rights accord with a likelihood that the finders will release the objects for market consumption:

[Do you see a clash between that argument and the argument that you were previously making that individuals who find something should be able to own that find? Why is it different for an individual who has perhaps a small plot of land to correctly own everything he finds on that plot of

land, but not for a country to own everything that they find within their country?]

That's a very good question, and frankly speaking I haven't thought about it. It's a very good question. Let me think about it for a minute. I've never thought about it. Why? Well, first I believe that we respect individual property on the condition that it's not harmful to the general good... and I believe that if one doesn't respect individual property then there's no individual freedom. And at the moment, what is the right of an individual if he hasn't got a right to his property?... But people don't really know about these things – bureaucrats who don't care? I don't know. I mean Nigeria is now a Muslim country, and they don't give a damn about their antiquities. About Nok terracottas, Benin bronzes; they don't look after it. But it's money, it's tourism, and they claim them back... it's not for the love of the art, or conserving it, or publishing it, or exhibiting it. Is there a contradiction between an individual saying "I found it on my land, it's mine" and a government saying "in our country it's ours?" Oh, I don't know...

[Isn't this argument all to do with retentionism?... You don't like the idea that a State owns an object because the State wants to keep that object in the country. But the fact that an individual finder owns an object is okay, because that finder is likely to want to pass the object out of the country and make some money out of it? So if all individual finders in source countries decided that they wanted to keep all of their objects for themselves...]

Of course they wouldn't.

[But by corollary of that, if source countries would ultimately flourish into the traders that these individual finders are? I suspect that your problem is not with the source countries themselves, but more with their restrictive attitude?]

Absolutely! I think you're absolutely right! It's a restrictive attitude, and they wouldn't allow other countries to have anything. (Geneva Collector 1)

While the argument, as used by the market, may be in rather transparent contradiction to its other lines of thinking, it does help to explain why local source populations are willing to dig up 'their heritage' and sell it. Often, they do not see the objects under the ground as 'their heritage' at all:

[In the Bangkok Post *recently there's been a lot about the illegal trade in wildlife, but not much about antiquities.]*

No. I think wildlife, it's really close to people's feelings, but I think that artefacts, you know, and it's not even Thai.

Khmer artefacts found in Thailand – there's nothing to make them feel 'this is us', you know? People don't really feel that way, in comparison to the wildlife. (Bangkok Archaeologist 1)

5.3 TRANSITION TO THEORY-GENERATION

A combination of the arguments 'the market is a 'good' and 'those who would try to stop the market are bad' provides a powerful rationale to market traders to keep trading. I have suggested that a way to justify problematic behaviour is to appeal to its benefits. Such a contradiction is evident at an early stage here; 'looting cannot be approved of, but look at all the good it does':

I don't think anybody can approve of looting in a rational way. In principle looting is bad, of course. On the other hand, sometimes looting has preserved things that would otherwise have been destroyed by building roads, by war, by bombing, by whatever. In the ideal world, looting is wrong. But in the practical world, it has served a function and a purpose. It has certainly destroyed a lot of data which can be, obviously, very useful. It can preserve objects. I think it shouldn't be obviously encouraged, but I think that it's up to the source nation to find ways of dealing with it which is not just, say, hanging people for looting, or shooting them, that's not really the solution. Because in a way the more you drive it underground, the more you make it difficult. In a sense you just encourage people to do it. This is proven in every, not just in art – if you look at the '30s with prohibition in America, that's what it did, it just created people making booze at home and selling it for a huge amount of profit. So I'm just saying that I think that it's a very big issue that should be approached nation by nation, and should be approached by source nation probably and maybe with the help of the west as well. And that's looting of course. Very often you have a chance find and then it will turn into looting, of course. When people find by chance a tomb, because they're digging in the field, they take a few things and then they, you know. But let me tell you a recent story. It's somewhere in China that I was told that the nomads were finding gold objects. And they were just taking the animals for grazing. And they were bringing it to the local goldsmith. And these were quite ancient gold, fifth, sixth, seventh century. And the local goldsmith melted these things down because these would be broken pieces and would then make a necklace for the ladies of the village. This went on for quite some months and quite a lot was melted, until somebody from another village, a bigger village with a little bit more understanding about the value of these things went to the goldsmith by chance and said "what are these things?" The goldsmith bought them by weight. And the guy said "I'll give you double what you pay, but don't melt them,

*keep them for me". And things got preserved in that way.
Now ideally, you would like a certain point in this chain for
the proper authorities to get hold maybe of the site where
these things have been found and make some proper
excavation and documentation. Again, unfortunately a lot
of proper archaeological finds are often not properly
published because of lack of funds, because the
archaeologists die etc. So even the archaeologists create
damage I feel... and I'm not an archaeologist, and they serve
a wonderful function, but it does make sense to me that
very often they, if there are five levels and they are interested
in the fifth one, down there, they might not take very good
care of the first four levels. So damage to our heritage has
been done on a daily basis, not just by the looters. I think
chance finds should be appreciated.* (London Dealer 7)

Clearly this is not the first time that the interviewee has thought
of the issues, but the apparent lack of structure in his
representation of the issues might lead us to suspect that he himself
feels as overwhelmed by the depth and intransigence of the issue
as does the reader of his transcript. In fact, it is my suggestion that
this conversational style reveals more about the interviewees than
simple confusion when thinking out the issue. It is evidence of the
balancing act that dealers, collectors and perhaps museum buyers
perform in their minds when making purchase decisions; a
balancing of 'goods' and 'bads' which will be examined in more detail
in the next chapter. The purported difference between the value of
looting in principle and in practice is false, for the principled
disapproval of looting is based in the damage to context it causes in
practice. What the interviewee means in truth is that he knows
that there are powerful arguments discounting the value of looting,
with which on the level of rhetoric he must be seen to agree to
appear intelligent and balanced in his views, but that in practical
terms he is prepared to ignore these in favour of his own views. He
dismisses troublesome criticism of his trade as 'principle' as opposed
to 'practice'. He discounts it.

How can he do this without seeing he is wrapped in contradiction?
Because, I submit, of the sharp division between good and bad that
he employs in his mind. To him, there is no contradiction, because
other people's disapproval of the act of looting is simply something
to be weighed against the societal benefits of his purchases. This
psychological balancing act and the act of discounting will be put in
context and examined further in chapter 6. It holds the key to the
most difficult problem for researchers of white-collar crime: why
(and how) do people do things that they know are wrong?

CHAPTER 6

THE SOCIOLOGY AND PSYCHOLOGY OF THE ANTIQUITIES MARKET

PART 2: A THEORY

Building upon the categorisation of data set out in Chapter 5, in the present chapter I shall examine how the separation of the interviewees' perceptions of situations and actors as good and bad helps us to characterise the actions of participants in the antiquities market as the results of an internal process of accounting. I suggest a scheme of practical, moral and social accounting which would appear to encapsulate the decision-making processes of the market interviewees. Using this scheme, I outline a psychosocial theory of the decisions made by buyers of antiquities, which draws the importance of the concepts of 'empathy' and 'entitlement' together to create a new insight into the workings of the market. This theory requires us to re-examine accepted wisdom on the question of regulation in respect of this particular market, a task which is undertaken in Chapter 7.

6.1 WHITE-COLLAR DRIFT, ROUTINE ACTIVITIES AND AN ABSENCE OF CONTROLLING BONDS

The purpose of this section is to provide a base for the new ideas to be set out in section 6.2. I wish to show that my novel approach in 6.2 to the question of how the interviewees construct their worlds is built upon a grounded platform of established thought. In this way it will be seen as a particular extension of criminological, social and psychological theory, rather than an uncalculated leap into the unknown.

Aubert, in his research into violation of rationing regulations by Swedish businessmen, found that in addition to general 'universalistic' ties to conformity, the offenders saw themselves as having 'particularistic' obligations towards business colleagues.[1] These particularistic obligations existed within an ideological subculture which condoned many offences; we might call such offences 'routine'.

1 V. Aubert, 'White Collar Crime and Social Structure', (1952) 58 *American Journal of Sociology* 263.

Aubert concluded that white-collar criminals belong to groups which have an elaborate and widely accepted ideological rationalisation for the offences and great social significance outside the sphere of criminal activity. Here, with hindsight, we can observe a linking of what Sykes and Matza would come to call 'techniques of neutralisation'[2] with Sutherland's theory of differential association.[3] The subculture in which the business offender plies his trade surrounds him with normative values supportive of some classes of law-breaking. And those normative values are transmitted via a communications structure which offers ways for the offender to justify his offending behaviour to himself and to others.

These normative values should not be seen as deterministic. Rather, through condoning violations, they might be seen as enabling. In some circumstances there will be no pressure to offend, simply an opportunity to do so. In other circumstances, pressure to offend will be present. Among white-collar criminals generally, this pressure might take the form of an urgent desire for revenue to ensure business survival, the requirement to observe existing unlawful but accepted business practice, the desire of an employee to advance herself in the company, or perhaps pressure from above on an employee to maximise profits. Even when such pressures are present, however, white-collar workers can resist them and choose law-abiding activity.[4]

Neutralisation enables a drift into wrongdoing by working around legal and moral norms rather than rejecting them outright. Matza's delinquents were not committed to their illegal acts – indeed the overwhelming majority of his respondents in the study which formed the basis of his *Delinquency and Drift* book expressed disapproval of illegal acts shown to them in picture form on cards; acts which often they themselves had committed.[5] Deviance is not a full-time occupation for delinquents.[6]

Just as Matza's delinquent sample were for the most part committed to conventional norms, from which they occasionally dislocated themselves in a temporary drift into deviance, so our subjects in the core sample in this research are not committed to the pursuit of illicit activities to the exclusion of all law-abiding conduct. Most antiquities dealers, collectors and museum representatives do not enter the field because they harbour a burning desire to perform illegal or unethical acts. Most of them trade openly and many of their transactions, even of unprovenanced antiquities, are doubtless licit. Yet because of the structure of the antiquities system – because

2 G.M. Sykes & D. Matza, 'Techniques of Neutralisation: a Theory of Delinquency', (1957) 22 *American Sociological Review* 664.
3 E.W. Sutherland & D.R. Cressey, *Criminology* (1978, Philadelphia, Lippincott). 10th edn.
4 G. Geis, 'The Heavy Electrical Equipment Antitrust Cases of 1961', in M.B. Clinard & R. Quinney (eds) *Criminal Behaviour Systems* (1967, New York: Holt, Rinehart and Winston).
5 D. Matza, *Delinquency and Drift* (1964, New York, John Wiley) at p. 49.
6 D. Matza, & G.M. Sykes 'Juvenile Delinquency and Subterranean Values' (1961) 26 *American Sociological Review* 712.

of the mechanisms of trading which obscure the origin and past ownership history of objects for sale – at regular points in their careers dealers, collectors and museum curators will be presented with the opportunity to do wrong. That is, to buy material that the laws would define as illicit.

They may very well not be *sure* that the object they are offered at this time is illicit. Some (Class 1 buyers)[7] will buy it even if they are sure it is illicit. Others (Class 2 buyers) will buy one category of illicit antiquities (chance finds) and in relation to the other category (those deliberately looted) will exploit the fact that they cannot be sure of the provenance of any particular object to assume it to be either licit or a chance find. For both of these classes of buyer who operate on a day-to-day basis with many licit objects which have been circulating on the market for a considerable time, and who appear in most other areas of their lives to behave lawfully and properly, the act of purchase of an illicit antiquity can be seen as a drift into wrongdoing. The individual is free to drift because the deviance seems normal and unremarkable. But what causes this drift?

6.1.1 Will to do Wrong

A thorn in the paw of developing social control theories in the 1950s and '60s was the need to resolve the relationship between a deficit of conventional bonds and the impetus to wrongdoing. Put simply, not all citizens with poor ties to conventional norms and structures became delinquent. The absence of restraint against deviance, which these bonds would have provided were they in place, did not fully explain why some of the unrestrained drifted into delinquency and some did not. The missing element in these theories was a positive choice, Matza thought, exercised by the unrestrained individual:

> The periodic breaking of the moral bind to law arising from neutralization and resulting in drift does not assure the commission of a delinquent act. Drift makes delinquency possible or permissible by temporarily removing the restraints that ordinarily control members of society, but of itself it supplies no irreversible commitment or compulsion that would suffice to thrust the person into the act... I wish to suggest that the missing element which provides the thrust or impetus by which the delinquent act is realized is *will*.[8]

There are, we can imagine, situations where delinquency might be committed without much in the way of will on the part of an individual youth. Group dynamics may lead to the carrying out of delinquent acts by multiple individuals where no real element of will can be attributed to any one youth. Unlawful, or unethical,

7 For my initial division of buyers into Classes 1, 2 and 3, see section 2.1.4.4 above.
8 Matza, *op. cit.* note 5, at p. 181, emphasis in original.

purchases made by white collar antiquities dealers, collectors or museums present less of a problem in this regard, however. In transferring Matza's concept of drift to the business arena, we can with little difficulty agree with him that in addition to the freeing up of individuals to make suspect purchases, there is an impetus to do so, and that impetus is will.

Note that this use of the will to do wrong is more complex, and ultimately more satisfactory for that complexity, than the use of the concept of will made by rational choice theorists.[9] Their identification of pleasure/pain calculations in wrongdoers may or may not be correct, but more important is the propagation of an environment in which the offender sees himself as free to make such calculations and the choices they dictate. That environment, of broken or undeveloped ties to law-abiding social persons, institutions or values, of positive definitions of the illegal act in question or neutralising definitions of its evils, and of a resulting drift into occasional wrongdoing through the exercise of will, is the subject of strong analysis in Matza's work.

At this stage, then, we might return to the data to ask what will to wrongdoing there might be for the interview subjects. Here, we shall deal with the act of purchase back-to-front, looking first at the will to purchase, and then at the techniques of neutralisation employed in order to free the subject to exercise that will. Where then, when the opportunity presents itself to make an illegal or unethical purchase, and they find themselves able to do so through the exercise of techniques of neutralisation (to be examined in the following sections) do traders in the antiquities market find the will finally to do so?

The first element of the will to purchase an antiquity is aesthetic appreciation. This gives an object a value to a buyer which is independent of its status in law or ethics. A looted object is as beautiful to perceive as one which has been excavated legally:

> I'm interested in them for aesthetic reasons: for beauty, for learning, for the awe and inspiration that beauty inspires, and not for archaeological reasons. So there are other reasons for looking at these pieces, and that's a lot of what people are doing in museums all over the world. (New York Dealer 2)

> [It must be really exciting for a collector – that there could be really fantastic stuff out there to be discovered?]

> Yeah, absolutely. It's a dream. To be able to own, even briefly because as a dealer then you have to sell it, to be able to own a great work of art is an extremely exciting

9 R.V. Clarke & D.B. Cornish, 'Modelling Offenders' Decisions: a Framework for Research and Policy', in M. Tonry & N. Morris (eds) *Crime and Justice: an Annual Review of Research*, Vol. 6. (1985, Chicago, University of Chicago Press); D.B. Cornish & R.V. Clarke, (eds) *The Reasoning Criminal: Rational Choice Perspectives on Offending* (1986, New York, Springer-Verlag).

> *thing because it puts you in touch with something that you really love.* (London Dealer 7)

The 'learning' to which New York Dealer 2 refers, above, is an art historian's knowledge which is linked to the study and aesthetic appreciation of the object. He tries to put pieces of the jigsaw puzzle together, as an earlier interviewee was quoted as saying. One cannot help but wonder how he can put value on this type of knowledge as compared to archaeological knowledge, when we consider that if the object was legally excavated without the loss of archaeological knowledge, its place of origin and link to other objects would be that much easier to determine, rendering the aesthetic science of dealers all but unnecessary:

> *It's the building up of knowledge and it's just as important as archaeological knowledge, is the knowledge of collecting. In other words if you're an art historian and say you're studying old master drawings and you find a group here and there, or it's like Greek pottery, there's something about this drawing that relates to another drawing you've seen somewhere, and that leads you somewhere else and that leads on to something else. And soon you've identified a corpus or a body of work that has something in common which no-one has really noticed before. So that you've got either an attribution to a particular artist who you have a group of drawings, which maybe don't have the artist's name, but which relate together... so that once you gather your material together you then can begin to study it. And you don't know your material, you don't know it well, till you can study it. Till you can hold it and feel it and look at it.* (New York Dealer 2)

It is clear that at the root of this dealer's support for the value of his trade is a deep love of the objects themselves. He talks of antiquities in such emotional terms, the will to acquire is easy to discern:

> *As I said, so much benefit comes from collecting; knowledge as important as any knowledge coming from context is the knowledge we can gain from looking and studying objects that tell us something about a culture, about iconography, what style. But it's the object that lives, it's the object that's great, it's the object that no matter what theories one develops around what one should think about collecting, the object lives, the object will continue on and people will be admiring and inspired... by what people before them created. Nothing could be more humanistic. Archaeology is a non-humanistic discipline... This is what will live. No matter what opinion you have of collecting or not collecting, somebody will always be inspired by this.* (New York Dealer 2)

Dealers and collectors see their love of ancient art as an immutable part of the human psyche; an appreciative celebration of the bygone

genius of the race. Sometimes they identify as a gift their heightened sensitivities to the aesthetics of antiquities:

> *Something must have hit me... and it was the gift of perception. I don't mean to compare myself, so please don't get me wrong: where does Mozart get his gift to create beautiful music from? I don't know. So where do I get this gift? I don't know. But I have it... It's as though I spent my life doing a huge fresco, and one day, after some 40 years it was finished.* (Geneva Collector 1)

This collector sees his collection as a work of art in its own right. As with the creation of other works of art, the gift of perception brings with it the urge to give others the chance to share in the experience of art appreciation, whether that be by lending one's collection to museums for display, or the dissemination of ancient art through dealing:

> *I am for the free-flow of objects... and I dedicated my life really to diffusing art. Because I think it's like music you know: through art you can have glimpses of a different reality I think. You can get a different awareness of things. Especially when you're dealing with religious art.* (London Dealer 2)

Archaeologists perceive this desire to own objects for their beauty as an egotistical and culturally insensitive emotion:

> *When you deal with the artefact, people who value the artefact as an art object and people who value it as an archaeological item, you see things different. Because part of archaeology is to be able to understand the past; what is going on. You know, if you want to understand Pompeii, if everything is in situ like that, we know 'oh, this is what happened'... Every piece is like a piece to put the jigsaw together about the past, not just for Thailand, but for the world. But for the art historian or a lot of people who really craves it for the art object, it doesn't matter where it's come from, it doesn't matter whether you destroy the context of the object. It's so beautiful, it's so lovely, it has a value in art. And that it seems to be two end of the continuum, you know? And that's why it doesn't matter where it's come from, but how it can be get into my hands.* (Bangkok Archaeologist 1)

The second element of the will to purchase an antiquity is financial. Dealers, for all their aesthetic interests in artefacts, must turn a profit to keep their businesses alive. Most dealers interviewed rebuffed the suggestion that they were making large sums of money from their trade:

> *The western dealers, they'll make a nice living, but nobody's milking it.* (London Dealer 3)

It's not a very lucrative business. Contrary to archaeologists' assertions that somehow it's a very lucrative business and it's a big business, it's neither one of them: (a) it's not a very big business, (b) it's not very lucrative. Because when you're buying an object, you really don't know what the demand level for it is. And you're taking an enormous financial risk, because you don't really know whether or not your taste in a particular object is going to be widely shared; enough for people to part from their financial resources to acquire that from you. It's a very risky business in that regard. (New York Dealer 6)

This is hard to believe. Most of the interviews were conducted in premises in the most exclusive areas of London and New York. It is not possible to give street addresses in order to safeguard the identity of the interviewees. It is, however, possible for me to say that New York Dealer 6 occupied premises in one of the most upmarket shopping zones of Manhattan which was very impressively decorated and by no means gave the indication that its owner was involved in a high risk/low return business. The same is true of London Dealer 3's shop; a small but very classy boutique in one of the most desirable commercial areas of London. It is possible to say this without giving any clues as to these dealers' identities because many of their colleagues operate out of similarly impressive shops. Still, dealers resist the image of wealthy exploiters of heritage and appeal to their love of the objects; a love which seems very genuine:

[A lot of archaeological literature has a go at dealers because they say that you are making huge mark-ups on things. Is that true?]

No, it's not absolutely true. I can tell you that I sell more important things every year. That's what I'm trying to do. That's what I like. I like to deal in very beautiful things, things that I love, that I get an excitement about. And usually this means more expensive material. So the actual percentage margin is decreased, definitely over the years, for two reasons. First, it's more expensive to be a dealer: restoration, travel etc. But I know from my parents' experience, you used to buy things for a few thousand dollars that are worth 30, 40 thousand now. Nowadays maybe you buy something for $100,000 and it's worth $130,000. So you still make the $30,000 profit, but you have to invest a lot more money. So the reality in the actual margin is only 30%, it's not 300%. Of course there is a chain. In an illegal chance find, let's say, whoever finds the piece will get x, will sell it and whoever gets it next will get triple x and then it goes on. Of course there is a chain, like in everything. But to be honest if we were all making all this money, we wouldn't be doing it any more, we would be collectors by now, retired somewhere with $20 million in the bank and just enjoying life and buying works of art for ourselves. The margins are certainly lower.

> *It's not that I don't like my job, but to be honest I'd rather collect if I could.* (London Dealer 7)

Collectors, while often not so obviously interested in profit margins, are still conscious of the investment value of antiquities. The collection of ancient art is not the pastime of the middle or lower financial echelons of society. Desirable antiquities are often very highly priced, which excludes most of us from their collection:

> *One has to be pretty rich to collect in the first place.* (New York Museum 1)

> *I have very few objects and I always try and deal with the top end of the market.*
>
> *[So the pieces you own are pretty expensive?]*
>
> *Yes, generally.* (London Dealer 2)

> *... it's just a basic sort of theme which wealthy people have always wanted to collect beautiful things like that, and that's fuelled the demand for the trade.* (Melbourne Dealer 1)

The corollary of this financial hurdle to the collection of antiquities is that many of those who *can* afford it *do* collect. The popular image of collectors as upper-class inheritors of wealth whose interest in antiquities is somehow tied to their position in society, perhaps through a historical family interest in their collection, is supported in the data:

> *The old bourgeoisie I was mentioning at the beginning. I mean that's our type of collector, apart from museums.* (London Dealer 2)

Many in this category of collector, it is said, care deeply about the objects and their history:

> *People don't just collect for the sake of having a beautiful sculpture in their living room, but the most serious of our collectors, and I would say the majority of our collectors, are people who actually read about the art, they study the art, they sometimes write articles themselves in magazines about the art. So there is a kind of very keen interest in knowing a lot about the object.* (London Dealer 7)

Also supported in the data, however, is a more unexpected type of collector – the young guns who have enjoyed business success and find themselves with money to play with. The investment value of rare objects coupled with the cultured and sophisticated air they lend to their collector, seems to be the attraction here:

> *People want things that are fast, exciting, colourful, immediately accessible and easily recognisable. In the old days... you had antiquities and anybody would on the whole recognise what they were, where they come from. Nowadays,*

nobody does. Nobody knows. And people who collect also want... to show off their culture and refinement and distinction. (Geneva Collector 1)

Dealers have conflicting feelings about the entry of the uneducated *nouveau riche* into the market. On the one hand they are grateful for a wealthy client base which ensures the survival of their enterprise, but on the other there is a distaste for the crass collection of investments or dinner party conversation pieces, unaccompanied by any knowledge of or interest in the objects' place in history:

It is the new people, the Bill Gateses and all these people, of whom there are a large number who collect – but they are completely ignorant. People talk generically in the art market about 'collectors'. In certain specific fields like... arts and crafts silver, there are probably a large number of collectors around the world, but it's at the lowest level. At the highest level, there is practically no one who knows what they're doing at all; i.e. there are no collectors. My definition of a collector is someone who knows what they're doing. In the old days, when I started in business as a dealer, we would meet with various friends in certain places – at someone's house for coffee on a Saturday morning or whatever, and exchange information. And the older ones obviously taught the younger ones to a large extent. That's all disappeared, largely because Sotheby's and Christie's have taken over. And the really rich people are far too busy, if they come from LA or wherever. They say "I'm only here for two days"; they're probably in meetings for a day and a half. Maybe they pop into one dealer who's a friend of theirs, and Sotheby's or Christie's, probably not both, and that's where the collecting level is today at the high financial level. And the knowledge simply isn't there. And that's very depressing.

[I get the impression that in the good old days, dealing was a much more academic discipline almost, with the passing of information from dealer to dealer, and it was the dealer's responsibility to bring culture to the collector, to educate them in certain ways?]

Yes, yup... those days are completely over. I don't think there's any brand loyalty any longer. There were so many people. Across the board, the art market has been hung as being a smart thing to be in.

[From a financial point of view?]

Yes. And so much new money has come in. (London Dealer 4)

If I sell this frieze here for example, and the client says "this grey fits exactly the colour of our sofa" I would seriously – and this is not just speech – I would seriously consider

selling or not. Because it's a very important piece and I would like to see that in a proper collection. (London Dealer 5)

The feeling that these new generations of buyers are uncommitted to the subject of their investment, being more interested in the status a collection brings than the knowledge it might hold, perhaps indicates that they would be relatively easy to dissuade from the collection of antiquities if the field grows a reputation for being troublesome:

> [*Is the trade going to go the same way as the ivory trade, as the fur trade? Is it going to become a sort of social pariah? Is it in danger of becoming that?*]
>
> *Oh yes, oh absolutely. The nouveaux riches, who are the big buyers... have always wanted social status and recognition... it's always wanting acceptance, and acceptance always comes with what is fashionable, like buying French furniture in the eighteenth century... whatever is the expensive thing, which comes from the tasteful or rich or successful countries. So in the manner that antiquities become criticised – they say "oh, you have that, that's stolen, that's illicit, how did you get it, how can you buy such things?"– where is the recognition and social acceptance and the wealth?* (Geneva Collector 1)

There therefore appear to be varying degrees of will to purchase antiquities in the market, a situation which might be exploited by the policy maker who wishes to discourage the purchase of looted artefacts.

6.1.2 The Routinisation of Wrongdoing

As Matza identifies in the final chapter of *Delinquency and Drift*, one of the manifestations of will is 'behavioural'. By this he means that the first step into wrongdoing is the greatest – too great for many of us to make.

> The ordinary consequence of having been exposed to the 'causes' of deviant phenomena is not in reality *doing* the thing. Instead, it is picturing or seeing oneself, *literally*, as the kind of person who might possibly do the thing.[10]

Once that step has been taken, the relevant criminal act becomes one that our protagonist can repeat. He knows he can do it, and thinks that as he has got away with it once, he can get away with it again; it becomes part of his repertoire of action. The drift may therefore recur and in these recurrences the wrongful act becomes seen as relatively unremarkable. It is clear from the interview data that subjects saw their purchase of unprovenanced antiquities as unremarkable. In some cases they saw their knowing purchase of looted antiquities as

10 D. Matza, *Becoming Deviant* (1969, Englewood Cliffs, Prentice-Hall) at p. 112, emphasis in the original.

unremarkable. This is likely to stem, of course, from the fact that when many of the interviewees entered the trade, dealing in looted antiquities *was* unremarkable. Having been able to establish a business routine before the ethic, let alone the legality, of that routine was called into question, a large proportion of those in the market have negotiated their entry into this newly-criminalised field without incident. What is now seen in many quarters as destructive deviance is perfectly normal to dealers, collectors and museums who have cemented that deviance as a repetitive form throughout the years when it was seen as a legitimate business enterprise.

The first and most important task for the regulator here is to engineer ways to make these buyers see their illicit or unprovenanced purchases as worthy of remark.

6.1.3 Techniques of Neutralisation

The relevance of the concept of neutralisations to wrongdoing has been confirmed by a burgeoning literature over the last half century. In their seminal work on the subject, Sykes and Matza documented five techniques of neutralisation. They are: denial of responsibility; denial of injury; denial of the victim; condemnation of the condemners; and an appeal to higher loyalties.[11]

Although developed explicitly to explain the 'drift' of juvenile delinquents, it has been observed that Sykes and Matza's techniques of neutralisation are to some extent transferable to the realm of white collar and corporate crime. Denial of the victim has been noted in the case of large pharmaceutical companies who dispose of unsafe or untested products on the third world market, a consumer group from whom they are divorced in geographical and class-hierarchy terms. In such circumstances an 'out of sight, out of mind' approach to unethical behaviour is free to develop.[12] Similarly, companies have been observed as ready to blame industrial injuries on 'careless and lazy' workers or the development of brown lung in Negroes on their 'racial inferiority'.[13]

The decision-making structures of companies may in themselves be criminogenic in this regard, involving as they do a degree of shared responsibility and institutionalised procedure which removes from any one individual a feeling of responsibility for the actions taken by the company.[14] In addition to this denial of responsibility, denial of harm was observed by Geis in his study of price-fixing activities. An executive in that study described his activities as

11 G.M. Sykes, & D. Matza, 'Techniques of Neutralisation: a Theory of Delinquency', (1957) 22 *American Sociological Review*, 664.

12 J. Braithwaite, *Corporate Crime in the Pharmaceutical Industry* (1984, London, Routledge and Kegan Paul).

13 J. Swartz, 'Silent Killers at Work', in M.D. Ermann & R.J. Lundman (eds.) *Corporate and Governmental Deviance* (1978, Oxford, Oxford University Press) at p. 125.

14 A. Bandura, *Aggression: a Social Learning Analysis*. (1973, Englewood Cliffs: Prentice Hall).

"illegal... but not criminal... I assumed that criminal action meant damaging someone, and we did not do that".[15]

Matza sees the concept of neutralisation as an extension into the language of everyday experience of the excuses for the performance of the *actus reus* of a crime permissible within the structure of the criminal law:

> ... the idea of neutralization suggests that modern legal systems recognise the conditions under which misdeeds may not be penally sanctioned, and that these conditions may be unwittingly duplicated, distorted, and extended in customary beliefs.[16]

One such condition under which a misdeed may not be sanctioned penally is where necessity dictated the commission of the crime. The doctrine of necessity is in some form accepted in most criminal law systems around the world, and excuses the performer of a criminal act from some or all of the penal consequences of her wrongdoing. This would be the case where, for example, a person committed a crime in order to escape from the danger presented to his person by a natural disaster. Its use is highly restricted in law, normally being reserved for the most extreme circumstances of impending danger to the defendant or someone nearby. This might be characterised as the legal form of the 'appeal to higher loyalties' technique which Sykes and Matza identify as being among the five major observed techniques of neutralisation.[17] Appeal, that is, to a loyalty to self-preservation or the performance of a similar service to others, above a loyalty to the legal code.

In *Delinquency and Drift,* Matza places techniques of neutralisation in the realm of the social rather than the legal, viewing them as extensions of legal excuses which in law of course carry no weight. It is no excuse in law that you committed vandalism because your cohorts egged you on (denial of responsibility) or that your protection racket is no different to the one run by the local police force (condemnation of the condemners). Yet these neutralisations originate in legal discourse and expand and take shape as they work their way out of the law and into the real world. Antiquities dealers' primary concern, they say, is for the preservation of important objects. The similarity to the legal doctrine of necessity here is striking. Even in the face of laws which prohibit what they do, those in the antiquities market are prepared to buy objects in order to try to save them. The saving of property does not usually fall within the legal definition of necessity but as we have seen, the love of ancient objects displayed by the interviewees makes their imagined destruction

15 G. Geis, *White Collar Criminal: the Offender in Business and the Professions* (1968, New York, Atherton) at p. 108.

16 D. Matza, *Delinquency and Drift* (1964, New York, John Wiley) at p. 61.

17 Sykes & Matza, *op. cit.* note 11.

proximate in emotional terms to injury to humans in the minds of these subjects. This is an appeal to higher loyalties (than to the law).

All of the five traditional techniques of neutralisation are present in the interview data. The market interviewees deny that they are responsible for looting. They deny the victims of their actions by devaluing the worth of archaeology and the rights of source countries to the objects in their soil. They deny injury by opining that much looting is of graves containing duplicate items where no new archaeological knowledge rests. They condemn in various ways the archaeologists and source countries who condemn them, and they appeal to the higher loyalties of artistic appreciation and object preservation over a loyalty to archaeologists, source countries or the law. We shall explore their use of these techniques further now.

6.2 A Psychosocial Theory of the Importance of Empathy in Constituting the Criminal Act as an Entitlement

6.2.1 Empathy

Criminological theory may be roughly divided between theories which attempt to explain what motivates individuals to commit crime, hoping to affect crime rates by intervening to lessen those motivations, and theories which analyse the opportunities available to motivated offenders. These theories of opportunity by and large take for granted the question of motivation, and work to reduce crime rates by decreasing the amount, and attractiveness of, criminal opportunities in society. Examples of theories which emphasise motivation include strain theory,[18] labelling theory[19] and theories of subculture and differential association.[20] Examples of theories that accord major importance to opportunity include rational choice theory,[21] routine activities theory,[22] and theories which highlight the importance of informal social control, such as the social disorganisation theory of the Chicago school.[23]

The problems inherent in a rigid adherence to one strand of theory to the exclusion of the other are obvious, and in fact all of the theories mentioned include elements of both - the distinction is made on the

18 R.K. Merton, 'Social Structure and Anomie', (1938) 3 *American Sociological Review*, 672; *Social Theory and Social Structure* (1968, Glencoe, Free Press).

19 H.S. Becker, *Outsiders: Studies in the Sociology of Deviance* (1963, New York, Free Press); *Labelling Theory Reconsidered*, (1973, New York: Free Press).

20 A.K. Cohen, *Delinquent Boys: The Culture of the Gang* (1955, Glencoe, IL, Free Press); R.A. Cloward & L.E. Ohlin, *Delinquency and Opportunity* (1960, New York, Free Press); E.W. Sutherland & D.R. Cressey, *Criminology* (1978, 10th edn., Philadelphia, Lippincott).

21 D.B. Cornish, & R.V. Clarke, (eds) *The Reasoning Criminal: Rational Choice Perspectives on Offending* (1986, New York, Springer-Verlag).

22 L.E. Cohen & M. Felson, 'Social Change and Crime Rate Trends: a Routine Activity Approach', (1979) 44 *American Sociological Review* 588; P.J. Brantingham & P.L. Brantingham, 'Environment, Routine and Situation: Toward a Pattern Theory of Crime', in R.V. Clarke and M. Felson (eds) Routine Activity and Rational Choice (1993, New Brunswick, NJ, Transaction).

23 C.R. Shaw & H.D. McKay, *Juvenile Delinquency and Urban Areas* (1969, Chicago, University of Chicago Press).

basis of which they prioritise. The preventative insights of opportunity theory, correctly applied, will reduce the incidence of crime in relation to the particular opportunities that have been denied, but will do nothing to reduce the number of motivated offenders in society who may then simply turn their attentions to other available opportunities. This is the problem of displacement. Unless all criminal opportunities in society are removed, motivated offenders may, within certain bounds, pursue those which remain available. Concentration simply on theories of motivation ignores the fact that motivation may at times develop from little more than the presentation of opportunity. An example of this can be found in the 'lost letters' experiments where members of the public found themselves able to keep sums of money discovered in the street, in letters apparently mislaid by their owners.[24] Opportunity can create motivation to commit a crime; motivation which did not exist in the actor to the extent that they actively sought the opportunity. Likewise, an absence of motivation can change the nature of a social situation from 'criminal opportunity' to 'benign encounter': as the sums of money in the lost letters increased, the proportion of finders willing to keep the envelope and its contents decreased, illustrating that for most of us there is a cut-off point above which the crime is viewed as of such gravity that opportunities for the advancement of self-interest will not be taken. Small changes in the nature of the opportunity can affect motivation, which in turn affects the definition of the situation as an opportunity.

It would be sensible then to propose that the answer to 'why people do what they do', in the field of criminality at least, lies in both motivation and opportunity, and that while theories from each camp are not necessarily to be criticised for not explaining *everything* (they do after all allow the possibility of being 'bolted together' to produce an end-to-end approach), there may be worth in pursuing an investigation of concepts which might run through both categories. I wish to suggest a scheme for thinking about one such concept – empathy – and its possible place in a grander theory which views crime as an action that some individuals feel entitled to perform.

Chamlin and Cochran[25] have undertaken an empirical study of the relationship between what they call 'social altruism' and crime. They define that concept as:

> the willingness of communities to commit scarce resources to the aid and comfort of their members, distinct from the beneficence of the State.[26]

They find that social altruism is not a mediating factor in the effect of more conventional 'structural' variables on crime. These

24 D.P. Farrington & B.J. Knight, 'Stealing from a "Lost" Letter', (1980) 7 *Criminal Justice and Behaviour* 423.

25 M.B. Chamlin & J.K. Cochran, 'Social Altruism and Crime', (1997) 35 *Criminology* 203.

26 *Ibid.*, at p. 204.

structural variables they take from motivational, opportunity and compositional theories and include such staples as absolute and relative deprivation, population heterogeneity, population size and percentage of single-person households. They do find a relationship between social altruism and crime though:

> The multivariate analyses clearly show that net of other factors, United Way contributions negatively affect both property and violent crime rates.[27]

Here is revealed an irremediable flaw in their conclusion. Their chosen measure of social altruism is the amount of contributions made to a single charity, the United Way, in their various population samples. This would seem to be far from a suitable measure of social altruism. It is not even a suitable measure of financial philanthropy, since it excludes all other charitable and non-charitable donations made by the samples. Even if it were a reliable measure of financial philanthropy, that is perhaps an act qualitatively different from the kind of social altruism which might be thought to be important in improving crime-reduction measures in a community, such as informal social control. And even if financial philanthropy is a subset of the form of social altruism we should be measuring, it excludes all other acts of kindness which make up that set.

Still, the authors provide an introduction to the hypothesised importance of social altruism which is enlightening in its identification of the importance of the concept to three lines of criminological theory. Firstly, they see the concept in Braithwaite's work on reintegrative shaming,[28] particularly insofar as he sees reintegrative shaming (and by association, lower crime rates) in "social systems which foster values that teach their members that they have social and moral obligations to others above and beyond those produced by self-motivated relationships of social exchange".[29] Secondly, they see it in the critical extensions Messner and Rosenfeld[30] have made to Merton's strain theory:[31] 'To the extent that social institutions are subservient to the economic structure, they fail to provide alternative definitions of self-worth and achievement that could serve as countervailing forces against the anomic pressures of the American Dream'.[32] Communities which foster socially altruistic values therefore to some extent neutralise this anomie, it is thought, with associated lowering of crime rates. Thirdly, they see social altruism as an important underlying anti-

27 *Ibid.*, at p. 220.
28 J. Braithwaite, *Crime, Shame and Reintegration* (1989, Cambridge, Cambridge University Press).
29 Chamlin & Cochran, *op. cit.* note 25, at p. 205.
30 S.F. Messner & R. Rosenfeld, *Crime and the American Dream.* (1994, Belmont, CA, Wadsworth).
31 R.K. Merton, 'Social Structure and Anomie', (1938) 3 *American Sociological Review*, 672-82; *Social Theory and Social Structure* (1968, Glencoe: Free Press).
32 Chamlin & Cochran, *op. cit.* note 25, at p. 207.

criminogenic factor in Cullen's social support paradigm: "high rates of family disruption may operationalize not only adults' ability to exert surveillance over youths but also the availability to youths of both adult support networks and the opportunity to develop intimate relations".[33] Social altruism is therefore identified as a factor conducive to the establishment of social support networks which can lead to lower crime rates.

Given the presence of social altruism in these theories, we might look to see whether it is present in others. Rather than social altruism, I use a different, but connected, concept – 'empathy'. *Altruism* is the regard for others as a principle of action. *Empathy* is the power of identifying oneself mentally with (and so fully comprehending) the person or object one contemplates. There are two reasons for my focus on the latter term over the former. The first is colloquial usage. Empathy suggests thoughtfulness for others (perhaps in some cases particular known others) without the strict emphasis either on a universal sentiment towards 'society' in general or the outright benevolence that the term 'social altruism' suggests. Empathy is an understanding of the position of the other through placing oneself in his body and mind, which may lead to a socially constructive act. That act may, however, proceed along lines of 'common decency' or 'humanism' which, while falling within the classic definition of altruism, do not amount to the unilateral generosity that term has come to imply in common parlance. Empathy involves doing as you would be done by and may find its reward in the future actions of others towards oneself, whereas altruism (perhaps because it is so little found in our world today) has, I sense, come to imply an extraordinary act which is never likely to be rewarded.

The second reason to prefer empathy over altruism as an object of study is more scientific. Empathy is the psychological mind-state that creates altruistic acts. To re-iterate: empathy is how you think; altruism is what you do. Identifying oneself mentally with the other is likely to lend any subsequent act in respect of that other with the quality of altruism. Even if one starts with a decision to be altruistic in one's actions, one quickly arrives at the discovery that to have regard for others one must use empathy. The two concepts are linked then, but empathy appears to me to be the more important in the same way that any generative social or psychological mechanism which produces action is more important than the action itself.

The concept of empathy is of major importance to some of the most dominant theories in criminology. Rarely do we hear it called by that name, however. We are told that psychopaths lack a developed sense

33 F.T. Cullen, 'Social Support as Organizing Concept for Criminology: Presidential Address to the Academy of Criminal Justice Sciences', (1994) 11 *Justice Quarterly* 527 at p. 535.

of guilt;[34] they have an incapacity for emotional connection to the rest of humanity.[35] We are told that sociopaths as children have lacked stability and depth in their interpersonal relationships – particularly the affection of parents or guardians – leaving them with defective mechanisms of identification.[36] Parental conflict and abuse have been noted elsewhere (outside the realm of the pathological offender) as preventing children from internalising normative controls against violent behaviour.[37] Might we see this as an interruption of the normal process of empathy-formation which takes place to some extent in the home through the sharing of affection and the inductive use of guilt by temporary love-withdrawal when feelings are hurt?

Social bonds can operate as restraints against deviance,[38] partly it seems due to their provision of a 'stake in conformity',[39] but also perhaps because of the identification mechanisms they encourage in the individual. Through ties to significant others ('attachments' in Hirschi's theory) we learn and routinise empathy, with the result that a developed sense of consideration for others can ultimately become transferable from our friends to strangers in society generally, and we develop what we might term a social conscience.[40]

Delinquent peers provide positive definitions of offending[41] in which anti-establishment subcultural attitudes turn the world into an 'us and them' dichotomy[42] where allegiance to the group necessarily involves the discounting or abandonment of empathy for outsiders. The delinquent language offers up techniques of neutralisation which enable the offender to justify or excuse his crime.[43] None of Sykes and Matza's five techniques deals explicitly with the discounting of empathy, but in some it is implicit. Denial of injury might take the form "the homeowner is insured, therefore he suffers no loss through my burglary", or perhaps "he is so rich he can afford it", both of which are techniques for divesting the victim of any empathy he might otherwise deserve. Likewise, empathy-discounting can occur in the denial of the victim: "he asked for it"

34 H.M. Cleckley, *The Mask of Sanity: an Attempt to Clarify some Issues about the So-called Psychopathic Personality* (1976, St Louis, Mosby).

35 R.D. Hare, *Without Conscience: the Disturbing World of the Psychopaths Among Us* (1999, New York, Guilford Press).

36 B.L. Diamond, 'Failures of Identification and Sociopathic Behaviour', in N. Sanford & C. Comstock (eds) *Sanctions for Evil.* (1971, San Francisco, Jossey-Bass, Inc.).

37 R. Loeber & M. Stouthamer-Loeber, 'Family Factors as Correlates and Predictors of Juvenile Conduct Problems and Delinquency', in M. Tonry & N. Morris (eds.) *Crime and Justice*, Vol. 7. (1986, Chicago, University of Chicago Press).

38 T. Hirschi, *Causes of Delinquency* (1969, Berkley, University of California Press).

39 J. Toby, 'Social Disorganisation and Stake in Conformity: Complementary Factors in the Predatory Behaviour of Hoodlums', (1957) 48 *Journal of Criminal Law, Criminology and Police Science* 12-7.

40 M. Gottfredson, & T. Hirschi, *A General Theory of Crime* (1990, Palo Alto, CA, Stanford University Press).

41 E.W. Sutherland, & D.R. Cressey, *Criminology*, (1974, 9th edn, Philadelphia, Lippincott).

42 A.K. Cohen, *Delinquent Boys: The Culture of the Gang* (1955, Glencoe, IL, Free Press).

43 Sykes & Matza, *op. cit.* note 11.

is a popular technique in status challenges among young men which result in violence. The denial of the third world victims of unsafe pharmaceuticals mentioned earlier also qualifies as empathy-discounting. Finally, an appeal to higher loyalties involves the same process of empathy-discounting as the prioritising of group values and norms mentioned above: "my friends needed my protection/some money/some excitement", the point being that they deserve one's empathy and the victim does not.

Farrington has argued that "the criminal career is a legally defined subset of a longer-term and more wide-ranging anti-social career",[44] building on Robins' idea that there is an anti-social personality that arises in childhood and persists into adulthood.[45] The DSM-IV diagnosis tests for just this type of anti-social personality disorder. It is my contention here that rather than viewing such anti-social personalities as medically identifiable deviations from the norm, they are more properly categorised as the extreme end of a spectrum of behaviour which runs through all of us; *serious* anti-social behaviour involves particularly low levels of empathy (the emphasis is required as some of the behaviours included in Farrington's Cambridge Study in Delinquent Development[46] are arguable in their supposed anti-social nature).

Another way of talking of anti-social values is in terms of individual self-interest. Halpern initiated a quantitative study of the relationship between moral values and crime and discovered at an early stage that his chosen independent variable, 'moral tolerance', was not a concept that could be understood on a single dimension.[47] He therefore separated the moral value items into three factors; personal-sexual, self-interest and legal-illegal. He found that being male, being young, and living in a large city, all well-known covariants of crime, were associated with a tolerance of acts of material self-interest. Self-interest might be seen as the converse of empathy. Between 1969 and 1990 levels of self-interest were found to have increased across all of the sixteen nations studied, a trend "which may be able to explain the cross-national experience of rising crime".[48] Self-interest was found to be a moderator for inequality in the relationship between that factor and crime:

44 D.P. Farrington, 'Human Development and Criminal Careers', in M. Maguire, R. Morgan & R. Reiner (eds) *The Oxford Handbook of Criminology*, (1997, 2nd edn, Oxford, Clarendon Press) at p. 362.

45 L.N. Robins, 'Sturdy Childhood Predictors of Adult Outcomes: Replications from Longitudinal Studies', in J.E. Barrett, R.M. Rose & G.L. Klerman (eds) *Stress and Mental Disorder* (1979, New York, Raven Press).

46 D.P. Farrington & D.J. West, 'The Cambridge Study in Delinquent Development: a Long-term Follow-up of 411 London Males', in H.-J. Kerner & G. Kaiser (eds) *Criminality: Personality, Behaviour, Life History* (1990, Berlin, Springer-Verlag); D.P. Farrington, 'The Development of Offending and Antisocial Behaviour from Childhood: Key Findings from the Cambridge Study in Delinquent Development' (1995) 36 *Journal of Child Psychology and Psychiatry* 929-64.

47 D. Halpern, 'Moral Values, Social Trust and Inequality: Can Values Explain Crime?' (2001) 41 *British Journal of Criminology* 236.

48 *Ibid.*, at p. 243.

Hence, inequality *per se* is only modestly associated with higher victimization rates, but when it occurs in societies that are also characterized by high levels of self-interested values then its effects become more pronounced. This latter result may help to explain the familiar puzzle of why periods such as the Great Depression of the 1930s were not associated with soaring crime[49] ... If self-interested values have changed substantially in the intervening period, and if these moderate the effects of inequality, then the relationship between inequality and crime will itself have changed over the period.[50]

What I mean by empathy in relation to criminality is the formation of a bond between the would-be offender and the intended victim. The effect of the consideration of this bond by the would-be offender may be to dissuade him from the execution of an act harmful to the victim; he puts himself in the victim's shoes and chooses to do as he would be done by. It seems that empathy is central to explaining elements in the broad scheme of social action, and the more specific scheme of criminal action. Reducing or eliminating empathy for the intended victim is an important precondition to the violation of a legal rule which will result in harm to that victim. A hypothesis which will be explored here is that such empathy for the victim as might exist in the offender can be discounted in a process of psychological accounting to the extent that the offender arrives at the conclusion that he is entitled to commit his crime.

6.2.2 The 'Balance Sheet' Approach to Decision-Making in the Antiquities Market

I wish here to build on a metaphor used by Klockars in his 1970s case study of 'Vincent', a professional fence.[51] In his conversations with Klockars, Vincent sometimes sought to excuse his illegal behaviour by showing it to be outweighed by the good things that he did:

> Sure I've done some bad things in my life. Who hasn't? Everybody's got a skeleton in his closet somewhere. But you gotta take into account all the good things I done too....[52]

Klockars referred to this process by way of the metaphor of the ledger; a metaphor I wish to revive and expand upon here. The decision-making processes of antiquities dealers can be summarised quite accurately in terms of profit and loss accounting. They appear to employ three 'Balance Sheets' in making their illicit choices. I have called

49　D.J. Smith, 'Youth Crime and Conduct Disorders: Trends, Patterns, and Causal Explanations', in M. Rutter & D.J. Smith (eds.) *Psychosocial Disorders in Young People: Time Trends and Their Causes* (1995, Chichester, John Wiley).
50　Halpern, *op. cit.* note 47, at p. 247.
51　C.B. Klockars, *The Professional Fence* (1974, London, Tavistock).
52　*Ibid.*, at p. 151.

these the Practical Balance Sheet, the Moral Balance Sheet and the Social Balance Sheet. I shall deal with each of these in turn, illustrating how these imaginary balance sheets provide us with an heuristic tool for studying the decision-making process in this subset of white collar criminals. Central to each of these balance sheets is an internal process of accounting; a listing and weighing up of goods and bads, or pluses and minuses, or as I shall call them here, in keeping with the balance sheet metaphor, 'assets' and 'liabilities'. What is to follow can be represented diagrammatically:

6.2.2.1 The Practical Balance Sheet

The essence of the Practical Balance Sheet is the Benthamite weighing of pleasures and pains which has typified the crime policy approaches of classicists right up to the situational crime prevention measures devised by modern-day rational choice theorists; measures designed to harden specific targets, making them less attractive as criminal opportunities due to the hassle involved in the performance of the act, or perhaps an increased likelihood of apprehension. Also important here of course is the offender's perception of the weight of punishment to be visited upon him if he is indeed apprehended.

A positive outcome on an individual's Practical Balance Sheet is an entry requirement to this scheme of illicit purchase.[53] If the outcome

53 The scheme is presented as a synoptic tool for increasing our understanding of the decision to purchase illicit cultural material. It is interesting to consider whether it might, with due refinement, be applied more widely than this, to other forms of white-collar criminality, and indeed perhaps to the manifestation of criminal action which occupies the criminological 'mainstream'.

is in the negative, the subject is unlikely to proceed with the contemplated purchase. A negative balance will occur when liabilities outweigh assets, i.e. when the perceived punishment – including all social ramifications such as loss of employment and the informal sanctions levied by family and peers – and its likelihood outweigh the desire, or 'will', of the subject to commit the act. Desire/will here enables us to include in the scheme Matza's conception of individuals as carrying what we might call 'vocabularies of action'. I perceive great benefits from a bank heist, but I have little desire to perform one, irrespective of legal sanctions. My sense of routine, of capacity, and of self, operate at an early stage in my internal process of action-formation (earlier than my consideration of penal consequences) to lessen my desire to rob banks dramatically. Note that this is not a moral argument. I am expressly not saying at this point that I consider there to be anything morally wrong with robbing banks. I am simply observing that rational decision makers consider many factors in constituting the level of desirability of any given act beyond the perceived 'benefits to self' traditionally stated, and further that there are dispositional elements to actors which influence both the choices they are likely to make, and their very perception of what the available choices are (in fact, of course, these are multitudinous – but rarely perceived as such). The effect of my practical logic[54] here is that, irrespective of morals, I consider the act of bank robbery to be utterly outwith my normal repertoire of action.

The market interview sample displayed a high level of desire to buy unprovenanced antiquities, a perception of adverse consequences (penal and other) at or approaching nil, and a routine approach to the purchase of unprovenanced antiquities which suggested that the act had an established place in their 'comfort zone' of action.

If a positive balance is obtained on the subject's Practical Balance Sheet, he has the capacity to make the offending purchase. He has decided that he is unlikely to suffer any evil practical consequences from the performance of the act, or that his desire to perform the act outweighs any considered adverse consequences. He may proceed to step two: the Moral Balance Sheet.

6.2.2.2 The Moral Balance Sheet

If the Practical Balance Sheet can be subtitled 'perceptions of punishment', then the Moral Balance Sheet can in turn be subtitled 'perceptions of the inherent quality of the act'. The overriding question for the subject here is: "can I classify this act which I contemplate as morally good?"

The assets column of this metaphorical balance sheet contains those outputs or effects of the act in question which can be perceived

54 Cf. P. Bourdieu, *The Logic of Practice*. (1990, Cambridge, Polity).

as morally good or righteous. In the case of the antiquities trade, moral assets are those results of the trade which the dealers can classify as being beneficial for society. That which is of perceived social benefit is, to antiquities dealers, morally good. Here will be listed, in the dealers' minds, the factors we have identified under the heading 'the market is a 'good" in section 5.1, above. The liabilities column contains those outputs or effects of the act of purchase which are in some way seen as detrimental. Note that I have there said 'seen as' detrimental. The techniques of neutralisation which are part of the communicative makeup of this particular market system – the discourse which makes that system and in turn is re-made by it on a continually evolving basis – gives tools to the dealers with which they can alter their Moral Balance Sheets in two ways:

• They can discount liabilities
• They can turn liabilities into assets

Morality, as a quality of the act, is thus seen as a negotiated outcome, rather than an eternal truth, or the pre-determined branding of action by an ineluctable system of normative values.

6.2.2.2.1 Discounting liabilities

Liabilities can be discounted by condemning the condemners. Where the condemners are also the victims of the wrongful act, this discounting of liabilities can additionally be seen as denial of the victim. This is the case for two major categories of condemners of the antiquities market; archaeologists and source countries. Here we find put to use the accusations contained under the heading 'those that would try to stop the market are bad' in section 5.2, above.

'Moral empathy' is one of the major considerations for the liabilities column of an individual's Moral Balance Sheet. I propose 'moral empathy' as a term to encompass the general moral idea that to cause loss or injury to another is wrongful, which can therefore operate as a restraint to action both where there are immediate practical considerations of harm to another, and where there are not. In the first case, the identity and characteristics of the victim can change the offender's view of the morality of the act. In the second case, a moral rule applies which is not victim-specific. To revert to the bank heist example, moral empathy might tell us that to steal money generally is a bad thing to do since it causes harm to someone. We do not need to think of who those people might be – irrespective of their known or imagined identities, we have formed a general moral rule based on our moral empathy.

Moral empathy, therefore, is a liability in our Moral Balance Sheets. Its value can be discounted in certain ways. Antiquities dealers use denial of the victim/denial of injury/condemning the condemners to reduce the value of the moral wrongs they perpetrate

when they deal in looted antiquities. Lack of provenance in the market enables them to deny the practical damage their actions cause to contexts. Source country laws vesting ownership of antiquities in the State are seen as unreasonable and therefore amenable to circumvention.

Further, moral empathy is removed from the liabilities column of the Moral Balance Sheet by condemning the moral standing of archaeologists and source countries who condemn the market and therefore destroying their platform morally to criticise buyers. The non-specific victims in this case are archaeologists who suffer loss of data through looting, and source countries who suffer loss of the objects themselves. "If archaeologists do not publish their work effectively, if they cannot dig efficiently or secure the funding to dig widely, and if they themselves damage artefacts as part of their project, then they do not deserve our consideration", think the dealers. These arguments are used by antiquities dealers to condemn the condemners and they operate to discount moral empathy. Similarly, "if source countries do not protect their sites, and if they hoard in unsuitable conditions those objects that they do possess, they do not deserve our consideration either".. Moral empathy in the act of purchase can also be reduced by denying the victim: "although this object may have been looted, looting is not a 'real' theft and nobody gets hurt. My general moral rule against dealing in stolen objects is not triggered here".

It is not only antiquity dealers who discount liabilities. The discounting of liability is a daily event for most of the population. We know, for example, that driving cars causes pollution. In the assets column of our Moral Balance Sheet we put the fact that we have to get to work, otherwise our families may starve, or on a more general scale, if nobody could get to work, the economy would fail. The spraying of deodorant aerosols contributed, we were told in the 1990s before manufacturers lowered their CFC content, to the hole in the ozone layer. This entry in the liabilities column of our Moral Balance Sheets led some people to explore other types of non-harmful deodorants. Many more, however, continued to use aerosols as much as before. Sometimes, it seems, we do not even need a justification to discount a liability. If we can identify a profit which is seemingly indispensable (getting to work; socially acceptable standards of personal hygiene) we can simply ignore the items in the liability column. We dislocate ourselves from the harm our actions may be causing with reference to compliance with unshakeable demands. This is what Matza called an appeal to higher societal loyalties.

6.2.2.2.2 Turning liabilities into assets

Liabilities are turned into assets in the Moral Balance Sheets of antiquity traders through the manipulation of the deficient provenance information which will almost always accompany a purchased antiquity. This usually involves an exploitation of the

concept of the chance find, an appeal to the goodwill of the listener, and an abuse of trust.

Dealers and collectors rarely know where an object has come from, beyond the immediate seller. When they buy from auction houses, or through an agent for an undisclosed principal, they will very likely not even know the identity of the immediate seller. In such circumstances, there is no way for them to verify that the object they are buying is not looted. Rather than consider the possibility that it might be looted, dealers and collectors attribute to the object the status of chance find. In this way the liability element of the purchase (the damage to context caused by looting) is transferred to the assets column ("it is favourable to buy a chance find because in the absence of a market for such accidental discoveries, they would in some cases be destroyed"). The uncertain provenance and provenience of the artefact, instead of constituting a reason not to buy it, is turned into a reason why it should be bought. For the possible funding of the destruction of the past is substituted its certain preservation. A positive moral outcome is achieved.

6.2.2.2.3 The Moral Balance Sheet as a mode of internal and external performativity

This interpretation of the dealers' conversations with me as a profit and loss approach to the question of ethics enables us to see their representations as performative. Erving Goffman called these dramaturgical forms of impression-management 'fronts'.[55] Goffman identified such fronts as techniques, verbal and actioned, employed by people to avoid the attachment of stigma. Performative fronts are designed to present acceptable versions of self to the world. It is here that we can place the regularly observable discrepancy between what people say and what they do. Antiquities dealers say, for the most part, that they do not support the notion of looting. Yet in many instances they buy unprovenanced objects and resist all attempts to institute systems in the market which would enhance transparency in provenance. We might therefore identify their disapproval of looting in the interviews as a performative front. That this disapproval is performative rather than real may be seen from the refinement of the subjects' definitions of looting when they are pressed on the issue, and by their valuing in their personal balance sheets of other 'goods' over the 'good' which archaeologists seek to protect:

> I'm with him [Colin Renfrew] in believing that context is very important. There's no doubt about that. But if you're weighing up that against other goods, to my mind the balance tips over my side slightly... you have schoolchildren in America learning about Chinese art in a way that must be good, can only be good really. You know, international

55 E. Goffman, *The Presentation of Self in Everyday Life* (1959, Garden City, NY, Anchor).

understanding of art and stuff. In addition I think it's healthy that valuable things should be spread. I don't think that it should be kept in one country or within one country, in one location. Because of war, terrorism... (London Dealer 3)

Where I depart from Goffman is in his focus on fronts as external presentations. He followed Sartre in asserting that the fronts employed by people became of such overwhelming importance to the individual that in the maintenance of a flawless visible front the interior workings of the actor were sometimes neglected. The example he used was Sartre's[56] – the seemingly attentive pupil who is diverting such energy into appearing attentive that he in fact takes on board nothing that he hears.[57] The interviews are consistent with the presence of such fronts, but they go further I think. The dealers seem genuinely convinced of the righteousness of their actions. In other words, in addition to performative fronts designed to present acceptable reasons for their conduct to outsiders, the dealers employ what we might call 'psychological fronts' designed to support their actions in their own minds. Far from being overlooked in the maintenance of the external performative fronts, the interior workings of the actor are themselves massaged in a similar fashion. In the internal dialogue the dealers have with themselves, they use psychological fronts to secure their own approval. This interpretation of the interview data is consistent with Benson's findings in his study of white-collar criminals, mentioned in the methodological appendix.[58]

It does not seem that this act of balancing the moral pros and cons of action is undertaken each time the decision to buy is made. Rather, once having reached a positive definition of the purchase of unprovenanced antiquities through this act of mental profit and loss accounting, the market buyer is able to put such thoughts behind him and proceed with future purchases. In these future purchases he may sometimes (if, for example he is challenged) retrieve his Moral Balance Sheet for his and other people's scrutiny, and perhaps amendment. More often, though, he will simply be able to use the fact that he has at one stage in the past thought through the issue and arrived at a conclusion which will cover the act of

56 J.-P. Sartre, *Being and Nothingness*, tr. H.E. Barnes (1956, New York, Philosophical Library) at p. 60.

57 Goffman, *op. cit.* note 55, at p. 33.

58 It is, however, in contravention to Sutton's conclusion in respect of his study of second-hand goods dealers who bought stolen goods. He identified very similar strategies of purchase to those employed by antiquity dealers – business buyers of stolen goods wanted to ensure that they appeared clean and so would ask superficial questions of the seller such as "these all yours then?" or have the sellers sign a book giving their name and address, even though the buyer had every reason to suspect that the goods were stolen. He concluded that buyers had no moral problems with the purchase of stolen goods.(M. Sutton, 'Handling Stolen Goods & Theft: a Market Reduction Approach', *Home Office Research Study 178* (1998, London, Home Office) at p. 45) This is true, it seems, for a number of the core interviewees in the present research, but for many of the other antiquity dealers and collectors interviewed it is not that simple. They are aware of the harm their actions bring and must persuade themselves that overall they are doing good rather than evil to be able to continue with their trade in unprovenanced objects.

purchase about to be undertaken – he has checked the box of acceptable action, so to speak – as a basis on which to proceed with the current transaction without giving any further thought to the issue. An example can be found in a dealer in London who, while explaining his disapproval of the decapitation of statues by looters, made a revealing statement about the lack of vacillation the purchase of an antiquity involves for him:

> What is really sad, and which I try not to do is if you look in the gallery I have one single head here, which was taken off some statue. It's very unusual to find the Tibetan heads single, which is here, yeah? And what I try to avoid is all the thousands of Chinese heads on the market which have been ripped off statues and decapitated in all parts of China. I think that's a heinous crime. I really don't like that. If someone sells me a figure in Hong Kong, and it's the whole figure with head, no objections. I mean that's just the way it is, and if it's a beautiful thing I'll probably buy it, and won't think too much about what happened. If I see a head I get furious because I know somewhere the rest of the figure is decapitated. (London Dealer 6)

The communicative structure of the antiquities market is of a discourse which supplies neutralising forms of language capable of influencing the choices of buyers through their entry in a personal ethical balance sheet. Why (and how) do people do things that they know are wrong? They make use of discursive forms to manage their balance sheets in such a way that on this supposed weighing of goods and bads, they are presented with the apparently objective conclusion that they are *entitled* to proceed with the wrongful action in question. Through this process of mephistophelean accounting, they transform evil into virtue. This is what is colloquially called 'brainwashing' but with an extraordinary twist. Given the presence of a neutralising discourse on which to draw and a desire to perform the act deemed as wrongful, people can – and will – brainwash themselves.

The London dealer's quote is important in what it reveals about the relationship between empathy and entitlement. When the psychological front is created, perhaps by discounting moral empathy or by the trick of turning liabilities into assets and thereby removing the restraints of moral empathy altogether, it can lead to a conclusion by the actor that he is entitled to go ahead with his contemplated action. Once this stage of entitlement is reached, we can see that the trick (the front) has played its role and can be forgotten. Once an actor sees himself as entitled to act, there is no longer much need for the use of the front, for entitlement in itself can discount empathy. How that entitlement was reached is easily forgotten and the 'knowledge' of entitlement to commit an act which would otherwise be seen as wrongful by a clear-thinking actor gives the entitled offender grounds to over-rule any subsequent resistance his internal psyche might present by way of empathy for the victim

or for society more generally. Entitlement is good against all comers – it is (in this case) an internally-manufactured status which feels to the manufacturer as if it were externally given.

6.2.2.3 The Social Balance Sheet

The Social Balance Sheet can be given a subtitle, like the others. It is 'the social importance of the act'. Unlike the internal accounting of the Moral Balance Sheet – a personal analysis of the nature of the act in the abstract – the Social Balance Sheet is the individual's way of keeping track of where he stands with the world at large. The Social Balance Sheet, rather than being concerned with anything immanent to the contemplated act, is concerned with determining its 'social righteousness'. Perhaps the best way to explain the operation of social accounting undertaken through the medium of the Social Balance Sheet is by consideration of an example that will also enable us to recap on the other two balance sheets. If we found £100 in the street, some of us might be inclined to keep it, just as some of us might be inclined to return it. Analysing this decision in terms of balance sheets:

- Our Practical Balance Sheets give most of us the capacity to enter the next stage of calculation. We are unlikely to be apprehended for theft, although legally that may be the status of our act[59] (many will not be aware of the legalities of the situation and will assume that the rule is 'finders keepers' which makes for a circumvention of the Practical Balance Sheet altogether). We desire the money. So we have the capacity to take the money – to commit the crime – and we move on to the Moral Balance Sheet.

- It is morally wrong to take money that belongs to someone else. We know this, and we know that the money in the street is not ours. The law acknowledges this, making our act of taking a theft if indeed we do pick up the money with the intent to keep it, if we think there is a reasonable chance the owner might be found. All of this initially appears in our liabilities column on the Moral Balance Sheet. Many of us would stop here, and decide on this basis that the appropriate course of action is to return the money to the police. If nobody claims it, it will be ours anyway. But we can discount the moral empathy we have for the unknown victim – he is nowhere to be seen, and if he has discovered his loss, he has probably written it off. We can see that these discounting arguments may be quite spurious. It is only because society

59 Theft Act 1968: keeping the money will be a dishonest appropriation performed with the intention of permanently depriving the other of their property unless we are successful with a s2(1)(c) plea that we did not think the owner could be discovered by taking reasonable steps. Given the fairly large sum of money at stake, there is an argument that the owner would be likely to contact the police to whom we should therefore surrender the find; in other words the s2(1)(c) defence might very well not avail us.

acts in such selfish ways that he would have written off the money; if everyone returned all money they found to the police, we might project that claims made to the police for lost money would rise sharply. Importantly, the sustainability of the arguments we use to discount liabilities is not vital. In this process of psychological accounting, there is no auditor of our maths but ourselves. In the assets column of the Moral Balance Sheet in this instance is probably nothing at all. It is hard to think of any moral good that comes from us picking up the money. But many of us will discount liabilities to the extent that we view the act of taking as morally neutral, and we are entitled to proceed with morally neutral acts. If, however, we decide that on balance the act is morally wrong, we still have a final chance to find our entitlement to commit the crime through our Social Balance Sheet.

• Social Balance Sheets will be explained further below, but the question I want to raise here is this. Assuming that you are one of the category of money-finders who sees the act of taking and keeping as morally wrong, would your decision to take or not to take be affected by anything outside the immediate imagined situation? What if your bank had informed you two days earlier that an Internet hacker had transferred £500 out of your online account and that (for some reason) they were disinclined to reimburse you for this fraud? Might you feel that you had suffered an injustice? Might you feel that your having lost £500 through no fault of your own gives you an entitlement to take the hundred you find before you now? Rather than altering the moral balance of the dilemma, I suggest it to be better to view this 'social imbalance' as operative in colouring the offender's perception of fairness in a structurally-referential way, providing a route to over-rule moral prescriptions.

The Social Balance Sheet is therefore the mechanism through which antiquities dealers might conduct a purchase which their Moral Balance Sheets had told them was morally wrong. We can imagine here two types of accounting between the individual and society which would leave the individual with a feeling of entitlement to commit an act which they considered morally wrong (and for whom the Practical Balance Sheet stage has been passed with the outcome of 'capacity' as opposed to 'incapacity'). There may be more situations than two, but these will suffice for illustration. The first might be employed by a person of middle-class or higher, we may imagine, and the second by an unemployed and generally disempowered youth. They are:

• "Society owes me because I have added credit to it. Therefore I am entitled to make some withdrawals without penalty. Overall I will still be in credit."

- "Society owes me because it has credited others but not me. Therefore I am entitled to make some withdrawals to redress the inequity between my position and those of others."

The importance of empathy at this stage is, again, great. For it is only by neutralising all or most empathy for the victim that the offender can maintain the illusion that he is dealing with society rather than an individual human being. Society is an amorphous, faceless concept that is relatively easy to impute with a debt. It is much easier to justify a theft to oneself with the rationale that "society owes me this television" than to grapple with the difficult question of why the unknown homeowner whose property you are stealing might owe you their television. This sort of empathy we might call 'social empathy', its deficit involving the ability to dehumanise others, break bonds of consideration for them, and view individual others merely as the building blocks of a general society, among which blocks liability to you is (in legal terminology) 'joint and several'. That is to say that you are entitled to proceed against any one individual for the debt of the whole.

Halpern, in his study mentioned above, concluded that while his 'self-interest' indicators were a robust and significant predictor of victimisation rates in the countries he included in his model, his 'legal-illegal' factors were not. He offers a very plausible explanation for the discrepancy, which we can now read with the concept of social empathy in mind:

> Another way of looking at the 'self-interest' and 'legal-illegal' factors may be in terms of how disembodied, impersonal or 'distant' is the act and victim. The legal-illegal items tend to have a relatively clear victim, while the self-interest items tend to be relatively 'victimless' in form. This suggests that in as far as people are able to think of others in distant and impersonal ways, they are more likely to offend. Such a conceptual shift is reminiscent of the 'disembedding' that some theorists have argued characterizes modernity, and particularly with reference to money.[60] This theory is also supported by evidence from the British Social Attitudes surveys showing that people are much happier about cheating a large store out of money, by keeping incorrect change, than a small store[61][62]

The view of offenders as feeling that they are entitled to commit their crimes problematises the restraining effects of the law in its traditional

60 G. Simmel, *The Sociology of Georg Simmel*, tr. Kurt Wolff, (1950, New York, Free Press).
61 M. Johnson, 'The Price of Honesty,' in R. Jowell, S. Witherspoon and L. Brook, eds *British Social Attitudes: the 5th Report* (1988, Aldershot, Gower).
62 D. Halpern, 'Moral Values, Social Trust and Inequality: Can Values Explain Crime?' (2001) 41 *British Journal of Criminology* 236, at p. 249.

prohibitive form. Entitlement takes offenders outwith the scope of legal prohibitions, in their minds. After their accounting of social assets and liabilities, their relationship with society is in the black. The antiquities market does not think it needs to make amends with society for what liabilities there are, since these are outweighed by assets. Antiquities dealers are becoming more and more aware that people disapprove of the purchase of looted antiquities. They are increasingly being faced with the reality that society is not behind them. Their Social Balance Sheets, unlike their Moral Balance Sheets, are internally performative only. They cannot be opened up for public inspection like their Moral counterparts, for they are not externally justifiable. Neither are antiquities dealers underprivileged. The world has not dealt them an unfair hand and they are owed nothing in the name of the redistribution of wealth. They do, however, see their actions as having considerable social benefit and it is here that they find their right to make 'withdrawals' on the social credits they have amassed. For Class 2 buyers, these withdrawals take the form of the purchase of illicit antiquities other than chance finds, which they assume befalls them only occasionally, if at all.[63] In the profit-and-loss relationship which the interview subjects construct between themselves and the world, society *owes* them their crimes.

6.2.3 Entitlement

We are used to the concept of entitlement; we live with it from day to day. Entitlement is enshrined in various areas of law, as indeed is its obverse, obligation. Rights accrue to individuals sometimes through prescription. The regular traversing of a private field for a prescribed length of time (usually measured in decades) will establish a right of way along that path – an entitlement to walk there. Peaceful and uninterrupted possession of property, similarly, can vest title in the possessor after the expiry of a period of time – an entitlement to live in the property. Entitlement, in law, is in these examples recognised to have its roots in the routine performance of an act.

We are entitled to proceed along a main highway in priority to someone who wants to join the highway from a sideroad on the left. We can see, then, that legal entitlement can be a great discounter of empathy. Most of us would not consider whether the person wishing to join our highway might be in a greater rush to get to their destination than we are. We drive on, because we are entitled to do so. It is not hard to imagine many unsavoury acts perpetrated in the name of legal entitlement; acts which display little empathy for the 'victim'. Tenants are evicted, hostile corporate takeovers

63 Class 1 buyers see the purchase and preservation of all categories of looted antiquity other than some architectural pieces as socially creditworthy, and therefore do not even need to balance them out as withdrawals in their social balance sheets. Each such purchase is a clear asset in their scheme, rather than a liability.

consume small companies, and houses are built which obscure the pleasant views of neighbours, all within the bounds of legal entitlement. Where the application of the laws of men are uncertain, assumed entitlement based on other laws can again function as a discounter of empathy. The Middle East is torn with violence based on alleged entitlement to holy land, an entitlement ostensibly given by the laws of a God.

Where there is no law to give entitlement for action, it can be found through the performative and psychological fronts manufactured by Moral and Social Balance Sheets. Here, the inverse of the legal situations mentioned applies. Just as entitlement can discount empathy as described above, a discounting of empathy can lead to a feeling of entitlement. This occurs where moral empathy for the victim, which appears in the liabilities column of the Moral Balance Sheet is discounted such that a net asset result is obtained on that balance sheet. It also occurs where social empathy, which appears in the liabilities column of the Social Balance Sheet, is discounted such that a net asset result ("society owes me/ approves of my action") is obtained on that balance sheet. So we see that in a circular manner, discounting empathy can lead to entitlement, which then can lead to discounting empathy. Illicit antiquities can be bought, for example, because the arguments of archaeologists about destruction of context are discounted, and a sense of entitlement to buy results. That sense of entitlement persists, and encourages the further discounting of the arguments of the archaeological lobby in respect of future purchases: "I am entitled to buy this material, therefore I need not consider objections".

Competing entitlements can exist, of course, and much of what the law does in its day-to-day civil judicial practice is weigh such claims to rights. Antiquities dealers, source countries and archaeologists all claim entitlement to antiquities in one way or another. Antiquities dealers privilege their entitlement over that of others by discounting the value of other entitlements. In genocide and massacre, the divesting of the humanity of those to be killed – of their entitlement to life – is a precondition to an imagined entitlement to the act.[64] For antiquities dealers, it is the divesting of the source countries' and archaeologists' entitlement to retain the objects which is important in the creation of an over-riding entitlement in the dealers to buy them. Various arguments are used to divest the 'victims' of their entitlement, as we have seen.

A view of crime as entitlement is not unprecedented. Champion has postulated that entitling personality structures are associated with sexual aggression – his terminology involves 'cognitively structured

64 T. Duster, 'Conditions for Guilt-Free Massacre', in N. Sanford & C. Comstock (eds.) *Sanctions for Evil* (1971, San Francisco, Jossey-Bass, Inc.).

belief systems'.[65] Entitlement to engage in negative behaviours was also one of the eight thinking styles found to be common to prison inmates, giving rise to the Psychological Inventory of Criminal Thinking Styles.[66] However, entitlement as a manufactured mental construct deserves greater recognition and further exploration, as does its link with empathy.

Two different types of empathy have been identified: moral and social. An everyday example might serve to illustrate the operation of these types better than an example drawn from the special case of the antiquities market. Imagine while driving your car you have been 'cut up' four times in a row. Now, you are presented with an opportunity to cut up another driver. Do you? Moral empathy might prevent you from doing so because you think that cutting people up is a generally bad thing to do, irrespective of the characteristics of the other driver. Failing agreement on this sort of generally-applicable moral rule, it may be that the other driver is an old lady, and you have a moral policy of doing right by old ladies. In this latter case, the personal characteristics of the perceived victim have operated to create a moral consideration in favour of them which otherwise might not have existed. Social empathy might prevent you from performing the manoeuvre as you possess the ability to separate the identity of the driver you now see from those who cut you up. She is a separate person from them, and their wrongs against you do not constitute a justification for your moving in on her. 'Society' has not wronged you, the other four drivers have, and this driver need not therefore pay for society's wrongs.

Both types of empathy can therefore affect motivation to act. In the case of the antiquities market, their effect is on motivation to buy as they feature in the liabilities columns of balance sheets when the purchase is considered.

Can empathy also affect opportunities? In the sense that it engenders mechanisms of informal social control, the answer would appear to be yes. Neighbours might report suspicious loiterers to the police out of concern for their fellow homeowners, leading to an increased likelihood of apprehension for the burglars who see the curtains twitch next door. Shoppers who see that the shopkeeper has inadvertently left the till open while searching for an item at the back of the store

65 D.R. Champion, *Narcissism and Entitlement: Sexual Aggression and the College Male* (2003, New York, LFB Scholarly Publishing LLC).

66 G.D. Walters, 'The Psychological Inventory of Criminal Thinking Styles: Part I. Reliability and Preliminary Validity', (1995) 22 *Criminal Justice and Behaviour*, 307-25; 'The Psychological Inventory of Criminal Thinking Styles: Part II. Identifying Simulated Response Sets', (1995) 22 *Criminal Justice and Behaviour* 437-55; (1996) 'The Psychological Inventory of Criminal Thinking Styles: Part III. Predictive Validity', *International Journal of Offender Therapy and Comparative Criminology* 40: 105-12; G.D. Walters, W.N. Elliott, & D. Miscoll, 'Use of the Psychological Inventory of Criminal Thinking Styles in a Group of Female Offenders' (1998) 25 *Criminal Justice and Behaviour* 125-34.

might close it for him (rather than raiding it) to prevent opportunistic theft by others. Concerned members of the antiquities market might report suspicious sellers who make offers of material deduced to have been looted. Currently, it appears from the data, this type of informal social control is absent from the market.

The communitarianism of the societies Braithwaite identified as being most likely to implement shaming techniques in their treatment of offenders[67] leads them, I submit, to have the least concentration of citizens who see themselves as entitled to commit crime. Further, however, a developed sense of empathy for others may not have anything to do with 'interdependency' or its opposite 'individualism' as such. It is possible to be highly individual in the way one's life is led – private and ungiving of one's time and energies to any sort of community pursuits – while still possessing a high level of empathy for the position of others, both known and unknown, in society. The sort of tightly-knit communities which Braithwaite admires in his work might well strike a chord of panic in the hearts of those of us who spend much of our time creating private worlds. Relief for us comes in the form of the realisation that it may not be the kinship or social network structure of the community as much as the ability of its members to respect the needs of others that counts in the reduction both of motivated offenders and of suitable opportunities. This is not actually a deviation from Braithwaite – at most it is a shift of emphasis. In addition to the re-integrative effects of shaming, he identified the possibility that societies which encourage the development of feelings of moral obligation between their citizens may achieve a protective effect by reducing motivation to criminality.[68] How might we produce such a protective effect in the antiquities market?

In the final chapter I shall, amongst other things, evaluate the likely success of motivation and opportunity reduction strategies which attempt to increase empathy in the antiquities market. That discussion can be foreshadowed by summarising the key points of this chapter.

Antiquities buyers see themselves as doing good in the world. They see themselves as entitled – morally, socially, or both – to their trade or collection. They use a balancing process to reach this impression of entitlement. Some of the entries in this balancing process are given an externally valid weight (i.e. one that we might all agree upon as correct); some are 'internally' manipulated to diminish their negative weight, or even to make negative weight positive. This manipulation involves the employment of techniques of neutralisation. As a site for the application of these techniques,

67 J. Braithwaite, *Crime, Shame and Reintegration* (1989, Cambridge, Cambridge University Press).

68 *Ibid.*, at p. 61 *et seq.*

then, the balance sheets identified would seem to provide a link between the Matzian concepts of drift and will, and help explain the actualisation of wrongdoing. The will to buy antiquities and the application of techniques of neutralisation come together within the framework of Practical, Moral and Social Balance Sheets to produce purchases of illicit goods. Drift solidifies here as entitlement. It can be seen that removing this sense of entitlement is vital for regulators of the market.

One way to achieve the diminution of this sense of entitlement, in theory at least, would be through the encouragement of moral and social empathy in the market; i.e. bringing to mind at the time of purchase that a particular archaeologist or community has suffered through the looting of this object, or that generally looting is a destructive practice (moral empathy), and that, for example, because some government officials in some source countries are corrupt does not mean they all are, and therefore does not discount all consideration for the controls of source countries across the board (social empathy). In practice, the encouragement of empathy seems very difficult to achieve, and we might relegate these thoughts to our secondary, or support, line of engagement with entitlement in the market, while we productively look to other primary mechanisms which can achieve the control of entitlement we seek, in a more formal manner. One such mechanism is proposed as we take the matters of empathy, entitlement and balance sheets to their logical conclusion in the next, and final, chapter.

How Should We Regulate the International Market in Illicit Antiquities?

The conclusion of this research may be stated as follows:

- while there is a continuing desire on the part of antiquities traders and collectors to deal in ancient artefacts, and
- while they continue to use a balance sheet approach to perceptions of punishment, personal ethics and social responsibility, and
- while the continuing dearth of provenance information passed in the course of transactions allows them to alter their personal balance sheets in various ways so as always to arrive at an asset result in relation to the question of whether or not to buy any given object, then
- so long as their desire to trade persists, they will continue to do so, unless either:
 (i) legislation is put in place which so affects their Practical Balance Sheet calculations that they can no longer arrive at an asset result when considering the purchase of an antiquity. For this to work, the risk associated with purchase must become so great as to outweigh the possible gain, both emotional and financial, from the purchase (which is currently not the case with the existing legislation); or
 (ii) mechanisms of intervention are employed to alter the other balance sheet calculations being made by those in the market. Their discounting of moral liabilities such as moral empathy or their turning of liabilities into assets must cease, and their manufacture of psychological fronts must be interrupted so as no longer to incorporate the techniques of neutralisation which currently allow them to see themselves as morally and/ or socially entitled to buy objects which they know to be either actually or possibly looted.

In this final chapter I shall discuss the relevance of the qualitative data gathered during the course of this project, and set out in the previous chapters of this thesis, to the broader question of why legal efforts to control the international trade in illicit antiquities have not achieved their goal of harm reduction. This discussion will proceed by way of a logical progression from a statement of our goal

as regulators, through an application of the theoretical principles set out in Chapter 6, to an ultimate recommendation of one possible solution to the problem which the data and theory in this thesis suggest might be fruitful. That solution is a system of registration of antiquities, backed up by criminal penalties. It fits with the tenets of Braithwaite's approach to governance, and Routine Activities Theory, both of which have found much popular support in recent times as tools to guide policy formation.

7.1 WHAT IS OUR GOAL?

Our goal is both the protection of contextual information available to archaeologists from the findspot, and the objects themselves. Contrary to the contentions of the market, context is vitally important, and its protection from the deprecations of looters must be a priority for any attempt to regulate the market:

> *Context is essential to understanding the past. No doubt about it. To use a very bad analogy, it would be like saying you're a person in your own right, it doesn't really matter who your parents are, it's irrelevant. Well, it's not really: it's your being that makes sense of your whole identity. It's the same with artefacts. Artefacts on their own, unless you're purely an art for art's sake person, if you want to try and understand our, you know, humanity, society, economy at a complex level, which is I think what we want to do, you have to understand context. And you don't know the importance of that context until you've actually done the excavation. It's impossible to predict. But you have to – you can almost call it a law – that you have to respect the context. Anyone who argues the opposite only understands the past on a superficial level.* (London Archaeologist 1)

Our goal is also the preservation of a licit market in antiquities, with the educative function that entails. An end-to-end solution is required. A commitment is needed from both source governments and the market community to protect contexts, objects and the market itself.

7.2 SUMMARY OF RESEARCH FINDINGS

This research suggests that buyers in the antiquities market can be split into three classes, depending upon their attitude to the purchase of looted antiquities. These three classes emerged from the initial discussion of attitudes to provenance, in Chapter 2. At one extreme are Class 1 buyers who do not care if an object has been looted; they will buy it anyway. We have seen evidence of this attitude from some of the dealers interviewed, and it has been suggested that the attitude is even more prevalent among private collectors, although this is not possible to verify from the bias of the core sample towards dealers:

> *[You think everybody tries as hard as they can to make*
> *sure it's good?]*
>
> *Well, the dealers we deal with, yes.*
>
> *[The dealers you deal with? I'm not trying to suggest that*
> *this is the case and please tell me if it's not, but do you feel*
> *the market is split into people who are trying to pursue ethical*
> *acquisitions and people who don't really care much about*
> *where the stuff comes from?]*
>
> *I can say that I would be absolutely certain that a lot of*
> *private collectors don't care at all. Actually I had a verified*
> *case recently, it's purely anecdotal, but yeah, I thought if I*
> *don't buy this then someone else will, so yeah, there's that*
> *sort of aspect of it too.* (Melbourne Museum 1)

At the other extreme are Class 3 buyers who do everything they can to avoid purchasing looted antiquities, including extensive research into the provenance of the objects they are offered, and the employment of a strict personal ethic which instructs them to walk away from a purchase if there is any doubt over the origin of the object. The interview data did not suggest that this group formed a considerable proportion of the buyers in the market, but we can find slim evidence for the group's existence and therefore it is worth including it in our scheme.

The middle ground on our scale of buyers' attitudes to the purchase of looted antiquities is occupied by Class 2 buyers who would care about the illicit provenance of the objects they are buying if such information were available, but since it is not they proceed with purchases in the hope, rather than the knowledge, that the objects are not the product of intentional looting. Although chance finds which find their way onto the market are almost exclusively illicit as that term is defined in this thesis, Class 2 buyers (in common with Class 1) decline to see them as such. They will therefore buy this category of illicit material, and any object they can include therein by supposition. This results in a category that only really excludes those objects which have obviously been circulating on the market for several years. These will for the most part be amenable to purchase in terms of limitation laws. In short, both Class 1 and Class 2 buyers, though differing in mental position, buy almost anything.

Behind this willingness to buy 'almost anything' is a mental process in which buyers prioritise the moral good and social appropriateness of their purchases, discount or otherwise manipulate objections to their purchases, and arrive at the view that they are entitled, on balance, to buy the object they are offered. I have given examples of this process in Chapter 6, based on the interview data in Chapter 5.

In Chapter 3, I examined the laws governing the antiquities market, taking the example of Thai antiquities. It was observed that many

of the laws have significant structural flaws, but beyond this there is a greater problem. The interview data suggest that these laws do not 'fit' the market. They do not engage the major players in the market in any significant way – neither buyers at the demand end of the market, nor looters at the source end. Nor indeed do the mechanics of export and import present a challenge to those who transport antiquities from supply to demand. The market persists.

Through looking at the comparative illicit markets in drugs and wildlife, in Chapter 4 I made observations on the various approaches the law can take to such international problems. The drugs market demonstrates that where demand remains strong, prohibitive legislation alone can do little to stop supply. We noted qualitative differences in the 'end users' in the drugs and antiquities markets, which suggest that while prohibition of alcohol and drugs aimed at demand in market countries has a poor history of success, it has a better prospect of success in the antiquities market given the higher class and higher social visibility of purchasers here. We further noted that prohibitive strategies are only effective when they involve a considerable likelihood of capture, and therefore they must be combined with strategies that increase surveillance of market participants. The new Australian wildlife legislation demonstrates the increasing popularity of surveillance techniques, and an increasing willingness among law makers and enforcers to engage with the particular market through licensing and stock-reporting requirements. That market also demonstrates the slow move towards a more global approach to criminal markets, involving as it does a linking of the import controls of market nations with the export controls of source nations – a link significantly absent in the antiquities market.

7.3 What does the Research Tell us about the Best Way to Achieve our Goal?

Current approaches to regulation in the antiquities market can be categorised under two headings: punishment and persuasion. The former strategy is embodied by the legal prohibitions on unauthorised excavation and export in source countries, and the increasing application of the criminal law to possession and dealing in antiquities in market countries, such as the NSPA in the United States and the Dealing in Cultural Objects (Offences) Act 2003 in the United Kingdom. The latter strategy is evident in the international Conventions and codes of practice discussed in section 3.2, and the often-heard call for education of dealers and/or source populations in the destructive nature of looting.

I have, in section 4.4, mentioned the work of Braithwaite and others who draw together the philosophies of punishment and persuasion to create regulatory pyramids. In Chapters 5 and 6, I have developed a scheme for understanding how antiquities buyers construct their worlds which leads to the conclusion that our options in regulating

the antiquities market are limited. Currently popular in regulatory debates are approaches which suggest that we 'work with' the market in question; that we take a softly-softly tack; that we encourage market players to be responsible without alienating them through harsh regulatory interventions. For many markets, this co-operative style of approach seems quite sensible. The scheme developed in Chapters 5 and 6 frames our options in regulating the antiquities market in different terms, however. So long as buyers are able to insulate themselves from the damage looting causes through the manufacturing of a sense of entitlement to buy, collaborative approaches are rendered hopeless. The market does not want to change; it does not see why it should. In this particular market we need a specially designed pyramid to attend to the problem of creating buyers in the market who hold a different set of constructs from those currently in use.

Before constructing this pyramid, it is important to clear a platform on which it can be built. I intend to do this by further summarising the findings of the research on the inappropriateness of punishment and persuasion as they are currently employed; i.e. in isolation from each other rather than in conjunction.

7.3.1 Punishment

The research suggests the need for an approach to social control in this particular market which is broader than the traditional deterrence-based approach that forms the basis of much current lawmaking. Polk[1] has argued for a fourth limb to be added to the accepted three limbs of deterrence theory; certainty, severity and celerity of punishment.[2] His fourth limb is the requirement that there be an association in the mind of the would-be offender between the prohibited action and the existence and likelihood of punishment. The main finding of the present research is that owing to the micro-level practices of the market and the associated psychological machinations of buyers therein, the macro-level arena of law is not seen as relevant to the act of purchase. Such prohibitions and directions as it contains are thus ignored.

The discovery in the data of a conviction among buyers of antiquities that they are doing good fits with the results of other research into culture and the normalisation of deviance. For example, Diane Vaughan in her research into the 1986 explosion of NASA's space shuttle *Challenger* observed that:

1 K. Polk, 'Controlling the Traffic in Illicit Antiquities: Are Criminal Sanctions Appropriate?' Published in proceedings of the conference *Implementation of the UNESCO 1970 Convention* (2002, Institute of Art & Law and Art-Law Centre, Geneva, held at the Department for Culture Media and Sport, London).

2 L. Siegel, *Criminology* (1992, New York, West Publications); C.E. Marshall, 'Deterrence Theory', in D. Levinson (ed.) *Encyclopaedia of Crime and Punishment*, Vol. 2 (2002, Thousand Oaks, CA, Sage Publications).

... institutional, organizational, and interactional forces can affect the worldview of individuals in organizations, blinding them to the harm they do. As a consequence, they see benefits, not costs, as the result of their actions.[3]

As was the case for Vaughan, so my own research leads me to reject the amoral calculator model of white-collar offending. I favour something more complex: offenders as calculators of a moral mathematics which can be manipulated to their desired ends. It is this evasive micro-level question of what definition of a given opportunity an actor holds at the time of preference-formation which rational choice proponents acknowledge is of vital importance to the future development of their theory.[4] The present research has explored this question in the very limited case of buyers of antiquities. Relating this absence of a theory of preference-formation to the question of deterrence, Vaughan notes:

> A social control focus on punishment-oriented strategies intended to deter offenders neglects the social context that leads them to make the choices they do... Punishment is appropriate; however, as a strategy of social control it does not go far enough. It leaves the more-difficult-to-diagnose goals, policies, cultures, structures, and organizations unchanged, perpetuating the possibility of recurrence.[5]

As the interview data have shown, it is precisely the culture of the antiquities market that is responsible for the looting problem. This is a culture in which unprovenanced objects are the norm. Difficult questions about the origin of those objects are answered by the use of elements of a neutralising discourse, culturally provided and endorsed. Prohibitive laws in the market do not disrupt this culture, and in the face of continuing demand, prohibitive laws at source are ineffective.

Turning to recap on the problems at source, briefly, let us review our findings about the current system of State-vesting legislation which makes looting illegal by providing for nationalisation of undiscovered antiquities. This makes international civil law claims for the return of illegally-exported antiquities easier, by giving the plaintiff State title to sue *qua* owner, but does little to affect the behaviour of looters:

> *Human nature is such that nobody is going to pay any attention to the law, especially in this part of the world. If they think they can make money and they think they can*

3 D. Vaughan, 'Boundary Work: Levels of Analysis, the Macro-Micro Link, and the Social Control of Organisations', in P. Ewick, R.A. Kagan & A. Sarat (eds) *Social Science, Social Policy, and the Law* (1999, New York, Russell Sage Foundation) at p. 301.

4 D. Friedman, & M. Hechter, 'The Contribution of Rational Choice Theory to Macrosociological Research' (1988) 6 *Sociological Theory* 201; M. Hechter, & S. Kanazawa, 'Sociological Rational Choice Theory' (1997) 23 *Annual Review of Sociology* 191.

5 Vaughan, *op. cit.* note 3, at pp. 308-9.

avoid getting caught, they're going to go ahead and do what they were going to do anyway. (Bangkok Dealer 1)

Routine Activities Theory[6] suggests that three factors must co-exist in order for a crime to result:

a) a motivated offender;
b) a suitable target; and
c) the absence of a capable guardian.

This leads to three corresponding conclusions in respect of the protection of archaeological sites against looting:

a) we can act to remove the motivation for illicit digging;
b) we can decrease the suitability of the target by employing target-hardening measures at sites which, in the practical philosophy of situational crime prevention, increase the difficulty of committing the offence of illicit digging and excavation of antiquities;
c) we can introduce guardians to sites – security guards, an abundance of archaeologists, etc.

Although the interviewees would have us believe that illicit digging is a natural expression of curiosity, a major motivation for illicit digging on the scale it currently occurs worldwide is money. In respect of item a) therefore, we might look to removing the financial element of the motivation to dig by reducing the instances of purchase of looted antiquities internationally. Lack of funding in source countries currently militates against the practicability of options b) and c). This is not to say that it is not worthwhile to pursue methods of increasing available funds to enable these site protection measures to be implemented. Perhaps a method of trading in the antiquities market can be designed which will achieve all three methods of protection. Co-operative action between market and source States is the first step to effectively steering international illicit markets:

> ... States will have to realise that their slavish devotion to safeguarding national sovereignty is not only increasingly meaningless in a borderless world, but also a major hindrance to collective international action... Although each [illicit market] is different in its own way, they all transcend the ability of any one state to solve them.[7]

UNESCO has long proposed the creation of a fund to administer grants to source nations for such purposes as education, socio-economic support of source populations and site protection. The financing of the fund remains a matter of dispute; suggestions range from voluntary contributions from interested parties to the levying

6 L.E. Cohen, & M. Felson, 'Social Change and Crime Rate Trends: a Routine Activity Approach', (1979) 44 *American Sociological Review* 588.
7 P.B. Stares, *Global Habit: the Drug Problem in a Borderless World* (1996, Virginia, Donnelly & Sons) at p. 14.

of a form of consumer tax on museums and collectors. One of the dealers interviewed had an eminently sensible idea that detailed how money from the consumer end of the chain of supply of antiquities could trickle down to the source countries:

> *[So how would your idea work?]*
>
> *The collector would probably have to pay a fee. Some sort of licensing fee. Collector or dealer, or museum for that matter. Anybody who's interested in being what you might call an 'end user'. A dealer or a collector or a museum in the west that doesn't have access easily to these things that are coming from some other country, could perhaps initially participate by becoming a member; paying a fee. It needn't be a lot of money. Being approved for membership of whatever this organisation might be called. And then they might be invited on a per case basis to participate in financing particular buys. They don't necessarily have to be archaeological digs, but they could be things which are in situ in a certain place which are not required. They might have 1,001 Buddhas in a particular temple, so they might decide that they can legitimately sell off ten of them. So there might be a method by which that could be approved and documented and so on. And the temple would then also know that their pieces are in a perfectly good home in somewhere in the States or Western Europe or wherever it happens to be; in a collection or a museum or whatever. They would be able to go and visit if they wanted to, and similarly the collectors would know exactly where it came from, and the whole thing would be a much more tasteful operation. At the moment there's a lot of seedy operators in this business, and it would put them out of business. It's a little bit like legalising or decriminalising marijuana... You'd have to decide which things are really bad and which things are not bad and make laws appropriate.*
> (Bangkok Dealer 1)

In the absence of such collaborative efforts to solve the problem of looting, however, we are left with the standard legal strategy of the threat of punishment which alone is demonstrably failing to protect sites either through dissuading looters from their activities, or market buyers from theirs.

7.3.2 Persuasion

Since archaeologist Clemency Coggins[8] and journalist-turned-art historian Karl Meyer[9] made the first steps towards alerting the world to the issue of the looting of antiquities and the relationship between that looting and the international market, commentators have insisted that the most important foil to the market lies in education. Two recent writings illustrate this line of thought:

8 C. Coggins, 'Illicit Traffic of Pre-Columbian Antiquities', (1969) *Art Journal*, Fall, 94.
9 K. Meyer, The Plundered Past: the Traffic in Art Treasures (1973, New York, Atheneum).

The destruction continues apace. It is the view of the editors of this volume that the problem can only be solved through education. It is necessary to encourage citizens of the source nations to value more highly their own patrimony, and to seek to see it displayed and admired locally, so that there is also a benefit for local communities. And it is necessary to encourage museums and private collectors to value more highly the information about the past which is lost when they buy unprovenanced antiquities.[10]

In the Introduction, reference was made to the need for a sustained campaign in all media highlighting the destruction caused by taking antiquities from illegitimate sources... Education and publicity must cover all States affected and all levels of society. Concentration on the public in the market States is not sufficient. There must also be education of local peoples where clandestine excavation is a problem. Particular segments of society may need to be specifically targeted.[11]

In fact, allusions to the remedial effect of public- (both source and market) and trade- education in the nature of the market are drawn in most, if not all, of the works on the topic thus far cited in this book. It is terribly difficult to achieve an effect on the market through education targeted at source populations. An impossibly high level of educated cultural sensitivity would be required to combat the pressure on finders to enrich themselves at the expense of their cultural heritage so long as there are relatively large financial incentives illegally to dispose of objects that are discovered. This is not to say that education of source populations is worthless, but simply that it must be coupled with initiatives to reduce the demand for looted antiquities.

Market-end education is gradually happening, not through any market government initiatives, but through increasing academic and media attention to the looting issue which brings trickledown awareness-raising effects to the general public; the more this happens, the more members of the trade will have cause to re-examine their activities:

> *I, like all my colleagues, feel totally demonised. And actually in the past you were an unusual person with a very interesting life. Totally outside the establishment, which is my obsession. Not to be involved. And now, you know, I was telling an old friend that I'd been to Winchester cathedral with my kids and they have these wonderful fourteenth-century tiles, and he said "did you bring your Swiss knife?" This is an old*

10 C. Renfrew, 'Foreword', in N. Brodie, J. Doole & C. Renfrew (eds.) *Trade in Illicit Antiquities: the Destruction of the World's Archaeological Heritage* (2001, Cambridge: McDonald Institute for Archaeological Research) at p. xii.

11 P.J. O'Keefe, *Trade in Antiquities: Reducing Destruction and Theft* (1997, London, Archetype) at p. 89.

friend. But he would have never thought of that, and this is why, I can see people consider me a shady figure. And actually what we've done is we've built great collections; I've sold to over twenty, twenty-five museums in the world, you know, I think I've done my part... It's very heartbreaking sometimes. And actually I'm ready to quit now... it's not because of what people think, but it's because I think what we've done makes less and less sense. (London Dealer 2)

The research, however, suggests that while buyers in the market are increasingly aware of the foibles of their practice, their mental accounting processes have insulated them from the effects of this 'education'. Constructing balance sheets which show the act of purchase of an unprovenanced antiquity to be good, leads them to the conclusion that they are entitled to make the purchase. It is difficult to see how education can break down these processes.[12] In the minds of the market interviewees, 'education' is a synonym for the re-statement of the archaeologists' arguments, which they have already discounted in their balance sheets using the processes detailed in Chapter 6.

It is worthwhile, of course, to train local populations to recognise the value of their cultural heritage, both in its worth to them in terms of their history, and in its potential for commercial exploitation in ways less destructive than looting. As Renfrew notes 'most countries with such a system make much more today from international tourism than ever the looters did as profit'.[13] The establishment of local museums to preserve, display and control finds from nearby sites, would also be an important step for the national antiquities services of source countries to take. Aside from the obvious tourist benefits of such a network, the maintenance of the bond between an object and its findspot fosters local pride in the historical richness of a population's home and would be much more likely to encourage the reporting of finds than a centralised Bangkok agency into the hands of which antiquities surrendered or confiscated disappear with no apparent benefit to the finders, their families or their villages. However, the research suggests that education of source populations will do little to slow the market in the face of a continuing demand for illicit artefacts.

Dealing appropriately with chance finders is a persuasive tactic that source countries should use in the place of current prohibitive

12 Education of consumers in market countries was, of course, of paramount influence in the reduction of demand in the fur and ivory trades. These trades can be distinguished from the antiquities trade, however, when we consider the different mental constructs of buyers. Unlike the beneficial aspects of antiquity purchase put forward by the interviewees, there is nothing obviously 'good' about buying a fur coat, or a tusk. The mental ledgers of buyers of fur and ivory were therefore more delicately balanced, and more amenable to manipulation through an educative discourse. With no appeal to the 'good' these markets did, all educators had to do was work on diminishing the validity of the neutralisations used (e.g. "mink are vermin, therefore I am not troubled by their killing").

13 Renfrew, *op. cit.* note 10 at p. xi.

strategies which achieve little. A straightforward solution would be to offer the farmer who turns up an object with his plough one of two options. The first is to report the find to the local government agency who must then decide whether they want to send archaeologists to investigate the findspot and surrounding areas, in which case they must provide the farmer with appropriate compensation for his lost income through these investigations. The alternative is for the farmer to elect when reporting the find not to have archaeologists on his land, at which point the find should be surrendered to the local agency without penalty or reward to the farmer. If findspot information cannot be recorded, it is still better to preserve the object than for it to be destroyed. Coupled with education programmes in source countries it would be hoped that increasing numbers of finders would choose the first option. The attraction of the first option could be increased by offering the finder a share of the sale price if the object was sold by the source government in the event that he exercised that option rather than the second. Either way, the object would be recorded and given provenance documentation which would stay with it whether it passed into a national collection or onto the international market. The third option for the farmer would of course be to sell the object on the local black market and make himself a profit. Again we see that persuasion alone is not a solution to the illicit market in the face of continuing demand. To remove this option, we require market-end initiatives to reduce demand for unprovenanced antiquities. To this I now turn.

7.4 A Regulatory Pyramid for the Antiquities Market

So long as objects come without provenance, Class 2 buyers can think them to be chance finds. So long as buyers employ the thought processes identified in this thesis, persuasive education washes over them. So long as perceptions of punishment are low, deterrence is not operative against this category of white-collar criminal. A regulatory pyramid[14] built of persuasion and punishment can work for regulators of this market, but the two levels of persuasion and punishment must be more integrated than is currently the case. I suggest here a mechanism for achieving this integration of pyramid layers in the form of a system of registration. This is a controversial idea, resisted by many of the interviewees, perhaps precisely because it would achieve the effect of reducing their access to financial gain from trading in illicit antiquities.

7.4.1 Pyramid, Lower Level: Registration Making Possible the Recognition of Illicit Antiquities

Imagine a group of several hundred matches on the floor. All of them are different; different lengths, different colours, some broken, some

14 J. Braithwaite, 'Responsive Regulation in Australia', in P.N. Grabosky & J. Braithwaite (eds.) *Business Regulation and Australia's Future* (1993, Canberra, Australian Institute of Criminology), discussed above at secton 4.4.3.

not. Occasionally you leave the room with the pile of matches on the floor and when you come back you suspect that the pile has grown. How might you find out if someone is adding to the pile while it is unattended? You could try to catch the culprit in the act of bringing new matches into the room, but you might well miss them: you cannot guard the pile at all times.

You pick up a match. How do you know if it has always been in the pile or if it has recently been added? There is nothing about the match that will tell you; there are countless matches out there. The simplest and most effective way to know whether a match is new is to have previously made a catalogue of the matches you have. If this match you hold does not correspond with a catalogued entry, it must be assumed to be new.

Antiquities might be registered. Registration is an effective way to combat the mechanism which is central to the survival of the international market in illicit antiquities – the arrival on the market of recently looted objects which cannot be told apart from those which were already circulating. Currently it is an axiom of the market that there is no reliable method of distinguishing the licit objects from the illicit:

> *You get so many pieces that are out there and have no history anyway, that you don't own, that a dealer doesn't own, that may come to a dealer through an auction house, through somebody who inherits it and doesn't know what it is, and then it has no history basically, like your grandfather's chair. So does that mean that object has a cloud over it? How can you tell what's licit and what's illicit?* (New York Dealer 2)

Murphy, in his exposition of Chinese cultural property law, cites a journal article from the early 1990s which advocated the adoption of a scheme instituted by the local cultural relics department in a district of Henan Province, under which relics in private collections had to be registered and certified. "This not only protected the lawful rights of the owners of the cultural relics", the author thought, "but also ensured the control of the cultural relics departments over those relics, thereby efficiently limiting illegal transfers of privately collected cultural relics".[15] While this method provides some structure to the domestic market in antiquities, it does little to address the issue of the huge and continuing outflow of cultural objects from China identified in Murphy's book. Foreign buyers do not insist on evidence of prior registration in China.

Registration in a public register of antiquities held by individuals should be distinguished from registration of buyer and seller details

15 Anonymous, 'Strengthen Management of Circulation of Cultural Relics', *Fazhi Ribao*, 7 February 1992: 3, cited by J.D. Murphy, *Plunder and Preservation: Cultural Property Law and Practice in the People's Republic of China* (1995, Hong Kong, Oxford University Press) at pp. 101-2.

by dealers, in books administered by those dealers and kept on their premises. The latter idea has been the subject of proposition by several different sources, among them UNESCO[16] and in fact has been implemented by several countries, often in relation to second-hand dealers generally rather than in the specific form of antiquities registration. Australia is an example.[17]

This type of registration requirement, however, does not include in its ambit the many private transactions between collectors that do not involve dealers as middle-men. The system of licensing of dealers operating in New Zealand does, however, while remaining in the form of dealer-held individual registers of transactions, incorporate an element of public registration of the artefacts themselves which is instructive. It is as well to quote Prott and O'Keefe's explanation of that system in full:

> Under s15 [of the *Antiquities Act 1975*], no second-hand dealer (i.e. a person who holds a licence under the *Secondhand Dealers Act 1963*) is permitted to trade in artefacts (defined in s2) unless he has a licence so to trade from the Secretary for Internal Affairs. Licensed second-hand dealers are one of the four categories of person to whom an artefact may lawfully be sold or disposed of in New Zealand – the other three being a registered collector, a public museum or a licensed auctioneer. The licence granted a dealer is subject to a number of conditions (s15): notification to an authorised public museum of every artefact that is to be offered for sale; that sales are to be made only to public museums, other licensed second-hand dealers, licensed auctioneers or registered collectors; the maintenance of a register showing the name and address of both vendor and seller [this must be a misprint; I assume they mean 'purchaser'] and a description of the artefact; a copy of the register entry to be forwarded to the National Museum to form the basis of a central register of artefacts; the register to be made available for inspection by any authorized person; a notice to be displayed on the premises drawing attention to the provisions of the Act. The licence will be revoked if the dealer is convicted of any offence under the Act or the *Historic Places Act 1980* or if he ceases to be licensed under the *Secondhand Dealers Act 1963*. Failure to comply with any of the conditions of the license is an offence under the Act carrying a fine of up to $2000.[18]

16 UNESCO (1981) 'Second Session of the Intergovernmental Committee for Promoting the Return of Cultural Property to its Countries of Origin or its Restitution in Case of Illicit Appropriation', *UNESCO Doc. CC-81/CONF.203/10*.

17 L.V. Prott, & P.J. O'Keefe, *Law and the Cultural Heritage, Volume 3: Movement*. (1989, London, Butterworths) at p. 328.

18 *Ibid.*, at p. 331.

For all the admirable publicity and recording requirements of these provisions, what they fail to do is to require registered dealers to sight provenance or provenience documentation before purchase of objects coming from abroad. If looted or stolen antiquities can enter the register, it is not a solution. A register of *licit* antiquities is. Measures must be implemented to ensure that only licit antiquities can be registered.

At present, there is no general requirement in market and transit States that antiquities dealers be registered, other than sometimes as second-hand dealers. Where they are registered as second-hand dealers, there are generally no additional requirements levied upon them, peculiar to the antiquities trade. Thus, licence revocation (a threat we have seen to be part of the control mechanisms employed to regulate the market in illicit wildlife) is not currently a deterrent which can be used against antiquity traders in these jurisdictions, who do not deviate from any general requirements as might apply to second-hand dealers.

A public register of holdings, ideally in all market countries but initially at least in the United States and United Kingdom, would enable the tracing of antiquities through their stages of private and public ownership; would be useful for the purposes of insurance; would discourage the purchase from sellers within those countries of antiquities not listed, on the inference that they were looted; and would enable museums and historians to track down items which they might care to inspect or borrow for the purposes of scholarship or display. Antiquities surfacing for the first time, i.e. having no documentary record of having been in circulation prior to the institution of the register, would need documented archaeological provenance to be registrable. A register of antiquities holdings would have to allow all antiquities held at the date of passing of the legislation to be registered without documentation. Arbitrary and unfair though it may seem, we have to start somewhere. If the aim is the protection of context, then those antiquities already on the market, whether looted or not, have lost their context and we would do well to focus on implementing methods of protecting what is still in the ground rather than trying to chase down looted antiquities and return them to their countries of source while new batches of looted material continue to supply the market.

Two important issues arise and should be clarified at this point. The first is the question of the fit between a system of registration of holdings among licensed dealers and collectors and the global nature of the market. The second is the question of the actual mechanism of the proposed register. I decline here to describe the detail of an appropriate system of registration other than to clarify some potential points of contention. Properly to delineate a suitable system would involve a document dedicated to that task, and it is not the purpose of this book to enter such a level of detail. Importantly also, it is the

principle of registration and tracking of antiquities which must be accepted to progress towards a solution to the market's current problems. It would be narrow-minded indeed to contend that there could be no better design than the tracing system imagined here.

The system envisaged is a computer database on which is held object descriptions and details of provenance. Each country concerned with the antiquities trade could establish its own database to hold details of the antiquities possessed by those operating under its jurisdiction. These computer registers could be linked, to make possible quick and cheap searches between registers, and therefore between countries. In this way, objects originating in countries that have such a register will be traceable through to their final registration in their market destination.

What of objects which originate or pass through countries which choose not to establish a compatible register of holdings? If extracted by an archaeologist, they will be registrable in their market destination, provided they arrive with the appropriate certification of licit excavation. Objects which have been circulating for years in jurisdictions without a register, and which therefore do not carry with them such documentation, will not be amenable to purchase in market destinations which employ a register. An exception to this rule might be made if it can be proven by way of documentation that the objects were in circulation at the date of entry into force of the register in the relevant market jurisdiction. If, as is proposed, the major market destinations adopt a registration approach to antiquity possession, these markets will be denied externally circulating objects without such documentation. However, rather than punish markets for their turn to registration, it is likely that the removal of potential markets from the scope of dealers within external non-registered jurisdictions will encourage those countries to adopt the registration norm in order to recover access to points of sale. At the very least it would encourage them to begin a documentary trail of provenance, if not a system of registration, to maintain future access to registered markets. The message of a systemic market-based approach is here in strong voice again. Piecemeal measures taken by individual nations can only achieve limited success in combating the illicit trade. A common global approach is required to deal with a common global problem. Talk of global approaches can quickly seem hopelessly utopian, but where solutions are cheap and effective this criticism is not so damning.

This brings us to the second issue above; the major consideration here seems to be one of cost. Who will pay for the upkeep of a register? In the United Kingdom, which is currently discussing a domestic art loss register, there are few hands in the air in response to an invitation to cover the cost. There are many ways to cut the costs of a register, though. A simple one would be to allow dealers, collectors and museums to register their holdings online. An honesty system

could operate, through which they vouch by their entry of objects on the register that they are in possession of the required provenance documentation. Spot checks could be conducted in respect of those whose names are on the register to verify that (a) all the antiquities they hold are registered and (b) they do indeed hold appropriate documents for all those objects. In this way registration would cost nothing and the only costs to the State (or a trade body who offered to run the system) would be the upkeep of a website and the salaries of a number of inspectors.

Collectors may object to a public register of holdings on the basis that it will make them identifiable to thieves who check the register. In a climate, however, in which holdings are publicly registered, a good faith buyer will check the register to ensure that the object for sale features there, and that the seller is the owner. Once a public register becomes the accepted means of dealing in antiquities, selling stolen antiquities on the legitimate market will be impossible, for it will be obvious to a good faith buyer that the thief who is trying to sell them the object is not the owner listed on the register. Antiquities looted or stolen will have only underground routes of disposal, and while the press is rife with stories of members of the criminal underworld who trade in hot antiquities, this seems rather far-fetched, even to members of the trade themselves:

> I think it is... true that unless you believe in the principle of mad millionaires gloating over things in basements, on the whole most art of all types will come through the open market sooner or later... I really don't think people are putting this stuff in basements. I don't think anybody really believes in that. (London Dealer 8)

Even if such criminal gloaters do exist, we might suppose that their willingness to deal in illicit antiquities might diminish if a system of registration existed which ensured that they would never be able to dispose of the objects they hold by conventional means for value.

The United Kingdom's current move to create a register of art stolen abroad and at home has favoured a design which, like the Art Loss Register, can protect only those objects catalogued by the owner, subsequently known to have been stolen, and then registered. It cannot solve the problem of the sale of looted antiquities. A network of domestic registers of antiquities in the possession of dealers, collectors and museums can do so, as part of a compliance-inducing regulatory pyramid.

It is envisaged that registration would be the major strategy on the lower level of the pyramid. Other strategies of persuasion might be pursued on this level, simultaneously with a registration initiative, to contribute to the creation of the requisite climate of compliance with the demands of a licit market in antiquities. Climate-setting seminars run by museums, trade bodies, or international organisations, together

with other persuasive tactics, would be useful in providing a platform at this lower level of the pyramid for the satisfactory implementation of the more concrete structure of registration.

Moving from the lower level of the pyramid, where a climate of persuasion to abide by the desired ends of regulators is established, on the upper level we require a further 'end of the line' persuasive device. This is a symbolic threat which will crystallise as a real, and undesirable, consequence for those who are not persuaded to comply at the lower level. Here we find the deterrent threat of punishment that we earlier identified as being of value in relation to white-collar criminals in the antiquities market.

7.4.2 Pyramid, Upper Level: the Criminal Law

Given the potential importance of criminal sanctions in terms of deterrence of white- collar subjects from purchase or possession of antiquities, the observed relationship between supply and demand in criminal markets, and the ineffectual deterrence component of the existing system of civil recovery, we can predict that the implementation of criminal legislation *in an appropriate form* might have a considerable protective effect for source deposits of cultural material, providing some level of 'pre-emptive' protection to cultural heritage rather than (and indeed, as well as) simply providing mechanisms for the recovery of that heritage once it has been looted and the archaeological context lost forever.

Interestingly for criminologists, we are at the time of writing witnessing in two important jurisdictions the gradual movement of a category of activity from 'not crime' to 'crime', somewhat comparable to the gradual criminalisation of certain categories of drugs which occurred from the late nineteenth century.[19] In the United States, following the decision in *Schultz*[20] the transition has progressed further than it has in the United Kingdom. What remains in the United States to complete the transition is for the *Schultz* case in its re-affirmation of *McClain*[21] to become a regularly-used tool in the prosecution of dealers in illicit antiquities. In the United Kingdom the classification of such an act of illicit dealing as criminal is less developed than in New York. It is still a very grey area. The major difficulty with such criminal prosecutions as those envisaged by ITAP (the Illicit Trade Advisory Panel) in the UK will be evidentiary, brought about due to the significantly higher standard of proof required for a criminal conviction than is required for a successful civil suit. This standard will include proof of the accused's knowledge or belief that the object was tainted. Criminal guilt must

19 R.F. Perl, *Drugs and Foreign Policy: a Critical Review* (1994, Boulder, CO, Westview Press).
20 178 F. Supp. 2d 445 (S.D.N.Y. 2002), 333 F.2d 393 (2d Cir. 2003), 147 L.Ed 2d 891 (2004).
21 545 F.2d 988 (5th Cir. 1977), 593 F.2d 658 (5th Cir. 1979), cert. denied, 444 U.S. 918 (1979).

be proved beyond reasonable doubt, while civil cases are won on the balance of probabilities – a substantially lower hurdle.

As we have seen, criminal penalties currently exist in most market nations for the possession of stolen goods. These, however, are difficult to apply in the case of looted antiquities, not least owing to the inherent difficulty in proving the circumstances surrounding the midnight excavation and clandestine export of an artefact which was likely buried and unknown until found and stolen. The requirement that all holders of antiquities in market nations lodge details of such holdings with a public register would provide us with an opportunity to attach criminal penalties to possession of a non-registered antiquity – something much more evidentially tangible and therefore legally provable.

This proposed requirement for relatively mundane and low-level civil law requirements to register holdings, combined with the threat of impressive[22] criminal penalties for non-compliance, fits well with Braithwaite's regulatory pyramid and should create a climate of compliance among collectors and dealers which is both relatively unburdensome to the individual and administratively manageable. These criminal penalties could include high-level fines, imprisonment and seizure of unregistered antiquities in the accused's possession. This latter action might in itself provide great financial incentive to register antiquities. We have noted earlier the trend toward deterrence in white-collar crime through severe penalties with reference to the example of insider trading. This trend is evident currently in many other areas of white-collar criminality. In financial institutions fraud, for example, US violators of 18 U.S.C. section 1344 (1994) – which deals with fraud on a financial institution – face maximum penalties of $1 million in fines and 30 years' imprisonment, or both. Additionally in terms of section 982(a)(2), the court shall order the person convicted of violating or conspiring to violate section 1344 to forfeit to the US any property constituting, or derived from, proceeds the person obtained directly or indirectly as the result of such violation.[23]

Once we approach the issue of regulation through the construction of a pyramid we see that, on a general theoretical plane, the importance of the existence of sanctions at the upper level is in encouraging compliance at the lower level. For this compliance to

22 Severe enough to rationally deter but not, of course, disproportionate. Harm is generally acknowledged to be the central feature of the common law of sentencing. In Australia, for example, the court is required by the Crimes Act 1914 (Cth), section 16A(2)(a) to address the 'nature and circumstances of the offence'. Under section 16A(2)(e) 'any injury, loss or damage resulting from the offence' may be taken into account. Given the incontrovertible supply and demand relationship between the collection of illicitly obtained antiquities and the destruction at source of the world's cultural heritage, and therefore our access to precious historical knowledge, it can be persuasively argued that high penalties are warranted.

23 M.J. Shepherd, S.N. Wagner, & N.M. Williams, 'Financial Institutions Fraud', (2001) 38 *American Criminal Law Review* 843.

occur, the application of the upper level sanctions must appear to those regulated as a real and likely result of their violation of a lower level requirement. Application of the sanctions to individual cases of violation is therefore essential to the success of the pyramid. Only through the regular punishment of offenders when the pyramid is introduced as a mechanism to regulate the market, can the sanctions take on the symbolic threat necessary to induce compliance with the registration requirements of the lower level. The rarity of cases such as *Schultz*, accounted for in part by the difficulty of their prosecution, presently condemns punishment to be seen by the market as a high-profile aberration, rather than a real risk for all traders. In the language of the pyramid, punishment does not currently persuade. The symbolic threat necessary to secure compliance with prescribed methods of transacting is absent. Indeed, aside from the rather hopeful proclamations of the international treaties and codes of practice mentioned in Chapter 3, there is little in the way of prescription of acceptable methods of transacting either. The pyramid, correctly applied, attends to both of these deficits.

By taking measures which encourage one part of the system (buyers) to research the provenance of objects conscientiously, and which appeal to that part's rationality and conventional involvement, we alter the environment in which another part (sellers) operates and remove the illicit profit opportunity which currently exists in that environment. Surveillance of one party by non-official others in the environment who have an interest in making sure that person complies is a cost effective and socially integrative method of control. The benefits of such 'community restraints', as opposed to the centralised bureaucratic mechanisms of pure legalism, have long been identified as central to a working criminal justice policy[24] and in the case of a small community like the antiquities market can create an environment where it is simply not possible, or very difficult and awkward, not to comply. In this way, requirements by all buyers of antiquities that sellers divulge their sources is a powerful way to make sellers do just that.

The application of the criminal law to cases of antiquities prosecution and recovery has cost implications both for dispossessed source countries and the market State. The market State of course bears the cost of criminal prosecutions in terms both of investigations and the court and legal costs which would have been borne by the claimant in a civil action. While market States' criminalising of new forms of behaviour therefore puts an added strain on their treasuries, and as a result of that on their taxpayers, it relieves the complainant source State of their financial obstacle to the initiation of civil legal action.

24 S. Henry, *The Hidden Economy: the Context and Control of Borderline Crime* (1978, London: Martin Robertson & Co.), esp. ch. 8; D. Layton Mackenzie, 'Criminal Justice and Crime Prevention', in D. Layton Mackenzie (ed.) *Evidence-based Crime Prevention* (2002, London, Routledge).

This does not sound like an attractive proposition for market States, but we should remember that under the system of antiquities registration proposed here, the prosecution would not run into the evidentiary hurdles of proving knowledge or belief of wrongdoing, with which the current domestic criminal systems of market States have to contend. Proof of the offence will therefore be easier (and less time consuming and costly) even to the higher standard of proof required in criminal cases.

If criminal penalties were attached to the possession of non-registered antiquities rather than to the bare possession of stolen goods as is currently the case, the only major issues upon which a criminal conviction would depend would be:

a) that the item fell within the definition of 'antiquity' and therefore should have been registered;

b) that it was in the possession of the accused and that he or she bore the duty of such registration; and

c) that the item was not so registered.

These issues would require to be proven beyond a reasonable doubt, but that should not present the prosecution with undue difficulty.

7.4.3 How the Pyramid Controls the Market: Reducing Motivation and Opportunity

Within social systems, people make repetitive choices which reproduce themselves as routines. The antiquities market is an example of a system which routinely takes antiquities from source and moves them around the world. Insofar as the illegitimate side of this trade causes harm, what are needed to relieve the damage are regulatory impulses which take account of the systemic nature of the problem. Such impulses recognise that influencing the actions of one part of the system may well have consequent effects on other parts. In human systems, the power of some people in a system to control others, sometimes relatively unwittingly, has been found to be a productive and cost effective form of social control. Using Foucauldian ideas on surveillance and personal control,[25] Shearing and Stenning produced an analysis of human control systems built upon techniques of observation and the employment of environmental and architectural methods of control.[26] One of their examples was the queuing system used in Disneyworld. Systems of barriers are erected such that queue jumping is made impossible, aside from the two entirely blatant methods of joining the front of the queue rather than the end, or barging past the other queuers. In this way, the person in front of you in the queue keeps you in your place – each member of the queue controls the one behind, and without dealing

25 See, inter alia, M. Foucault, Discipline and Punish (1977, London, Allen Lane).

26 C.D. Shearing, & P. Stenning, 'From the Panopticon to Disney World: the Development of Discipline', in A. Doob & A. Greenspan (eds.) Perspectives in Criminal Law (1985, Toronto, Canada Law Book Co.).

in any way with human tendencies towards queue jumping we have removed the problem by removing the 'opportunity'. Were queue jumping a crime, this design would be an example of situational crime prevention, a popular tactic currently which arises directly out of the realist philosophy of rational choice theory.[27]

Moving this philosophy to the antiquities market, we might similarly expect to be able to control the dealings of some members of the system through the presence and influence of others. There are two categories of criminal opportunity to consider here; the opportunity to make illicit purchases ('purchase opportunity') and the opportunity to on-sell illicit antiquities ('sale opportunity'). Museums, which do not generally divest themselves of assets once acquired, and certainly not to the extent that we could consider them traders for the purpose of this analysis, need only avail themselves of purchase opportunity. Dealers avail themselves both of purchase and sale opportunity. So do collectors who wish at some point in the future to trade their artefacts or donate them to discerning museums ('Category A collectors'). This will be most collectors – only those who see no investment value in their collections and wish to keep them in their family in perpetuity need not be concerned with the future sale, gift or bequest of their collections, and the interview data suggest that this category of collector is very small, if indeed it exists at all (insofar as it might exist, we shall call this group 'Category B collectors').

Purchase opportunity in the antiquities market, in common with other stolen goods markets, arises in the context of an offer of an unprovenanced chattel for sale:

> The effect of offers on people's willingness to buy stolen goods is particularly important for the way stolen goods markets operate. If consumers do not seek out stolen goods, then accepting offers is the only other way they can knowingly buy them. For handlers of stolen goods, this is fundamentally linked with the concept of crime as opportunity.[28]

Statements by the interviewees such as "all antiquities end up in museums" and "I buy mainly from auction" might conjure an image of a market where there is something of an unbroken straight line from source to ultimate consumer. In fact, the more appropriate image of the market is a cyclone which circulates many of the

27 R.V. Clarke, 'Situational Crime Prevention', in M. Tonry & D.P. Farrington (eds.) *Building a Safer Society: Strategic Approaches to Crime Prevention* (1995, Chicago, University of Chicago Press).

28 M. Sutton, 'Handling Stolen Goods & Theft: a Market Reduction Approach', *Home Office Research Study 178* (1998, London, Home Office), at p. 47, citing P. Mayhew, R.V. Clarke, A. Sturmann & J.M. Hough, 'Crime as Opportunity', *Home Office Research Study 34.* (1976, London, Home Office).

objects interminably.[29] Still, at some external boundary there will be a point of entry of an object into the international 'consumer' market and a corresponding point of entry into one of its subsets; a western domestic market.[30] Rather than, or indeed in addition to, attempting to remove purchase opportunity from dealers and category A collectors at these points of entry by reducing the number of illicit offers made to them (for example by targeting looted antiquities at source) we might productively attempt to influence their uptake of these 'external' purchase opportunities by altering the reaction of buyers within the relevant domestic market when presented with unprovenanced offers. If we can reduce sale opportunity domestically for dealers and Category A collectors, this will in turn reduce their incentive to avail themselves of external purchase opportunity. In time it seems reasonable to project that without a consistent uptake, unprovenanced offers, and therefore external purchase opportunity in this group, will decline. Targeting and reducing the uptake of purchase opportunity by domestic museums (who are highly visible and therefore amenable to considerable legal control), collectors (both of Category A and B) and dealers in a western market centre will reduce the sale opportunities of those who make illicit external purchases, provided similar measures are adopted in other major market centres to prevent the displacement of the market to the jurisdiction with the lowest level of control.

We have seen that collectors and dealers, because of their higher than average social status and ties to conventional people and institutions, make good subjects for general deterrence, when there is an appropriate correlation between the act prohibited and the punishment threatened. The threat of high-level fines, confiscation of personal assets and possible imprisonment would ensure a healthy level of compliance with a requirement to register holdings of antiquities among this group. Rather than run the risk of being caught with an unprovenanced, and therefore unregistrable antiquity, it is likely that museums, collectors and dealers would when buying exert considerable pressure *inter se* to ensure their acquisition of such information in documented form, which would in turn reduce the demand among dealers (or other sellers) for illicit or dubious goods; a chain reaction would occur from demand up to supply as purchasers declined the criminal purchase opportunity presented to them by unprovenanced offers. The pressure to resist purchase opportunity will be cyclical – dealers and Category A collectors will not buy without provenance because they will not be able to sell, and they will not be able to sell because their customers will not buy without provenance. External points of entry for illicit antiquities into domestic markets become sealed. This focus on systemic change originating in the regulation of demand as a means

29 I.M. Stead, *The Salisbury Hoard.* (1998, Gloucestershire, Tempus) at p. 75; this chart provides a good example of the circulation routes of traded artefacts.

30 Entry into a subset may happen more than once as the object circulates internationally.

to reducing supply is in keeping with the Market Reduction Approach advocated by Sutton as the most appropriate way to combat markets in stolen goods:

> The key new principle of the Market Reduction Approach... is that it does not focus merely upon specific theft situations or specific thieves. Instead, it seeks to deal with the market and the players in it who affect many situations and many thieves by providing incentives and incitement for theft... the Market Reduction Approach involves reducing demand and supply.[31]

At several stages in the movement of antiquities from source to market, we encounter unwillingness of players to accept responsibility (even partial) for attempting to determine whether those antiquities may be illicit. In respect of transit states, this reluctance has sometimes been explicit. Prott and O'Keefe quote a 1976 statement by a representative of Singapore which makes resort to the popular feeling among capitalist trading nations that maintaining a high magnetism of their markets towards trade – important for the prosperity of their citizens – necessitates, and indeed excuses, their ignoring immoral or otherwise undesirable aspects of that trade, alleged or known:

> ... a sizeable volume of antiquities is being exported from the neighbouring countries through Singapore where no control over exportation or importation is exercised, apart from customs duties if applicable. It therefore does not seem reasonable to expect our customs officers and others who are connected with the examination of such materials to be in any position to decide whether or not the materials are genuine antiquities or whether they are part of an illicit transaction.[32]

This perception that responsibility for determining the licit or illicit status of antiquities is someone else's is also evident in the way we have seen the market interviewees relate to auction houses, and vice versa. A registration requirement backed by criminal penalties would make it clear that it is the possessor's responsibility to obtain appropriate provenance documentation.

We talked of the three heads of prevention inspired by Routine Activities Theory in terms of site protection. Registration of antiquities would achieve each of these three crime prevention goals at the demand end of the market, by:

a) Removing the motivation of offenders who buy looted antiquities – dealers will no longer reach the stage of

31 Sutton, *op. cit.* note 28, at p. xii.
32 L.V. Prott, & P.J. O'Keefe, *Law and the Cultural Heritage, Volume 3: Movement.* (1989, London, Butterworths) at p. 571.

psychological accounting where they are able to manipulate their Moral and Social Balance Sheets to favour the purchase of illicit (or possibly-illicit) antiquities, since the incontrovertible practical effect of a suitably implemented register of holdings on the trade will be that newly-surfacing unprovenanced objects will be unregistrable and effectively unsaleable. In other words, the perceived benefits of the act will be lowered such that the Practical Balance Sheet stage of reasoning does not reveal an asset result and the choice is therefore made at that stage not to perform the act;

b) Decreasing the suitability of the targets (looted antiquities) – unprovenanced antiquities now being of diminished financial value and having substantial criminal penalties attached to their possession. Further, in the context of this particular form of white-collar crime there appears little likelihood that antiquities dealers will displace their offences to the purchase of other, more suitable, illicit commodities;

c) Introducing capable guardians into the chain of commerce in the form of buyers who want to be assured to a high standard of proof that their purchases are licit and registrable, thus ensuring the implementation of stricter controls on purchase and possession than currently exist in the market.

Presently the market, while clearly highly 'organised' in many incontrovertible ways, is a variant on 'socially disorganised' in the sense the Chicagoans used the term;[33] those in the antiquities market are not geographically transient in the way the immigrants to Chicago were, but they share the lack of firm bonds to their fellows, resulting in a comparable social environment where no one individual feels responsible for censorship of the conduct of anyone else, or indeed closely tied enough to capable others to foresee the likelihood of censorship being visited on himself. Perhaps a better term for this market would be social 'unorganisation'. For the most part, dealers make a conscious decision to keep their lives and works private. In this climate, an ethereal sense of the group exists, which gives an individual the capacity to see himself as one of many 'protectors of culture', and which can be crystallised into a real and powerful community when the group is under threat, as with the current mobilisation of the dealers' lobby in North America. As in high-class neighbourhoods where neighbours respect each others' privacy, to the point perhaps where they do not even know each others' names, community exists on a level above the practical but can become practical in an instant, when the group is under threat.

This strong individuality coupled with an underlying sense of group membership is a feature of the antiquities market that presents the regulator with many problems. The community structure which

33 C.R. Shaw, & H.D. McKay, *Juvenile Delinquency and Urban Areas* (1969, Chicago, University of Chicago Press).

houses the individual dealers allows a discourse to develop, as we have seen, which provides techniques of neutralisation and empathy-discounting mechanisms that lead to impressions of entitlement in the outcome of internal balance sheet calculations. This discourse and its use by the interview subjects has many of the features of 'groupthink' identified by Irving Janis. The constant reaffirmation of group norms through language and practice is symptomatic of this type of failure to step back and rationally critique decisions being made:

> The main criterion used to judge the morality as well as the practical efficacy of the policy is group concurrence. The belief that "we are a wise and good group" extends to any decision the group makes: "since we are a good group", the members feel, "anything we decide to do must be good".[34]

Among the eight principles of groupthink examined by Janis, two are particularly relevant here. The groupthinkers have:

> an unquestioned belief in the inherent morality of the in-group, which inclines the members to ignore the ethical or moral consequences of their decisions

and pursue:

> shared efforts to construct rationalisations in order to be able to ignore warnings and other forms of negative feedback which, if taken seriously, would lead members to reconsider the assumptions they continue to take for granted each time they recommit themselves to their past policy decisions.[35]

The market, therefore, gives enough sense of community for dealers to characterise their purchases as the acts of a good group, rather than the acts of an immoral individual, with the risk-spreading and blame-reducing inferences that characterisation brings.[36] This is a mental form of spreading responsibility which is a diluted version of Matza's first technique of neutralisation, the denial of responsibility, peculiar to group identity. The market does not, however, give enough of a sense of community to give individuals the impression of an obligation to control or bear the responsibility for the aberrant decisions of their fellows. The private worlds of dealers and collectors are fragmented and insular in that regard; increasing integration can turn each into the guardian of the other, but this integration must be worked in a way which takes account of the propensity of an integrated community to propagate

34 I.L. Janis, 'Groupthink Among Policy Makers', in N. Sanford & C. Comstock (eds) *Sanctions for Evil* (1971, San Francisco, Jossey-Bass, Inc.) at p. 78.
35 *Ibid.*, at p. 80.
36 This type of blame reduction is the subject of analysis in relation to the extraordinary acts of army officers in T. Duster, 'Conditions for Guilt-Free Massacre', in Sanford & Comstock *op. cit.* note note 34.

neutralising discursive forms. In this way, surveillance of the buying decisions of those in the system is increased. The pyramid proposed incorporates elements of integration, surveillance and incentive which give no quarter to neutralising excuses and justifications. It therefore promises effective control of the market.

7.5 In Final Conclusion: Regulators must Control the Building Blocks of Entitlement

The practical, moral and social balance sheets through which buyers of antiquities in the market find entitlement to purchase and deal in illicit antiquities employ elements of a neutralising discourse which requires to be addressed. We must:

1. Remove the **economic** incentive to collect illicit antiquities by ensuring that dealers and collectors in illicit goods are not financially rewarded for their acquisitions.

2. Address the **political** issues which allow system actors to discount their behaviour with strategies that amount to blaming the victim, such as references to source countries being hoarders, unable to take care of their heritage.

3. Promote the value of **scientific** knowledge to dealers and collectors and the potential worth of dealing and collecting to the scientific community, by way of immanent preservation, encouragement of public esteem for antiquities and the knowledge they have given to archaeology, and financial sponsorship of exploration and excavation.

4. Establish a workable **legal** structure within which the legitimate market can flourish but the illegitimate market cannot.

Items 1 and 4 are addressed by the regulatory pyramid proposed here. Items 2 and 3 are external to that pyramid, but might be pursued in conjunction with that regulatory approach. The propensity of the pyramid to focus the minds of buyers in the market on the provenance of their purchases can be seen to itself have positive correlative effects in disrupting the market discourse which is part of a culture of insulated consumerism. In this sense, then, the pyramid also attends to items 2 and 3.

In conjunction with the pyramid, pro-active initiatives on behalf of source countries can change the structure of the market. If they institute a program of protection, archaeological excavation and sale funded by the market, they stand to take the system by the reins and steer it in a manner which has the potential to stem the looting, serve the cause of history, feed the market with licit objects and enrich financially struggling source governments. It was earlier argued in section 3.1.7 that the tightening or loosening of export restrictions is of little consequence to an illicit market where levels

of demand remain unchecked. Through reducing that demand in the market, however, we can see that the situation changes and sensible, balanced export policies on the part of source countries are needed to keep an important market in cultural exchange afloat. The removal of illicit artefacts from the market is likely to result in a sharp drop in the objects being excavated and traded, and it is for source countries to consider ways to fund programs of licit excavation and sale in order to conserve the worthy educative and preservative functions the market currently performs. The market, for its part, must give source nations assurances that it will attempt seriously to prevent the operation of its buyers outwith this licit market. This might involve the pyramid described; the institution of a system of registration of holdings with attendant criminal sanctions.

Western buyers do not want second-rate antiquities and source countries do not want to let their first-rate antiquities go. Is this really an insuperable problem? Source countries are already losing their heritage, first and second-rate, at an alarming pace. There is no reason why they could not control the distribution of objects from funded digs within their territories, keeping what is truly important to them for themselves. The future in this regard is one of negotiated compromises. Some of the justifications for illicit purchase which the interviewees produced held weight, and should not simply be discounted. Chance finds do need to be saved. Objects do need to be properly cared for once excavated, and if they can be displayed to the public, so much the better. Source governments do need to attend to the corruption which seems endemic in developing political regimes. The pyramid denies the relevance of these neutralisations in its strict approach to the actions of the market, but insofar as the issues go unsolved they remain culturally problematic. Some of these fragments of discourse are not just 'neutralisations' but are real problems. Truly to remove access to these neutralisations, the real problems themselves must be resolved.

In bringing this future of negotiated compromises to fruition, we must move away from the adversarial debate engendered by an appeal to a rights discourse parallel to that employed by law as its favoured method of dispute resolution. In its rights discourse, the law has created a monster; 'rights' and 'entitlement' when filtered from the courts and statute books into the realm of the social are uttered as ideological riot horses, sent forth to forge a blinkered alley through a noisy crowd of resisters. While the discourse of the antiquities market enables buyers to see themselves as *entitled* to make illicit purchases – as having a right to do so – charity and virtue in the making of these decisions, and empathy as regards the real effects on the victims of their practice, do not feature.

It is interesting to observe that even the heavily practical methodology of Situational Crime Prevention has seen a recent

addition to its tactics in the form of 'removing excuses' for offences.[37] The discourse of the antiquities market, analysed in this book, is filled with excuses, manipulated and employed by the market interviewees to manoeuvre themselves into positions, psychologically and performatively, where they can take advantage of the opportunity to buy looted antiquities with which the systemic workings of the market regularly presents them. As well as reducing that opportunity by kick-starting internal market self-control where collectors, museums and dealers require of each other documented provenance, our targeted impulses – social, educational, political and legal – must encourage and support a move towards the regulatory structure proposed, by working to diminish the validity of the market's excuses and their very practical worth. There is a place for law in all this then, but it is not in the conventional form of prohibition of excavation/export/purchase of stolen goods which is the current structure and which, in attempting to speak to this market system from the outside, does not register compliance on the part of those within.

[37] D.B. Cornish, & R.V. Clarke, 'Opportunities, Precipitators and Criminal Decisions: a Reply to Wortley's Critique of Situational Crime Prevention', in M.J. Smith & D.B. Cornish (eds.) *Theory for Situational Crime Prevention: Crime Prevention Studies Vol. 16* (2003, Monsey, NY, Criminal Justice Press).

APPENDIX I

METHODOLOGY

This section describes the qualitative research techniques used to investigate the research problem. The central method here is the qualitative interview. I shall use this section to describe the collection and analysis of the interview data. Those data are supplemented by a qualitative field observation process encompassing visits to museums, auctions, dealers' outlets, collector's homes and archaeological sites. I have also in this research engaged in a textual legal analysis, which has involved documenting and critiquing the relevant laws, including the consideration of commentaries made both at the time of drafting those laws and thereafter. The methods for these supplementary forms of data being relatively straightforward, I shall attend only to the interview method in what follows.

DATA COLLECTION BY INTERVIEW

The main source of field data for this research was interviews. A total of 40 interviews were conducted in Melbourne, Sydney, New York, London, Geneva, Bangkok, Chiang Mai and Hong Kong between September 2001 and January 2003.

These data consist of a core of 28 interviews conducted by the author with a sample of respondents identified as key informants in relation to the research question. This core sample of interviews is supplemented by twelve others which will be detailed below.

The Core Sample

The categories of interviewee in the core sample of 28 interviews were:

Melbourne: two dealers, one museum
New York: six dealers, one museum, two lawyers
London: nine dealers, one museum, one archaeologist
Geneva: one collector
Bangkok: one dealer, two archaeologists
Chiang Mai: one collector
Hong Kong: one auction house

This totals 29 interviewees. One interview was conducted with two interviewees simultaneously. These interviews ranged in length

between 30 minutes and 1½ hours. Most of the interviews were approximately one hour long. All 28 interviews were tape recorded with informed consent and then transcribed verbatim by the author. Only one interview was excluded from the analysis: this was the transcript of one of the New York lawyers who insisted upon reviewing the transcript before allowing its release, and then, despite much chasing, never found the time or the will to do so.

Some rules of construction apply to all quotes used. The data are represented verbatim with no correction of grammar or spelling, lest the sense be inadvertently altered. Any insertions of my own I have made bracketed in regular type in order to differentiate them from the words of the interviewees, which appear in italics. I have made these as little as possible; where they appear they are intended to give sense to the interviewee's statements or help protect an identity which might otherwise be revealed. Ellipses are used to indicate an omission from the interviewee's transcript, where, for example, non-essential phrases or sentences have been left out in order to present the data in as concise a manner as possible.

All interviewees were offered anonymity in the write up, and indeed advised to take it. Most did. Some expressed no desire either way as regards the publication or concealment of their identity, and a very few declared their steadfast desire to have their name published along with their data. This last group were expressly motivated in this desire by 'having nothing to hide'. Some, I detected, felt that their data might carry more weight with readers if their name were published, given their status as major players in the field, and in this they were probably correct. I have, however, resisted the temptation to accede to these requests to name some interviewees for several reasons.

Continuity aside, the two main reasons are these. It is not as easy to control the exact content of speech as it is with prose, which can be amended before it is opened to public display. Only two of the interviewees requested to see and approve their transcript before it entered the thesis (this was discouraged as much as possible due to the natural desire to amend or delete statements which, although true, one regrets making). In the event, then, most of those who declared their intention to be publicly named did go on to make statements which in my opinion reflected poorly on them and might lead to action against them by colleagues, opponents or authorities were they named. This is exemplified by the response of one of the two interviewees who requested to vet his transcript. Upon seeing the transcript, he replied in very strong terms that he would not want his words to be published. After some negotiation a compromise was reached in which he approved selected excerpts from the transcript for publication, provided his identity was concealed.

The second reason for universal anonymity is simply that although those who wished to be mentioned by name are undoubtedly high-

level players in the market, so too are many of those who accepted the offer of concealed identity. Publishing the names of some respondents might give the reader unwarranted reason to privilege their data over those of others.

This rather detailed exposition of my decision to conceal the identity of all respondents is necessary, I think, as it is the only step I have taken which contravenes the wishes of a proportion of the interview sample. I feel that this is the correct way to proceed, however, and I hope that they will understand that my concerns are very much that they will not suffer individually for their honesty. Interviewees are referred to by their place of business, their trade designation and a number, for example 'New York Dealer 4'.

Can the sample be said to be representative of the views of the market? 'Do the data collected give a true picture of the area being studied'?[1] The number of subjects targeted initially as key informants in the field was 160, and all were contacted. The intention being to create a final sample frame of important members of the antiquities market, rather than including peripheral informants, the list of 160 targets was compiled using adverts in major trade magazines, names published in association with high-value artefacts in a sample of leading auction house catalogues, and personal referral from leading figures in the market. Only 31 responded positively to the request for interview. One of these was ill at the relevant time, one could not make time for a meeting due to a hectic schedule and one requested not to go on record. The number of interviews conducted was therefore 28. The sample is thus clearly biased, as all such samples are, in favour of those who responded positively to the request for interview. The important question here is whether the fact that most of those asked to take part in the research declined tells us something important, and relevant, about them which would lead us to suspect that the sample finally interviewed was unrepresentative.

Contact with the 160 targets was made by way of e-mail. A personalised letter was e-mailed to each target, with a follow-up e-mail sent if no reply was received within around two months of first contact. Many targets responded to neither e-mail, at which point they were dropped from the sample. Some targets declined interview via e-mailed replies, which tells us something of the reasons for their reluctance to take part in the research. Some of these replies suggested a misunderstanding of the looting issue, sometimes coupled with a rather intolerant rebuff of any attempt at communication on the topic:

> ... I can see no point in engaging about debate on this. I do not import at all – all items I sell are sourced at public auction here in the UK.

1 P. McNeill, *Research Methods* (1990, New York: Routledge) at p. 15.

> ... [I] *am no longer dealing in Asian antiquities except those with provenance and have no further comment.*

And this from a major auction house in London:

> *Unfortunately, we are unable to accommodate your request for an interview but would like to point out that ...* [the auction house] *is extremely sensitive to and concerned about cultural property issues ... Specifically, it is* [the auction house's] *firm policy that we will not offer for sale any item that we know has been illegally exported and that we will obey the law in each jurisdiction in which we operate... Although we appreciate your request for an interview and would like to assist, we do not feel it would serve any useful purpose in respect of the research project you have undertaken.*

A further letter sent requesting some expansion of the details above received no reply and the tone of the correspondence generally gives us justification to conclude that this company simply does not welcome inquiry into its business. It would only be the most blatantly illegitimate business which did not, for example, have a 'firm policy' to obey the law in each jurisdiction in which they operate. The assertion that the auction house will "not offer for sale any item that we know has been illegally exported" may sound rather grand, but in practical terms the instances in which such illegality is known will be few. I did manage to access a high-level representative from the auction house's Hong Kong branch through art world connections established during the fieldwork, who at one point in the interview described the title-checking stage as one in which unless suspicions are aroused for some reason, the representations of the seller as to his title to the object for sale will be accepted. Although the policy of legal obedience is followed:

> *at present there is no law that demands that there is absolute proof as to where something absolutely comes from.*
> (Hong Kong Auction House 1)

Such formulaic ripostes to inquiry as are seen in the company's letter therefore conceal day-to-day practices which are highly relevant to this research project, and it reflects badly on this auction house that it thinks that important inquiries can be fobbed off with misleading assurances of concern about the issue.

Other replies showed that the looting issue was one with which dealers felt uncomfortable. They identified that the opening up of their practices to scrutiny might result in adverse consequences for them, and expressed a desire not to draw attention to themselves:

> *... I must turn down your offer of interview because traditionally we as antique dealers are not very keen on expressing our views on this sensitive issue.*

... considering the environment of the governments of the west as well as India I am hesitant to put my name and I remember that you you mentioning even though you can keep the name out on the initial publication that you will have to disclose at some stage to some authorities. Which concerns me very much. I would like to help you but at the same time do not want to come to the lime lite [sic].

... As we are members of the Antiquities Dealers' Association of Great Britain, I would refer you to that body for its [sic] *official views on the issues which are of interest to you. I do not wish to participate in any interview.*

... I am retiring from business in a few weeks and really want to distance myself from these matters.

Overall, then, the responses received from declining targets support the representative nature of the sample finally interviewed. This is particularly so if the e-mails from the declining targets represent reasons for reluctance to interview common to all those who did not accept the invitation, even those who did not reply. The interview sample may be 'braver' than the declining targets, or simply see more of the necessity to have their views recorded, but this does not bias them in any significant way. They may understand, or think they understand, the issues to a degree more lucid than the declining targets, but again this does not bias the sample in any way that would be fatal to the data. The market generally is ill at ease with the increasing focus on its trade and some are more prepared to speak out than others.

To the majority of the targets who did not reply, we might impute business practices less ethical than those of the group finally interviewed. That group, after all, were prepared at least to talk about the issues involved and open themselves up to the scrutiny that involves. In truth, however, we simply cannot tell. If it is the case that those who did not reply were motivated by a desire to conceal their unethical practices, then the present research is made all the more strong. Its call for increased regulation of the market will be strengthened if it is in fact the case that the sample interviewed, and on whose practices that call for regulation is based, are the more ethical end of the market.

A further degree of triangulation was built in to the study. A multi-method, multi-data approach was taken which gives us confidence in the validity of the data collected. The interview data are situated in a study of the existing literature on the looting issue, which gives the raw data context. Although the interview sample consisted mainly of dealers, these being seen as the market participants most relevant to the research question, effort was made to include in the sample representatives of other market groups. Had the sample consisted only of dealers, the research might have been seen either

as an unbalanced attack on that group or, had it turned out more favourably for them, as an apologia for their activities. Consisting as it finally did of dealers, museums, archaeologists, auction houses and collectors, the sample can fairly be said to be a multiple data set including views from all major groups affected by the looting issue, while still retaining its focus on the trade of the objects by western dealers. These sometimes conflicting accounts of matters help to provide a check on the overall veracity of the data by including different perspectives on the research question and enabling comparability of data.

The interviews were semi-structured, proceeding on the basis of the schedule of questions listed at the end of this appendix, but with the flexibility to go outwith this schedule to explore areas which the respondents saw as important, or pursue lines of inquiry which seemed pertinent but were unanticipated. The semi-structured interview format enabled me to keep the interviewees on subjects relevant to the research question while allowing them to talk about their own experiences. An entirely unguided interview would have produced much irrelevant data, while a highly structured discourse would not have allowed for the inclusion of areas which the interviewees saw as relevant but which I had not considered in the drafting of the instrument.[2] The research paradigm was, for the most part, inductive. After studying the literature it had occurred to me that a register of objects might be an appropriate element of a solution to the problem of the illicit market, and therefore a line of questioning was included in the interview schedule to gather feedback on this suggestion. To an extent, then, this introduced a hypothetico-deductive element into the research. Owing to the open nature of the questions, however, even this hypothesis-testing part of the interview generated much in the way of inductive data as the conversation proceeded to the interviewee's thoughts on regulation generally, or sometimes went on to reveal important facets of the interviewee's dislike of intervention, register-based or otherwise. The inclusion of such propositions in the semi-structured interview format enables the researcher to explore his initial thoughts and assumptions without being limited by them.

As the research proceeded, my role as interviewer evolved. Initially it was immediately apparent to the respondents that I was an outsider. Despite my best attempts to sound like a seasoned antiquities enthusiast, it became obvious at an early stage in the first interview that I did not have the bank of inside knowledge to support this. My terminology was accurate and my questions pertinent, but the subtle deficiencies in the way I used what jargon I had assimilated from the texts made my talk sound 'clunky' to the interviewees. Correctly identifying that I was swimming slightly

2 R.G. Burgess, 'The Unstructured Interview as a Conversation', in R.G. Burgess (ed.) *Field Research: a Sourcebook and Field Manual*. (1989, London: Unwin Hyman) at p. 107.

out of my depth, they treated me like the 'daft laddie', generously giving of information and seemingly pleased to have a fresh and receptive mind to make their case to. As the many hours of interviews progressed, I unconsciously picked up buzz phrases. I began to arrive at interviews equipped with a bank of information from prior conversations which I found I could put to use in establishing a different sort of rapport with the interviewee than the teacher-pupil rapport I had cultivated in earlier encounters.[3] I was able to raise issues ("this seems to be the feeling among dealers..."; "what is your response to someone who might say...") which I found struck a chord of recognition in the interviewees, who then often went on to reveal information in the rather conspiratorial tones of those who would not normally speak so honestly or bluntly. In truth I never lost my status of outsider, but that status became diluted to the point that I moved closer to becoming an insider than I had hoped possible. I was accorded by the interviewees the role of an outsider whose contacts with the market credited me with a right to ask questions about their methods and attitudes which would otherwise be seen as rude and impertinent and would have been rebuffed accordingly.

The Supplementary Sample

The core interview data are supplemented by data obtained in a different set of interviews, conducted by the author with another researcher. Those interviews (n = 12) formed part of a project designed by Professor Ken Polk and Dr Andrew Kenyon at the University of Melbourne to compile data on art thefts from Australian galleries, with a view to producing a register of such stolen items in the future. The subjects came mainly from commercial art galleries, but the sample also included representatives of three of Australia's major auction houses and one collector who bought antiquities as well as more modern works of art. These interview data are not drawn on verbatim in the book,[4] nor are specific ideas in the thesis attributed to specific members of this sample (the same is true for an additional two conversations with subjects who would have formed part of the core sample but for their desire for our discussion to remain 'off the record'). The supplementary data

3 Incidentally, the establishment of rapport with the interviewees was undoubtedly aided by the fact that I was of similar race (white Caucasian), gender (male), class (middle) and educative level as almost all of the interviewees. Two of the archaeologists and one museum representative were female. All of the dealers, as is the norm in the market destinations studied, were white males. While enjoying a significantly greater level of financial stability than is the lot of the graduate researcher, this difference was the cause of much general amusement on the part of the interviewees and I was indulged for the most part as an equal in socio-economic terms. Just as cross-cultural research into different race or gender groups can be impeded by differences between the researcher and the researched, where those differences do not exist the researcher finds himself on a significantly privileged platform of inquiry.

4 A more detailed analysis of these interviews can be found in an article written specifically for that purpose: A.T. Kenyon, & S. Mackenzie, 'Recovering Stolen Art - Legal Understandings in the Australian Art Market', (2002) 21 *University of Tasmania Law Review*, 1.

are used in the main to give general context to the core data that are actually presented verbatim in the text, and have helped me to be sure that these verbatim quotes do not misrepresent the market they help to describe. In particular, the data provide evidence that the problems of buying stolen goods and fakes are not specific to the antiquities market but extend more generally across the whole art market, in which the lack of provision of provenance information is routine. Additionally, data from the three auction houses in the supplementary sample support the data obtained from the one auction house in the core sample, which in the absence of such supporting data might be suspected to be unreliable.

Of these supplementary interviews, eleven were tape recorded and transcribed while one was, at the request of the interviewee, recorded by the author making hand-written notes. The categories of interviewee in the supplementary sample were:

Melbourne: five dealers, two auction houses

Sydney: three dealers, one auction house, one collector.

Analysis of the interview data: discourse analysis, grounded theory and critical discursive social psychology

Originating in the work of Gresham Sykes and David Matza,[5] the concept of 'techniques of neutralisation' as cognitive and discursive elements of personal accounts of action has become widely accepted. Sykes and Matza noticed that delinquent youths often justified some illegal behaviour in ways which allowed them to avoid guilt.[6] Scott and Lyman[7] further studied these neutralisations, labelling them 'accounts' for their analysis and dividing these accounts into 'excuses' (where wrongdoing is admitted but responsibility denied) and 'justifications' (where the action is admitted, but it is denied that it was wrong).

Benson took the idea further, with a particular focus on white collar criminals.[8] He noted that their desire to maintain a non-criminal self-concept led them to neutralise their labelling as moral and legal deviants by employing accounts which were directly tied in social psychological terms both to their impression management[9] – loosely, what others might think of them – and individual cognitive event interpretation – again loosely, what they construct as their personal interpretation of events, for their own use. There is much research from various disciplines which supports the use of such neutralising accounts by individuals, not least from the field of discursive social

5 G.M. Sykes, & D. Matza, 'Techniques of Neutralisation: a Theory of Delinquency', (1957) 22 *American Sociological Review*, 664.

6 *Ibid.*; D. Matza, *Delinquency and Drift* (1964, New York, John Wiley).

7 M. Scott, & S. Lyman, 'Accounts', (1968) 33 *American Sociological Review*. 46.

8 M. Benson, 'Denying the Guilty Mind: Accounting for Involvement in a White-Collar Crime' (1985) 23 *Criminology*, 583.

9 E. Goffman, *The Presentation of Self in Everyday Life* (1959, Garden City, NY, Anchor).

psychology.[10] The construction of identity through linguistic devices such as these is not necessarily a 'front', employed knowingly by a wrongdoer to deceive an inquirer as to the true nature of the act, but rather it often seems to be implicit in the very carrying out of the act itself. Such techniques are not always used to rationalise the behaviour after it has occurred, but are often used in advance of deviant conduct in order to neutralise the values which forbid it. And because of the constructive effects such excuses and justifications have on individual psychology, impression-management and self-persuasion in Benson's terms often slide into each other, so that the employment of techniques of neutralisation leaves the wrongdoer believing the interpretation of events and intention which he or she has constructed.

The use of language by subjects of study to socially (re)position themselves leads us to recognise an aspect of the grounded theory approach of Glaser and Strauss[11] which might be improved upon, particularly when interviewing subjects of middle to high social and financial status who might reasonably be assumed to wish to maintain a law-abiding and morally laudable image. The guiding principles of grounded theory, which dictate that the researcher start with a theoretical clean slate, and build a picture of the area of study through accumulation and inter-relation of the data given to him or her by the interview subjects, have been criticised on the basis that such a method almost naively assumes that detailed analysis of people's talk provides an insight into what they really think.[12] Following the critical discursive social psychological acknowledgement of the strategic use of neutralising accounts in discourse we can see that, particularly when dealing with the type of socially adept interviewee that we encounter in this study of the antiquities market, we must work into the grounded theory method a critical insight into the motives for the particular talk of the interviewees. As Goffman says:

> Words are mere and shouldn't be worth anything at all, but, in fact, every statement, in one way or another, is a performative utterance.[13]

This strategic use of discourse on the part of interviewees is unlikely to have been invented by them during the course of the interview, but rather will involve their drawing on discursive patterns already present in the communicative forms of their system. In a critical analysis of the talk of individual participants in the antiquities

10 M. Billig, S. Condor, D. Edwards, M. Gane, D. Middleton, & A. Radley, *Ideological Dilemmas: a Social Psychology of Everyday Thinking*, (1988, London, Sage); J. Potter, & M. Wetherell, *Discourse and Social Psychology: Beyond Attitudes and Behaviour* (1987, London, Sage).

11 B. Glaser & A. Strauss, *The Discovery of Grounded Theory* (1967, Chicago, Aldine).

12 K. Henwood, & N. Pidgeon, 'Qualitative Research and Psychological Theorising', (1992) 83 *British Journal of Psychology*, 97.

13 E. Goffman, *Strategic Interaction*. (1969, Philadelphia, University of Pennsylvania Press), at p. 136.

market, looking through their personal accounts to the more general communications which give them form within which to think of and talk of their system, we can get closer to the truth of the workings of the market.

An analytic process was therefore adopted for the analysis phase which integrates into the classic constructivist grounded theory approach,[14] tools of language-structure recognition pulled from critical discursive social psychology.[15] This combination of methods has been used to good effect before in studies such as of the relationship between unemployment and masculinity[16] and of the self-image of white collar criminals.[17]

In the open coding stage of analysis, the codes developed over time as they began to be filled by the data. If they started too broad, they became narrower. More often though what I initially coded in an early interview as a specific point was shown through links with text in later interviews to be one part of a larger area of interest. In this inductive fashion, the process of open coding proceeded not just as an exercise in tagging data, but as a reflexive production of themes. The tags that were initially created to organise the data were themselves organised by the data as the process continued, leading ultimately to fully saturated and all-inclusive codes.

In this way, theory was allowed to emerge from the analysis of the data. Merriam has emphasised that qualitative research is more concerned with the building of theory than its testing,[18] and this was the approach taken in this study. Analysis followed the open, axial and selective coding stages as advanced by Strauss and Corbin[19] and explained in comparison to other qualitative data analysis techniques by Creswell.[20] In the open coding phase, using the constant comparative approach, the data were organised under 58 codes. In the axial coding phase, these 58 open codes were filed under seven category headings which seemed to best represent the common themes shared by groups of the coded data. In the selective coding phase, the relationship of the seven axial codes was examined and a theory took shape which could explain the connections between these codes.

14 Glaser and Strauss, *op. cit.*note 11.
15 I. Parker, 'Discourse: Definitions and Contradictions', (1990) 3(2) *Philosophical Psychology*, 189.
16 S.A. Willott & C. Griffin, 'Wham Bam, Am I a Man? Unemployed Men Talk about Masculinities', (1997) 7 *Feminism and Psychology*, 107.
17 S.A. Willott, C. Griffin & M. Torrance, 'Snakes and Ladders: Upper-Middle Class Male Offenders Talk About Economic Crime', (2001) 39 *Criminology*, 441.
18 S.B. Merriam, *Case Study Research in Education: a Qualitative Approach* (1988, San Francisco, Jossey-Bass).
19 A. Strauss & J. Corbin, Basics of Qualitative Research: Grounded Theory Procedures and Techniques (1990, Newbury Park, CA, Sage).
20 J.W. Creswell, *Qualitative Inquiry and Research Design: Choosing among Five Traditions* (1998, London, Sage).

This concludes the exposition of the interview and data analysis methods used in this research. The particular methodological approach taken led to the development of three questions, used as guidance in supplement to the original research question. These were:

1. What kinds of communication make up the discourse of the antiquities market?

2. Are any of these identifiable as responsible for the trade in illicit cultural objects?

3. If so, how can we influence their change?

Interview schedule for art market participants: Market States (New York, London, Melbourne)[21]

1) Biographical info
a) Name, age, occupation
b) How long have you been involved in the antiquities trade?
c) Have you worked in any other areas of the trade besides this one?

2) Purchase of antiquities
a) Grand tour questions
 i) Can you describe to me the mechanics of a typical acquisition?
 ii) Do you think it is possible to get full details of the provenance of an item you are buying?
 iii) Do you think that is desirable?
 iv) Imagine you have the power to pass laws over your fellows. What do you think you could do to ensure that they never bought an item without provenance?
 v) How much of what is on the market do you think is fake?
 vi) Do you use the Internet to purchase antiquities?
 (1) if so, can you describe the nature of these transactions?
 (2) which websites? How do you know they're reliable?
b) Planned prompts
 i) Who do you buy from?
 (1) occupational title
 (2) place of residence/business
 ii) What documentation do you get when you buy an antiquity? How would you know if it had been
 (1) stolen in or from its country of origin, or
 (2) illegally exported from its country of origin, or
 (3) illegally imported into your country, but not been noticed by customs?
 iii) What records do you keep of your stock

21 A similar schedule. with appropriate minor variations, was used for the source and transit State interviews, in Thailand and Hong Kong.

<blockquote>

(1) while you have it

(2) after it has been sold

</blockquote>

iv) Are there rules for second hand dealers re keeping a register of stock, with name and address of seller (as there are in NZ) and if so are you bound by them?

v) Are there any aspects of your business which would make it impossible/impracticable only to deal in items which you can verify as being legally excavated in and exported from their source countries?

vi) How often do you come across unprovenanced antiquities?

c) [FOR MUSEUMS]

i) What is the frequency ranking of how items come to be in your possession?

(1) purchase

(2) gift/bequest

(3) excavation

ii) Do the different methods of accession dictate different levels of inquiry into provenance on your part?

iii) Do donors get tax concessions for items gifted or bequested on their death to museums in this jurisdiction?

3) Sale of antiquities

a) Grand tour questions

i) Can you describe to me the mechanics of a typical sale?

ii) If a customer asked for details of the full provenance of an item, would you feel happy to give those details to them?

iii) Would it be possible to give those details? How much by way of detail do you have?

b) Planned prompts

i) How many (if any) customers try to obtain provenance details for items they purchase from you?

ii) Do customers who seek provenance defer to your assurances that the market does not provide such information?

iii) Do you have an established client base? Who (what kind of people) are they?

iv) Where do you sell? Local markets? Foreign buyers? (i.e. are you a 'market' dealer or a 'transit' dealer?)

4) Standpoint

a) What do you think of the controversy about leaving art objects in situ to safeguard their historical context, against advocating either a regulated export trade or an unregulated export trade?

b) What is your view on prohibitive excavation/export policies

enforced by source countries like Thailand?

c) What do you think about the recent decision of the court in New York to convict Frederick Schultz of possession of/dealing in stolen property?

d) What do you think of the Palmer Panel's recommendation in the UK of the creation of a new criminal offence 'dishonestly to import, deal in or be in possession of any cultural object, knowing or believing that the object was stolen, or illegally excavated or removed from any monument or wreck contrary to local law'?

e) Do you think the antiquities trade could effectively regulate itself?

 i) If yes, how?

 ii) Need for closure? How do you regulate all those who may choose to deal (i.e. the problem of 'one-off dealers')?

5) RULES PART I: Legal knowledge

a) Do you know the terms, impact or relevance to you of any local/national laws regulating the trade in antiquities?

b) Do you know the terms, impact or relevance to you of any international laws regulating the trade in antiquities?

c) If YES: What do you think about those Conventions in terms of

 i) Fairness

 ii) Applicability (i.e. likelihood that they might be invoked against you)

 iii) Fit/compatibility with local laws.

d) Do you think the current mechanism of international civil litigation by source nations to try to get what they allege is their property back from abroad is an appropriate one?

e) Would you say it was illegal to buy items which had been exported from their country of origin in breach of export restrictions?

 i) In any event, what would it take for your suspicion to be aroused that such events had taken place?

 ii) How could you further investigate matters?

 iii) Would suspicion or knowledge or both affect your decision to buy?

f) Do you think source state export restrictions are effective in preventing the passage of antiquities out of those countries?

g) Do you think there is a need for regulation in the antiquities trade?

 i) If YES, what do you think are the reasons for such a need for regulation: why is it necessary?

 ii) What should be its goals?

h) Do you know anything about limitation periods? I.e. time limits after which a dispossessed owner can no longer sue for the return of his or her property?

6) RULES PART II: System codes
a) Please summarise the rules that you work by:
 i) Day to day rules that govern your decisions to buy/sell
 ii) Written rules of conduct for dealers
 iii) 'Unwritten' rules of conduct for dealers
in relation to:
 (a) your business
 (b) customers
 (c) other dealers
 (d) anyone else?
b) Where does the pressure to follow these rules come from?
c) How strictly are they followed?
d) Is there an overall driving force which governs your participation in this market?
 i) Profit?
 ii) Love of the objects?
 iii) Love of history?
 iv) Compulsion to collect?

7) The Future (Ontological security/Systemic reproduction)
a) What do you see as the future of the trade?
 i) Where do you see the market in 25 years?
 ii) In 100 years?
b) Do you feel that there is support for the continuation of the trade as it is? By whom?
c) Do you feel that there are threats to the continuation of the trade? By whom / from where?
d) Do you feel that the law supports or hinders the trade? Is the law there to help you?

8) Regulation options feedback
a) What do you think about the desirability, feasibility and potential effects of the following ideas for regulation of the market?
 i) A licensing system for dealers similar to that employed in Australia to govern the international wildlife trade, including systems of registration and regular reporting of personnel and goods (at present many jurisdictions have a registration system for second-hand dealers, but records just have to be kept by the individual dealer rather than publicly). I.e. public accounting for imports, purchases, possessions and sales.
 ii) Taxation of the purchase of antiquities, the costs ultimately being borne by the consumers in market nations and the benefits passed back to source nations for the better preservation of their sites.
 iii) An amnesty, along the lines of the arms-return amnesties of recent times and the wildlife registration amnesty in Thailand, during which period all antiquities

in private ownership could be registered and provided with papers. This would then establish a base level of documentary provenance from a given date which could be implemented from then into the future, perhaps with transfers being registered as they occur with a central database agency. Unregistered antiquities would therefore arouse suspicion and (forged documentation notwithstanding) would be difficult to sell to a legitimate purchaser.

iv) Market nation interventions, as with the drug market, which recognise the dependence of impoverished local source populations on their 'produce' and work (perhaps by means of aid programs) to improve their socio-economic position such that programmes of education as to the cultural depredations they are performing are likely to have a real effect.

v) Programmes of education targeted at consumers in market nations.

vi) Regulation of museums requiring them openly to document the provenance details for all of the items they hold (not only those they choose to display). An end to the current policy of not revealing the identity of loaners, donors and sellers, which can frustrate provenance investigations.

Appendix II

UNESCO Convention on the Means of Prohibiting and Preventing the Illicit Import, Export and Transfer of Ownership of Cultural Property

Adopted on 14th November 1970 by the General Conference of Unesco

Article 1

For the purposes of this Convention, the term "cultural property" means property which, on religious or secular grounds, is specifically designated by each State as being of importance for archaeology, prehistory, history, literature, art or science and which belongs to the following categories:

 a) rare collections and specimens of fauna, flora, minerals and anatomy, and objects of palaeontlogical interest;
 b) property relating to history, including the history of science and technology and military and social history, to the life of national leaders, thinkers, scientists and artists and to events of national importance;
 c) products of archaeological excavations (including regular and clandestine) or of archaeological discoveries;
 d) elements of artistic or historical monuments or archaeological sites which have been dismembered;
 e) antiquities more than one hundred years old, such as inscriptions, coins and engraved seals;
 f) objects of ethnological interest;
 g) property of artistic interest, such as:
 i. pictures, paintings and drawings produced entirely by hand on any support and in any material(excluding industrial designs and manufactured articles decorated by hand);
 ii. original works of statuary art and sculpture in any material;
 iii. original engravings, prints and lithographs;
 iv. original artistic assemblages and montages in any material;
 h) rare manuscripts and incunabula, old books, documents and publications of special interest (historical, artistic, scientific, literary, etc.) singly or in collections;
 i) postage, revenue and similar stamps, singly or in collections;
 j) archives, including sound, photographic and cinematographic archives;
 k) articles of furniture more than one hundred years old and old musical instruments.

Article 2

1. The States Parties to this Convention recognize that the illicit import, export and transfer of ownership of cultural property is one of the main causes of the impoverishment of the cultural heritage of the countries of origin of such property and that international co-operation constitutes one of the most efficient means of protecting each country's cultural property against all the dangers resulting therefrom.

2. To this end, the States Parties undertake to oppose such practices with the means at their disposal, and particularly by removing their causes, putting a stop to current practices, and by helping to make the necessary reparations.

ARTICLE 3

The import, export or transfer of ownership of cultural property effected contrary to the provisions adopted under this Convention by the States Parties thereto, shall be illicit.

ARTICLE 4

The States Parties to this Convention recognise that for the purpose of the Convention property which belongs to the following categories forms part of the cultural heritage of each State:

a) cultural property created by the individual or collective genius of nationals of the State concerned, and cultural property of importance to the State concerned created within the territory of that State by foreign nationals or stateless persons resident within such territory;

b) cultural property found within the national territory;

c) cultural property acquired by archaeological, ethnological or natural science missions, with the consent of the competent authorities of the country of origin of such property;

d) cultural property which has been the subject of a freely agreed exchange;

e) cultural property received as a gift or purchased legally with the consent of the competent authorities of the country of origin of such property.

ARTICLE 5

To ensure the protection of their cultural property against illicit import, export and transfer of ownership, the States Parties to this Convention undertake, as appropriate for each country, to set up within their territories one or more national services, where such services do not already exist, for the protection of the cultural heritage, with a qualified staff sufficient in number for the effective carrying out of the following functions:

a) contributing to the formation of draft laws and regulations designed to secure the protection of the cultural heritage and particularly prevention of the illicit import, export and transfer of ownership of important cultural property;

b) establishing and keeping up to date, on the basis of a national inventory of protected property, a list of important public and private cultural property whose export would constitute an appreciable impoverishment of the national cultural heritage;

c) promoting the development or the establishment of scientific and technical institutions (museums, libraries, archives, laboratories, workshops . . .) required to ensure the preservation and presentation of cultural property;

d) organising the supervision of archaeological excavations, ensuring the preservation "in situ" of certain cultural property, and protecting certain areas reserved for future archaeological research;

e) establishing, for the benefit of those concerned (curators, collectors, antique dealers, etc.) rules in conformity with the ethical principles set forth in this Convention; and taking steps to ensure the observance of those rules;

f) taking educational measures to stimulate and develop respect for the cultural heritage of all States, and spreading knowledge of the provisions of this Convention;

g) seeing that appropriate publicity is given to the disappearance of any items of cultural property.

ARTICLE 6

The States Parties to this Convention undertake:

a) to introduce an appropriate certificate in which the exporting State would specify that the export of the cultural property in question is authorised. The certificate should accompany all items of cultural property exported in accordance with the regulations;

b) to prohibit the exportation of cultural property from their territory unless accompanied by the above-mentioned export certificate;

c) to publicize this prohibition by appropriate means, particularly among persons likely to export or import cultural property.

ARTICLE 7

The States Parties to this Convention undertake:

a) to take the necessary measures, consistent with national legislation, to prevent museums and similar institutions within their territories from acquiring cultura1 property originating in another State Party which has been illegally exported after entry into force of this Convention, in the States concerned. Whenever possible, to inform a State of origin Party to this Convention of an offer of such cultural property illegally removed from that State after the entry into force of this Convention in both States;

b) i. to prohibit the import of cultural property stolen from a museum or a religious or secular public monument or similar institution in another State Party to this Convention after the entry into force of this Convention for the States concerned, provided that such property is documented as appertaining to the inventory of that institution;

ii. at the request of the State Party of origin, to take appropriate steps to recover and return any such cultural property imported after the entry into force of this Convention in both States concerned, provided, however, that the requesting State shall pay just compensation to an innocent purchaser or to a person who has valid title to that property. Requests for recovery and return shall be made through diplomatic offices. The requesting Party shall furnish, at its expense, the documentation and other evidence necessary to establish its claim for recovery and return. The Parties shall impose no customs duties or other charges upon cultural property returned pursuant to this Article. All expenses incident to the return and delivery of the cultural property shall be borne by the requesting Party.

ARTICLE 8

The States Parties to this Convention undertake to impose penalties or administrative sanctions on any person responsible for infringing the prohibitions referred to under Articles 6(b) and 7(b) above.

ARTICLE 9

Any State Party to this Convention whose cultural patrimony is in jeopardy from pillage of archaeological or ethnological materials may call upon other States Parties who are affected. The States Parties to this Convention undertake, in these circumstances, to participate in a concerted international effort to determine and to carry out the necessary concrete measures, including the control of exports and imports and international commerce in the specific materials concerned. Pending agreement each State concerned shall take provisional measures to the extent feasible to prevent irremediable injury to the cultural heritage of the requesting State.

ARTICLE 10

The States Parties to this Convention undertake:

a) to restrict by education, information and vigilance, movement of cultural property illegally removed from any State Party to this

Convention and, as appropriate for each country, oblige antique dealers, subject to penal or administrative sanctions, to maintain a register recording the origin of each item of cultural property, names and addresses of the supplier, description and price of each item sold and to inform the purchaser of the cultural property of the export prohibition to which such property may be subject;

b) to endeavour by educational means to create and develop in the public mind a realization of the value of cultural property and the threat to the cultural heritage created by theft, clandestine excavations and illicit exports.

Article 11

The export and transfer of ownership of cultural property under compulsion arising directly or indirectly from the occupation of a country by a foreign power shall be regarded as illicit.

Article 12

The States Parties to this Convention shall respect the cultural heritage within the territories for the international relations of which they are responsible, and shall take all appropriate measures to prohibit and prevent the illicit import, export and transfer of ownership of cultural property in such territories.

Article 13

The States Parties to this Convention also undertake, consistent with the laws of each State:

a) to prevent by all appropriate means transfers of ownership of cultural property likely to promote the illicit import or export of such property;

b) to ensure that their competent services co-operate in facilitating the earliest possible restitution of illicitly exported cultural property to its rightful owner;

c) to admit actions for recovery of lost or stolen items of cultural property brought by or on behalf of the rightful owners;

d) to recognise the indefeasible right of each State Party to this Convention to classify and declare certain cultural property as inalienable which should therefore ipso facto not be exported, and to facilitate recovery of such property by the State concerned in cases where it has been exported.

Article 14

In order to prevent illicit export and to meet the obligations arising from the implementation of this Convention, each State Party to the Convention should, as far as it is able, provide the national services responsible for the protection of its cultural heritage with an adequate budget and, if necessary, should set up a fund for this purpose.

Article 15

Nothing in this Convention shall prevent States Parties thereto from concluding special agreements among themselves or from continuing to implement agreements already concluded regarding the restitution of cultural property removed, whatever the reason, from its territory of origin, before the entry into force of this Convention for the States concerned.

Article 16

The States Parties to this Convention shall in their periodic reports submitted to the General Conference of the United Nations Educational, Scientific and Cultural Organization on dates and in a manner to be determined by it, give information

on the legislative and administrative provisions which they have adopted and other action which they have taken for the application of this Convention, together with details of the experience acquired in this field.

ARTICLE 17

1. The States Parties to this Convention may call on the technical assistance of the United Nations Educational, Scientific and Cultural Organization, particularly as regards:
 a) Information and education;
 b) consultation and expert advice;
 c) co-ordination and good offices.
2. The United Nations Educational, Scientific and Cultural Organization may, on its own initiative conduct research and publish studies on matters relevant to the illicit movement of cultural property.
3. To this end, the United Nations Educational, Scientific and Cultural Organization may also call on the co-operation of any competent non-governmental organization.
4. The United Nations Educational, Scientific and Cultural Organization may, on its own initiative, make proposals to States Parties to this Convention for its implementation.
5. At the request of at least two States Parties to this Convention which are engaged in a dispute over its implementation, UNESCO may extend its good offices to reach a settlement between them.

ARTICLE 18

This Convention is drawn up in English, French, Russian and Spanish, the four texts being equally authoritative.

ARTICLE 19

1. This Convention shall be subject to ratification or acceptance by States Members of the United Nations Educational, Scientific and Cultural Organization in accordance with their respective constitutional procedures.
2. The instruments of ratification or acceptance shall be deposited with the Director-General of the United Nations Educational, Scientific and Cultural Organization.

ARTICLE 20

1. This Convention shall be open to accession by all States not members of the United Nations Educational, Scientific and Cultural Organization which are invited to accede to it by the Executive Board of the Organization.
2. Accession shall be effected by the deposit of an instrument of accession with the Director-General of the United Nations Educational, Scientific and Cultural Organization.

ARTICLE 21

This Convention shall enter into force three months after the date of the deposit of the third instrument of ratification, acceptance or accession, but only with respect to those States which have deposited their respective instruments on or before that date. It shall enter into force with respect to any other State three months after the deposit of its instrument of ratification, acceptance or accession.

ARTICLE 22

The States Parties to this Convention recognize that the Convention is applicable not only to their metropolitan territories but also to all territories for the international relations of which they are responsible; they undertake to consult, if necessary, the governments or other competent authorities of these territories on or before ratification, acceptance or accession with a view to securing the application of

the Convention to those territories, and to notify the Director-General of the United Nations Educational, Scientific and Cultural Organization of the territories to which it is applied, the notification to take effect three months after the date of its receipt.

ARTICLE 23

1. Each State Party to this Convention may denounce the Convention on its own behalf or on behalf of any territory for whose international relations it is responsible.

2. The denunciation shall be notified by an instrument in writing, deposited with the Director-General of the United Nations Educational, Scientific and Cultural Organization.

3. The denunciation shall take effect twelve months after the receipt of the instrument of denunciation.

ARTICLE 24

The Director-General of the United Nations Educational, Scientific and Cultural Organization shall inform the States members of the Organization, the States not members of the Organization which are referred to in Article 20, as well as the United Nations, of the deposit of all the instruments of ratification, acceptance and accession provided for in Articles 19 and 20, and of the notifications and denunciations provided for in Articles 22 and 23 respectively.

ARTICLE 25

1. This Convention may be revised by the General Conference of the United Nations Educational, Scientific and Cultural Organization. Any such revision shall, however, bind only the States which shall become Parties to the revising convention.

2. If the General Conference should adopt a new convention revising this Convention in whole or in part, then, unless the new convention otherwise provides, this Convention shall cease to be open to ratification, acceptance or accession, as from the date on which the new revising convention enters into force.

ARTICLE 26

In conformity with Article 102 of the Charter of the United Nations, this Convention shall be registered with the Secretariat of the United Nations at the request of the Director-General of the United Nations Educational, Scientific and Cultural Organisation.

Done in Paris this seventeenth day of November 1970, in two authentic copies bearing the signature of the President of the sixteenth session of the General Conference and of the Director-General of the United Nations Educational, Scientific and Cultural Organisation, which shall be deposited in the archives of the United Nations Educational, Scientific and Cultural Organisation, and certified true copies of which shall be delivered to all the States referred to in Articles 19 and 20 as well as to the United Nations.

APPENDIX III

UNIDROIT CONVENTION ON STOLEN OR ILLEGALLY EXPORTED CULTURAL OBJECTS

THE STATES PARTIES TO THIS CONVENTION,

ASSEMBLED in Rome at the invitation of the Government of the Italian Republic from 7 to 24 June 1995 for a Diplomatic Conference for the adoption of the draft Unidroit Convention on the International Return of Stolen or Illegally Exported Cultural Objects,

CONVINCED of the fundamental importance of the protection of cultural heritage and of cultural exchanges for promoting understanding between peoples, and the dissemination of culture for the well-being of humanity and the progress of civilisation,

DEEPLY CONCERNED by the illicit trade in cultural objects and the irreparable damage frequently caused by it, both to these objects themselves and to the cultural heritage of national, tribal, indigenous or other communities, and also to the heritage of all peoples, and in particular by the pillage of archaeological sites and the resulting loss of irreplaceable archaeological, historical and scientific information,

DETERMINED to contribute effectively to the fight against illicit trade in cultural objects by taking the important step of establishing common, minimal legal rules for the restitution and return of cultural objects between Contracting States, with the objective of improving the preservation and protection of the cultural heritage in the interest of all,

EMPHASISING that this Convention is intended to facilitate the restitution and return of cultural objects, and that the provision of any remedies, such as compensation, needed to effect restitution and return in some States, does not imply that such remedies should be adopted in other States,

AFFIRMING that the adoption of the provisions of this Convention for the future in no way confers any approval or legitimacy upon illegal transactions of whatever kind which may have taken place before the entry into force of the Convention,

CONSCIOUS that this Convention will not by itself provide a solution to the problems raised by illicit trade, but that it initiates a process that will enhance international cultural co-operation and maintain a proper role for legal trading and inter-State agreements for cultural exchanges,

ACKNOWLEDGING that implementation of this Convention should be accompanied by other effective measures for protecting cultural objects, such as the development and use of registers, the physical protection of archaeological sites and technical co-operation,

RECOGNISING the work of various bodies to protect cultural property, particularly the 1970 UNESCO Convention on illicit traffic and the development of codes of conduct in the private sector,

HAVE AGREED as follows:

CHAPTER I — SCOPE OF APPLICATION AND DEFINITION

ARTICLE 1

This Convention applies to claims of an international character for:

(a) the restitution of stolen cultural objects;

(b) the return of cultural objects removed from the territory of a Contracting State contrary to its law regulating the export of cultural objects for the purpose of protecting its cultural heritage (hereinafter "illegally exported cultural objects").

ARTICLE 2

For the purposes of this Convention, cultural objects are those which, on religious or secular grounds, are of importance for archaeology, prehistory, history, literature, art or science and belong to one of the categories listed in the Annex to this Convention.

CHAPTER II — RESTITUTION OF STOLEN CULTURAL OBJECTS

ARTICLE 3

(1) The possessor of a cultural object which has been stolen shall return it.

(2) For the purposes of this Convention, a cultural object which has been unlawfully excavated or lawfully excavated but unlawfully retained shall be considered stolen, when consistent with the law of the State where the excavation took place.

(3) Any claim for restitution shall be brought within a period of three years from the time when the claimant knew the location of the cultural object and the identity of its possessor, and in any case within a period of fifty years from the time of the theft.

(4) However, a claim for restitution of a cultural object forming an integral part of an identified monument or archaeological site, or belonging to a public collection, shall not be subject to time limitations other than a period of three years from the time when the claimant knew the location of the cultural object and the identity of its possessor.

(5) Notwithstanding the provisions of the preceding paragraph, any Contracting State may declare that a claim is subject to a time limitation of 75 years or such longer period as is provided in its law. A claim made in another Contracting State for restitution of a cultural object displaced from a monument, archaeological site or public collection in a Contracting State making such a declaration shall also be subject to that time limitation.

(6) A declaration referred to in the preceding paragraph shall be made at the time of signature, ratification, acceptance, approval or accession.

(7) For the purposes of this Convention, a "public collection" consists of a group of inventoried or otherwise identified cultural objects owned by:

 (a) a Contracting State

 (b) a regional or local authority of a Contracting State;

 (c) a religious institution in a Contracting State; or

 (d) an institution that is established for an essentially cultural, educational or scientific purpose in a Contracting State and is recognized in that State as serving the public interest.

(8) In addition, a claim for restitution of a sacred or communally important cultural object belonging to and used by a tribal or indigenous community in a Contracting State as part of that community's traditional or ritual use, shall be subject to the time limitation applicable to public collections.

ARTICLE 4

(1) The possessor of a stolen cultural object required to return it shall be entitled, at the time of its restitution, to payment of fair and reasonable compensation provided that the possessor neither knew nor ought reasonably to have known that the object was stolen and can prove that it exercised due diligence when acquiring the object.

(2) Without prejudice to the right of the possessor to compensation referred to in the preceding paragraph, reasonable efforts shall be made to have the person who transferred the cultural object to the possessor, or any prior transferor, pay the compensation where to do so would be consistent with the law of the State in which the claim is brought.

(3) Payment of compensation to the possessor by the claimant, when this is

required, shall be without prejudice to the right of the claimant to recover it from any other person.

(4) In determining whether the possessor exercised due diligence, regard shall be had to all the circumstances of the acquisition, including the character of the parties, the price paid, whether the possessor consulted any reasonably accessible register of stolen cultural objects, and any other relevant information and documentation which it could reasonably have obtained, and whether the possessor consulted accessible agencies or took any other step that a reasonable person would have taken in the circumstances.

(5) The possessor shall not be in a more favourable position than the person from whom it acquired the cultural object by inheritance or otherwise gratuitously.

CHAPTER III — RETURN OF ILLEGALLY EXPORTED CULTURAL OBJECTS

ARTICLE 5

(1) A Contracting State may request the court or other competent authority of another Contracting State to order the return of a cultural object illegally exported from the territory of the requesting State.

(2) A cultural object which has been temporarily exported from the territory of the requesting State, for purposes such as exhibition, research or restoration, under a permit issued according to its law regulating its export for the purpose of protecting its cultural heritage and not returned in accordance with the terms of that permit shall be deemed to have been illegally exported.

(3) The court or other competent authority of the State addressed shall order the return of an illegally exported cultural object if the requesting State establishes that the removal of the object from its territory significantly impairs one or more of the following interests:

(a) the physical preservation of the object or its context;
(b) the integrity of a complex object;
(c) the preservation of information of, for example, a scientific or historical character;
(d) the traditional or ritual use of the object by a tribal or indigenous community,

or establishes that the object is of significant cultural importance for the requesting State.

(4) Any request made under paragraph 1 of this article shall contain or be accompanied by such information of a factual or legal nature as may assist the court or other competent authority of the State addressed in determining whether the requirements of paragraphs 1 to 3 have been met.

(5) Any request for return shall be brought within a period of three years from the time when the requesting State knew the location of the cultural object and the identity of its possessor, and in any case within a period of fifty years from the date of the export or from the date on which the object should have been returned under a permit referred to in paragraph 2 of this article.

ARTICLE 6

(1) The possessor of a cultural object who acquired the object after it was illegally exported shall be entitled, at the time of its return, to payment by the requesting State of fair and reasonable compensation, provided that the possessor neither knew nor ought reasonably to have known at the time of acquisition that the object had been illegally exported.

(2) In determining whether the possessor knew or ought reasonably to have known that the cultural object had been illegally exported, regard shall be had to the circumstances of the acquisition, including the absence of an export certificate required under the law of the requesting State.

(3) Instead of compensation, and in agreement with the requesting State, the possessor required to return the cultural object to that State, may decide:

 (a) to retain ownership of the object; or

 (b) to transfer ownership against payment or gratuitously to a person of its choice residing in the requesting State who provides the necessary guarantees.

(4) The cost of returning the cultural object in accordance with this article shall be borne by the requesting State, without prejudice to the right of that State to recover costs from any other person.

(5) The possessor shall not be in a more favourable position than the person from whom it acquired the cultural object by inheritance or otherwise gratuitously.

ARTICLE 7

(1) The provisions of this Chapter shall not apply where:

 (a) the export of a cultural object is no longer illegal at the time at which the return is requested; or

 (b) the object was exported during the lifetime of the person who created it or within a period of fifty years following the death of that person.

(2) Notwithstanding the provisions of sub-paragraph (b) of the preceding paragraph, the provisions of this Chapter shall apply where a cultural object was made by a member or members of a tribal or indigenous community for traditional or ritual use by that community and the object will be returned to that community.

CHAPTER IV — GENERAL PROVISIONS

ARTICLE 8

(1) A claim under Chapter II and a request under Chapter III may be brought before the courts or other competent authorities of the Contracting State where the cultural object is located, in addition to the courts or other competent authorities otherwise having jurisdiction under the rules in force in Contracting States.

(2) The parties may agree to submit the dispute to any court or other competent authority or to arbitration.

(3) Resort may be had to the provisional, including protective, measures available under the law of the Contracting State where the object is located even when the claim for restitution or request for return of the object is brought before the courts or other competent authorities of another Contracting State.

ARTICLE 9

(1) Nothing in this Convention shall prevent a Contracting State from applying any rules more favourable to the restitution or the return of stolen or illegally exported cultural objects than provided for by this Convention.

(2) This article shall not be interpreted as creating an obligation to recognise or enforce a decision of a court or other competent authority of another Contracting State that departs from the provisions of this Convention.

ARTICLE 10

(1) The provisions of Chapter II shall apply only in respect of a cultural object that is stolen after this Convention enters into force in respect of the State where the claim is brought, provided that:

 (a) the object was stolen from the territory of a Contracting State after the entry into force of this Convention for that State; or

 (b) the object is located in a Contracting State after the entry into force of the Convention for that State.

(2) The provisions of Chapter III shall apply only in respect of a cultural object that is illegally exported after this Convention enters into force for the requesting State as well as the State where the request is brought.

(3) This Convention does not in any way legitimise any illegal transaction of whatever nature which has taken place before the entry into force of this Convention or which is excluded under paragraphs (1) or (2) of this article, nor limit any right of a State or other person to make a claim under remedies available outside the framework of this Convention for the restitution or return of a cultural object stolen or illegally exported before the entry into force of this Convention.

CHAPTER V — FINAL PROVISIONS

ARTICLE 11

(1) This Convention is open for signature at the concluding meeting of the Diplomatic Conference for the adoption of the draft Unidroit Convention on the International Return of Stolen or Illegally Exported Cultural Objects and will remain open for signature by all States at Rome until 30 June 1996.
(2) This Convention is subject to ratification, acceptance or approval by States which have signed it.
(3) This Convention is open for accession by all States which are not signatory States as from the date it is open for signature.
(4) Ratification, acceptance, approval or accession is subject to the deposit of a formal instrument to that effect with the depositary.

ARTICLE 12

(1) This Convention shall enter into force on the first day of the sixth month following the date of deposit of the fifth instrument of ratification, acceptance, approval or accession.
(2) For each State that ratifies, accepts, approves or accedes to this Convention after the deposit of the fifth instrument of ratification, acceptance, approval or accession, this Convention shall enter into force in respect of that State on the first day of the sixth month following the date of deposit of its instrument of ratification, acceptance, approval or accession.

ARTICLE 13

(1) This Convention does not affect any international instrument by which any Contracting State is legally bound and which contains provisions on matters governed by this Convention, unless a contrary declaration is made by the States bound by such instrument.
(2) Any Contracting State may enter into agreements with one or more Contracting States, with a view to improving the application of this Convention in their mutual relations. The States which have concluded such an agreement shall transmit a copy to the depositary.
(3) In their relations with each other, Contracting States which are Members of organisations of economic integration or regional bodies may declare that they will apply the internal rules of these organisations or bodies and will not therefore apply as between these States the provisions of this Convention the scope of application of which coincides with that of those rules.

ARTICLE 14

(1) If a Contracting State has two or more territorial units, whether or not possessing different systems of law applicable in relation to the matters dealt with in this Convention, it may, at the time of signature or of the deposit of its instrument of ratification, acceptance, approval or accession, declare that this Convention is to extend to all its territorial units or only to one or more of them, and may substitute for its declaration another declaration at any time.

(2) These declarations are to be notified to the depositary and are to state expressly the territorial units to which the Convention extends.

(3) If, by virtue of a declaration under this article, this Convention extends to one or more but not all of the territorial units of a Contracting State, the reference to:

(a) the territory of a Contracting State in Article 1 shall be construed as referring to the territory of a territorial unit of that State;

(b) a court or other competent authority of the Contracting State or of the State addressed shall be construed as referring to the court or other competent authority of a territorial unit of that State;

(c) the Contracting State where the cultural object is located in Article 8 (1) shall be construed as referring to the territorial unit of that State where the object is located;

(d) the law of the Contracting State where the object is located in Article 8 (3) shall be construed as referring to the law of the territorial unit of that State where the object is located; and

(e) a Contracting State in Article 9 shall be construed as referring to a territorial unit of that State.

(4) If a Contracting State makes no declaration under paragraph 1 of this article, this Convention is to extend to all territorial units of that State.

ARTICLE 15

(1) Declarations made under this Convention at the time of signature are subject to confirmation upon ratification, acceptance or approval.

(2) Declarations and confirmations of declarations are to be in writing and to be formally notified to the depositary.

(3) A declaration shall take effect simultaneously with the entry into force of this Convention in respect of the State concerned. However, a declaration of which the depositary receives formal notification after such entry into force shall take effect on the first day of the sixth month following the date of its deposit with the depositary.

(4) Any State which makes a declaration under this Convention may withdraw it at any time by a formal notification in writing addressed to the depositary. Such withdrawal shall take effect on the first day of the sixth month following the date of the deposit of the notification.

ARTICLE 16

(1) Each Contracting State shall at the time of signature, ratification, acceptance, approval or accession, declare that claims for the restitution, or requests for the return, of cultural objects brought by a State under Article 8 may be submitted to it under one or more of the following procedures:

(a) directly to the courts or other competent authorities of the declaring State;

(b) through an authority or authorities designated by that State to receive such claims or requests and to forward them to the courts or other competent authorities of that State;

(c) through diplomatic or consular channels.

(2) Each Contracting State may also designate the courts or other authorities competent to order the restitution or return of cultural objects under the provisions of Chapters II and III.

(3) Declarations made under paragraphs 1 and 2 of this article may be modified at any time by a new declaration.

(4) The provisions of paragraphs 1 to 3 of this article do not affect bilateral or

multilateral agreements on judicial assistance in respect of civil and commercial matters that may exist between Contracting States.

ARTICLE 17

Each Contracting State shall, no later than six months following the date of deposit of its instrument of ratification, acceptance, approval or accession, provide the depositary with written information in one of the official languages of the Convention concerning the legislation regulating the export of its cultural objects. This information shall be updated from time to time as appropriate.

ARTICLE 18

No reservations are permitted except those expressly authorised in this Convention.

ARTICLE 19

(1) This Convention may be denounced by any State Party, at any time after the date on which it enters into force for that State, by the deposit of an instrument to that effect with the depositary.

(2) A denunciation shall take effect on the first day of the sixth month following the deposit of the instrument of denunciation with the depositary. Where a longer period for the denunciation to take effect is specified in the instrument of denunciation it shall take effect upon the expiration of such longer period after its deposit with the depositary.

(3) Notwithstanding such a denunciation, this Convention shall nevertheless apply to a claim for restitution or a request for return of a cultural object submitted prior to the date on which the denunciation takes effect.

ARTICLE 20

The President of the International Institute for the Unification of Private Law (Unidroit) may at regular intervals, or at any time at the request of five Contracting States, convene a special committee in order to review the practical operation of this Convention.

ARTICLE 21

(1) This Convention shall be deposited with the Government of the Italian Republic.

(2) The Government of the Italian Republic shall:

 (a) inform all States which have signed or acceded to this Convention and the President of the International Institute for the Unification of Private Law (Unidroit) of:

 (i) each new signature or deposit of an instrument of ratification, acceptance, approval or accession, together with the date thereof;

 (ii) each declaration made in accordance with this Convention;

 (iii) the withdrawal of any declaration;

 (iv) the date of entry into force of this Convention;

 (v) the agreements referred to in Article 13;

 (vi) the deposit of an instrument of denunciation of this Convention together with the date of its deposit and the date on which it takes effect;

 (b) transmit certified true copies of this Convention to all signatory States, to all States acceding to the Convention and to the President of the International Institute for the Unification for Private Law (Unidroit);

(c) perform such other functions customary for depositaries.

IN WITNESS WHEREOF the undersigned plenipotentiaries, being duly authorised, have signed this Convention.

DONE at Rome, this twenty-fourth day of June, one thousand nine hundred and ninety-five, in a single original, in the English and French languages, both texts being equally authentic.

ANNEX I

(a) Rare collections and specimens of fauna, flora, minerals and anatomy, and objects of palaeontological interest;
(b) property relating to history, including the history of science and technology and military and social history, to the life of national leaders, thinkers, scientists and artists and to events of national importance;
(c) products of archaeological excavations (including regular and clandestine) or of archaeological discoveries;
(d) elements of artistic or historical monuments or archaeological sites which have been dismembered;
(e) antiquities more than one hundred years old, such as inscriptions, coins and engraved seals;
(f) objects of ethnological interest;
(g) property of artistic interest, such as:
 (i) pictures, paintings and drawings produced entirely by hand on any support and in any material (excluding industrial designs and manufactured articles decorated by hand);
 (ii) original works of statuary art and sculpture in any material;
 (iii) original engravings, prints and lithographs;
 (iv) original artistic assemblages and montages in any material;
(h) rare manuscripts and incunabula, old books, documents and publications of special interest (historical, artistic, scientific, literary, etc.) singly or in collections;
(i) postage, revenue and similar stamps, singly or in collections;
(j) archives, including sound, photographic and cinematographic archives;
(k) articles of furniture more than one hundred years old and old musical instruments.

Appendix IV

Dealing in Cultural Objects (Offences) Act 2003

An Act to provide for an offence of acquiring, disposing of, importing or exporting tainted cultural objects, or agreeing or arranging to do so; and for connected purposes. [30th October 2003]

1 Offence of dealing in tainted cultural objects

(1) A person is guilty of an offence if he dishonestly deals in a cultural object that is tainted, knowing or believing that the object is tainted.

(2) It is immaterial whether he knows or believes that the object is a cultural object.

(3) A person guilty of the offence is liable—

(a) on conviction on indictment, to imprisonment for a term not exceeding seven years or a fine (or both),

(b) on summary conviction, to imprisonment for a term not exceeding six months or a fine not exceeding the statutory maximum (or both).

2 Meaning of "tainted cultural object"

(1) "Cultural object" means an object of historical, architectural or archaeological interest.

(2) A cultural object is tainted if, after the commencement of this Act—

(a) a person removes the object in a case falling within subsection (4) or he excavates the object, and

(b) the removal or excavation constitutes an offence.

(3) It is immaterial whether—

(a) the removal or excavation was done in the United Kingdom or elsewhere,

(b) the offence is committed under the law of a part of the United Kingdom or under the law of any other country or territory.

(4) An object is removed in a case falling within this subsection if—

(a) it is removed from a building or structure of historical, architectural or archaeological interest where the object has at any time formed part of the building or structure, or

(b) it is removed from a monument of such interest.

(5) "Monument" means—

(a) any work, cave or excavation,

(b) any site comprising the remains of any building or structure or of any work, cave or excavation,

(c) any site comprising, or comprising the remains of, any vehicle, vessel, aircraft or other movable structure, or part of any such thing.

(6) "Remains" includes any trace or sign of the previous existence of the thing in question.

(7) It is immaterial whether—

(a) a building, structure or work is above or below the surface of the land,

(b) a site is above or below water.

(8) This section has effect for the purposes of section 1.

3 Meaning of "deals in"

(1) A person deals in an object if (and only if) he—

(a) acquires, disposes of, imports or exports it,
(b) agrees with another to do an act mentioned in paragraph (a), or
(c) makes arrangements under which another person does such an act or under which another person agrees with a third person to do such an act.
(2) "Acquires" means buys, hires, borrows or accepts.
(3) "Disposes of" means sells, lets on hire, lends or gives.
(4) In relation to agreeing or arranging to do an act, it is immaterial whether the act is agreed or arranged to take place in the United Kingdom or elsewhere.
(5) This section has effect for the purposes of section 1.

4 Customs and Excise prosecutions

(1) Proceedings for an offence relating to the dealing in a tainted cultural object may be instituted by order of the Commissioners of Customs and Excise if it appears to them that the offence has involved the importation or exportation of such an object.
(2) An offence relates to the dealing in a tainted cultural object if it is—
(a) an offence under section 1, or
(b) an offence of inciting the commission of, or attempting or conspiring to commit, such an offence.
(3) Proceedings for an offence which are instituted under subsection (1) are to be commenced in the name of an officer, but may be continued by another officer.
(4) Where the Commissioners of Customs and Excise investigate, or propose to investigate, any matter with a view to determining—
(a) whether there are grounds for believing that a person has committed an offence which relates to the dealing in a tainted cultural object and which involves the importation or exportation of such an object, or
(b) whether a person should be prosecuted for such an offence, the matter is to be treated as an assigned matter within the meaning of the Customs and Excise Management Act 1979 (c. 2).
(5) Nothing in this section affects any powers of any person (including any officer) apart from this section.
(6) "Officer" means a person commissioned by the Commissioners of Customs and Excise under section 6(3) of the Customs and Excise Management Act 1979.

5 Offences by bodies corporate

(1) If an offence under section 1 committed by a body corporate is proved—
(a) to have been committed with the consent or connivance of an officer, or
(b) to be attributable to any neglect on his part,
he (as well as the body corporate) is guilty of the offence and liable to be proceeded against and punished accordingly.
(2) "Officer", in relation to a body corporate, means—
(a) a director, manager, secretary or other similar officer of the body,
(b) a person purporting to act in any such capacity.
(3) If the affairs of a body corporate are managed by its members, subsection (1) applies in relation to the acts and defaults of a member in connection with his functions of management as if he were a director of the body.

6 Short title, commencement and extent

(1) This Act may be cited as the Dealing in Cultural Objects (Offences) Act 2003.
(2) This Act comes into force at the end of the period of two months beginning with the day on which it is passed.
(3) This Act does not extend to Scotland.

INDEX

TABLE OF CASES

TABLE OF LEGISLATION